Superfine

TAILORING
BLACK STYLE

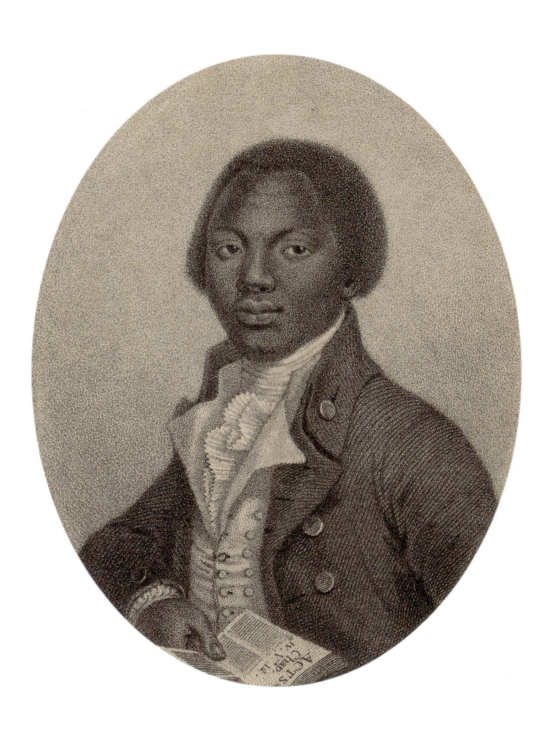

TAILORING BLACK STYLE

Monica L. Miller
with
Andrew Bolton
William DeGregorio
and
Amanda Garfinkel

photographs by
Tyler Mitchell

THE METROPOLITAN MUSEUM OF ART, NEW YORK
DISTRIBUTED BY YALE UNIVERSITY PRESS, NEW HAVEN AND LONDON

CONTENTS

7
Director's Foreword

9
Sponsor's Statement

10
Preface
ANDREW BOLTON

13
Portrait of the Modern Dandy
TYLER MITCHELL

47
"No Indifferent Appearance"
Superfine: Tailoring Black Style
MONICA L. MILLER

63
Ownership

89
Presence

105
Distinction

129
Disguise

147
Freedom

177
Champion

201
Respectability

223
Jook

245
Heritage

269
Beauty

289
Cool

313
Cosmopolitanism

333
Epilogue
IKÉ UDÉ

339
Making Superfine

Interviews with
TORKWASE DYSON
TANDA FRANCIS

350
Contributors

352
Checklist

361
Credits

362
Selected Readings

368
Acknowledgments

DIRECTOR'S FOREWORD

It is my pleasure to introduce *Superfine: Tailoring Black Style*, The Costume Institute's spring 2025 exhibition at The Metropolitan Museum of Art. This compelling show offers an enlightening examination of how fashion and style have enriched Black identities across the Atlantic diaspora. Focusing on a cultural and historical examination of the Black dandy, the exhibition and this catalogue feature rare historical garments alongside modern and contemporary men's fashion, as well as paintings, photographs, prints, and other significant objects. Together, these works illuminate key concepts of sartorial style and culture that emerged in Enlightenment Europe during the eighteenth century and that continue with today's twenty-first-century incarnations, created primarily by Black artists and designers in international cosmopolitan fashion centers. They also demonstrate the power of the dandy's signature tools—style, gesture, and wit—to break down limiting identity markers. The result is a groundbreaking presentation of men's clothing and adornments that celebrates the power of style as a democratic tool for challenging stereotypes and unlocking new possibilities for creativity and self-presentation.

The inspiration for this exhibition was the 2009 book *Slaves to Fashion: Black Dandyism and the Styling of Black Diasporic Identity*, authored by Monica L. Miller, Professor and Chair of Africana Studies at Barnard College, Columbia University. We are fortunate that Professor Miller agreed to guest curate the exhibition and contribute to this publication, expanding and updating her original work with new insights and information gathered since its release, particularly regarding costume and society. Andrew Bolton, Curator in Charge of

The Costume Institute, collaborated closely with her to develop and oversee this presentation with support from Associate Curators William DeGregorio and Amanda Garfinkel.

We also had the privilege of working with several extraordinary artists who contributed creatively to this project. Torkwase Dyson brought her experience as an artist and sculptor to the original design of the exhibition. Photographer Tyler Mitchell conceptualized and captured the images for the catalogue, photographing both in the studio and on location with live models. And artist Tanda Francis crafted the heads that were produced in multiples for the mannequins used in both the exhibition and the photography sessions.

Furthermore, this exhibition and its accompanying publication would not have been possible without the generous support of numerous organizations and individuals. Our deepest gratitude goes to Louis Vuitton for their lead sponsorship of both the exhibition and this year's Met Gala. We also extend our thanks to Instagram, the Hobson/Lucas Family Foundation, Africa Fashion International and Dr. Precious Moloi-Motsepe, and The Perry Foundation. We are especially grateful for the continued commitment from our longstanding partner Condé Nast, including CEO Roger Lynch and Chief Content Officer and Global Editorial Director Anna Wintour, a Museum trustee and tireless advocate for The Costume Institute's work.

Finally, I would like to express my heartfelt appreciation to the dedicated staff and individuals whose expertise has been instrumental in bringing this important exhibition to life.

MAX HOLLEIN
Marina Kellen French Director and CEO
The Metropolitan Museum of Art

SPONSOR'S STATEMENT

Louis Vuitton is honored to support *Superfine: Tailoring Black Style*, The Costume Institute's spring 2025 exhibition at The Metropolitan Museum of Art.

Illuminating the Black dandy, the exhibition and this accompanying catalogue spotlight the significance of sartorial style in the creation of Black identities in the Atlantic diaspora. The exploration is a reflection of themes and intents central to the practice of Pharrell Williams at Louis Vuitton. As men's creative director, Williams—who is co-chair of this year's Met Gala—consistently employs the medium of fashion to shine a light on the historical and contemporary impacts of Black cultures and subcultures on our present-day wardrobes, bringing attention to the unsung roots of the popular dress codes that bind us together across the world.

The dandy and the art of sartorialism serve as continuous leitmotifs in the men's collections of Louis Vuitton.

Williams views dandyism as a transformative tool for the notions of opportunity and enhancement at the heart of the philosophy that drives his work. In celebration of the Black dandy, Louis Vuitton's support of *Superfine: Tailoring Black Style* is a demonstration of the Maison's commitment to those core values.

The sponsorship expands on a legacy ignited by Virgil Abloh during his time at the Maison between 2018 and 2022. The late men's artistic director devoted his platform to representations of Black identities and the recognition of the Afro-diasporic canon of art. His imprint on fashion history is characterized by the documentation of Black cultures' influences on modern-day style for the enlightenment of future generations. Carried on by Pharrell Williams today, this objective embodies Louis Vuitton's support of *Superfine: Tailoring Black Style*.

LOUIS VUITTON

D IS FOR DANDY

ANDREW BOLTON

D

Dandy
An 18th century label for the obsessive male dresser later defined by Charles Baudelaire as the male aspiration to becoming "uninterruptedly sublime." Today, the term can be employed to describe sartorial values or looks. Also: an adjective for something great. "His penny loafers were just dandy."

—Virgil Abloh, "The Vocabulary According to Virgil Abloh," 4th ed., January 2020

Beginning with his inaugural spring/summer 2019 menswear collection for Louis Vuitton, Virgil Abloh—the first Black American artistic director of a French luxury fashion house—published extensive show notes that included "The Vocabulary According to Virgil Abloh." A list of words, phrases, and definitions that reads like a lexicographical stream of consciousness and that gives insights into his sources of inspiration and personal philosophies, Abloh's "Vocabulary" was updated and expanded with every collection. Accompanying his pre-fall 2020 collection, the fourth edition features *dandy* for the first time, defining the figure as "an 18th century label for the obsessive male dresser later defined by Charles Baudelaire as the male aspiration to becoming 'uninterruptedly sublime.' Today, the term can be employed to describe sartorial values or looks. Also: an adjective for something great. 'His penny loafers were just dandy.'" From his debut collection, which opened with a white tailored suit comprising a boxy double-breasted jacket and baggy pleated trousers, Abloh had drawn upon dandiacal modes of self-presentation—from Brummellian fastidiousness to Wildean flamboyance. While his pre-fall collection was no more dandified than his previous collections, its emphasis on "generational suiting" evidently prompted Abloh to include *dandy* in his "Vocabulary." The addition signaled Abloh's consciousness not only of the figure of the dandy specifically but also of his impact on Black style and culture more generally. This awareness played out in subsequent collections, perhaps most notably in his autumn/winter 2021–22 collection, which was deeply and profoundly inscribed with autobiographical references to his Ghanaian cultural heritage and his Illinoisan subcultural experiences.

Titled "Ebonics/Snake Oil/The Black Box/Mirror, Mirror"—the last element an allusion to the dandy's principal vehicle of self-scrutiny and a nod to Baudelaire's observation that "a *Dandy* should seek to be *sublime* without interruption; he should live and sleep in front of a *mirror*"—the collection was informed by James Baldwin's essay "Stranger in the Village," originally published in *Harper's Magazine* in October 1953. The essay recounts Baldwin's experiences visiting Leukerbad, Switzerland, where residents were fascinated by his Blackness, perceiving him as a "living wonder," in the words of the author. "From all available evidence," writes Baldwin, "no Black man had ever set foot in this tiny Swiss village before I came." Relating his feelings of isolation and alienation with those of the Black American experience, the story unfurls as a broader commentary on the history of race relations in the United States. In his collection—presented as a film directed by Wu Tsang titled *Peculiar Contrast, Perfect Light*, which centers on the spoken word, written and performed by Saul Williams, Kai-Isaiah Jamal, and Yasiin Bey (formerly known as Mos Def), and resonates with the poetics and politics of Black consciousness—Abloh used Baldwin's essay as a catalyst to explore the concept of the art heist as a metaphor for the biases instilled in our collective consciousness about the origin and ownership as well as the creation and consumption of art. This examination evolved into a meditation on the dialectic Abloh termed "Tourist vs. Purist," which appeared as a slogan on garments and accessories. "Tourist," he explains in the ninth edition of his "Vocabulary," published to accompany the collection, "defines the curious outsider, who observes and aspires towards an esoteric domain of knowledge, while Purist defines the consecrated insider, who already inhabits it." With no formal training in fashion (but with degrees in civil engineering and architecture), Abloh had coined the expression "Tourist vs. Purist" only hours after his appointment as artistic director of Louis Vuitton menswear in 2018, in the hope of reaching and reconciling "an understanding of the contrasting camps he would now occupy as a simultaneous outsider and insider in the fashion industry—one foot in the establishment, the other forever planted in the community that created him," as the "Ebonics" show notes elucidate.

In terms of the social practice of dandyism, Abloh's concept of "Tourist vs. Purist"—a society's binary structure of cultural outsiders versus insiders as reflected in the external

hostilities and internal anguishes described by Baldwin in his essay—pervades *Superfine: Tailoring Black Style*. As men who exist in the margins of masculinity and femininity, heterosexuality and homosexuality, dandies appear to be forever poised between the status of tourist and purist. When the figure is racialized, as it is with the Black dandy, his indeterminacy of gender and sexuality is both complicated and compounded by race, as well as class and nationality. However, his unique and singular indefiniteness—observed in the historically contested but transformative space between his skin and his clothing— enables, empowers, and emboldens the Black dandy to disrupt, destabilize, and deconstruct these normative categories of identity. The Black dandy's embodiment and arbitration of this intersection of limiting racial, sexual, gender, national, and economic identities at different times and places is the subject of this catalogue and related exhibition, which visualize and expand upon Monica L. Miller's groundbreaking 2009 book *Slaves to Fashion: Black Dandyism and the Styling of Black Diasporic Identity*. Our first exhibition devoted to menswear in more than twenty years, *Superfine: Tailoring Black Style* comes at a time of renewed interest in men's fashion, a renaissance being spearheaded by Black designers, many of whom are featured in the pages of this book. Highly cognizant of and particularly conversant in the history of Black style and Black visual representation, these creatives are actively participating in and contributing toward the ongoing discourse on Black dandyism that not only extends its aesthetic expressions but also reveals its political motivations. For The Costume Institute, *Superfine* reflects our ongoing commitment to the fundamental principles of diversity and inclusion in a way that is genuine and authentic to the department. Indeed, what makes it possible to transform Miller's pioneering book into an equally pioneering exhibition is our collection of high-style menswear, which serves as a foundation for imagining and realizing a sartorial history of Black dandyism.

Politically and aesthetically, Black dandyism is an expression of the Black imaginary, a concept that was central to Abloh's design practice at Louis Vuitton, as well as his own label, Off-White. Abloh included *Black Imagination* in the sixth edition of his "Vocabulary," published to accompany his spring/summer 2021 collection, defining it as "a term used for the transformative process of rethinking and overturning the inherited and often unconscious expectations tied to Black identities through history, and creating an encouraging Black consciousness for the present and future." In *Superfine*, the Black imaginary unfolds over twelve sections that encapsulate transhistorical and transatlantic expressions of Black dandyism. While reminiscent of Abloh's "Vocabulary," the words used to describe these thematic groupings and their related epigraphs (all quotations from Black voices) are, as a conceptual framework, inspired by Zora Neale Hurston's 1934 essay "The Characteristics of Negro Expression," in which she identifies twelve main elements of Black expressive culture. The sections in *Superfine* comprise a wide variety of objects that include not only fashion but also prints, drawings, paintings, and decorative arts to create self-contained illustrative tableaux vivants in which past, present, and future conceptions of Black dandyism are both presented and represented. This collaging of histories and materialities that telescope the past and the present situates Black dandyism within a broader cultural history of the imaging and imagining of Black masculinity. What transpires is a story of liberation and emancipation through sartorial experimentation, a story in which fashion, masculinity, and Blackness converge in expressions of self-creation and self-invention, self-possession and self-determination, self-enunciation and self-actualization. For the Black dandy, fashion can be a mode of freedom—freedom, that is, from the limiting identity markers of race, class, gender, sexuality, and nationality. In the context of *Superfine*, Black dandyism emerges as a tangible symbolic representation of the Black imaginary, offering a vision of the Black male body that is constituted outside of restrictive binaries and is defined inclusively and not in terms of opposition. Abloh declares in a January 14, 2021, interview in *Manifesto* magazine, "It is called *Black Imagination* because it is a way of manifesting Black dreams in real life." With his dream of living beyond the boundaries of racial, sexual, gender, national, and economic identities, the Black dandy is a compelling and captivating personification of the Black imaginary. As a figure that constantly questions and interrogates normative and essentialist conventions of masculinity and heterosexuality, the Black dandy both expresses and embodies the infinite and affirmative possibilities of the Black imaginary, a visualization of Black identity that is rooted in the past, plays out in the present, and is projected into the future.

PORTRAIT OF THE MODERN DANDY

—◆—

PHOTOGRAPHS BY
TYLER MITCHELL

Beauty was not simply something to behold; it was something one could do.
—Toni Morrison, *The Bluest Eye*, 1970

Look the part, be the part, motherfucker.
—Proposition Joe, "Game Day," *The Wire*, August 4, 2002

My understanding of the power and performance of clothes clicked long before I entered the world of fashion. A white friend visiting my hometown of Atlanta had marveled at how stylish Black people in the city were. What he noticed was something I had always known: our singular ability to "style out," to show up, "when the occasion calls for it, and, more tellingly, often when it does not," as Monica L. Miller writes in *Slaves to Fashion: Black Dandyism and the Styling of Black Diasporic Identity*. Whether donning a color-coordinated sweatsuit paired perfectly with a New Era hat, or an expertly tailored suit with complementary cufflinks, a tie bar, and a hat with the brim curled just right, Black people have long understood the transformative power of clothes and the stories they tell about who we are.

In this visual essay, my aim was not only to depict visions of profound camaraderie, beauty, and joy—though that alone would have been a worthy pursuit—but to explore how Black individuals have appropriated and transformed classical European fashion into something uniquely our own. Featuring models in garments from *Superfine: Tailoring Black Style* alongside fabulously self-styled men in vintage or the wearer's own attire, this project is a love letter to modern Black dandyism. It's about the embodiment of clothes and their wearers creating agency, self-possession, and what American writer and musician Greg Tate calls "the capacity to freak the mundane into magic."

When invited to contribute to this catalogue, I realized that this project had to go beyond documenting mannequins. It needed to capture the humanity, pride, playfulness, and intentional wit that define dandyism. These images celebrate how tailoring has always been radically reimagined and elevated by Black men across generations and throughout history.

I want to express my deepest gratitude to the incredible men and boys I photographed for this project. Your style, spirit, and confidence brought this vision to life, honoring not only the garments but the vibrant legacy of all that Black style, dandyism, and all-around flyness mean and have meant through time.

T. M.

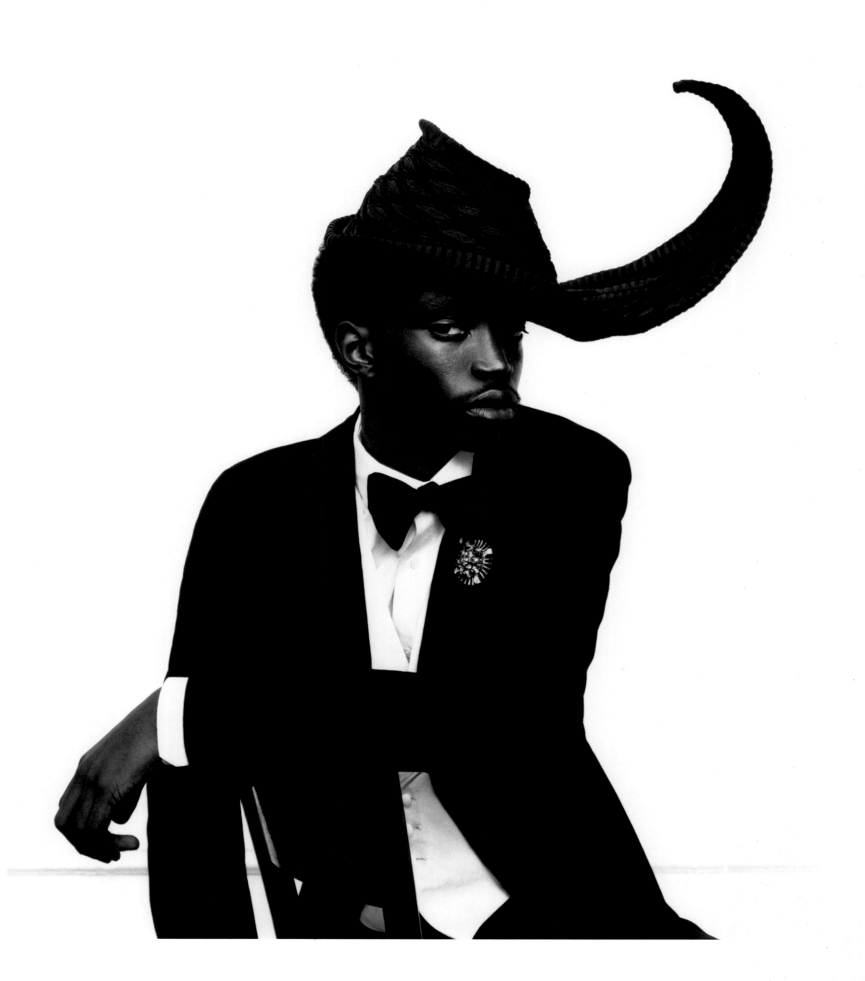

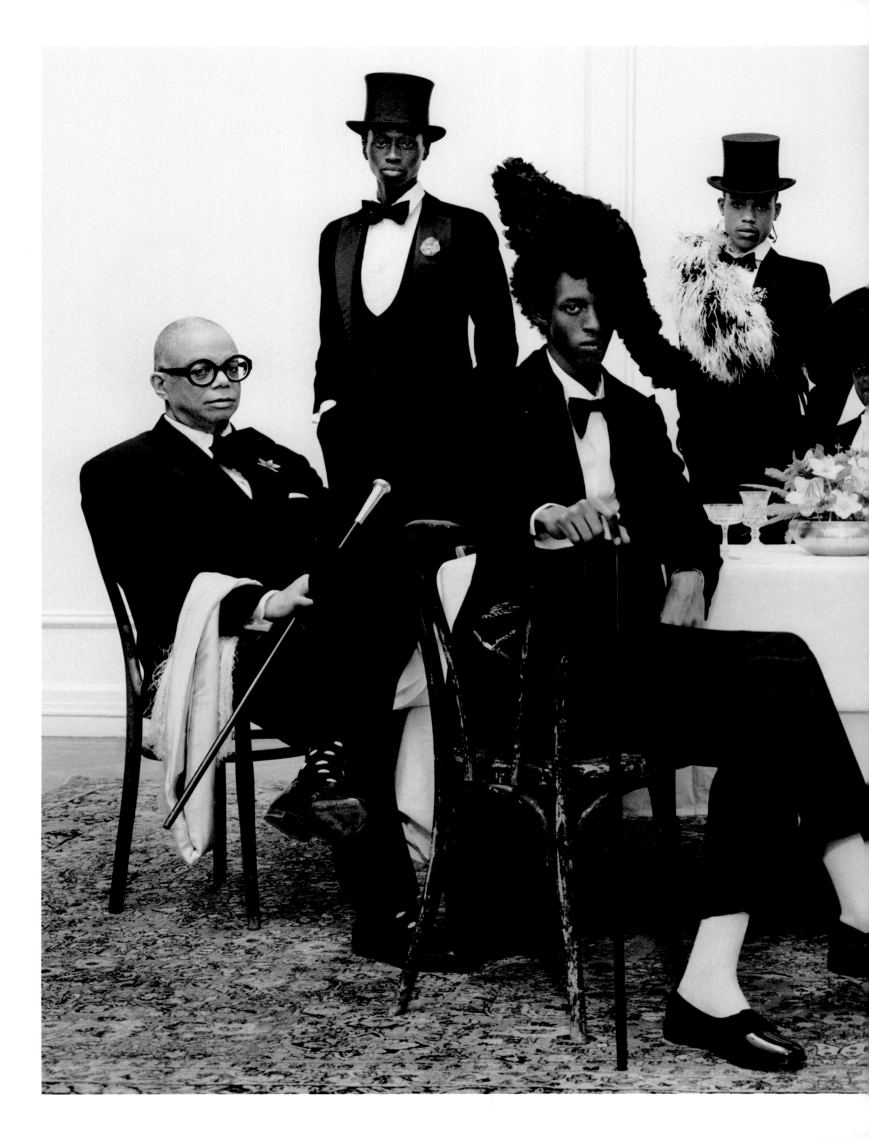

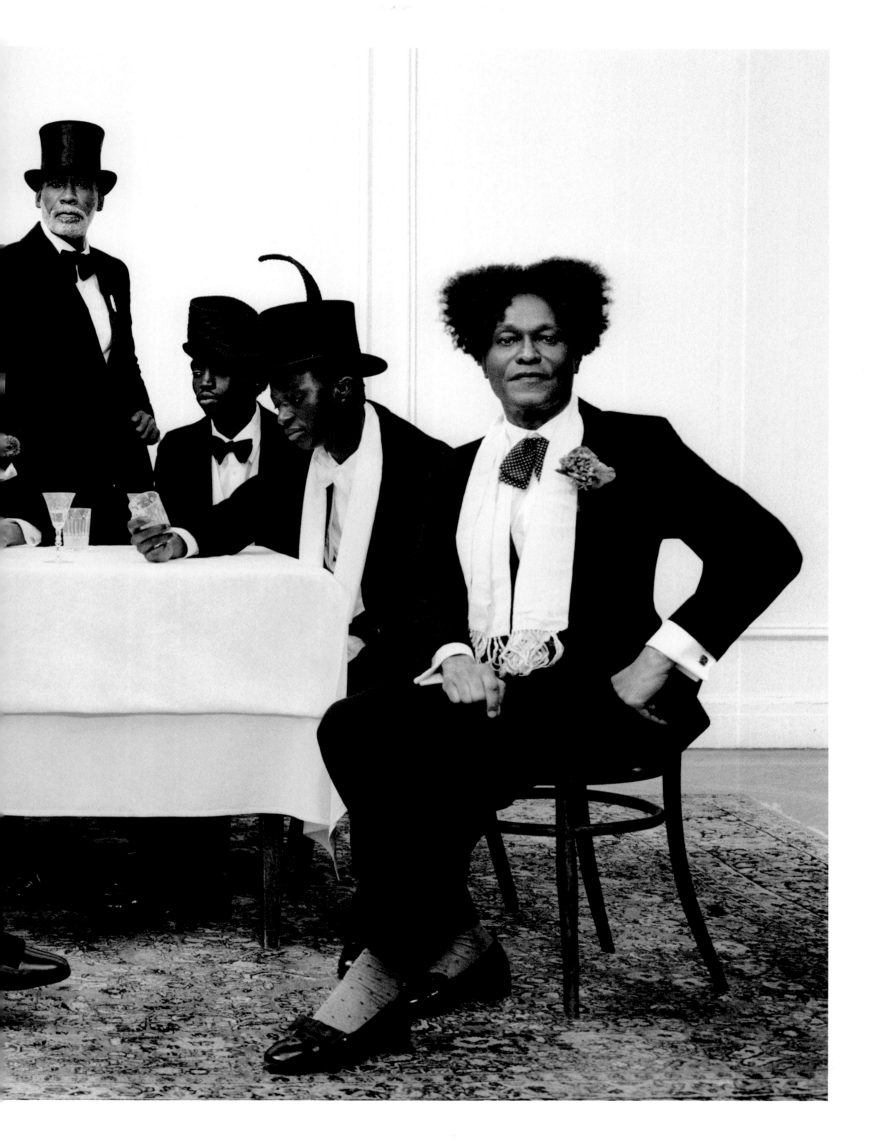

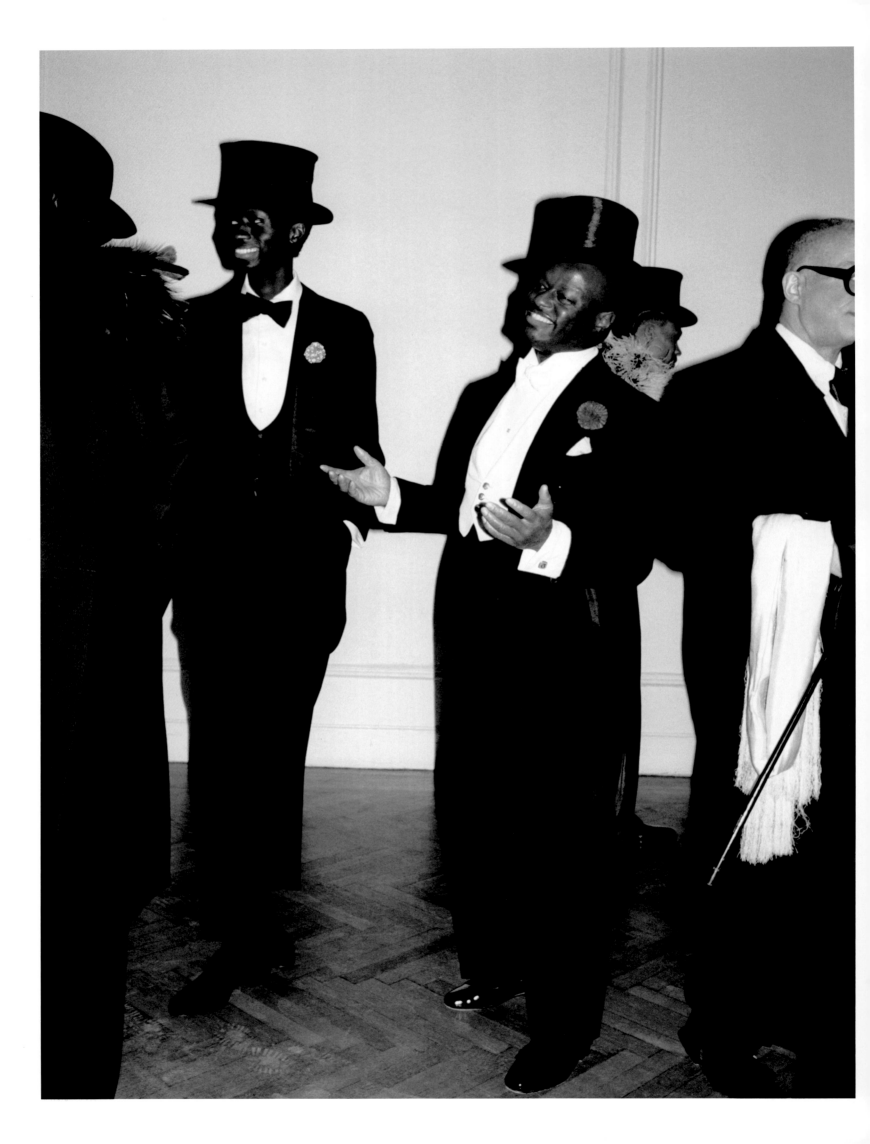

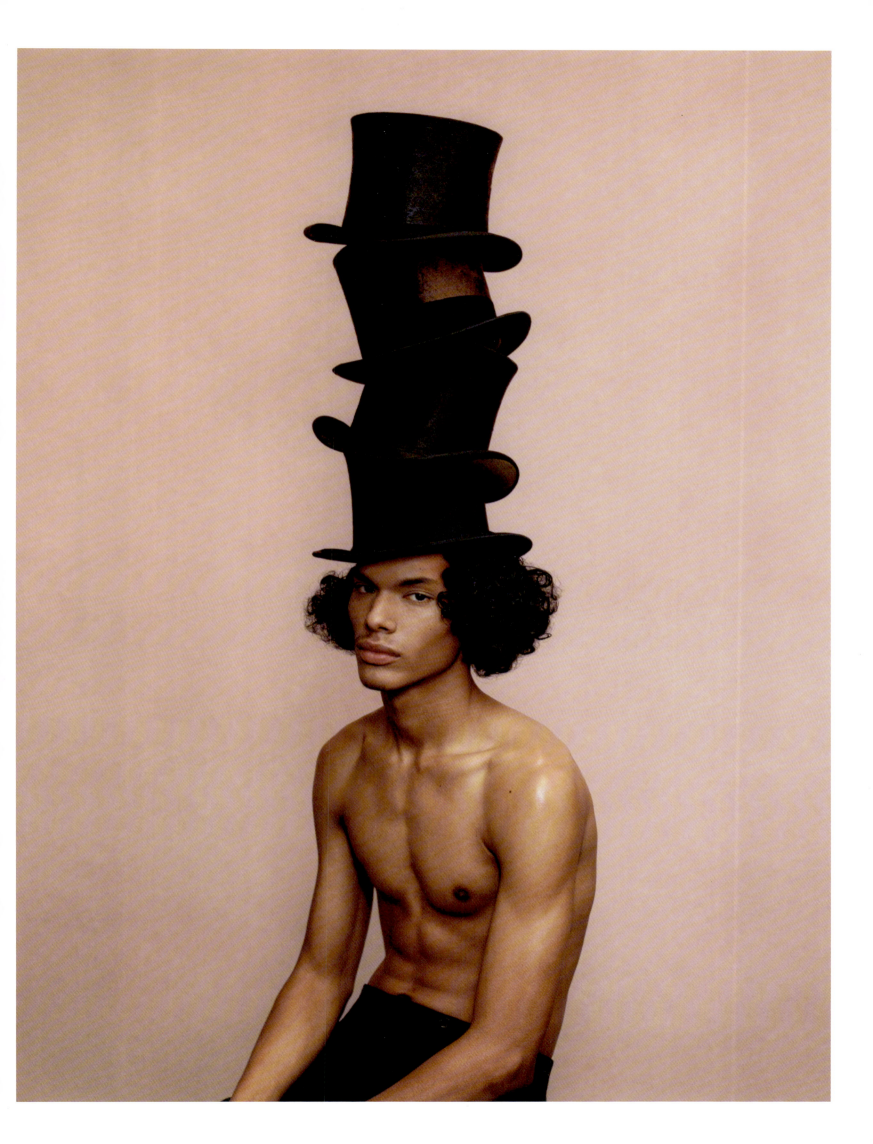

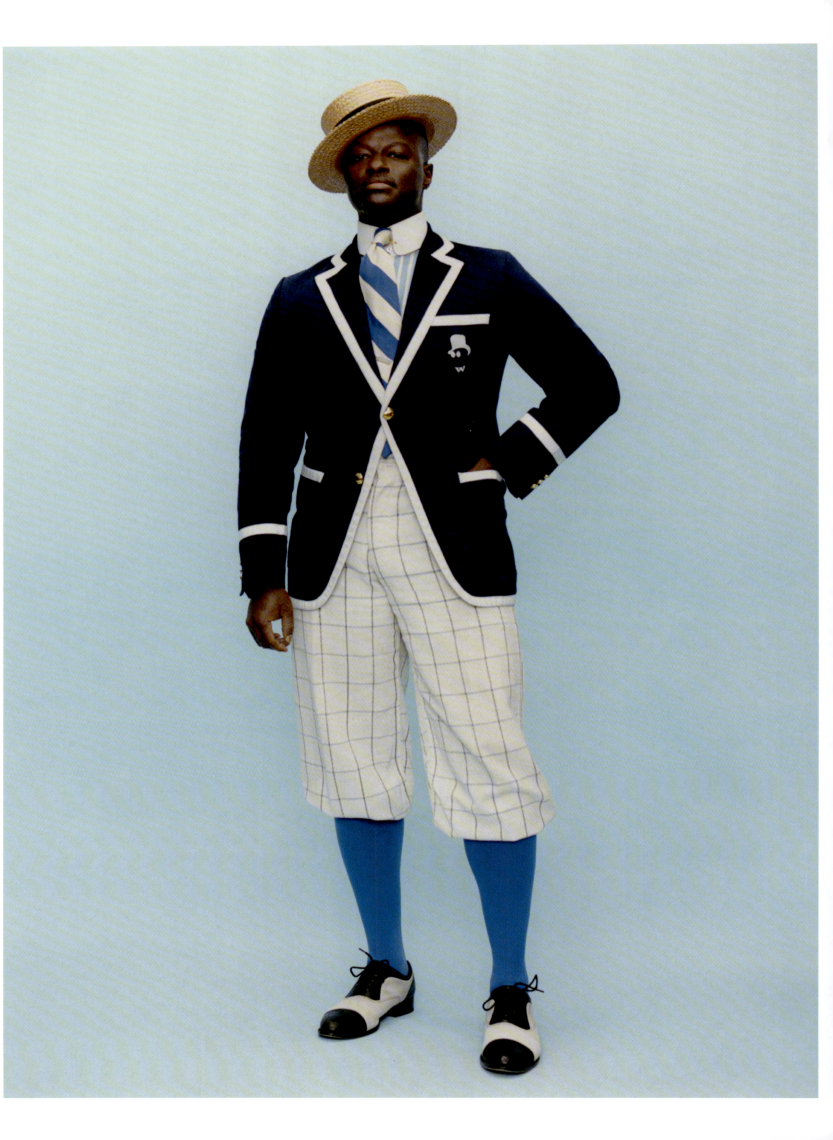

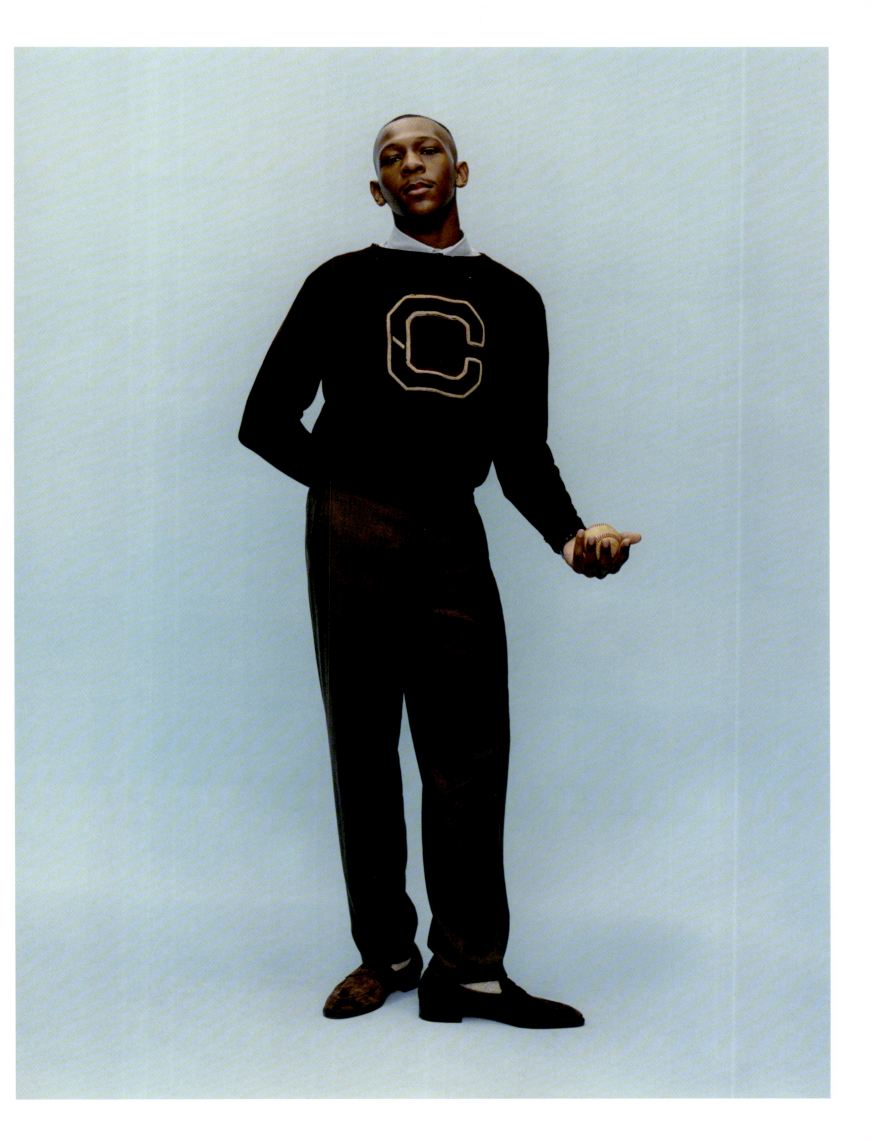

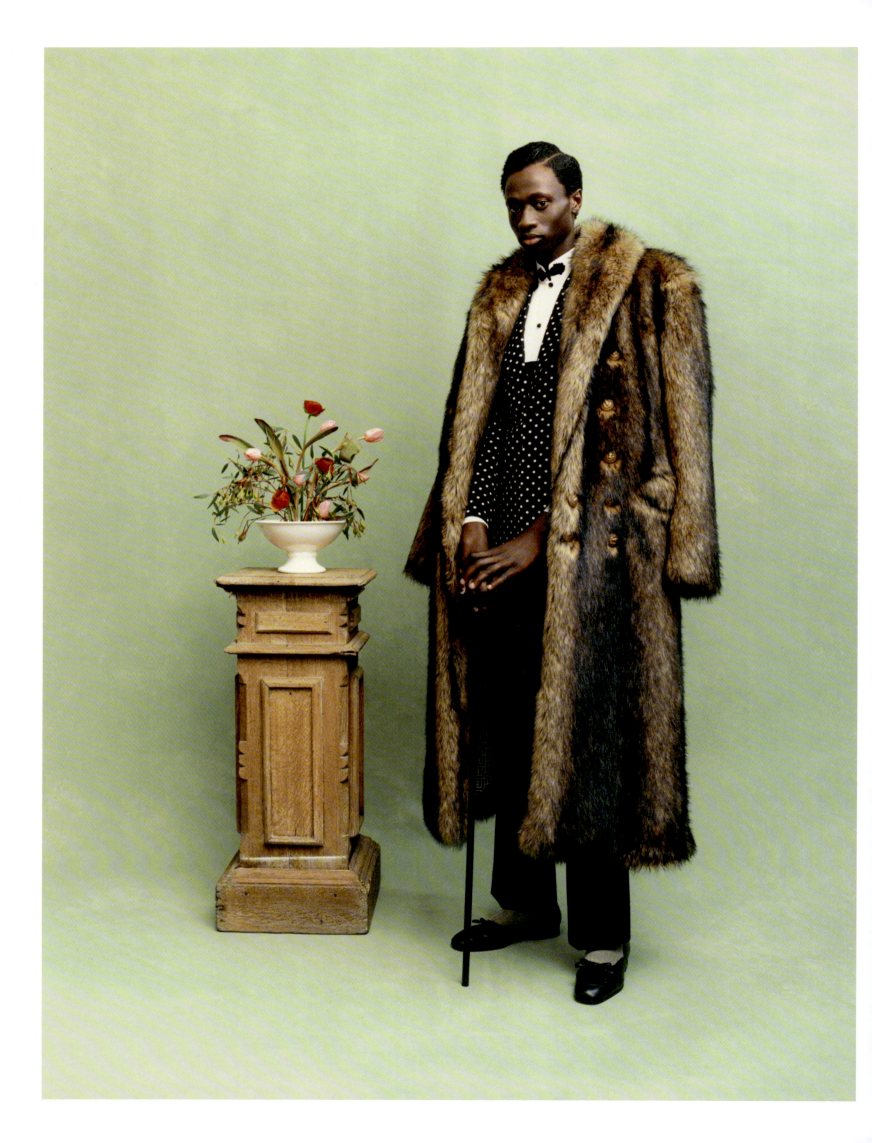

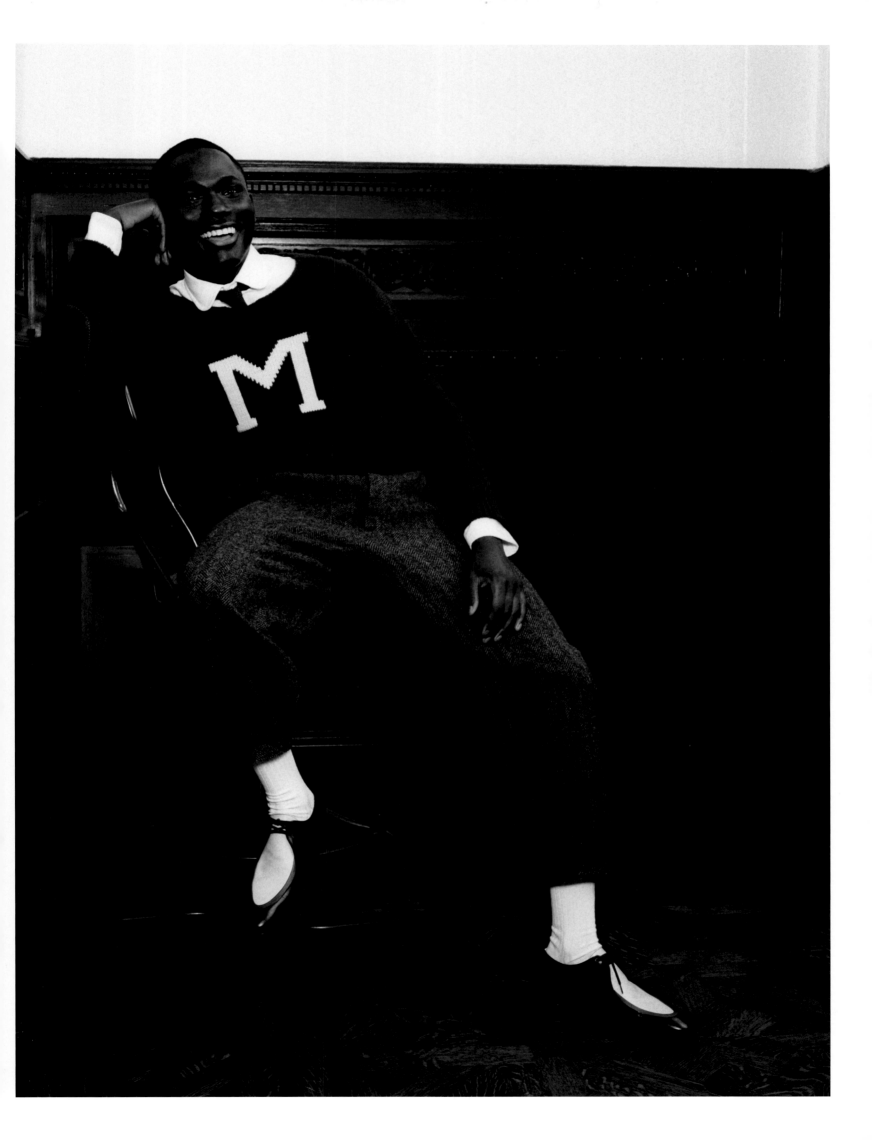

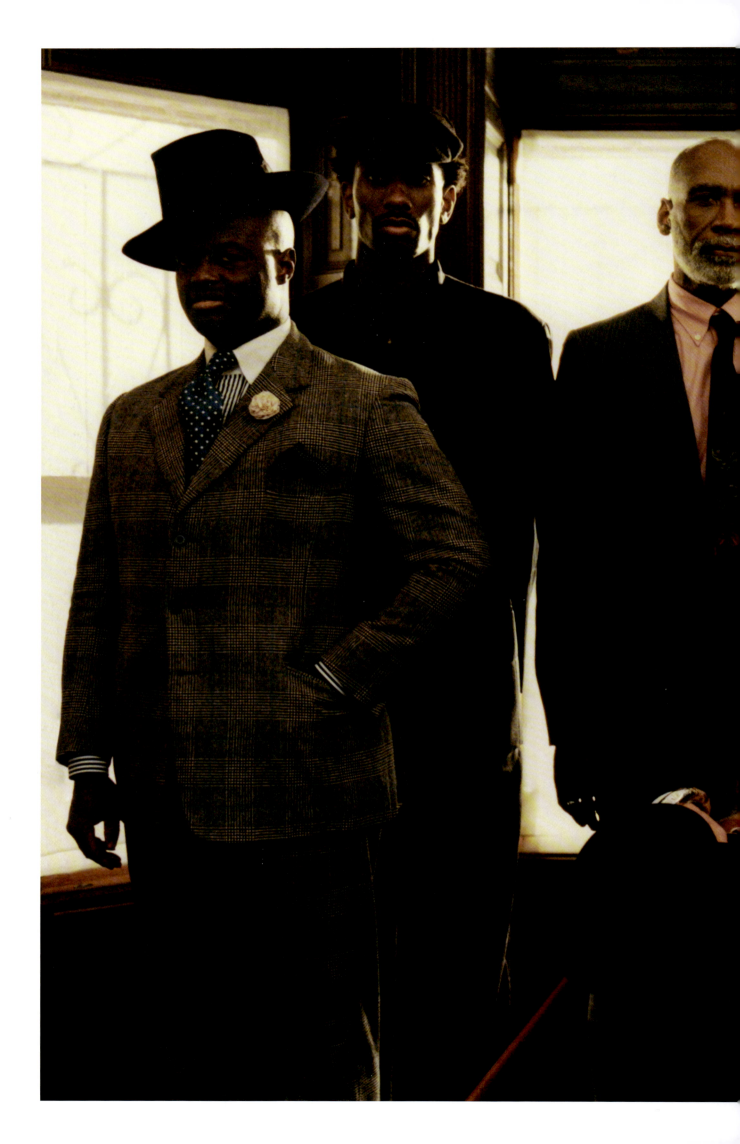

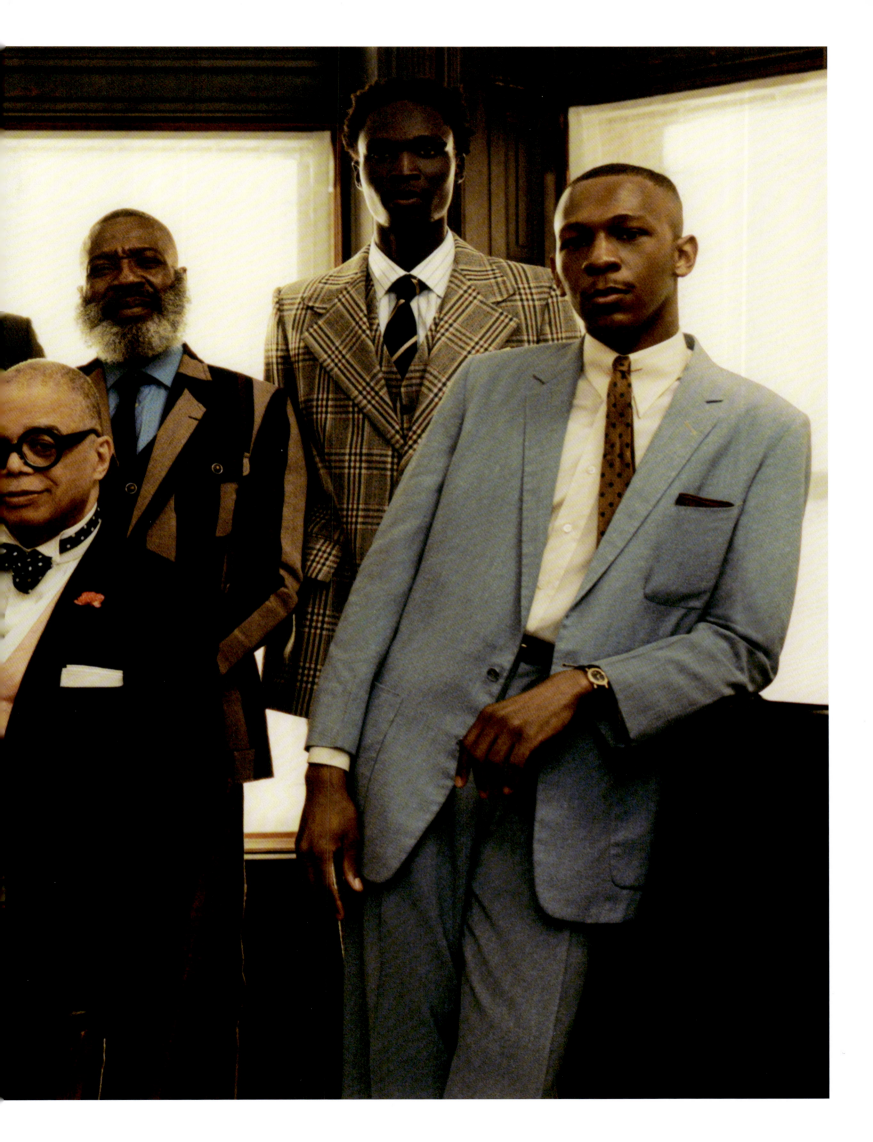

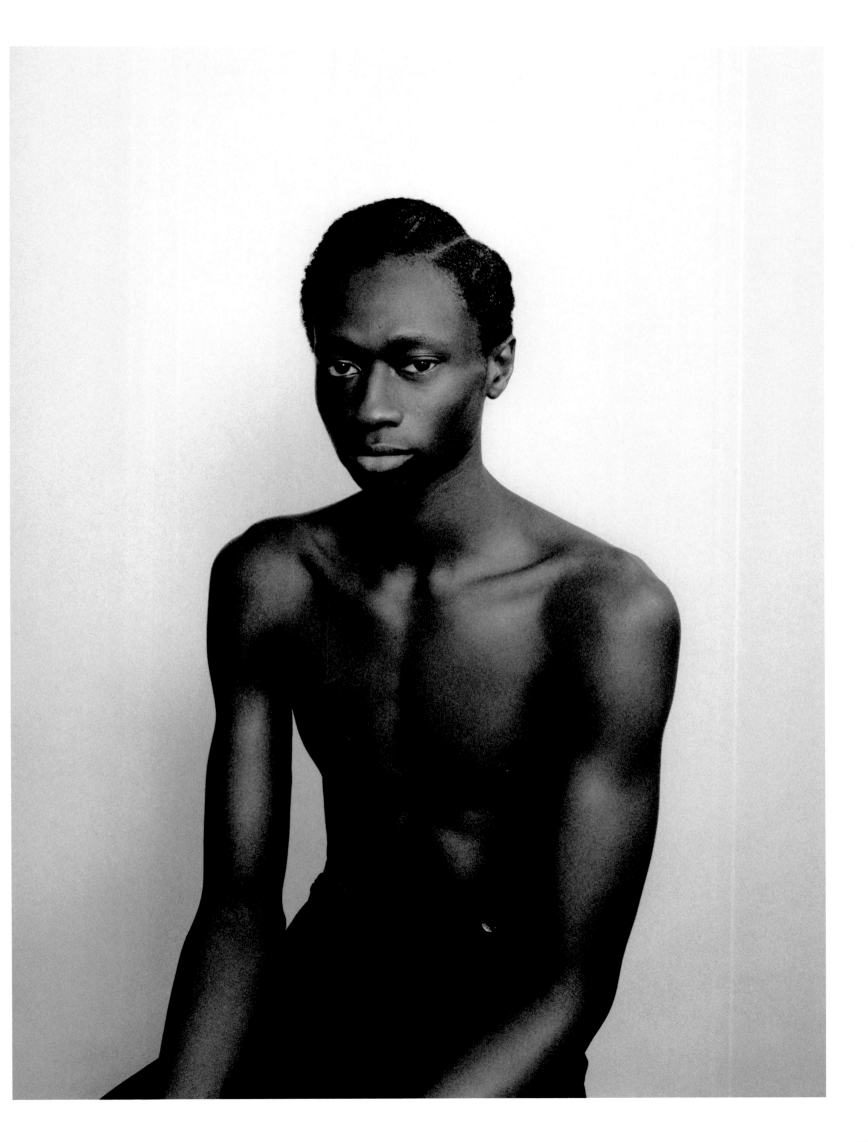

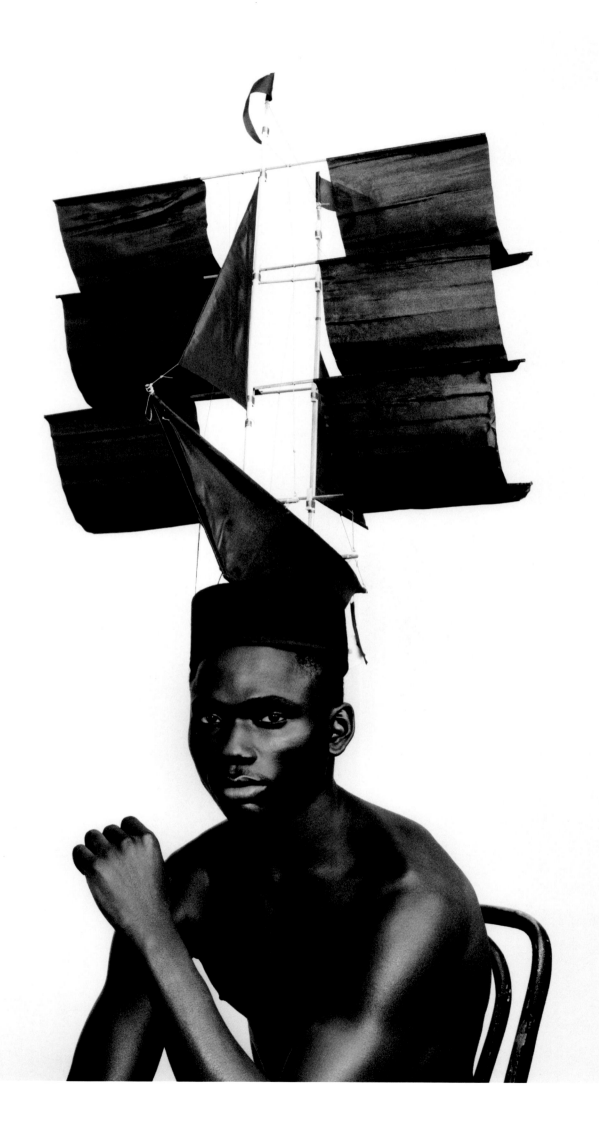

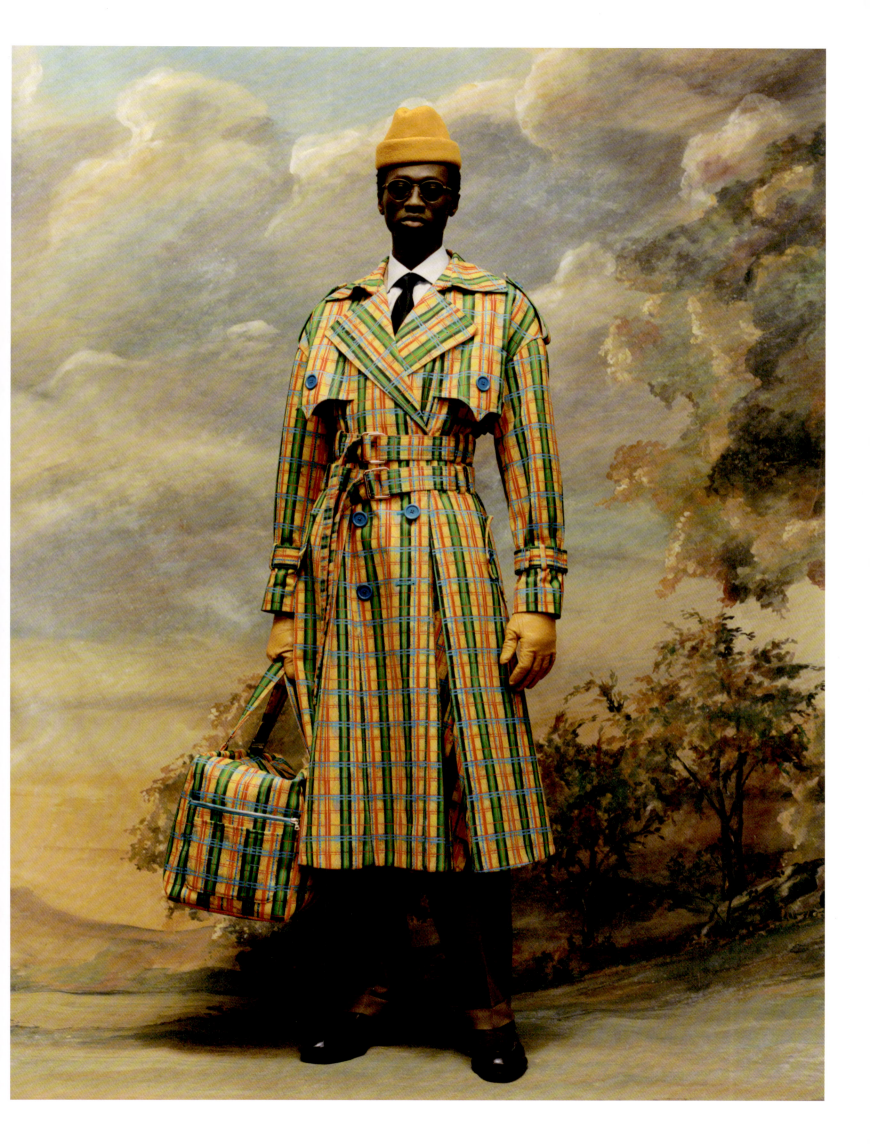

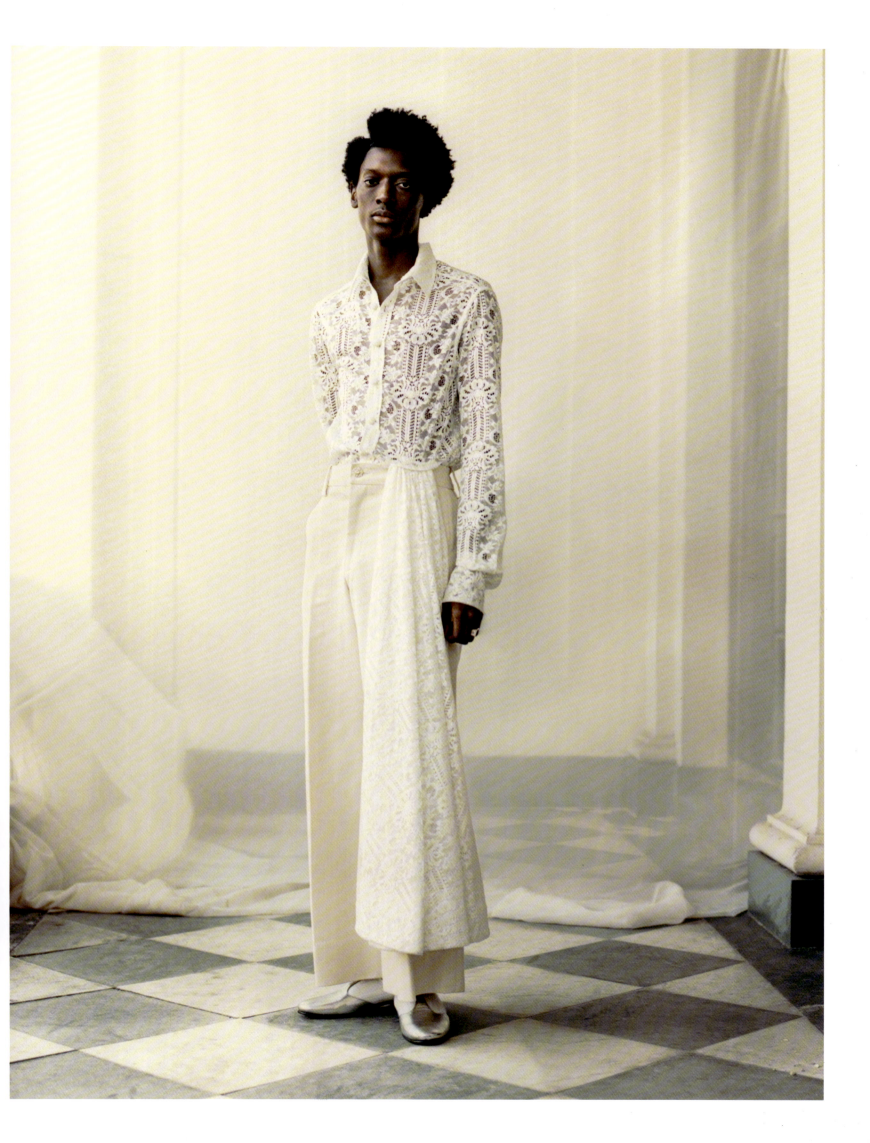

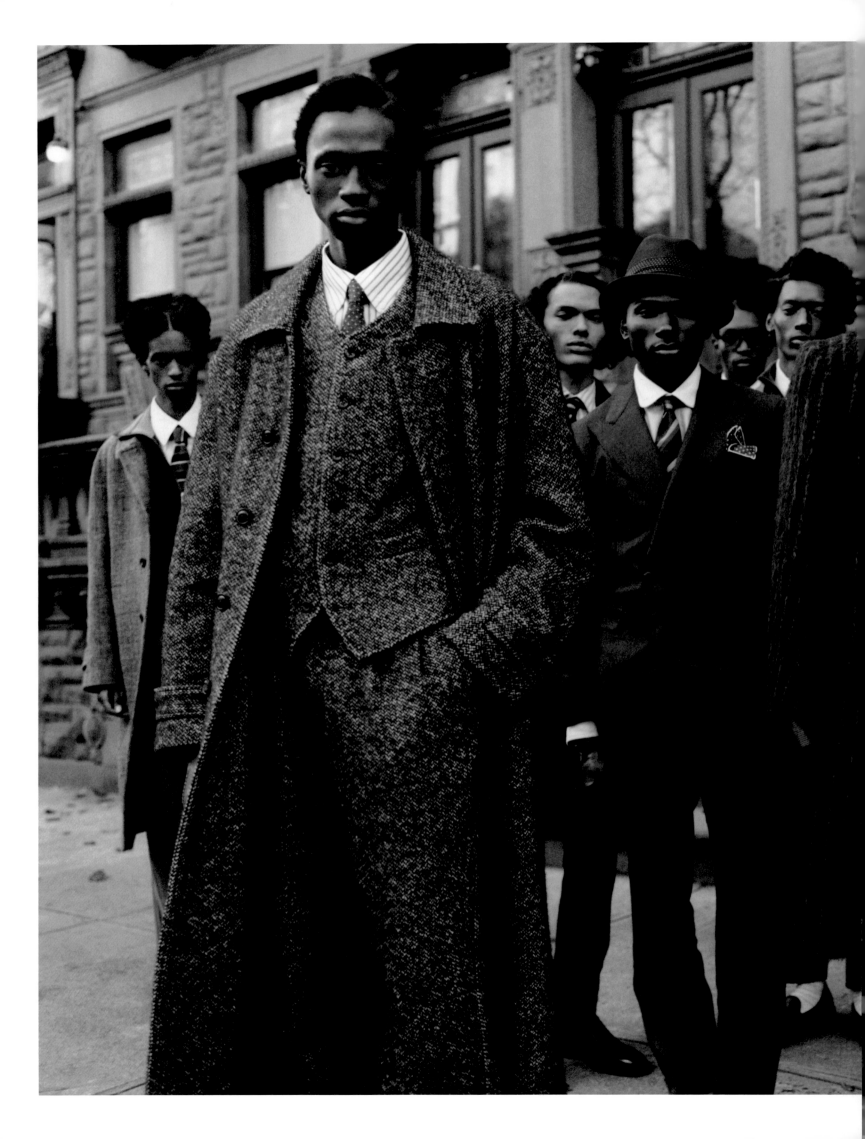

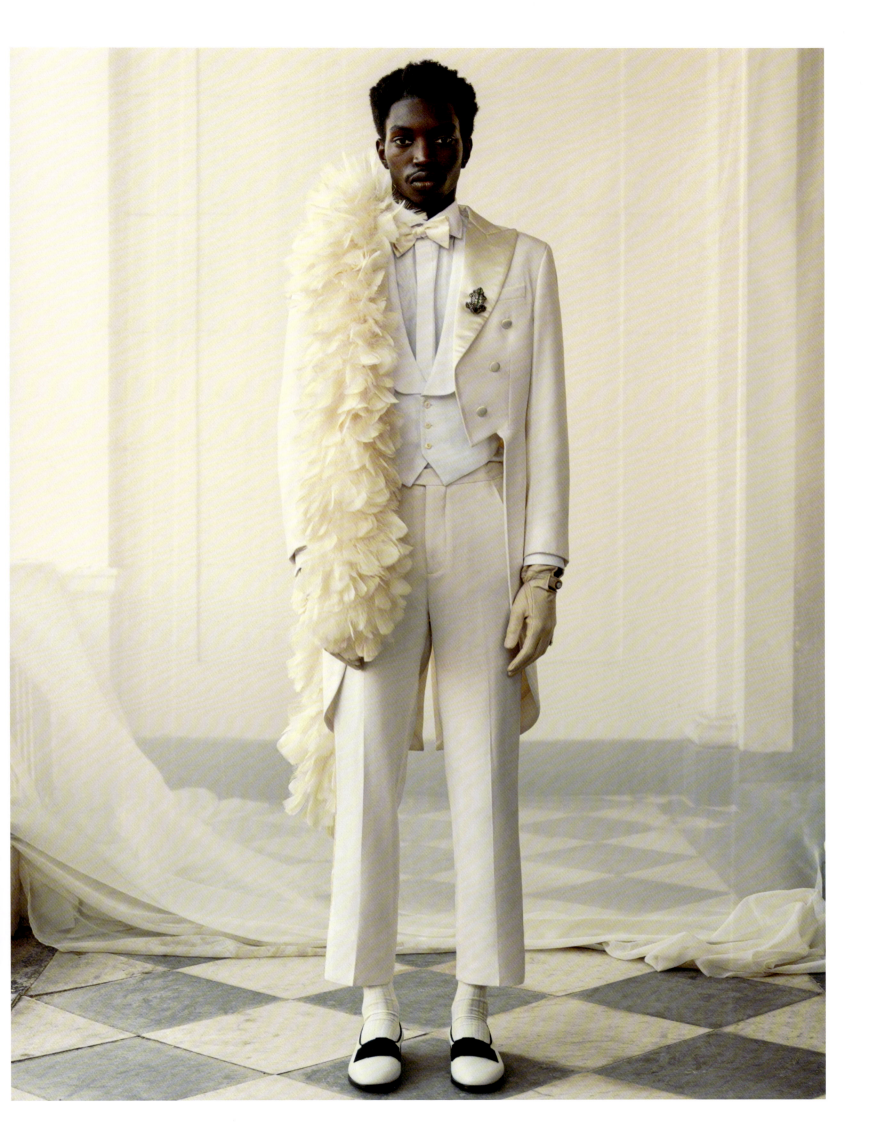

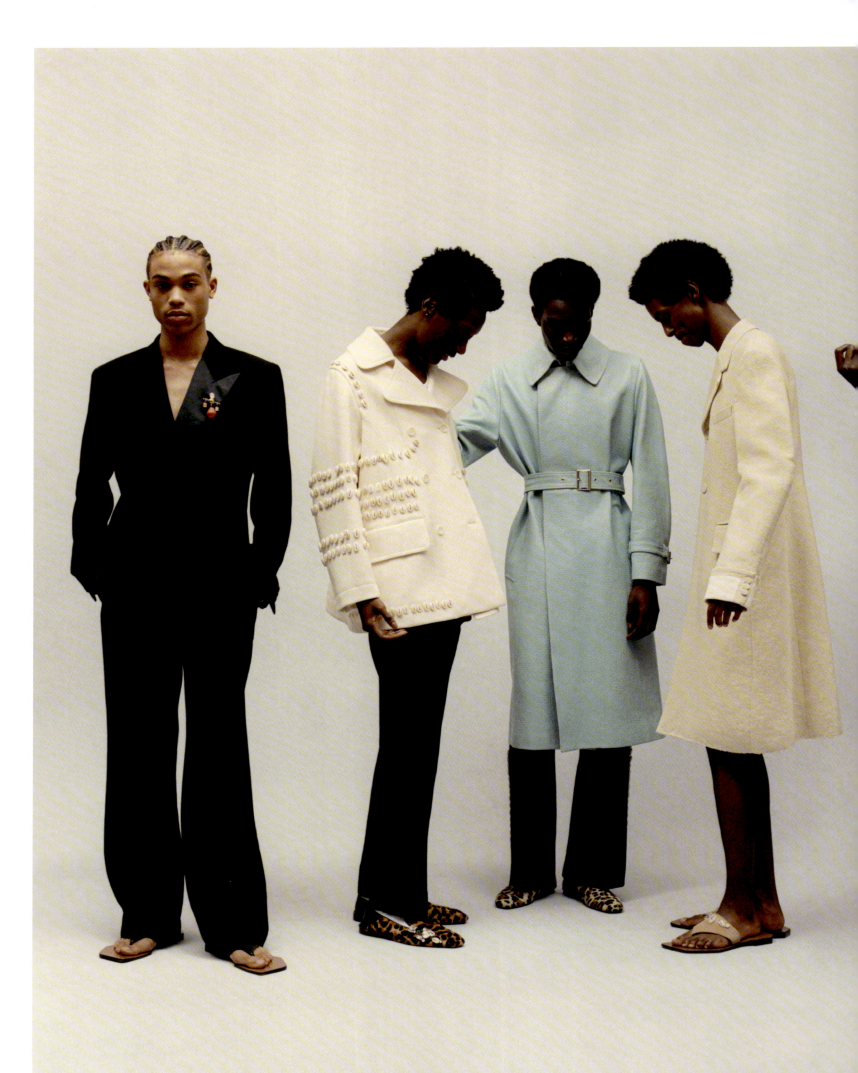

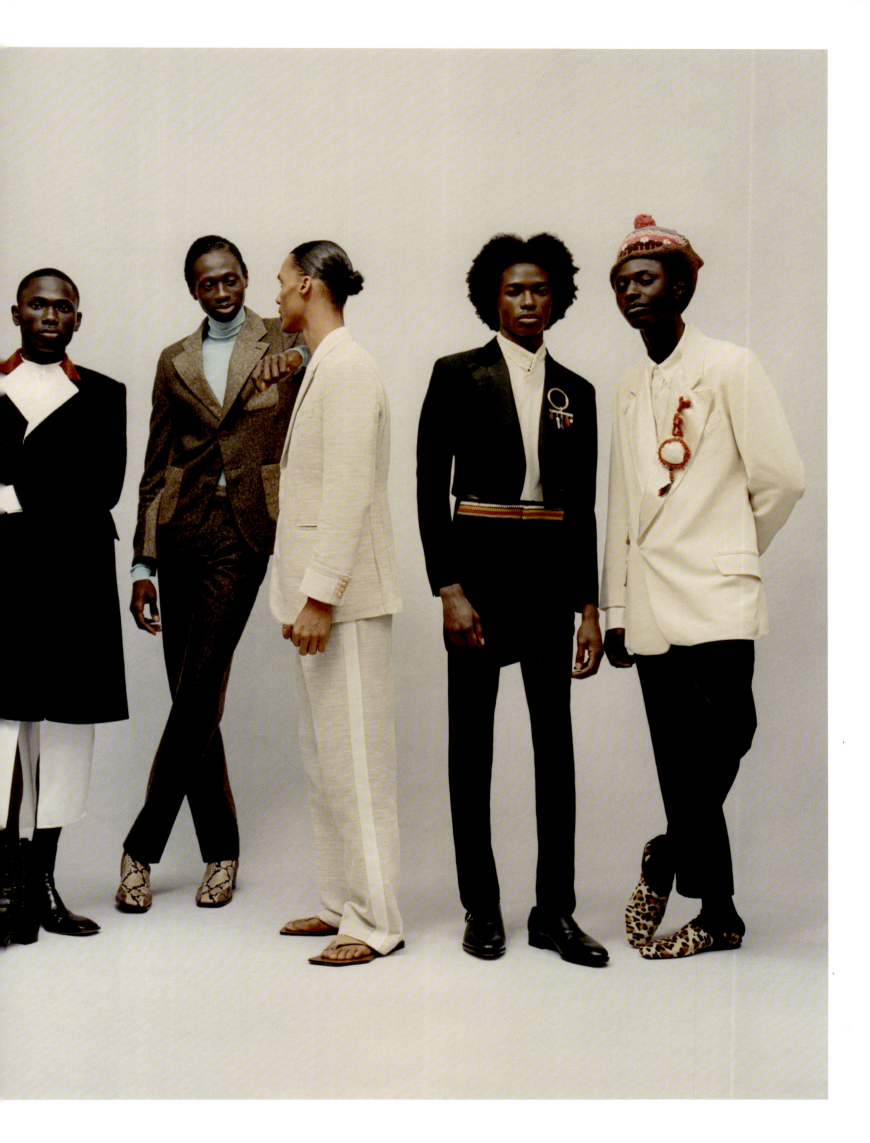

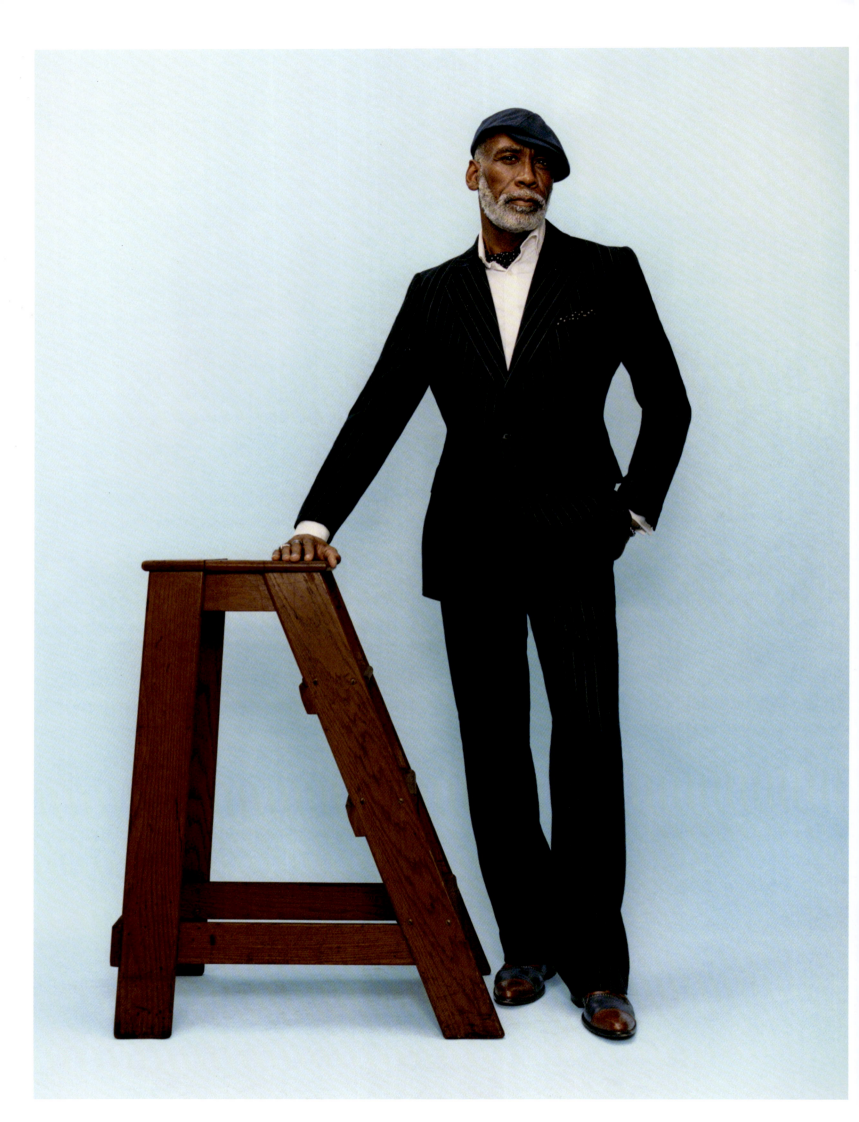

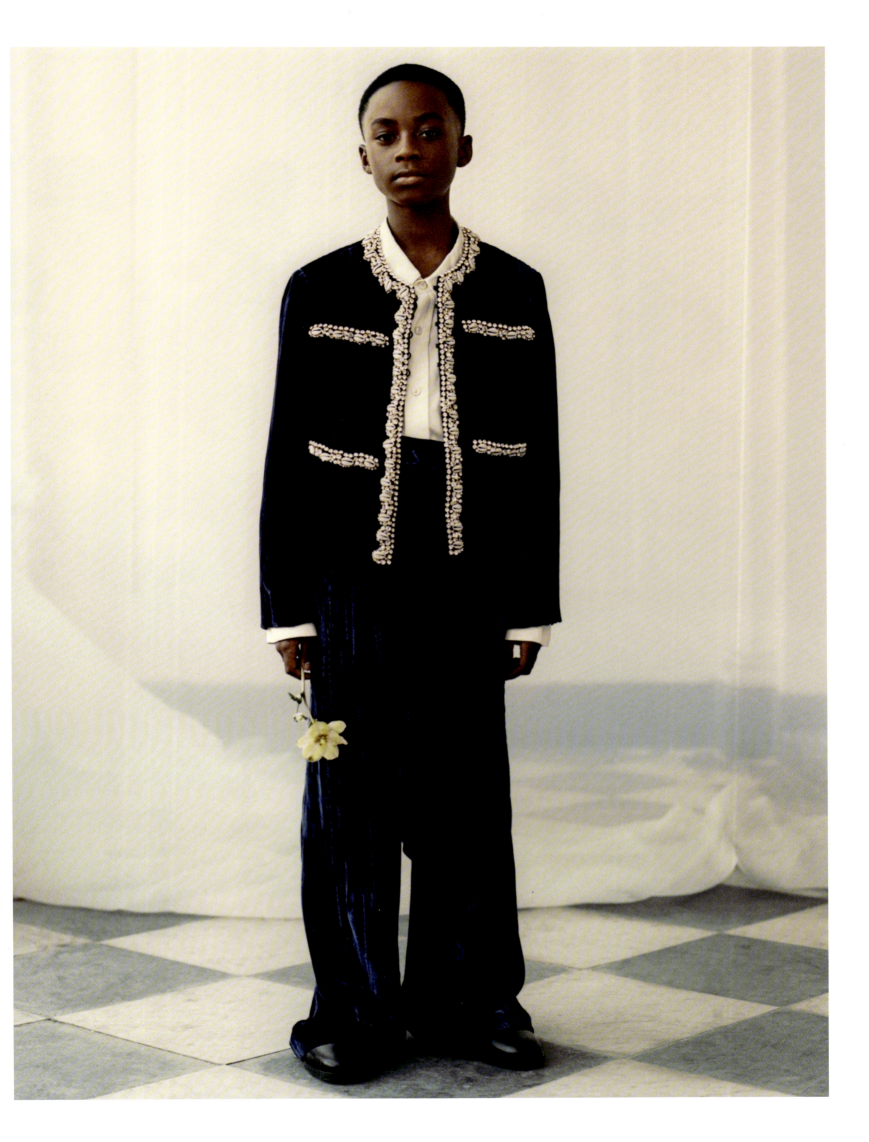

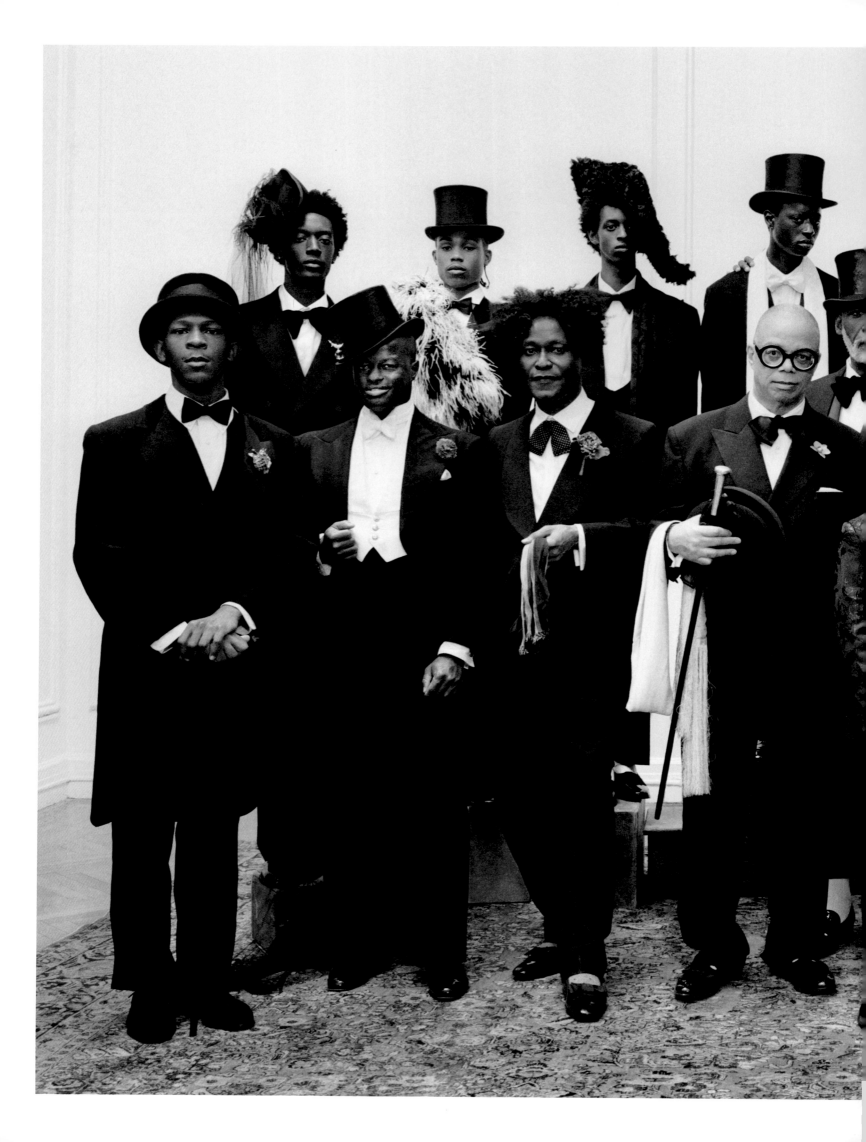

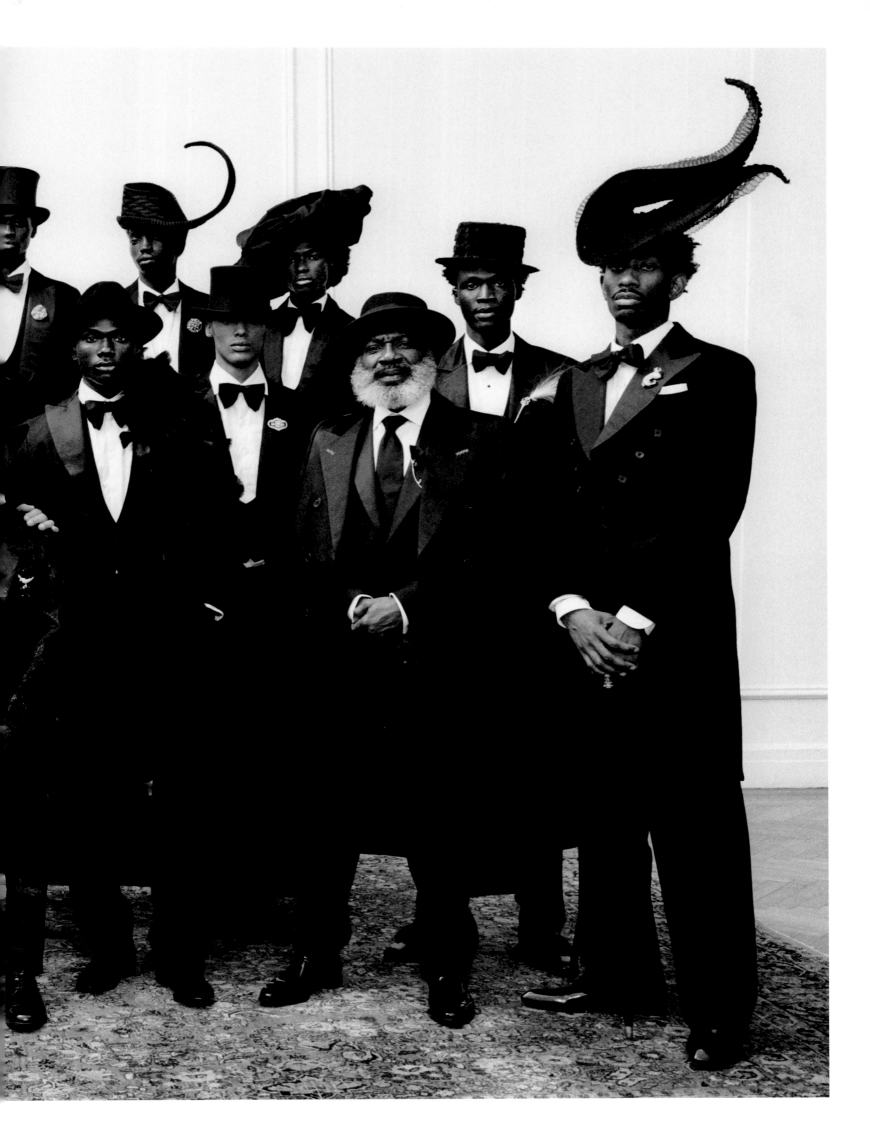

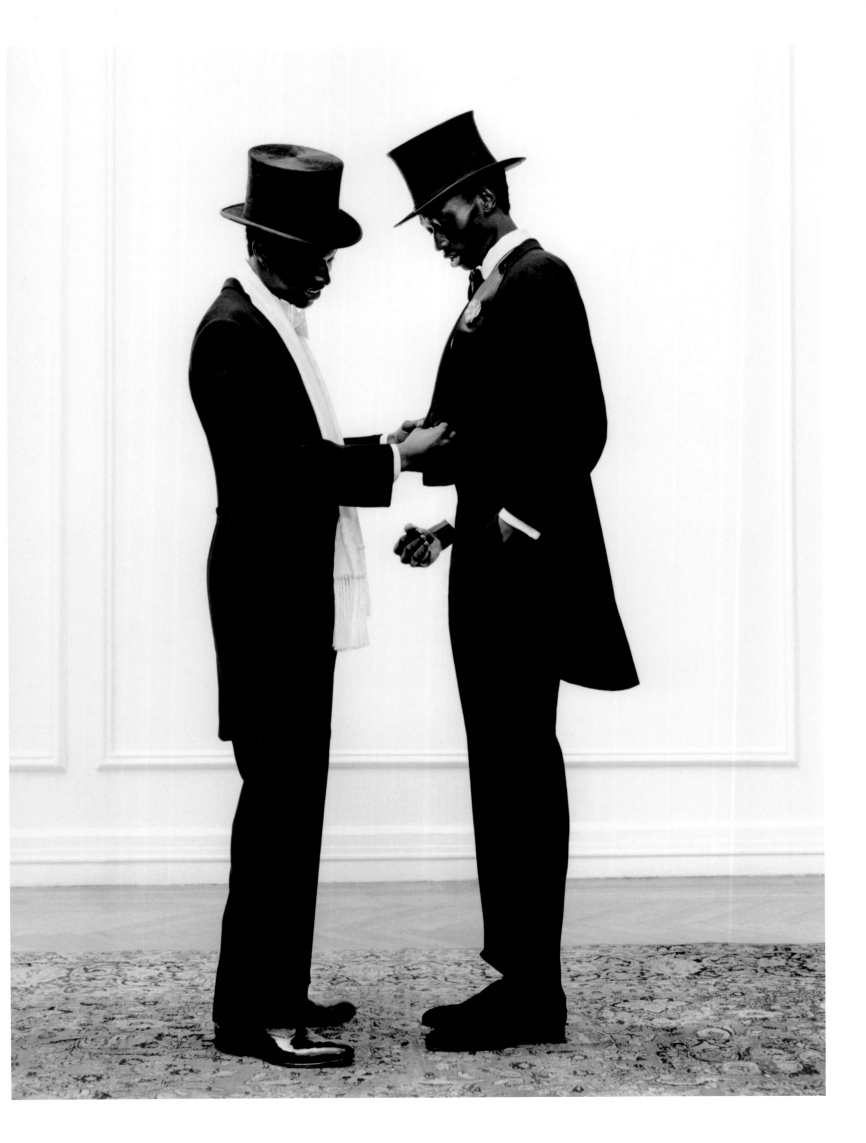

MITCHELL

I.
Lamine at the Dinner Party

II.
The Dinner Party

III.
Stolen Moment (Abdou and Dandy)

IV.
Tippy Top Hat

V.
Dandy Wellington in Blue

VI.
Cameron André as the Prep

VII.
Untitled (Abdou Classic Portrait)

VIII.
Untitled (Mou in Ralph Lauren)

IX.
To the Nines

X.
Untitled (Abdou Shirtless)

XI.
Untitled (Mou with Boat Hat)

XII.
Untitled (Abdou in Agbobly)

XIII.
Untitled (Portrait of Ken on the Porch)

XIV.
Harlem Stoop

XV.
Untitled (Lamine in White)

XVI.
Afro-Atlantic Group (in Wales Bonner)

XVII.
Grailing Showing Out

XVIII.
Untitled (Aaron in Wales Bonner)

XIX.
The Group Portrait

XX.
True Care

Full credits appear on page 361.

"NO INDIFFERENT APPEARANCE"

Superfine:
Tailoring Black Style

———————◆———————

MONICA L. MILLER

I laid out above eight pounds of my money for a suit of superfine clothes to dance with at my freedom.

—Olaudah Equiano, *The Interesting Narrative of the Life of Olaudah Equiano, or Gustavus Vassa, the African. Written by Himself*, 1789

In 1789 Olaudah Equiano, who was also known as Gustavus Vassa, published a memoir that recounted his remarkable life. Enslaved in West Africa at the age of eleven, he was transported to the Caribbean and eventually to colonial Virginia, where he was bought by a British naval captain. He sailed on British warships for a number of years until he was again sold, this time to a merchant trading sugar and slaves between the American South and the Caribbean. Equiano's travels taught him the value of letters and numbers; he also knew his own worth as an experienced, literate sailor who was well versed in the merchants' trade. Equiano began to buy, sell, and trade goods on his own in the hope of saving money to purchase his freedom. When he had assembled nearly all of the funds and emancipation appeared certain, he explains in his autobiography, "I laid out above eight pounds of my money for a suit of superfine clothes to dance with at my freedom." For Equiano, a "suit of superfine clothes" would be made from finely woven wool, an expensive luxury item, and it would be a manifestation of his newfound ability to define his future self. To procure and wear this particular form of dress represented liberation for him—a decisive and poignant moment of literal and metaphorical self-fashioning.

In the 1780s, men who paid distinct and sometimes excessive attention to dress were known as dandies. The *Oxford English Dictionary* defines the figure from this time as one who "studies above everything else to dress elegantly and fashionably." Historical manifestations of dandyism range from absolute precision in dress and tailoring to flamboyance and fabulousness in dress and style. Whether a dandy is subtle or spectacular, we recognize and respect the deliberateness of the dress, the self-conscious display, the reach for tailored perfection, and the sometimes subversive self-expression. Dandyism can seem frivolous, but it often poses a challenge to or a transcendence of social and cultural hierarchies. When Equiano imagined his superfine suit, or commissioned a portrait of himself beautifully clad for the frontispiece of his memoir (fig. 1), he participated in dandyism, using fine or fancy clothing as part of a repertoire of self-definition.

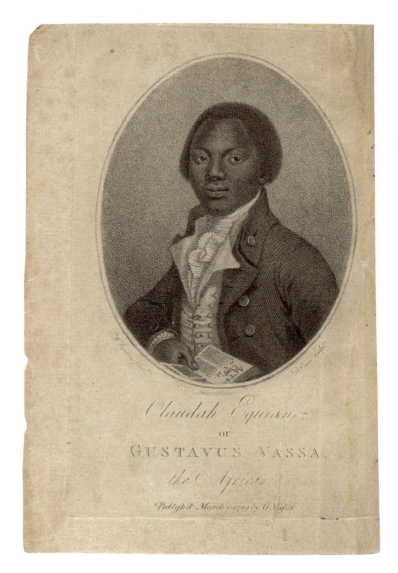

Fig. 1. Daniel Orme (British, 1766–1837), after a composition by William Denton (British, act. 1792–95). Frontispiece to *The Interesting Narrative of the Life of Olaudah Equiano, or Gustavus Vassa, the African. Written by Himself*, 1789. Stipple engraving, 6⅛ in. × 3¾ in. (15.6 × 9.5 cm). British Library (1489.g.50)

How and when does Black dandyism begin, and what are its multiple meanings? What other enslaved and free people experienced and manipulated the power of clothing and dress to define a social position or enhance cultural and political possibility? In the eighteenth century, dandyism was imposed on and utilized by Black people swept up into the political realities of the time—namely, the slave trade, colonization, imperialism, revolution, and liberation. Dandified servants, then known as "luxury slaves," were used as figures of conspicuous consumption, their finery evidence of symbolic rather than manual labor. Others, like Equiano, might not have been dressed in this way, but through their necessary observation of the social world around them, the appreciation of which was central to their survival, they understood where and when "fancy" dress mattered and how it could signify as liberatory and oppressive. Part of the facility for reading and comprehending

these codes and values had to do with West African traditions of dress and display, especially as Western and African cultures and styles confronted each other on the Atlantic coast (p. 249). Fine textiles were used as currency and a means of exchange: A bolt of fabric could pay for a person; African merchants adorned themselves in abaya-like garments and top hats (p. 248). So, those situated in the Atlantic diaspora had indigenous traditions that strategically utilized fancy dress; they immediately understood and redeployed the effects of dressing elegantly and fashionably and its relationship to race and power. Thus, Black dandyism is a sartorial style that asks questions about identity, representation, and mobility in relation to race, class, gender, sexuality, and power. *Superfine: Tailoring Black Style* explores dandyism as, among many other things, a dialectic—a movement between being dandified and taking on dandyism as a means of self-fashioning. In *Superfine*, dandyism is both an aesthetic and politics, a pronouncement and provocation.

When Equiano danced in his new superfine suit at his freedom, he broadcast the importance and profundity of the joy of self-possession and agency. Although he knew the word *superfine* in relation to the quality of a fabric, over two hundred and fifty years later we also understand it as a particular mood and attitude associated with feeling especially good—fantastic even—in one's own body and in clothes that profoundly express the self. This feeling is often so evident that it is instantly recognized by others, who will announce—with admiration and enthusiasm on seeing you in that suit, with that hat, as you strut—that you *are* superfine. Wearing superfine and being superfine are, in many ways, the subject of this exhibition. The separateness, distinction, and movement between these two states of being in the African diaspora from the 1780s to the present animate this show. Having bought his freedom and wearing his suit, Equiano recounts, "In short, the fair as well as the black people immediately styled me by a new appellation, to me the most desirable in the world, which was freeman; and at the dances I gave, my Georgia super-fine blue clothes made no indifferent appearance, I thought."

———

Superfine: Tailoring Black Style is inspired by my book *Slaves to Fashion: Black Dandyism and the Styling of Black Diasporic Identity*, a cultural history of the phenomenon published in 2009. This literary and visual study primarily examines Black dandyism from Enlightenment England to contemporary New York and London. It chronicles how the representation of Black people transformed from them being dandified, costumed, and dressed luxury slaves during enslavement, colonization, and imperialism to self-fashioning individuals who use fashion, dress, and style to assert their humanity and agency. As such, Black dandies create and experience moments of mobility and transcendence in the personal and the political realms, critically questioning and redeploying their relationship to consumption and self-regard. To discern the distinctive nature and power of Black dandyism as a tool of self-definition, and understanding it as both personal and political, this analysis relies on what literary scholars call "close reading" techniques of the cultural and historical contexts of various literary, visual, and filmic texts. Dandyism is identified as a phenomenon that has particular meaning in times of political, social, and cultural transition—say, for example, during the abolition of slavery and the subsequent emancipation, the Great Migration, urbanization, and decolonization. In these moments, changing clothes and "stylin' out" announces and explores new identities; Black folks do this for themselves, their communities, and the societies in which they live. In this setting, dandyism is an interrogative practice: A Black person in fancy dress—exquisitely styled, accessorized, and coiffed—calls into question what we think we know about race, gender, class, and sexuality. Black dandies press and propel, serving as agents of what Iké Udé, the aesthete-artist whose self-portrait is featured on the cover of *Slaves to Fashion*, calls "the luxurious deliberation of intelligence in the face of boundaries" in Kobena Mercer's essay "Post-Colonial Flaneur."

In the last twenty-five years, the study and exhibition of Black fashion and dress cultures have exploded, changing and growing significantly along the way. I hoped a book on Black dandyism would be of interest to scholars in African American studies and of the Black diaspora. But amazingly it also had an impact on fashion studies. Written at the same time as the appearance of new scholarship on the history of slavery and emancipation—when the varying archives of Black life were being theorized and explored, when race was being seen as both a materiality and a performance, when identities and disciplines were being queered—*Slaves to Fashion* captures a moment of inflection for Black studies and fashion studies. After the book was published, I was surprised and delighted to be asked to lecture and participate in conferences and symposia at the Fashion Institute of Technology and Parsons School of Design, as well as at galleries and museums. Much of this attention resulted from how the text uses Black dandyism to

historicize and focus the then-contemporary conversations about Black male representation and how the aesthetic expresses "new masculinities." Black male visibility and invisibility, both of which could be strategic (and provocative), were at issue. In the wake of Thelma Golden's groundbreaking 1995 exhibition *Black Male* and a new wave of Black dandyism that could be seen in popular culture and, more importantly, on the streets, Black dandy style came into vogue just as I was writing about it. In the years after the work was published, I continued researching and writing about Black style and stylization and their relationship to fashion history, working alongside other scholars operating at the intersection of Black studies and fashion studies. These extraordinary curators and scholars—Carol Tulloch, Christine Checinska, Elizabeth Way, Ekow Eshun, Shantrelle Lewis—inspired me and a new generation of scholars.

Superfine is clearly related to *Slaves to Fashion*, but they are not the same. In guest curating the exhibition, I have had to translate the book from text and image to garment and object—from an interdisciplinary cultural analysis of Black dandyism that privileges literature and visual culture to a transtemporal, multigeneric exploration of Black dandyism that centers fashion objects. *Slaves to Fashion* is about Black self-fashioning—the power of clothing and dress as a tool and strategy for identity formation—but it is not about *Fashion* with a capital *F* and all that word seems to imply: fashion design, designers in the industry, or the business of fashion. As guest curator of *Superfine* at The Metropolitan Museum of Art's Costume Institute, I have had to think about the relationship between fashion, dress, style, and costume, as these concepts are defined differently and communicate variously depending on how or where they are referenced inside or outside of the academy, the museum, the media, and the fashion industry. What makes *Slaves to Fashion* possible as an inspiration for a Costume Institute exhibition is its focus on "high style." The Costume Institute collection includes historical and contemporary menswear illustrative of this sensibility and of dandyism. Even though the vast majority of the menswear collection was not worn by or created by people of African descent, it offers a base and background on-site for imagining what this exhibition can look like.

Being tasked with thinking like a curator has been a happily challenging process that has allowed me to transform and expand the narrative of the original analysis. Originally, I followed the written, visual, and performance-based archive. Parsing a single footnote about W. E. B. Du Bois's dandyism (and his fury at being referenced in this way) sent me backward in time in search of understanding a dandy's social, political, and cultural critique as well as the figure's specific resonances and tensions within Black history and culture. At the time, my references for dandyism were not only straight out of my childhood in the 1970s and 1980s but also literary: I recalled my father and my uncles in three-piece plaid suits, accessorized with cocked hats and heeled shoes in contrasting leather when the occasion called for it (and sometimes when it did not). I observed my cousins building entire outfits around gold chains, links both curbed and roped, repping hip-hop styles just emerging out of New York. I had read Regency drama, Oscar Wilde, and modernist fiction, all of which included dandy figures for whom the sartorial practice was a gesture at control or a strategy of rebellious, subversive distinction in a rapidly changing modern world. I had also pored over the autobiography of Malcolm X, in which a young Malcolm Little, preparing himself for the Lindy Hop dance floor and a career as

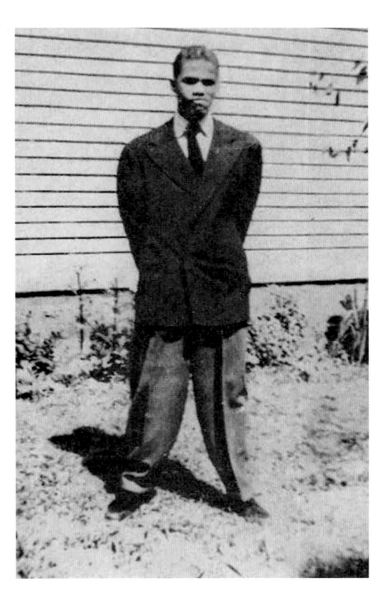

Fig. 2. *Untitled* [*Malcolm Little, 15*], ca. 1940, published in *The Saturday Evening Post*, September 12, 1964

a hustler, glories in his first zoot suit (fig. 2). I had ripped from a newspaper article and hung on my teenage bedroom wall a photograph of a young Jean-Michel Basquiat, cool and regal in a combination of formal suiting and streetwear (fig. 3).

Understanding the tension and relation between these things—what it means when a dandy is racialized and when a Black person uses dandyism as a tool or strategy—sent me back to the eighteenth and nineteenth centuries, to moments of contact between Africans and Europeans, when clothing, dress, and even cloth became noticeable vessels of power. I was able to see Africans and then men of African descent thrust into an emerging diaspora negotiating their identities and possibilities with the clothes on their backs. Men were most visible in this archive, as they were the most chronicled in travel narratives and some of the first authors of memoirs detailing their enslavement and actual and metaphorical liberation; their expanded mobility, when compared to that of women, garnered more notice and helped enter their experiences into the historical record. I could trace their use of dandyism from the eighteenth century to the present, in their own words and other's words, in histories of the stage and theatrical productions, in fiction, prints, caricature, and painting, in film and photography.

How could I see my book differently as an exhibition? Most importantly, where would I find the garments? While the textual archive of Black self-fashioning might go back to the eighteenth century, or even earlier if one knows where and how to look, the material archive is much more limited. Clothing worn (or made) by enslaved individuals, regardless of whether they toiled in domestic settings or in the fields for Southern planters, Northern merchants, royalty or aristocracy in the Americas or Europe, was overwhelmingly neither valued nor preserved. Standard-issue clothing was often made of homespun, coarse fabric like osnaburg, hemp, flax, or cotton (fig. 4), which disintegrates with use and over time, as Katherine Gruber explains in "Clothing and Adornment of Enslaved People in Virginia." While I knew of, for example, festivals such as Jonkonnu, Negro Election Day (fig. 5), and

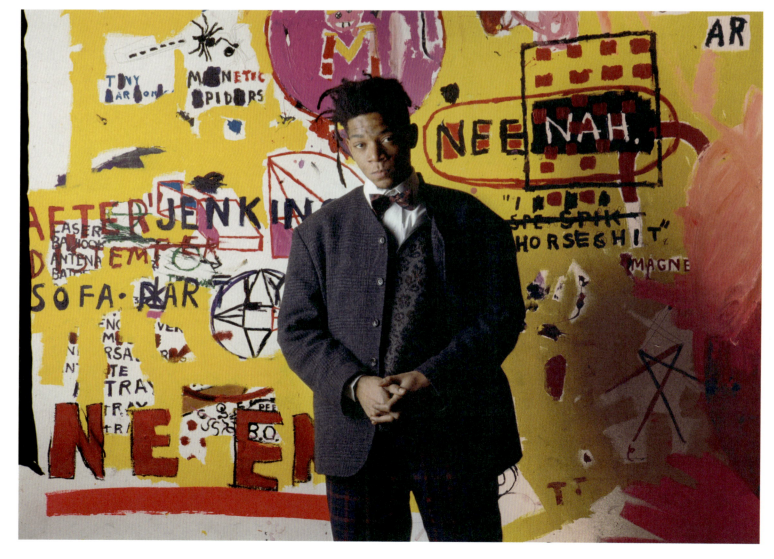

Fig. 3. Julio Donoso (Chilean, act. 1980s). *American painter Jean-Michel Basquiat*, 1988

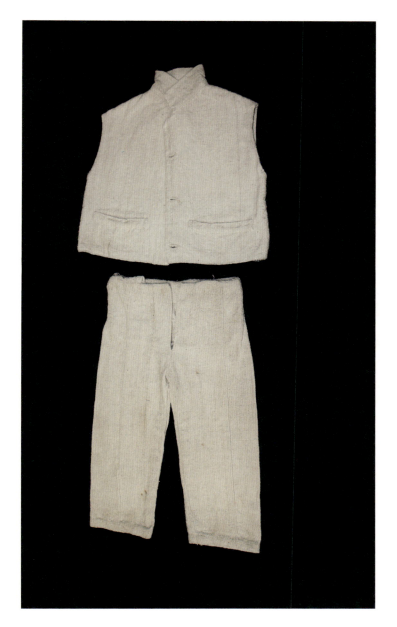

Fig. 4. *Child's "slave cloth" sleeveless jacket and pants from Louisiana.* American (1850s). Undyed hand-spun woven cotton. Shadows-on-the-Teche, a Site of the National Trust for Historic Preservation, New Iberia, La. (NT59.67 .644 [5B])

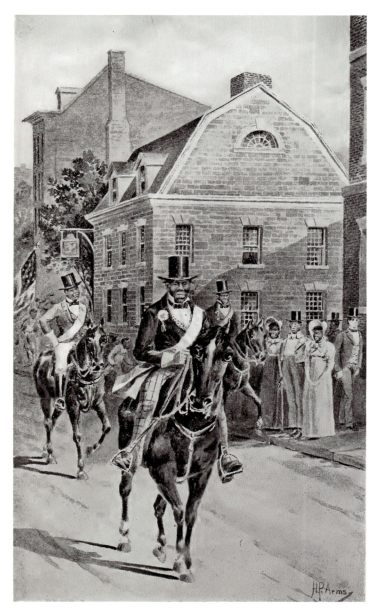

Fig. 5. Hiram Phelps Arms (American, 1854–1925). *An Election Parade of a Negro Governor*, published in volume 5, issue 6 of *The Connecticut Magazine*, June 1899

Pinkster, in which captive people paraded in fancy dress borrowed or inherited from their enslavers or that they created themselves, I did not know of any surviving garments. I was aware of the desire of many enslaved people, like Equiano, to "change clothes" at the moment of their liberation. Ads posting fugitives from slavery detail the quantity and quality of clothing that people escaped with; whole closets were carried away. And yet, very little remains.

While this dearth was true of the eighteenth and nineteenth centuries, the twentieth century provided a different challenge: In the early part of the twentieth century, some garments and accessories of notables like Cab Calloway (fig. 6) and Duke Ellington were preserved as part of their estates and archives, but the attire of ordinary people who chose to dress to the nines for a night out in Harlem or a wedding or funeral on Chicago's South Side was largely not extant. To reimagine the book as an exhibition, I would have to think not only interdisciplinarily but across disciplines and genres. We could fill in the gaps in fashion history as I had done in my own research, with paintings, prints, and decorative arts depicting the dandified and self-fashioning dandies themselves. But as a curatorial team, we would also have to locate garments and accessories worn and made by superfine folks, digging deep into the holdings of historical museums and societies such as the Historic New Orleans Collection, the Chicago History Museum (figs. 7, 8), and the GLBT Historical Society in San Francisco. We would have to contact the archives of "race men" such as Douglass and Du Bois, and the estates

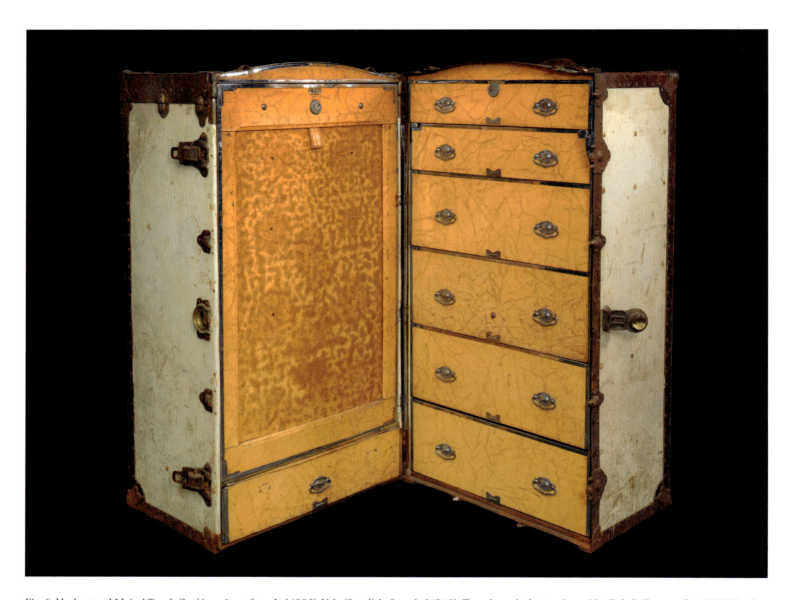

Fig. 6. Herkert and Meisel Trunk Co. (American, founded 1888). Yale (Swedish, founded 1840). *Travel wardrobe trunk used by Cab Calloway*, after 1927. Wood, lead-based paint, iron alloy, copper and copper alloy, nickel and nickel alloy, velvet, muslin, textile materials, lacquer, elastic, and leather, 28½ × 43½ × 23⅝ in. (72.5 × 110.5 × 60 cm). Smithsonian National Museum of African American History and Culture, Gift of Cabella Calloway Langsam (A2015.273.1.1)

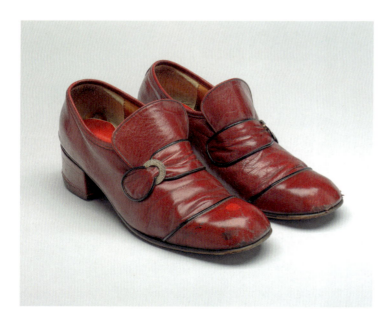

Fig. 7. Piper & Piper Custom Tailors (American, act. 1920s–70s). Scotty Piper (American, 1904–1987). *Shoes worn by Scotty Piper*, 1973. Red and black leather; buckle of gold metal. Chicago History Museum, ICHi-178231 (1975.116.2e–f)

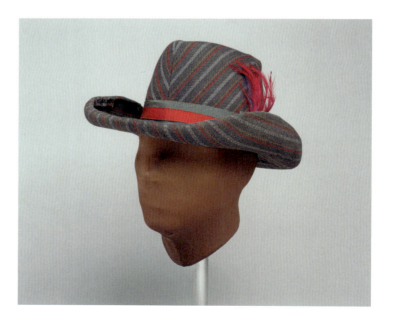

Fig. 8. Piper & Piper Custom Tailors (American, act. 1920s–70s). Scotty Piper (American, 1904–1987). *Hat worn by Scotty Piper*, 1973. Polychrome striped wool-polyester twill; band of gray and red silk grosgrain; pink feather. Chicago History Museum, ICHi-178215 (1975.116.2a–f)

of legends like Muhammad Ali. We would talk to tailors like James McFarland, known as "Gentleman Jim," who was active on Harlem's 125th Street in the 1960s and 1970s, outfitting, among many others, Ali, Jackie Robinson, and James Brown; we would call Ozwald Boateng, celebrated Savile Row–trained fashion designer, who was the first tailor to show at Paris Fashion Week. We would negotiate with private collectors of vintage and contemporary fashion and accessories on both sides of the Atlantic. We would have to think about and beyond visual culture, respecting and strategizing with the archiving and collecting practices of the community.

We would also think from contemporary fashion design to the past and explore the aesthetic and historical influences of the designers that we celebrate in the exhibition. We would look to Grace Wales Bonner and Virgil Abloh to examine the ways in which each designer communicated their own knowledge and study of Black diasporic history writ large and small. Inspired by writers Ishmael Reed and Ben Okri as well as by outsider artist "St. James" Hampton, Wales Bonner's autumn/winter 2019–20 collection "Mumbo Jumbo" focused on magic and mysticism within the Black Atlantic. As Reed himself says of Wales Bonner, "Like Charlie Parker who obeyed the key signatures required by the songs he played, but did something different when improvising the chords attached to these songs, Grace Wales Bonner looks backward to traditional European modes of fashion, but comes up with original designs. . . . She's an artist." The show notes implore, "Honour our ancestors. Honour the lineage." Wales Bonner does so here and in all of her collections; although her own Jamaican and British heritage often functions as an influence, her design collections establish her as a citizen of an Afro-cosmopolitan, Afro-futurist world. As described in the show notes for the spring/summer 2019 "Ezekiel" collection, looks in this world include "restrained mohair suits in ebony . . . , with brilliant white starched shirting" (fig. 9) as well as "floating spirituals in ivory frock coats, [and] romantic silk shirt dresses." Her autumn/winter 2020–21 "Lover's Rock" collection (p. 301) featured what the show notes call "tropes of the British wardrobe: Donkey jackets, repurposed 1960s Saville [sic] Row tailoring. A moleskin double-breasted blazer adorned with found buttons." Wales Bonner's study of life and living in the African diaspora functions as an examination and appreciation of Black fashion and style history; they are coeval and commensurate. *Superfine* would need to chronicle and honor this depth of knowledge and practice.

We would also foreground those working within tailoring traditions who are an indelible and profoundly important part of the history of artisanship within the community. In this exhibition, tailoring is an actual practice and a metaphor that defines Black style and stylization; the curation would have to reflect the materiality and symbolic importance of these traditions. So many tailors and designers are nurtured in families with members or even ancestors who have worked as tailors, seamstresses, quilters, menders, home sewers, and needleworkers. This knowledge and skill pass down through families and communities for reasons of both economic survival and the pleasure in and satisfaction of pushing the boundaries of style. To tell this story, we would have to go back to the nineteenth century and think about what it meant for a Historically Black College and University (HBCU) like Hampton University to offer classes in tailoring

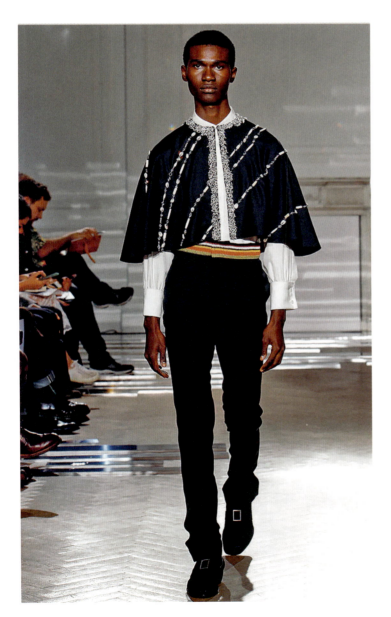

Fig. 9. Marcus Tondo (German, b. 1974). [*Runway image of Look 14 from Wales Bonner's "Ezekiel" collection by Grace Wales Bonner*], 2016

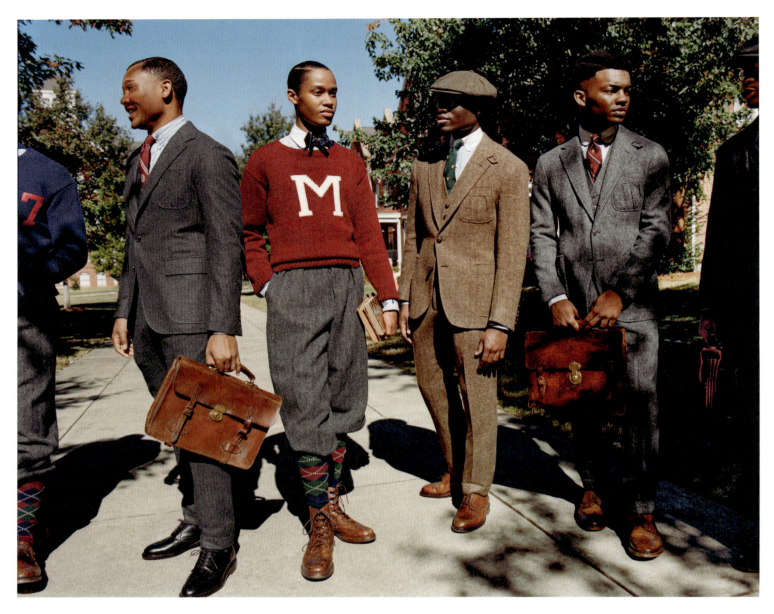

Fig. 10. Nadine Ijewere (British, b. 1992). *Morehouse Students Dimone Long, Jerry Yekeh, Jalen Campbell, Darian Bogie, and Model Caleb Elijah*, 2021. Ralph Lauren Corporation Collection

to its students (p. 212), training young men for a trade and an art that facilitated the respectable presentation that so many of their graduates, future representatives of the race, would covet. We would need to account for the impact the Great Migration would have on fashion and style: The growth of urban centers in the North and West created new opportunities for folks to express themselves differently for themselves and for each other on a grand and gorgeous scale. Just as Equiano danced at his freedom, new-to-the-city folks strutted too, as Toni Morrison describes in *Jazz*, her novel set in 1920s Harlem: "Here comes the new. Look out. There goes the sad stuff. The bad stuff. The things-nobody-could-help stuff. The way everybody was then and there. Forget that. History is over, you all, and everything is ahead at last." Tailors made the three-piece and zoot suits that these new environments demanded and required.

Over the course of the twentieth century, the Black tailoring tradition seeded the eventual emergence of fashion designers like Dapper Dan, while more traditional menswear designers apprenticed with design houses, rising within their ranks before branching out on their own. Designing for Ralph Lauren, Calvin Klein, and then his own label, iconic designer Jeffrey Banks made this journey; James Jeter, the lead designer of the HBCU capsule collection for Ralph Lauren (fig. 10) and now the label's creative director for its Polo brand, is on a similar path. In England fashion design has hewed close to Savile Row, given the street's indelible influence on menswear all over the world: The Casely-Hayford family—notably, the late innovator Joe and now his son Charlie—designs with a combination of respect and playfulness that updates and upends traditional Savile Row tailoring. Contemporary tailors and designers like Boateng, Charlie Allen (himself a third-generation

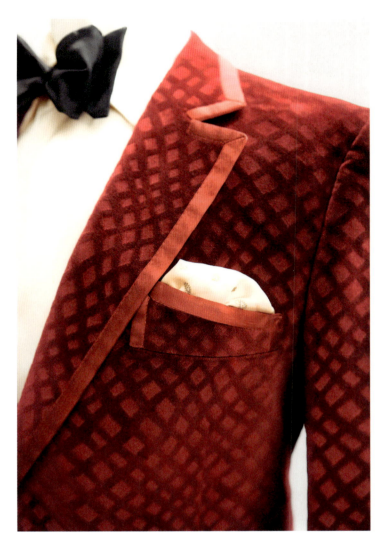

Fig. 11. Maurice Sedwell (British, founded 1938). Andrew M. Ramroop OBE CMTT (British Trinidadian, b. 1952). *Tuxedo jacket*, ca. 1975. Red silk patterned velvet edged with matching silk satin. Andrew M. Ramroop Collection

tailor), and Andrew Ramroop of Maurice Sedwell (fig. 11) infuse their meticulously constructed bespoke menswear designs with innovations that are sometimes related to their Caribbean and African heritages but are always exemplary of their self-determined sense of style.

Superfine brings all of these narratives together and organizes them as expressions of Black style through the art of dandyism. *Expressions* is the operative word here, as this exhibition does not seek to be definitive, even as it necessarily and joyously offers some modes in which dandyism is defined and articulated. Curator in Charge of The Costume Institute Andrew Bolton often describes such exhibitions as "essays" rather than statements; additionally, these essays are often inspired by theoretical and literary texts. As a conceptual inspiration for the exhibition, I looked to an essay that may not mention fashion but is nevertheless centered on critically examining and celebrating African American style: In her "Characteristics of Negro Expression" (1934), Zora Neale Hurston identifies twelve characteristics that she believes are building blocks of Black expressive culture, the second of which is "the will to adorn," which she discusses primarily in terms of decoration. Elaborated on as "the feeling . . . that there can never be enough of beauty, let alone too much," this desire for beauty infuses Black life with another of Hurston's characteristics: drama. For me, the beauty (and drama) in this exhibition can be seen on many levels: in the signifyin' and showin' out that drives Black dandyism's dialectic, critique, and force; in the intelligently conceived and carefully stitched and tailored garments themselves; and in the scale on which this story will be told through (occasionally unexpected) elements of style. These elements are sometimes small accessories—for example, buttons (p. 110) said to have been affixed to Toussaint L'Ouverture's coat—and also whole ensembles, like André Leon Talley's Juicy Couture tracksuits, the jackets of which have the words *Emperor* (p. 307), *Tsar,* or *King of the Universe* embroidered on the back. In "Characteristics of Negro Expression," beauty and drama—as well as other traits like angularity, asymmetry, dancing, and originality—combine to make style, specifically and wonderfully, Black.

Rhetorically, Hurston's essay is organized, but wonderfully eclectic. *Superfine* is too, as it describes characteristics of Black dandyism using twelve themes that are each transtemporal as well. The thematic groups—Ownership, Presence, Distinction, Disguise, Freedom, Champion, Respectability, Jook, Heritage, Beauty, Cool, and Cosmopolitanism—are arranged historically, beginning in the early eighteenth century and closing out in the present. Each group is introduced by a historical garment or object that exhibits a theme that is traced through to a contemporary garment or accessory by a Black designer working with explicit reference either to the motif or to apparel that exemplifies the topic. For example, "Presence" opens with a 1772 print of Julius Soubise (p. 93), one of the first known Black dandies, and tracks his status from luxury slave to infamous man-about-town in eighteenth-century London. This grouping emphasizes florals, a nod to Soubise's love of hothouse flowers and a way to explore the dandy's "blossoming" as an individual. Juxtaposing historical and contemporary accessories such as a British perfume bottle (ca. 1750–55) in the shape of a bouquet and a carryall adorned with flowers from Virgil Abloh's autumn/winter 2022–23 collection for Louis Vuitton, "Presence" both invokes and interrogates the romance associated with Soubise's flourishing.

Pivoting between a 1940s zoot suit and a white tuxedo designed by Brandon Murphy, "Jook" explores dandyism as a form of Black expressive culture with a particular relationship

to music and nightlife. Here, zoot suits are spotlighted, as are tuxedos and their status as multifaceted "formal" garments. The tuxedo distinguishes its wearer, whether it is donned as a uniform by a service worker or as a dressy garment by a wealthy patron attending a fancy function or by an entertainer or musician appearing onstage. When worn by provocative women, like the blues singer Gladys Bentley, famous for her white tuxedo and top hat (p. 240), the tuxedo can be an elegant vehicle for communicating a playful yet assertive queerness, a sharp-edged androgyny, and an unapologetic sex appeal. In "Zora Neale Hurston's Essays: On Art and Such," literary critic Cheryl Wall asserts that Hurston "offers multiple examples and several lists [in her "Characteristics of Negro Expression"], which allow spaces for the reader to enter the text, affirm his or her independent knowledge of the metaphors, or to provide his or her own examples." It is my hope that *Superfine*'s organization and design, inspired by the expressive content and form of Hurston's essay, allow for a similar sense of openness and engagement with Black dandyism and its many manifestations and meanings.

There are multiple throughlines or narrative threads in the show, as it is a story about the archive of Black fashion and dress, about the numerous and diverse articulations of Black masculinity across time and space, about the imbrications of race, class, and sexuality, among many other possibilities. As much as it is an essay, the exhibition also functions as a group of related short stories about liberators, gentlemen, shape-shifters, artists, proud funky people on the move toward what artist Lyle Ashton Harris calls in "Black Widow: A Conversation" the "future perfect"—that is, "the need for an immediate political, aesthetic, and psychic intervention . . . a new framework in which to refashion the body and mind." Visitors to the exhibition and readers of this catalogue are also guided through this essay and these stories by Black voices: Each thematic grouping of objects is introduced by a quotation from a writer who explicates, queries, or reinforces the theme. Thus, a vocabulary or grammar of Black style—in text, image, and dress—emerges and gives rise to a conceptual language important in the endeavor toward freedom and happiness.

Torkwase Dyson's exhibition design and Tanda Francis's bespoke mannequin heads both reinforce the openness and sense of possibility within the exhibition's narrative. Dyson's attention to Black dandyism's relationship to liminality, agility, and resistance is everywhere, evident especially in the structures that she designed to hold—sometimes gingerly, at other times with a firmer grasp—the exhibition's contents. Interested in the way in which dandyism can be an act of private self-creation or a performance of identity on a much larger stage, Dyson developed a version of her signature architectural shape language, or "hyper shapes," for *Superfine*, focusing on the camera's aperture and the proscenium stage, as well as on structures and design elements more evocative of mirrors and sight lines. Moments of concentration and flight communicate with others more reminiscent of display or resistance, strategic presence or absence, echoing the dandy's play with a proud visibility or a necessary disguise. In their work for the exhibition, both Dyson and Francis were determined to invite ancestors into the space and honor them. Modeled on a likeness of one of the first Sapeurs active in early twentieth-century Congo, an African returning home from Paris, Francis's mannequin heads feature this face rendered as if the figure were also wearing a mask, the gesture meant to indicate both closeness to and distance from this African ancestry. The mannequin head with the profiles seemingly comments on this tension: Designed to mimic the pages of an open book, the profiles enable each mannequin to be the site of different and multiple narratives. As a group, the profiled mannequins serve as ancestor figures as well as beacons of futurity in the exhibition space, the layout of which facilitates transcendence. Both the architecture and the mannequins guide the visitor literally and symbolically around the diaspora and across time.

———

Like the exhibition, the catalogue is organized according to the twelve characteristics noted above and bookended by two provocative views of modern dandyism, one visual, the other literary: an opening photo essay by Tyler Mitchell, who also photographed the garments and accessories for the publication, and an epilogue by Iké Udé. Mitchell's essay stunningly evokes the panache of dandyism, whether embodied by a fabulous individual or a group of gentlemen styling out for themselves and each other. Featuring professional models in ensembles from the exhibition or in vintage clothing, as well as fashionable gentlemen in their own amazing, self-styled garb, Mitchell's essay insists on Black dandyism as pride and joy, community and camaraderie. Udé's literary essay offers a portrait of a modern dandy aesthete in the form of witticisms and quips seemingly innocent but deadly in cut. These aphorisms—or "Sartorial and Aesthetic Sympathies"—function as testament to the sartorial practice and life philosophy of the fictional

character of Kofi, whom we meet and follow in his "sartorial frame," a mode of self-discipline and ontology of stylish being.

Instead of explicating the exhibition with a set of traditional academic essays, we have instead incorporated a host of voices into this text, making *Superfine*'s exploration of Black dandyism polyphonic. Just as Hurston's essay invites her readers to explore the Black American expressive culture with her, these voices in *Superfine* perhaps add their own examples to those she provides, offering complementary perspectives—sometimes personal, sometimes scholarly—on garments and objects in the exhibition or on the exhibition's larger topics and themes. Here, thirty artists, designers, tailors, curators, dandies, stylists, writers, and scholars discuss the evolution of Black style, giving this catalogue a dynamism and swing. Examining and extending Black dandyism's aesthetics, politics, cultural impact, and enduring legacy, these voices are the beginnings of new conversations about what it means to be and to wear that which is superfine.

necessity of inventing possibility, the desire for diasporic connection as a means of survival and flourishing. Many, many years later, post-emancipation, in a moment of decolonization, another man confronting similar barriers to self-actualization, Frantz Fanon, declared, "In the world in which I travel, I am endlessly creating myself." If *Superfine: Tailoring Black Style* communicates any one thing, I hope that it visualizes, through fashion, clothing, and dress, the liberating quality of the imagination, the profundity and joy, the self-making process enabled by cutting "no indifferent appearance."

In Olaudah Equiano's memoir, achieving freedom and liberation is a function of imagination and will. As is the case with so many authors exploring, rhetorically and perhaps psychologically, the territory between enslavement and freedom, Equiano self-liberated long before his legal emancipation day and the purchase of his superfine suit. Like Frederick Douglass in his own narrative, Equiano was determined to show "how a man was made a slave . . . [and] how a slave was made a man"; self-fashioning, figurative and literal, is key to this process, a distinctive part of realizing and announcing humanity and self-worth. As a narrative of this journey, Equiano's story is unique in that he is one of the only narrators who claims to remember his capture in West Africa, the Middle Passage, and the process by which an African becomes Black, British, diasporic. In recent years, the facts of Equiano's account have been questioned: In *Equiano, the African: Biography of a Self-Made Man*, Vincent Carretta points to records that indicate Equiano may have actually been born in South Carolina, suggesting that, in an act of literary invention, he claimed African birth to bolster his narrative's distinctiveness and suitability for the abolitionist cause. While some consider this aspect of the story disqualifying, I've always thought about this rhetorical flourish as the genius of the book; the whole text then privileges, on multiple levels, the power of imagination, the

Superfine
TAILORING
BLACK STYLE

OWNERSHIP

PRESENCE

DISTINCTION

DISGUISE

FREEDOM

CHAMPION

RESPECTABILITY

JOOK

HERITAGE

BEAUTY

COOL

COSMOPOLITANISM

EPILOGUE

WITH CONTRIBUTIONS BY

ADRIENNE L. CHILDS 73

JONATHAN MICHAEL SQUARE 77

SOULL AND DYNASTY OGUN 83

JEREMY O. HARRIS 99

CHRISTINE CHECINSKA 111

NIGEL LEZAMA 119

TANISHA C. FORD 127

MARY N. ELLIOTT 133

CHARLIE ALLEN 137

ELIZABETH WAY 141

RICHARD J. POWELL 157

ANDRÉ 3000 183

TREMAINE EMORY 187

LEWIS HAMILTON 191

DENISE MURRELL 211

MICHAEL HENRY ADAMS 217

DANDY WELLINGTON 227

BRENT HAYES EDWARDS 233

KAI TOUSSAINT MARCEL 243

DEBORAH WILLIS 251

GABRIELLA KAREFA-JOHNSON 253

GRACE WALES BONNER 257

CAROL TULLOCH 259

MARIELLE BOBO 273

MADISON MOORE 275

KIMBERLY M. JENKINS 279

AMY SHERALD 295

ALPHONSO D. MCCLENDON 297

EKOW ESHUN 317

JASON CYRUS 327

IKÉ UDÉ 333

Ownership

"Disembodiment. The dragon that compelled boys I knew, way back, into extravagant theater of ownership."

TA-NEHISI COATES
Between the World and Me, 2015

OWNERSHIP

"Ownership" explores dandyism's relationship to conspicuous consumption and currency through the material signifiers of gold and silver coinage, and the embodiment of those signifiers through garments and accessories trimmed with or seemingly made from these precious metals. Here, we highlight the dialectic between being fashioned by others and fashioning the self—that is, how the manipulation of clothing and dress can both dehumanize and grant agency and self-possession. While Black men in the eighteenth century were sometimes dandified as servants—made to dress in conspicuously outdated, outrageous, or exoticized garments known as livery—several contemporary Black designers have re-signified this history of denigrative valuation by recontextualizing the material expressions of currency. With these garments and accessories, paired with historical referents, the wearers "own" this history, exchanging it for a future glittering in silver and gold.

In the eighteenth-century Atlantic world, dandyism arose as a sartorial practice primarily associated with men who "stud[y] above everything else to dress elegantly and fashionably," in the words of the *Oxford English Dictionary*. A new culture of consumption, fueled by the slave trade, colonialism, and imperialism, enabled access to goods such as clothing that marked wealth, distinction, and taste, communicating social hierarchy, status, and aspiration. *Dandy* does not have a definitive etymology, but the word might derive from a silver coin known as a dandiprat (p. 66), minted in the sixteenth century during the reign of Henry VII and probably worth twopence. Its small physical size and value came to be associated with insignificance more generally and its name was applied as a derisive term toward men of similar triviality. In this way, the sartorial style of dandyism identifies with the multiple meanings of *currency* and forms of exchange, signaling price and pricelessness, or value and devaluation, sometimes simultaneously. The "Kalinago Royal Coin #8" pendant by Soull and Dynasty Ogun for L'Enchanteur (p. 67) is presented here as a counterpoint to the dandiprat. It is the reimagined currency of the Indigenous Kalinago, or Carib, peoples of the Lesser Antilles who inhabited the islands prior to Spanish colonization in the fifteenth century. Like L'Enchanteur's "L'E Goldwill" bullion (p. 82), the coin is cast with the image of an ancestor and represents not only an object of personal and cultural value but also a currency independent of European systems.

As the slave trade grew, Africans captured, enslaved, and transported around the Atlantic were sometimes used as "luxury" servants by royalty, the aristocracy, and upstart merchants. Two images—a watercolor from 1766 (p. 74) and an engraved fashion plate from 1779 (p. 75)—show young Black men being treated as accessories to their lavishly attired female enslavers. These servants were dressed in ornate garments, gold and silver collars, turbans, and livery made of sumptuous fabrics and trimmed with metal braid—all indications of their objectification. Arrayed in this way, African captives immediately understood the power of clothing and dress to define group and individual identity. In this new Atlantic economy, dandyism became a strategic tool for Black people claiming and visualizing their own worth and value.

In the painting *Roch Aza et Louis Armand Constantin Rohan, prince de Montbazon (1732–1794)* (p. 68), Rohan, French governor of Saint-Domingue (present-day Haiti), is portrayed with his enslaved servant. The governor's reticulated steel armor highlighted with gold suggests an element of protection and represents his military power. His servant, tentatively identified as Roch Aza, wears a silver collar and a gold earring, along with a red suit of livery trimmed with gold passementerie and matching turban, signaling his subjection as well as value to his owner. Each figure is, in effect, in a kind of uniform that connotes his adherence to a broader social order, intended to convey both real and symbolic messages about the vastly different status of the wearer. The silver collar around the enslaved boy's neck echoes the armor of his enslaver, though where one is designed for protection, the other suppresses. A silver teapot made in France at around the same time (p. 69) materializes the objectification of Black male bodies, emphasizing an interplay

between the valuable metal from which its body is made and its ebony wood handle, carved into the figure of a Black man. This teapot seemingly suggests a "natural" metonymic connection between products and people of African origin, situated within a broader web of colonial goods that included the exotic beverage contained within.

At once objectified and individualized, the young man at the center of the composition of Hyacinthe Rigaud's *Portrait d'un jeune homme noir* (p. 70) wears a wide metal collar to indicate his enslavement, while silk garments, a drapery of fine velvet, and a turban topped with a gold tassel render him an embodiment of the exotic and the luxurious. Rigaud—himself the son of a tailor—lavished attention on the sumptuous textiles worn by the unnamed enslaved figure: The green silk of his antiquated doublet-style jacket features shiny silver-wrapped buttons, and his turban, a generic symbol of non-European identity, is held in place by what is probably a length of cotton imported from India. Without the gleaming collar that literally reflects this finery, this man might be confused for one of the figures in the artist's many sycophantic portraits of European aristocracy, who often donned attributes intended to associate them with mythological or allegorical figures. In this case, the bow brandished by the sitter possibly alludes to the famed Nubian archers of antiquity, an ironic symbol of martial might given the man's subjugated status. In this way, the image mediates between power and powerlessness, with luxurious garments and weapons contradictorily serving to reinforce rather than subvert the sitter's oppression.

A livery coat and waistcoat of purple velvet worn by an enslaved man in Maryland in the mid-nineteenth century (p. 71) operates under similar codes: It is deliberately antiquated in style, cut to imitate courtly European garments of nearly a century earlier, while its metallic trim signals the wealth of the enslaver rather than that of the wearer—a sort of dress meant to underscore its wearer's bondage. Another livery coat of buff wool worn by a young enslaved man in Louisiana just before the Civil War (p. 76) is similarly historicizing, mixing vestigial elements of eighteenth-century dress, such as large pocket flaps on the coattails, with more recent, though still out-of-date, elements—namely, the cutaway front. The large silver-tone metal buttons are stamped—like coins—with the falcon emblem of Dr. William Newton Mercer, owner of Laurel Hill Plantation and the twelfth-largest slaveholder in the state.

The 1749 portrait of William Ansah Sessarakoo (p. 78) demonstrates the power of garments to negotiate and reinforce a change in social status. The son of a Fante ruler from what is now Ghana, who himself traded in gold and slaves from West Africa, Sessarakoo was sent to England for educational and diplomatic reasons but was sold into slavery in the West Indies by an unscrupulous ship captain instead. Brokering his son's recovery by English forces in 1748, Sessarakoo's father demanded that his royal offspring be furnished with "a Lace Coat"—that is, one trimmed with metallic galloon (p. 79) or lace—as a sign of England's respect. Thus attired in this painting and other portraits, he became, for a time, a celebrity in London and issued a memoir, *The Royal African: or, Memoirs of the Young Prince of Annamaboe* (1749). Whereas earlier Africans had been objectified by fancy dress, in this case Sessarakoo used clothing to distinguish himself as free, wealthy, and distinct from the enslaved people around him, highlighting the ways in which he and others at this time understood and took advantage of the strategic power of garments to convey changes in social status.

The contemporary fashion that follows re-signifies this history of dehumanization and denigrative valuation, bestowing agency and self-possession upon its wearers. The spectacular contemporary garments by Virgil Abloh for Louis Vuitton (pp. 80–81), Grace Wales Bonner for Wales Bonner (pp. 84–85), and Emeric Tchatchoua for 3.Paradis (pp. 86–87) deploy silver, gold, metallic lace, cowrie shells, and historical as well as contemporary currency to empower their wearers and thus visualize self-worth.

OWNERSHIP

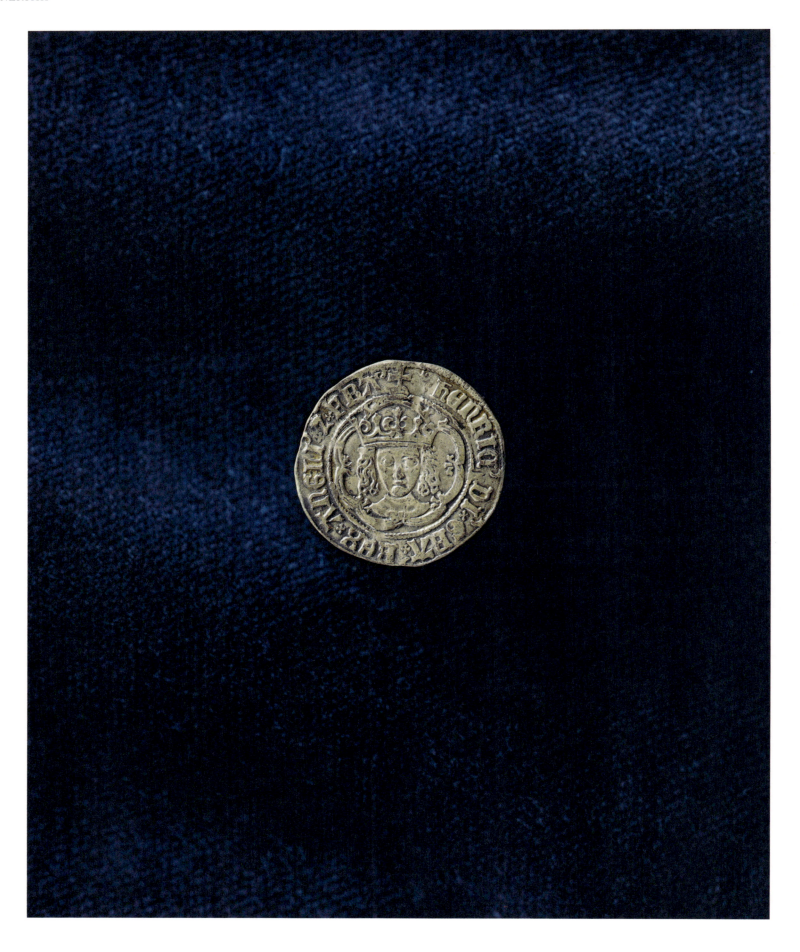

Half groat of Henry VII (1485–1509). British (15th–16th century)

OWNERSHIP

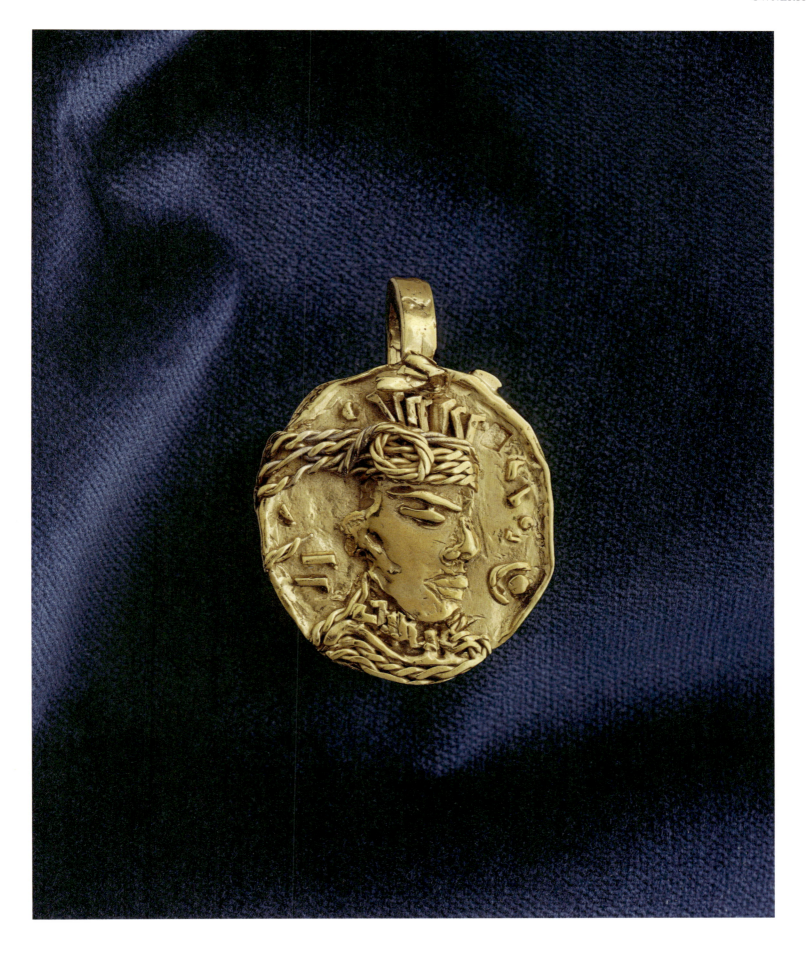

L'ENCHANTEUR. Soull and Dynasty OGUN. *"Kalinago Royal Coin #8" pendant*, 2023

OWNERSHIP

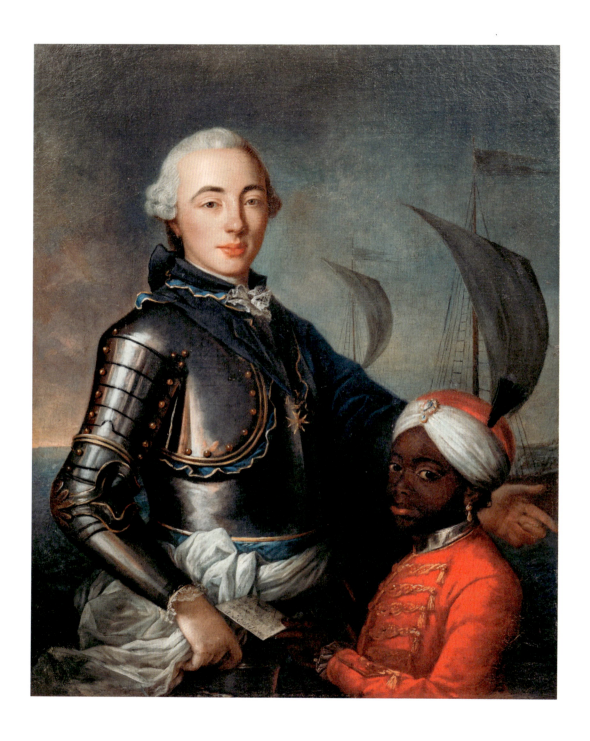

Workshop of Jean-Marc Nattier. *Roch Aza et Louis Armand Constantin Rohan, prince de Montbazon (1732–1794)*, 1758

OWNERSHIP

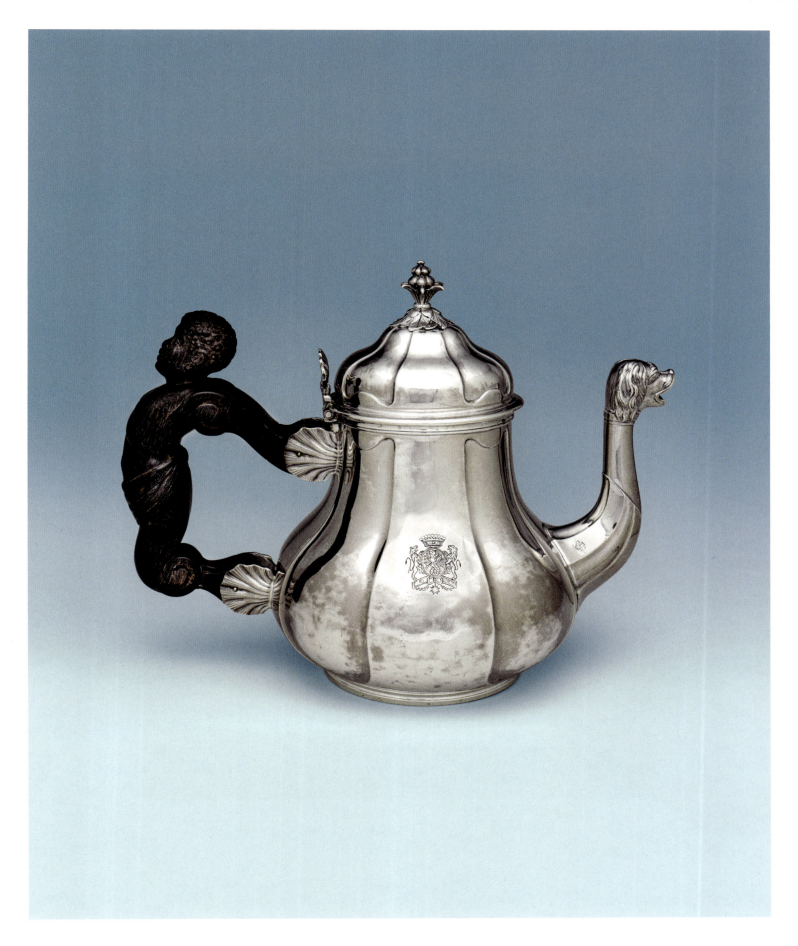

I.M.P. *Teapot*, mid-18th century

OWNERSHIP

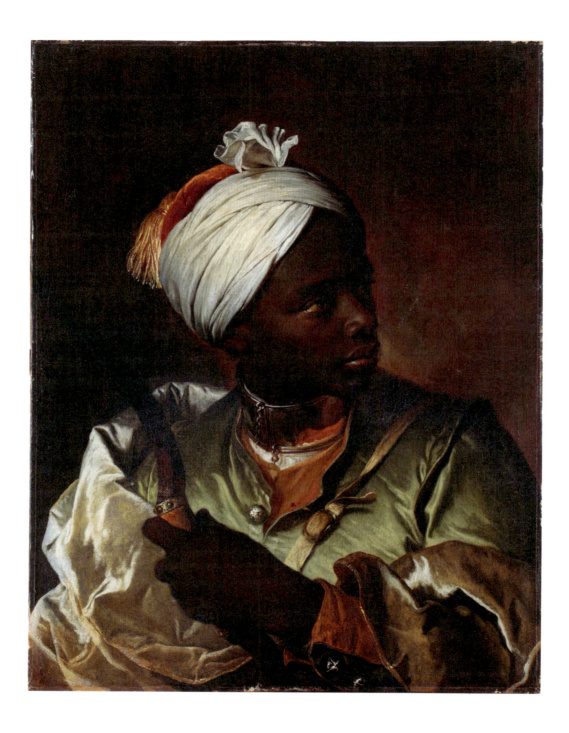

70 Hyacinthe Rigaud. *Portrait d'un jeune homme noir*, 1710–20

OWNERSHIP

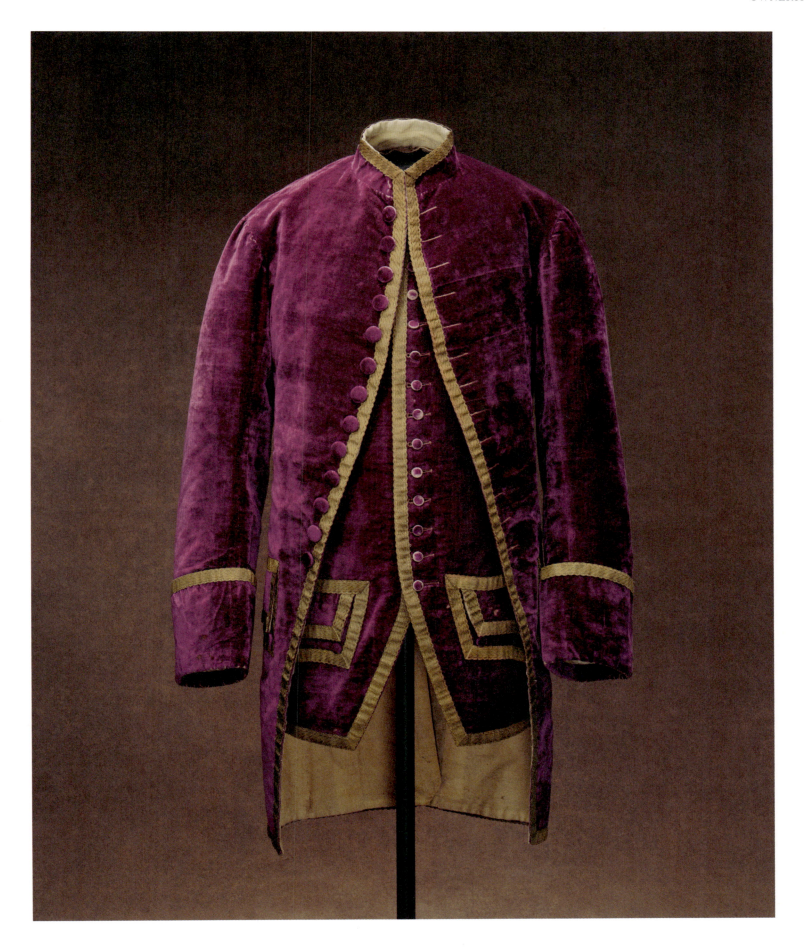

Livery coat and waistcoat. American (ca. 1840)

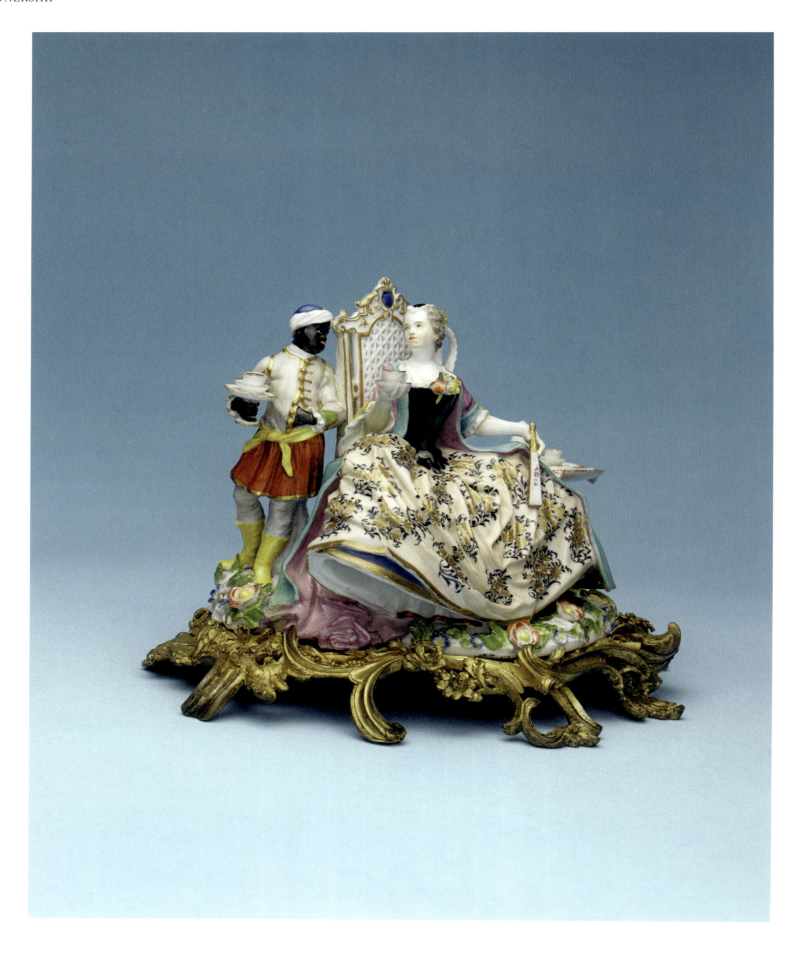

Meissen Manufactory. Modeled by Johann Joachim Kändler, after compositions by Laurent Cars and François Boucher. *Lady with Attendant*, ca. 1740

OWNERSHIP

BUT WHAT OF *HIS* FASHIONABILITY, HIS BEAUTY, HIS BLACKNESS?

ADRIENNE L. CHILDS

Livery . . . emerges as a fraught symbol of the contradictions between liberty and servitude,
consent and constraint.

—Urvashi Chakravarty, "Livery, Liberty, and Legal Fictions," 2012

Black servitude, fashion, and luxury consumption converge in *Lady with Attendant*, an eighteenth-century Meissen porcelain figure group in which a liveried young Black male cuts a striking figure (opposite). Although formed from a medium in which whiteness was highly valued, the Black attendant was a stock character in porcelain design. This ubiquitous persona demonstrates how style, ornament, and exotic flair can obfuscate the political dimensions of Black servility, normalize the horrors of colonial enslavement, and control the enigma of the Black body.

Lady with Attendant was manufactured by Meissen, the first major European producer of hard-paste porcelain. Established by the Saxon court, Meissen became the eighteenth century's leading trendsetter in porcelain design. *Lady with Attendant* is typical of the genre labeled "crinoline group," a type of decorative porcelain confection that features women in fashionable hoop skirts served by attendants, admired by suitors, or both. The Black male attendant, servant, or slave—often referred to as a "Moor" or a "blackamoor"—is an enduring character in Meissen's crinoline group variations. These popular amusements celebrate the leisure pursuits and romantic exploits of the courtly classes and were destined for display in porcelain cabinets—rooms designed to exhibit porcelain—or used as tabletop or mantel decorations.

In *Lady with Attendant*, a liveried Black attendant serves a chocolate beverage to a white woman in a voluminous dress. The figures gaze at each other in an intimate exchange—his adoration of her is a primary function of his presence in this scene. The young man wears an elegant white, red, and yellow tunic trimmed in gold. His sleeves are accented with green details; his sash and heeled boots are yellow. While the variety of colors enliven his costume, the pure white of his ruffled sleeves and turban establishes a contrast that amplifies his skin's pure blackness—perhaps his most distinguishing feature. Indeed, his undifferentiated blackness—echoed in the bodice of her dress and the scrolling designs on her skirt—is more decorative than

natural and is deployed to enliven *her* white skin and blushing cheeks. Of course, whiteness—a celebrated quality of porcelain—was a mark of her beauty. His blackness was her foil.

Although fictional characters in Meissen objects, actual Black servants were de rigueur in eighteenth-century European society. To own a Black attendant was a form of conspicuous excess that signified wealth, a taste for the exotic, and possible colonial connections. Black servants, frequently adorned with a pastiche of feathered turbans, pearl earrings, and sumptuous livery, were conventional accessories to white aristocratic sitters in paintings from the seventeenth century onward. This trope that yokes fashion and luxury to Black subservience most certainly influenced Meissen designers, who often looked to trends in painting as inspiration for their fanciful subjects.

Meissen's blackamoor attendant's fraught mélange of Blackness and European style is aimed at embellishing others, not at representing himself. Indeed, his very presence in the woman's world—servant to her served, admirer to her admired, Black to her white—is designed to showcase *her* fashionability, beauty, and whiteness. But what of *his* fashionability, his beauty, his Blackness? What of the discordant relationship between the realities of Black servitude and the elite leisure pursuits celebrated in this figurine? What of the backbreaking Black labor that brought the chocolate and sugar to this lady's table? The rumblings of these forces frame *Lady with Attendant*, yet they are veiled by the smoke and mirrors of style and the decorative conceit. In fact, this object lays bare the way a seemingly benign bauble—an object of genteel desire—can be an insidious political agent that both recognizes and obscures Black subjugation. Liveried Black servants in European luxury arts are more than decorative fictions; they are avatars of Africans ensnared in transatlantic slavery. Even though they are shrouded in European clothing and immobilized by luxury materiality, they recall real Black bodies and real Black labor and are thus the unwitting symbols of the wealth built on their degradation.

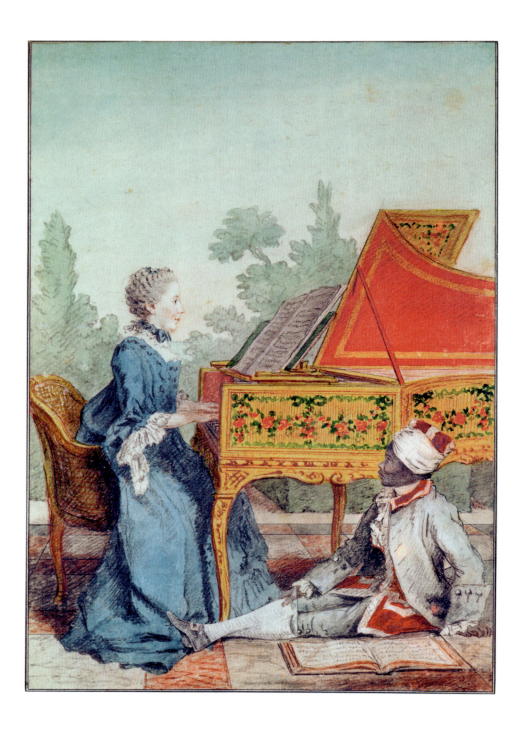

Louis de Carmontelle. *Mlle Desgots, de Saint Domingue, avec son nègre Laurent*, 1766

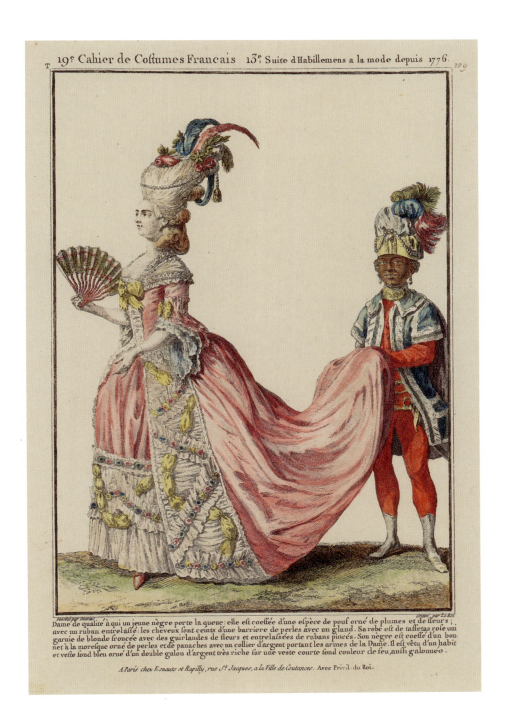

Claude Louis Desrais. *Dame de qualité à qui un jeune nègre porte la queue*, published in cahier 19 of *Gallerie des Modes*, 1779

OWNERSHIP

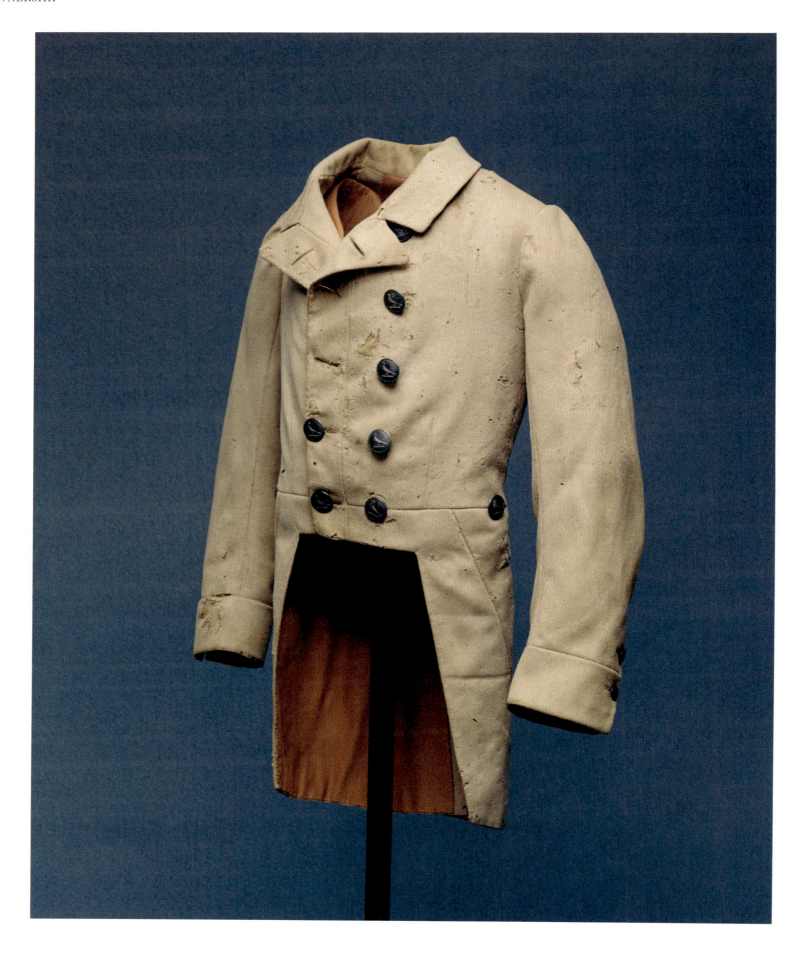

Brooks Brothers. *Livery coat*, 1856–64

OWNERSHIP

DANDIES ON DISPLAY: LIVERY, LUXURY, AND THE ENSLAVED BODY

JONATHAN MICHAEL SQUARE

For enslaved individuals, clothing was far from a trivial matter; it directly influenced their treatment and perception. In the eighteenth and nineteenth centuries, liveries were more than just uniforms; they were visual representations of the power and social standing of the families who owned them. These garments, often antiquated in style and rich in symbolism, played a crucial role in maintaining social hierarchies and reinforcing the boundaries between freedom and bondage. This essay examines the significance of livery in the context of slavery, exploring how these uniforms were used to display a family's status, assert their authority, and mark the enslaved as distinctly separate from the free. The discovery that a coat, waistcoat, and breeches (p. 71), once thought to belong to prominent Maryland lawyer and politician Charles Carroll, were worn by an unidentified enslaved man underscores the deeper implications of livery in a slave society.

Livery was intentionally designed to be highly visible, ensuring that enslaved individuals wearing it were immediately recognized as the property of a wealthy family. The style of livery was often deliberately antiquated to create a clear distinction between those serving and those being served. In the case of the coat, the deep, regal purple velvet was not just a choice of luxury but a calculated display of wealth. Purple, historically associated with royalty and exclusivity, would have made the enslaved person wearing it an immediate marker of their owner's affluence. The fabric's rich texture and deep hue would have drawn attention to the enslaved individual, turning them into a living symbol of conspicuous consumption. The craftsmanship of the coat further emphasizes this dynamic. The intricate gold trim and buttons running down the front reflect an air of opulence, with the bright, metallic embellishments acting as visual markers of the wealth and power that dictated every aspect of the wearer's life.

The clothing worn by enslaved men was often adorned with symbols of a family's wealth, such as crests or other heraldic emblems. These symbols were not merely decorative; they were a clear assertion of a family's control and dominance. For example, the Ridgely family of Hampton Mansion in Baltimore County, Maryland, dressed their formerly enslaved manservants Tilghman Davis and Thomas Brown in liveries (now in the permanent collection of the Maryland Center for History and Culture) that prominently featured the family's stag's head.

In her essay "Hidden in Plain Sight: Uncovering the Livery of Tilghman Davis and Thomas Brown," Norah Worthington describes how the stag's head was displayed not only on the buttons of the manservants' coats but also throughout the Ridgely estate, ornamenting chairs, curtain tiebacks, letter openers, bookplates, and paperweights and serving as a constant visual reminder of the family's social status and authority. "Worn by highly visible male servants—men accompanying carriages, footmen, waiters and the like—livery was an elaborate and expensive uniform whose symbolism was not lost on contemporaries," explains Linda Baumgarten in her article "Clothes for the People, Slave Clothing in Early Virginia." Bespoke details, such as buttons emblazoned with symbols of enslavers' dynastic prosperity, communicated the genteel sophistication of the enslaving class of pre–Civil War Maryland.

The significance of livery is further reinforced by the example of Brooks Brothers, a two-hundred-plus-year-old American clothing company with historical ties to slavery. Brooks Brothers provided fine coats not only to wealthy patrons but also to their domestics, some of whom were enslaved, as this author discusses in "A Stain on an All-American Brand: How Brooks Brothers Once Clothed Slaves." For instance, Dr. William Newton Mercer, a wealthy enslaver and Brooks Brothers customer, purchased two of their coats for his enslaved valets in New Orleans. Now housed in the Historic New Orleans Collection, these coats, like the one opposite, were crafted from fine silk and wool and adorned with the Brooks Brothers label, signifying the wealth and status of their owner. Moreover, like the coats worn by Tilghman Davis and Thomas Brown, these Brooks Brothers coats feature buttons emblazoned with a heraldic symbol of the enslaver—in this case, a falcon.

Through their clothing, enslaved individuals were compelled to embody the wealth and power of their enslavers, even as they were denied the freedom and autonomy that such symbols of status might imply. However, the man enslaved by Charles Carroll likely cut a dashing figure in the purple coat and waistcoat, whose color is one that many, at least in a Western context, associate with regality. The strictures of clothing, though imposed, were not entirely totalizing. Even when forced to wear prescribed garments, enslaved people found ways to assert their individuality and transform these items into something uniquely their own, likely imbuing them with beauty and personal significance.

OWNERSHIP

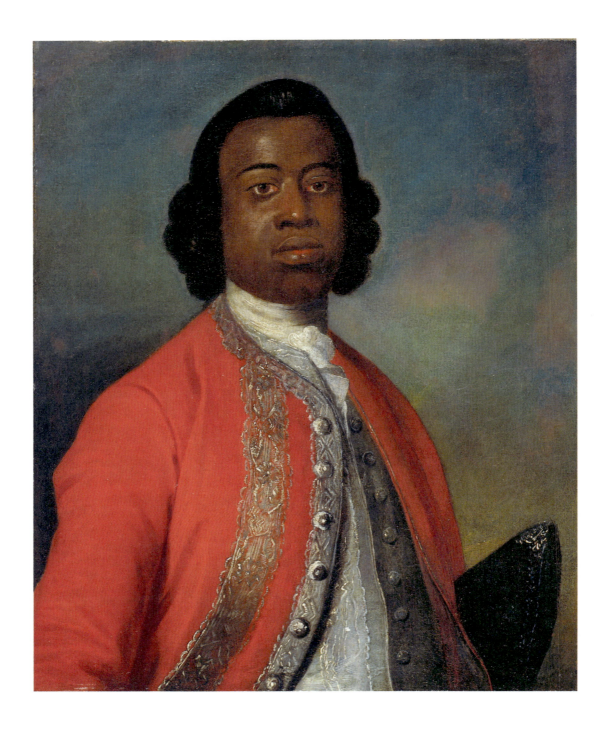

Gabriel Mathias. *Portrait of William Ansah Sessarakoo, Son of Eno Baisie Kurentsi (John Currantee) of Anomabu*, 1749

OWNERSHIP

Galloon. Italian or French (17th–18th century)
Galloon. European (late 18th–early 19th century)

79

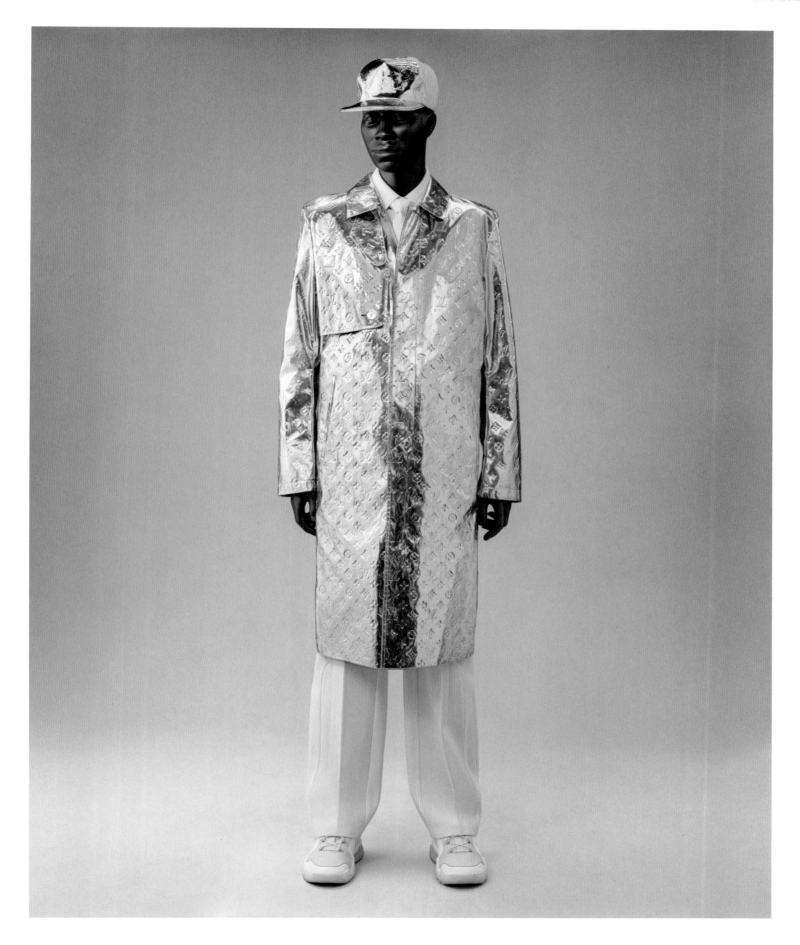

LOUIS VUITTON. Virgil Abloh. *Ensemble*, autumn/winter 2021–22 menswear

OWNERSHIP

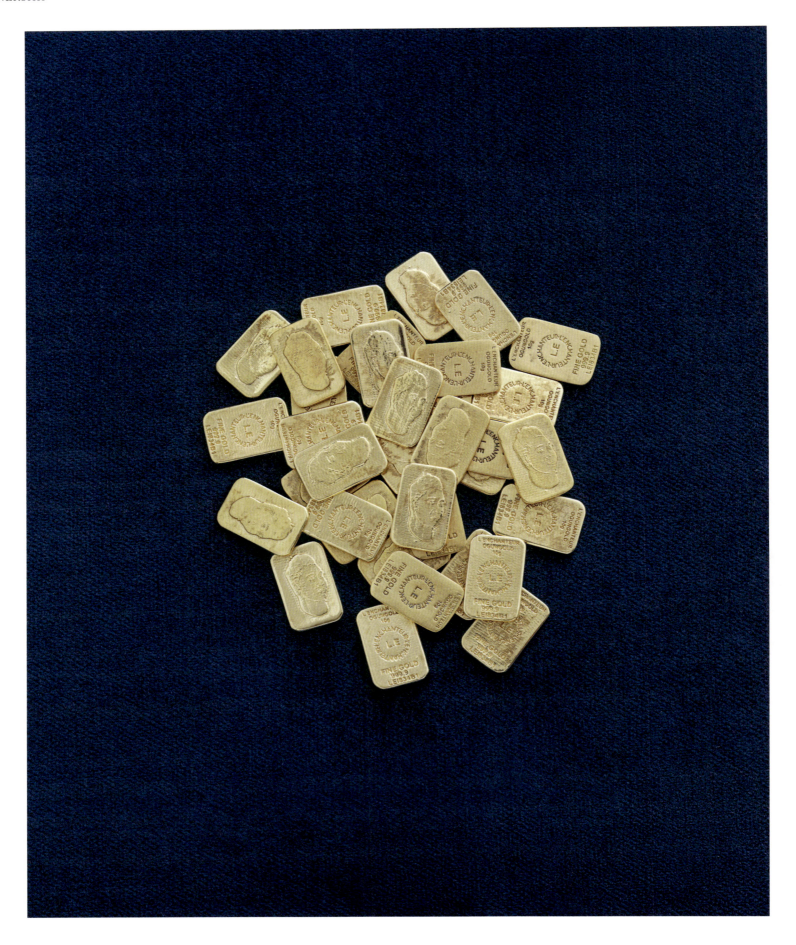

82 L'ENCHANTEUR. Soull and Dynasty OGUN. *"L'E Goldwill" bullion*, 2023

THE BULLION OF THE PAST AND THE L'E BULLION OF THE FUTURE

SOULL AND DYNASTY OGUN

Bullion refers to precious metals that have been transformed into bars, ingots, or coins. The history of bullion—particularly gold and silver bullion—is deeply interwoven with the evolution of trade, currency, and wealth.

Early humans used gold and other precious metals in their most natural forms for decorative purposes. Soon, gold became associated with the sun and was said to have mystic energy and powers, as it was the sun on Earth. Gold had been a form of adornment, though it is misleading to think that only those of the upper classes wore and used gold; everyone had and used gold, no matter the creed.

In ancient Sumer, the first recordings of gold being used as currency and for trade date back to 3000 B.C.E. In precolonial Africa, the Kingdom of Kush is the earliest African civilization to mine gold for currency; its rulers minted coins and traded with Egypt and other cultures. In ancient Egypt, gold became closely associated with the divine and with pharaohs who were often buried with it to carry to the next life. The Mali Empire was renowned for its vast gold reserves. On his hajj, the Mali ruler Mansa Musa is said to have handed out so many gold coins and bars that it devalued the currency for the next twelve years, changing the city's economy. Timbuktu in northern Mali became a major center for the gold market and a place where gold bullion was used for local commerce and as a currency for international trade. In the sixth century, ancient Rome and Greece were inspired not only by the studies of Alexandria, Egypt, but also by their teachings of the purity and beauty of gold. The Romans and Greeks began to mint gold coins of specific weights and purity levels, establishing the foundation for the modern bullion trade.

The L'E bullion (opposite) recognizes the expansion into the portal of equity and currency and merges it with art and design. In its design, there is a definite call to remain true to original bullion while adding our mystic style to it. L'E bullion wants to immortalize the image of the creators' mother, who signifies the importance and activation of lineage. By reimagining and restating bullion gold as heirlooms, the bullion becomes a means of leaving a legacy. It also creates an avenue toward reestablishing wealth and equity as attainable assets that appreciate in value.

In establishing the L'E bullion as a usable currency, we are also blending assets, fashion, and jewelry. In a culture where gold is the mark of steady currency, we create a world where natural resources serve as an entryway into reinstating equity among wearable art and technology. L'E bullion is an investment that hedges against modern inflation and economic uncertainty, carving an access point for New Age futurists.

Bullion has evolved from being a symbol of the sun, divinity, wealth, and power in ancient civilizations to a cornerstone of contemporary global financial systems and equity. Its roles as a commodity, medium of exchange, and investment asset have been central to economic development throughout millennia. Even despite the rise of fiat, paper currency, precious metals like gold continue to be regarded as stable, valuable assets for individuals and nations. The L'E bullion is writing itself into economic history, creating a modern-day account for future civilizations. The L'E bullion merges past, present, and future economic timelines while bridging the timelessness of art and design. The future of currency is designing both art and a means to participate in the gold trade.

OWNERSHIP

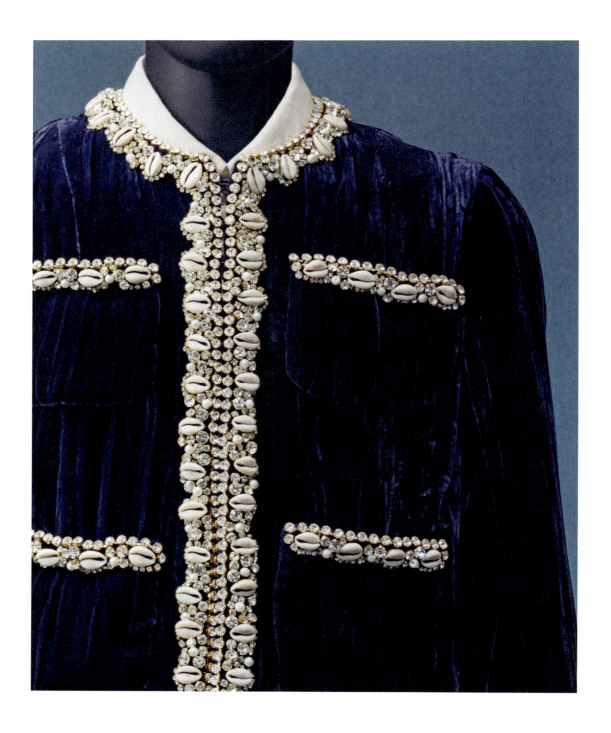

OWNERSHIP

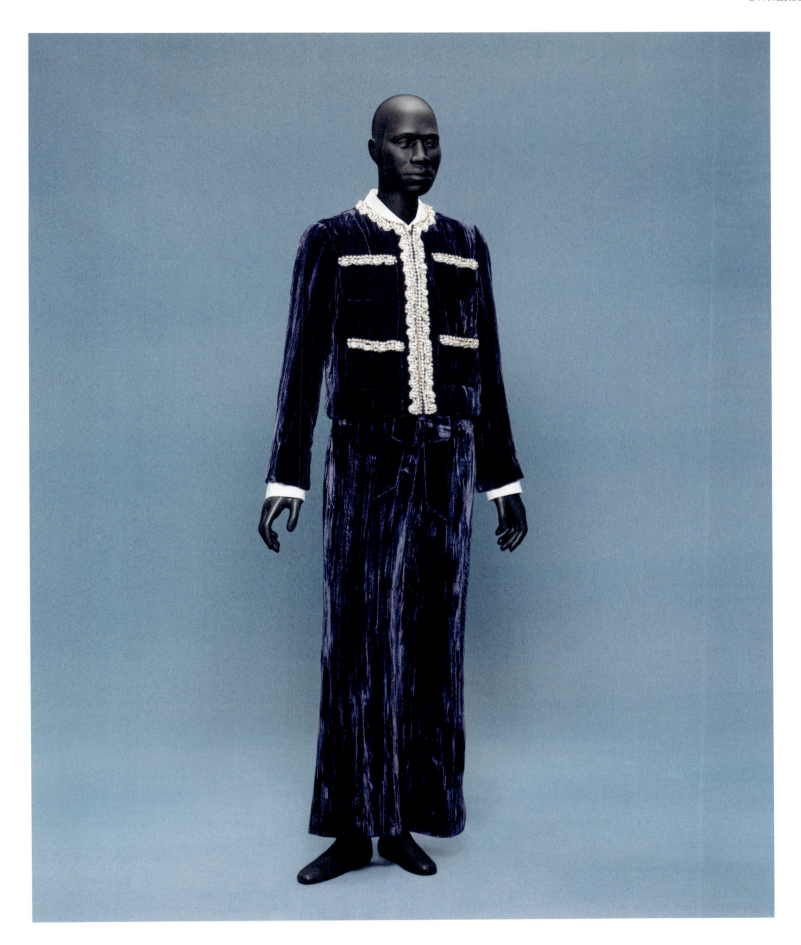

Wales Bonner. Grace Wales Bonner. *"Aime" ensemble*, autumn/winter 2015–16

OWNERSHIP

86

OWNERSHIP

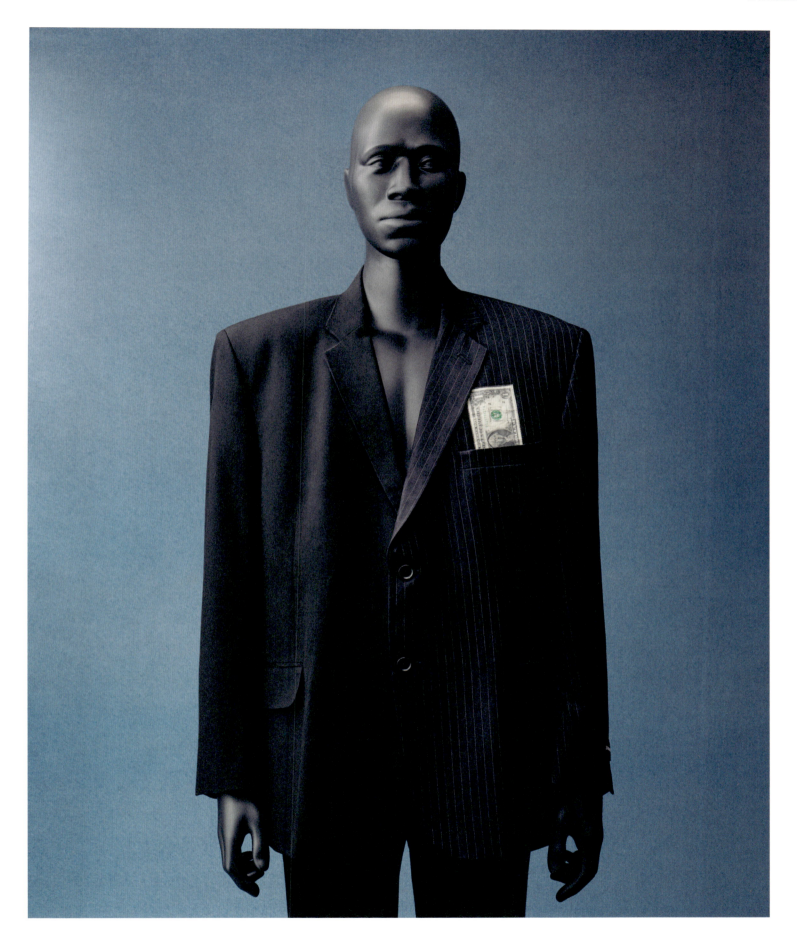

3.PARADIS. Emeric Tchatchoua. *Jacket*, autumn/winter 2019–20

Presence

"She must have loved the idea of my presence,
the combination of my looks, tall and honey colored;
my impeccable manners and grooming;
my blossoming unorthodox style.
Plus my master's degree!"

ANDRÉ LEON TALLEY
The Chiffon Trenches: A Memoir, 2020

(In)famous in eighteenth-century London, Julius Soubise was one of the first recognizably self-fashioning Black dandies in Europe, known for a style and manner that challenged society's norms. Born into slavery in the Caribbean, he was transported to England and given as a "gift" to the Duchess of Queensbury, who, in addition to manumitting him, provided him an education in the genteel arts of music and fencing. Soubise—highly visible as a Black man of fashion—and his antics were recorded by his contemporaries in both print and caricature. As a free man and retainer of the duchess, he defied social conventions for a formerly enslaved person, taking boxes at the opera, enjoying elaborately furnished apartments, and joining exclusive men's clubs where fellow Black men were bought and sold. As Henry Angelo, Soubise's fencing instructor, later wrote in his 1830 memoirs, "Soubise . . . had private apartments, unknown to the family, where he assumed the habits of an extravagant man of fashion. He had a constant succession of visitors, and his rooms were supplied with roses, geraniums, and other expensive green-house plants, in the spring. He was equally expensive in perfumes, so that even in the lobbies at the theatres, the fops and the frail would exclaim, 'I scent Soubise!'"

Despite his perceptible social agency, which made him conspicuous, Soubise left relatively little historical evidence of his own—the fate of so many Black dandies to follow. To borrow from the language of perfume (of which he was so fond), Soubise left behind *sillage*, or a wake, containing a trace of his existence, one marked by the outsize effect his sensorial presence left in the minds of white observers and critics. In fact, our only access to Soubise today comes primarily by way of the images and descriptions authored by these white viewers, demonstrating his paradoxical hypervisibility and invisibility, even as he remains one of the few Black dandies from the eighteenth century identifiable by name. "Presence" denotes this ghostliness as a metaphorical concept: At once here and gone, Black dandies like Soubise could be easily subsumed into broader (white) typologies, their subversive power neutralized as they were simultaneously endowed with uniqueness and robbed of the agency of true individuality. The images of him that remain for us today are caricatures, themselves based on earlier prints of white figures, that not only give Soubise space but also mark him as merely one of a type.

Soubise's rise as a social celebrity coincided with the zenith in England of the Macaroni Club, members of which were a sort of prototype of the dandy and whose tight, colorful garments, oversize wigs, and sometimes effeminate manners—derived, it was believed, from exposure to Continental fashions and customs on the Grand Tour—made them easy targets for ridicule. Macaronis pushed boundaries of dress, gender, and sexuality, and Soubise added race to this list. The caricature "portrait" of Soubise published by Matthias and Mary Darly (p. 93) mirrors contemporary images like that of the so-called *Nosegay Macaroni* published in *The Macaroni and Theatrical Magazine* in February 1773 (p. 92). Although the former print is missing the conspicuous floral accessory of which Soubise was apparently quite fond, William Austin's

engraving published in May 1773 (p. 94) includes a large nosegay—as well as the tricorne hat (p. 95) and cane that were also part of the macaroni's uniform—discarded on the ground so Soubise can fence with his patroness, the Duchess of Queensbury. This print is in turn adapted from engravings included in Domenico Angelo's 1763 fencing manual *L'ecole des armes*, demonstrating how Soubise's public image and presence were determined by white precedents.

Black dandies like Soubise were disruptors of social norms, creating outsize anxieties that could only be quelled by ridicule (caricature) and the creation of categories into which the men could be lumped, and therefore excluded. Soubise, in turn, provided a blueprint for later Black dandies whose sensory-arresting accessories and proud physical bearing made them targets for being inventoried as "men of parts" rather than as individuals. Recalling Darly's portrait of Soubise, the description of a "Mulâtre," or biracial dandy, from the Antilles included in the pseudo-anthropological *Les Français peints par eux-mêmes* (p. 100) concludes, "Mulatto [men] cherish more than anything all the vain pleasures of dressing," loving "to have the cut of their clothes and the flexibility of their cavalier bearing admired, to display the gigantic knot of a voluminous cravat, to strike the attention of passers-by with the metallic sound of their spurs and the crunch of their shiny boot." This imagery, partially derived from blackface caricatures (p. 152), became a pervasive visual stereotype of the over-accessorized, overconfident Black dandy (p. 101).

Soubise's "flowering" as an individual, expressed through his confident pose and association with nosegays, is reflected in contemporary fashion and accessories that use florals as elements of elegance and self-possession. The daisies, yellow alyssum, pink strawflower, and purple statice bouquet embroidered onto a suit of black wool pinstripe by Emeric Tchatchoua for 3.Paradis (p. 98) evoke the boutonniere and its scent of fresh flowers, Soubise's macaronic marker. Tchatchoua's dried blossoms are a vibrant and luxurious counterpoint to the simulacra of leather adorning a Louis Vuitton bag by Virgil Abloh (p. 97). The Romantic appreciation among men for the beauty of the natural world and the tradition of giving, receiving, and wearing flowers is thus translated into a surreal and assertive format for twenty-first-century dandies.

The bold, colorful, affirmative styling of contemporary dandies—their insistence on presence un-deniable—is embodied by artist and aesthete Iké Udé, who lives and works in the dandy tradition. In his art and life, Udé self-styles as an elegant man of fashion, using visual wit and eclecticism to make and leave a mark. His photographs are not merely aspirational self-portraits designed to celebrate and critique the world of fashion as the theater of the absurd; rather, they create a transhistorical archive of African elegance and colonial encounter and, increasingly, of cosmopolitanism and globalization, written and worn on the body. Clothes-wearing men (and women) exhibit a knowingness about seeing and being seen, an incisive sense of the sometimes fabulous but always serious optics of race, fashion, and power.

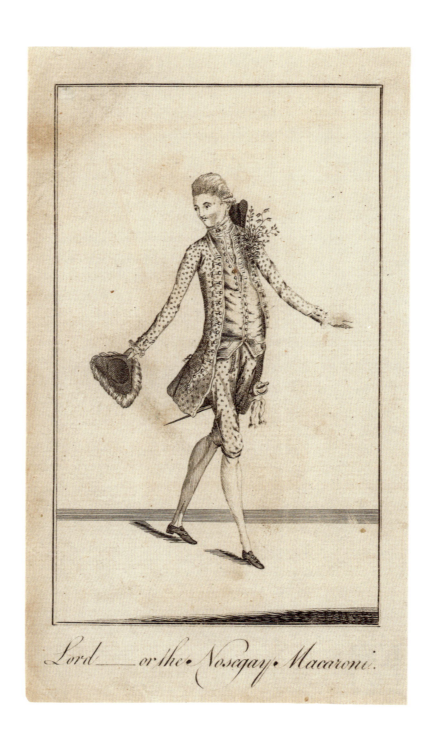

Lord —, or, The Nosegay Macaroni, published in *The Macaroni and Theatrical Magazine, or Monthly Register, of the Fashions and Diversions of the Time*, February 1773

PRESENCE

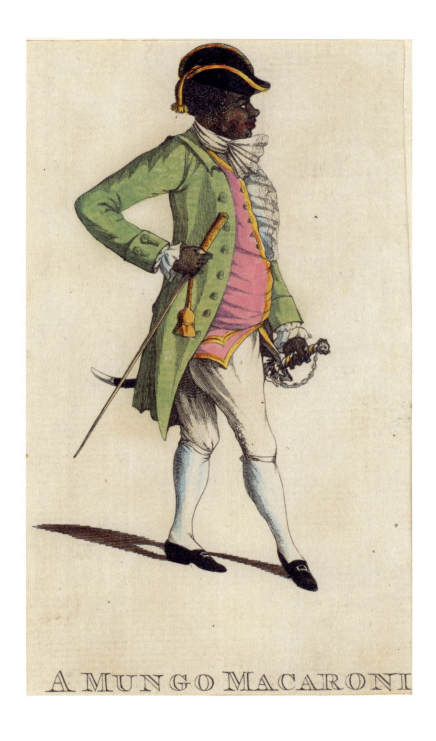

Matthias and Mary Darly. *Portrait of Julius Soubise ("A Mungo Macaroni")*, 1772

93

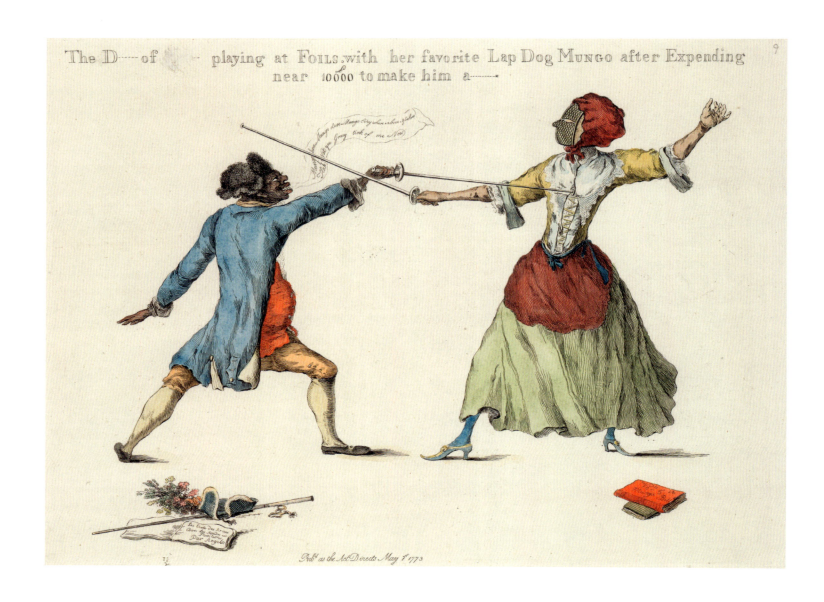

William Austin. *The D— of [. . .]—playing at foils with her favorite lap dog Mungo after expending near £10000 to make him a —**, May 1773

PRESENCE

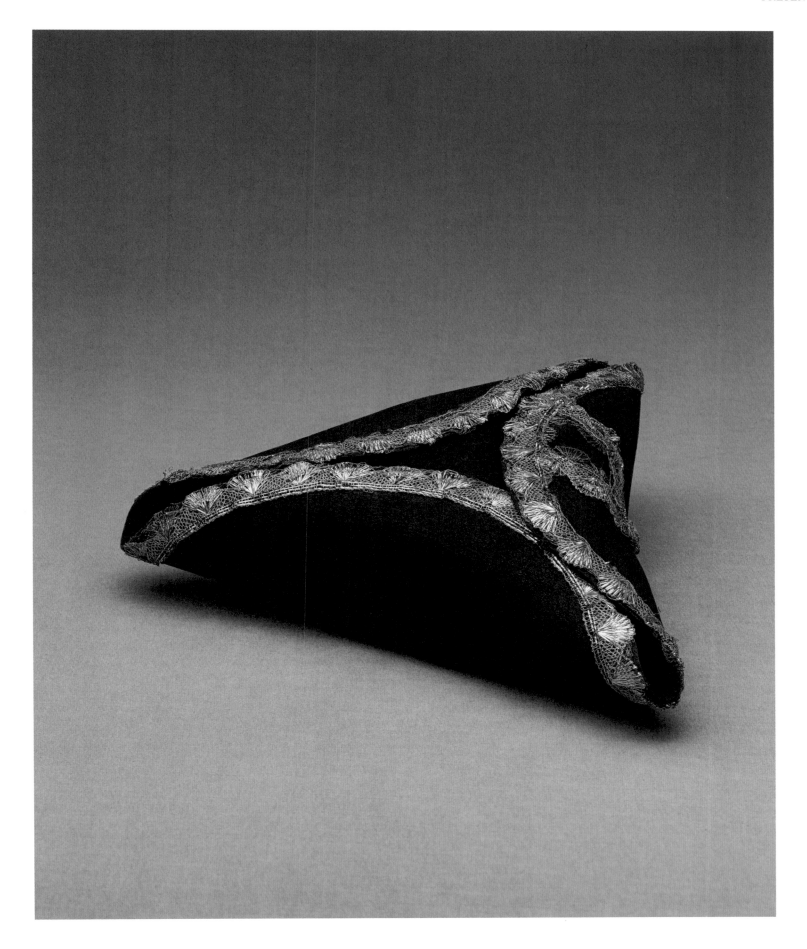

Tricorne. Italian (mid-18th century)

PRESENCE

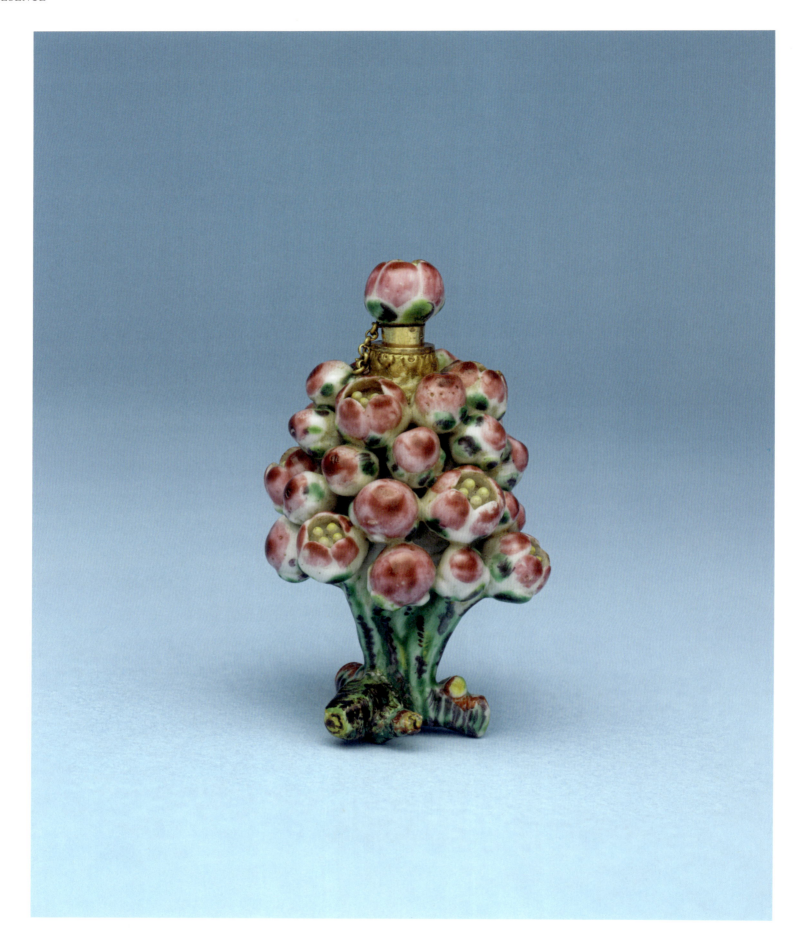

96 Saint James's Factory. *Scent bottle*, ca. 1750–55

PRESENCE

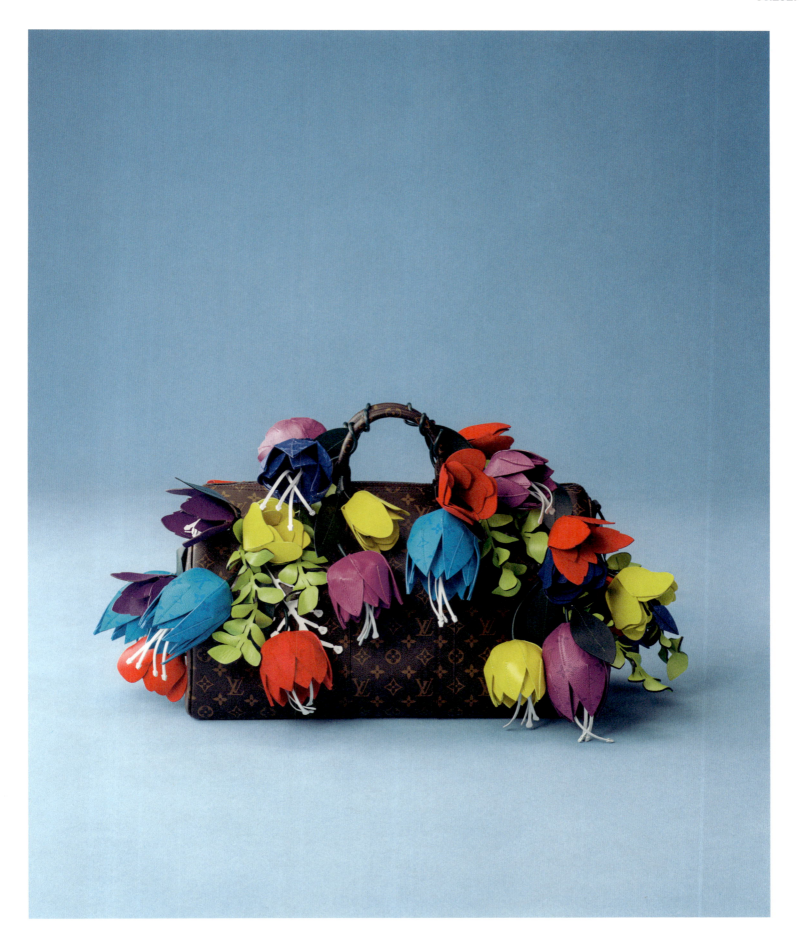

LOUIS VUITTON. Virgil Abloh. *Bag*, autumn/winter 2022–23 menswear

PRESENCE

3.PARADIS. Emeric Tchatchoua. *Jacket* (detail), 2021

DANDIES MOST HIGH

JEREMY O. HARRIS

The deacons always looked the best—monochrome, wide legged, broad shouldered, and often in a hat. These were the sartorial flourishes all others aspired to as Sunday neared. They would comb the racks of JCPenney after shifts at Goodyear Tire or American of Martinsville, crafting the skeleton for a life in the American South none of them could afford outside of the annual blowout sales. What our mothers knew that our fathers did not was that the deacons—often factory workers as well but off the floor because God had blessed them with modest managerial positions—had their suits made much like those of their wives: by Mr. Rippe of Rippe's. Yet, bereft of the deacons' and Rippe's money, our fathers and mothers made do, crafting glorious facsimiles of those monochromatic uniforms so that they, too, could cry out in the glory of the Lord wearing apparel that telegraphed a proximity to him. For that's what an angel was in the churches of Martinsville, Virginia: a dandy Most High, dancing like David to praise God, unashamed if those garments fell off broad shoulders or down wide legs, dotting the ground like little pieces of heaven.

Debt was not a concern in this pursuit to dress for being in the company of the Lord. Therefore, a practice was developed for finding a way out of no way, for building a closet as diverse and dynamic for those Sunday jaunts as the bodies we might one day meet in heaven. Tithes and offerings aimed to express your gratitude for all that the Lord bestowed upon you in life—as did sacrifice. So, if a pair of Stacy Adams dress shoes for you and Dad to wear at next Sunday's revival meant that the family ate syrup sandwiches for lunch all week, it was all in service of praising the Lord. In this life, our men were burdened by trials and tribulations, marked by their downturned shoulders as they returned home in blue jumpsuits over the course of a working-class week. And yet on Sundays, we could envision man as God intended: adorned somewhere between Steve Harvey and Isaac Hayes with Fonzworth Bentley's accessorized flair.

The goal for the average man was to ascend to deacon. Yet, for me—the young queen in pew number three—the aspiration was pastor, the most gilded and most rarified of the Lord's dandies. He showed that manifesting a seat closest to God did not mean only adopting an attire befitting heaven; it also meant having access to a loud voice and a theatrical wit, wild with warbled, winding, winded alliterations. If you were to ascend to the pulpit as pastor, there would be robes that flowed like royal silks and jewelry that sparkled like the gold left with the frankincense and myrrh at baby Jesus's manger; your fingers and neck would clink and clatter as you held an audience with simply your countenance. The dandies Most High who sat the most high in my imagination, who shaped me into the peacock I've become, were not the rappers on BET, the queens at the ballrooms on TV, or even the men who populated Spike Lee's screens, for the dandy who birthed them all was the pastor they'd seen.

The deacons always looked the best. The pastor? The pastor was the embodiment of a man of God. What are dandies if not the men of gods?

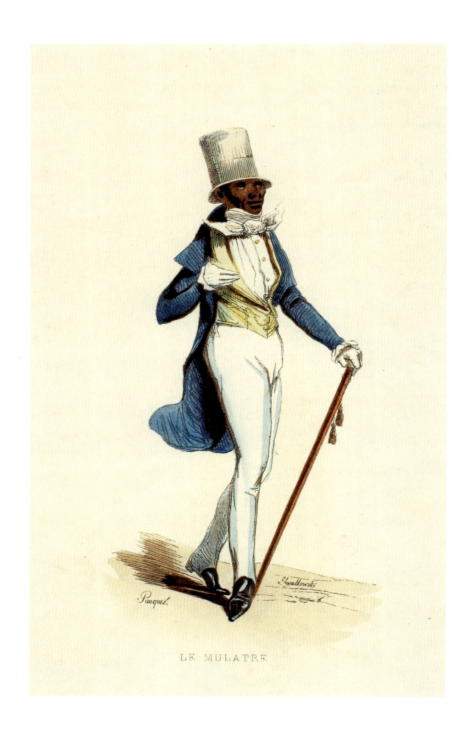

Hippolyte-Louis-Emile Pauquet. *Le Mulâtre*, published in tome 3 of *Les Français peints par eux-mêmes,* or *Encyclopédie morale du XIXᵉ siècle,* 1842

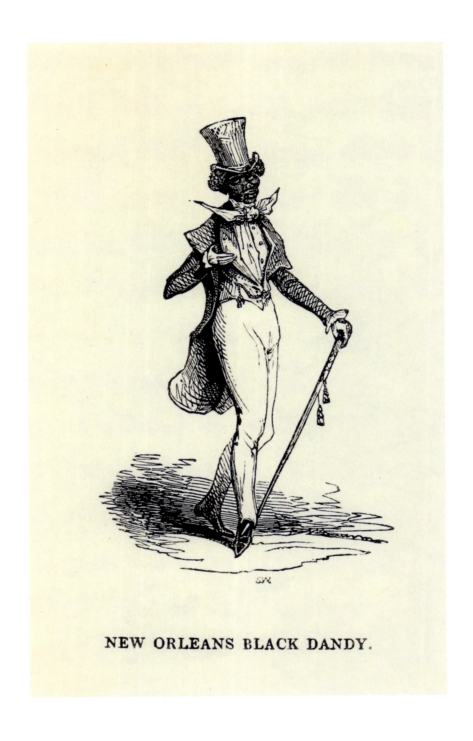

S. W. *New Orleans Black Dandy*, published in volume 2 of *Texas and the Gulf of Mexico, or Yachting in the New World* by Matilda Charlotte Houstoun, 1844

PRESENCE

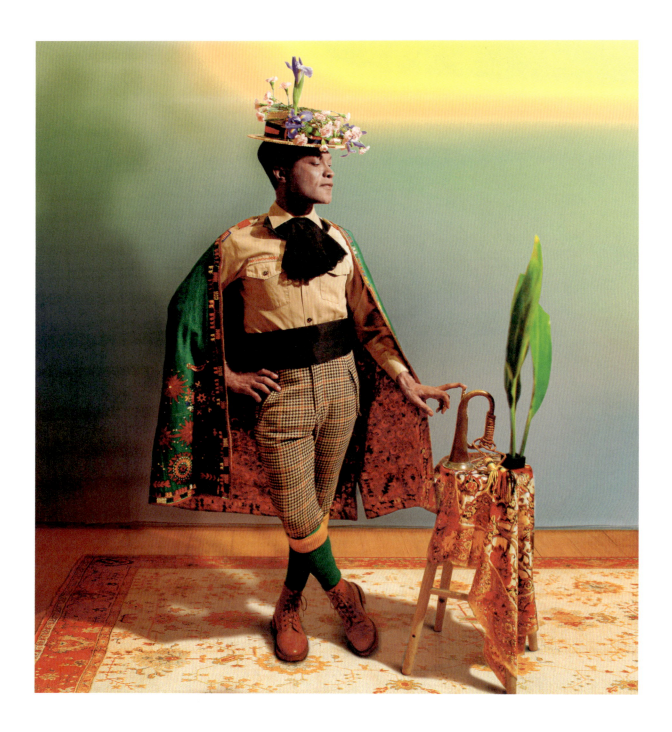

102 Iké Udé. *Sartorial Anarchy #4*, 2012

PRESENCE

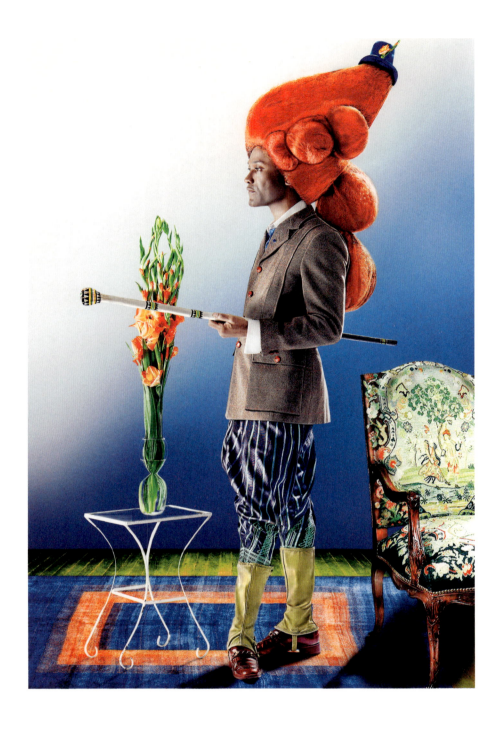

Iké Udé. *Sartorial Anarchy #5*, 2013

103

Distinction

—◆—

"War gives numerous opportunities for distinction, and especially
to those who in peace have demonstrated that they would
be available in war; and soldiers can win distinction in both peace
and war if they will but seize their opportunities."

HENRY O. FLIPPER
The Colored Cadet at West Point, 1878

"Distinction" examines military dress as a particular form of fastidious Black masculine self-representation, symbolic of a command of political and cultural authority. In 1804 a successful revolt by previously enslaved people established Haiti (formerly Saint-Domingue) as the first independent Black republic in the Western Hemisphere. Inspired by Enlightenment philosophy and the French Revolution's emphasis on the "rights of man," leader Toussaint L'Ouverture led an uprising of people determined to liberate themselves, becoming brigadier general of the French army in 1795 and commander in chief of Saint-Domingue two years later. The only images of L'Ouverture made during his lifetime are engravings, all by white artists who had never encountered the already legendary military leader. Alexandre François Louis de Girardin's portrait of 1804–5 (p. 108) commemorates L'Ouverture after his death in a French prison, following his capture by Napoleon Bonaparte's troops in 1802. In this painting, L'Ouverture is resplendent in military dress and a French revolutionary officer's bicorn hat, complete with tricolor cockade and plume. That the portrait is in oil and Toussaint is styled with such dignity speak to his stature and cultural command. A Dior coat created for fashion editor André Leon Talley by John Galliano (p. 109) both capitalizes on and subverts the strict codes of military dress that L'Ouverture embodied. Mixing recognizable elements like gold braid and buttons with an off-kilter asymmetry, the coat evokes a sultry combination of command and ease. Depictions of other Haitian leaders from the period like Jean-Pierre Boyer (p. 114), president from 1818 to 1843, exude similar elegance and distinction through military garb appropriated from European examples—themselves influenced by fashionable dress. Such attire was used to mark the status of these revolutionaries as equal to that of their white counterparts. Gold embroidery on Boyer's uniform connotes both luxury and military rank and demonstrates the ostentation afforded to men in positions of leadership, even as civilian clothing became increasingly restrained from the end of the eighteenth century onward.

This story is told not only through portraits of revolutionary men but also through historical accessories and contemporary garments that allude to military styles. For example, an elaborately decorated presentation sword (p. 115) manufactured in Birmingham, England, and belonging to Faustin-Élie Soulouque, president and, later, the first emperor of Haiti, is as much a symbol of martial power as a sumptuous accessory and not unlike a dandy's cane in its overwrought embellishment and impracticality. It mirrors similar examples seen in images of Haitian military leaders, such as a watercolor possibly depicting Henry Christophe, first king of Haiti, with an unknown general (p. 112), or in a ca. 1816 portrait of the king by Richard Evans (p. 113) that emphasizes Christophe's royal mien, replacing elaborate military garb with similar though more "Brummellian" or dandiacal fashionable attire, including shiny yellow Hessian boots and a gold-headed cane. Moreover, brass and glass buttons allegedly owned by L'Ouverture and portraying miniature scenes of life on the Caribbean island of Dominica (p. 110) fascinatingly comment on the period's race and class structures. Painted in the style of well-known Italian artist Agostino Brunias, famous for his portraits of West Indian society, the buttons depict the island's mixture of different races and classes through the figures' skin tones and styles of dress, thereby equalizing hierarchies.

Portraits of General Thomas-Alexandre Dumas and his son, the writer Alexandre Dumas *père*, allow us to think about the creation, inheritance, and use of Black masculine swagger in revolutionary times. Their body-conscious representations manifest the complexities related to being of African descent in an age of revolt—in politics, culture, and even the science of race. Born to an enslaved Haitian woman and a French nobleman in Saint-Domingue but educated in France, Thomas-Alexandre was legally recognized

as his father's heir and afforded a military career, becoming the first general of color in the French army in 1793. Alexandre was said to have been inspired by his father's military exploits, importing some of the action into *The Three Musketeers* and *The Count of Monte Cristo*, his celebrated novels of the 1840s. Dumas *père* recalls in his memoirs how his mother carefully protected his father's clothing, intending it to be his legacy. He writes, "I felt myself seized by the desire to look smart" at the age of sixteen, adding how he discovered "clothing fashionable enough to satisfy the most fastidious taste" in a chest containing the remnants of his father's wardrobe, which included "pantaloons of leather"—perhaps those Thomas Alexandre wears in Louis Gauffier's portrait of 1801 (p. 116). At this young age, Dumas could not help but compare his own body to the imposing musculature of his father's, lamenting, "My poor mother imagined that because I was heir to my father's breeches, I had also inherited his calves." Later known for his imposing height and long legs—as amply displayed in Achille Devéria's engraving (p. 118)—Dumas *père* came to exemplify the French dandy in the early nineteenth century, embodying distinction as a literary, rather than a military, icon, his legacy continued by his son, the author Alexandre Dumas *fils*. Jamaican Caymanian designer Jawara Alleyne recontextualized such historical mythologies of masculinity in his autumn/winter 2021–22 collection, which featured an ensemble of shirred fabric open at the neckline and molded to the waist and legs (p. 117), reminiscent of Thomas-Alexandre Dumas's heroic silhouette and attitude.

The first African American graduate of the United States Military Academy at West Point and the first commissioned Black officer in the U.S. Army, Henry O. Flipper (p. 120) was born into slavery in 1856. Despite the extreme prejudice he faced at West Point, he had a distinguished career as a Buffalo Soldier in an all-Black regiment involved in a series of land-rights conflicts known as the Indian Wars. (In 1881 he was unfairly court-martialed and dishonorably discharged from the army, which reversed this act posthumously in 1976, allowing for a full presidential pardon in 1999.) Flipper's 1878 memoir, *The Colored Cadet at West Point*, details his resilience and the way in which his uniform manifested his hard-won pride. A *New York Sun* article, quoted by Flipper, details the figure that he cut: "Lieutenant Flipper entered the room in full uniform. A heavy yellow horse-hair plume fell down over his cavalry helmet. His coat was new and bright, and glittered with its gold buttons and tasselled aigulets [aglets]. By his side hung a long cavalry sabre in a gilt scabbard. His appearance was the signal for a buzz of admiration. He is very tall and well made." Contemporary designers such as Daniel Gayle for denzilpatrick (p. 121) highlight, exaggerate, and sometimes deconstruct the uniformity of gold braid and epaulets on military dress both to question and to assert the association between militarism and Black masculine power.

"Distinction" also features more contemporary sartorial expressions of Black nationalism and revolutionary style in which military dress reifies the links between militarism, masculine elegance, and power. Garments and accessories from Black nationalist movements across the diaspora—from Ethiopia's fight for independence to Marcus Garvey's Back-to-Africa movement (p. 122) and the Black Power movement (p. 124) in the United States—demonstrate the agency and pride communicated by military dress. Historical accessories such as an iconic Black Panther beret and Black Power Afro pick (p. 126)—each featuring the movement's iconic raised-fist symbol—as well as a pick by Rushemy Botter and Lisi Herrebrugh for Botter (p. 126) and an ensemble by Telfar Clemens for Telfar (p. 125) illustrate the impact this history and style has had on modern-day design, which characterizes Black masculinity as warlike or itself in need of protection.

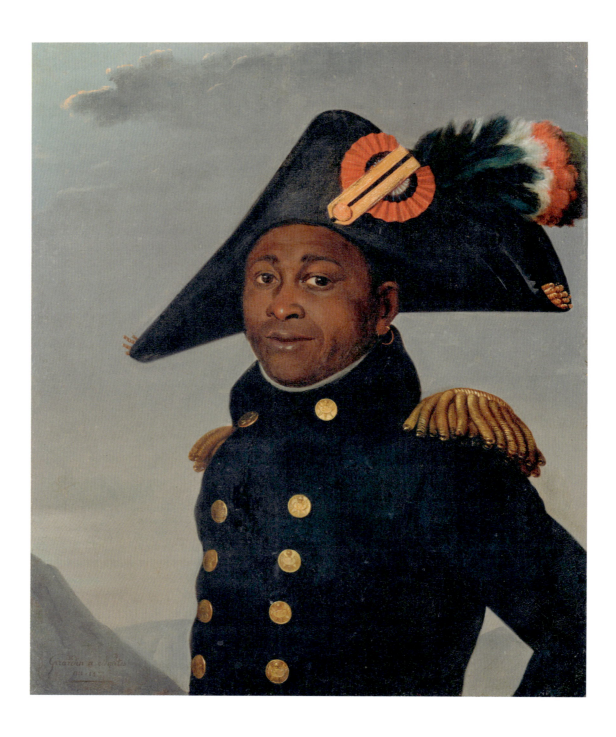

Alexandre François Louis de Girardin. *Portrait of Toussaint Louverture*, 1804–5

DISTINCTION

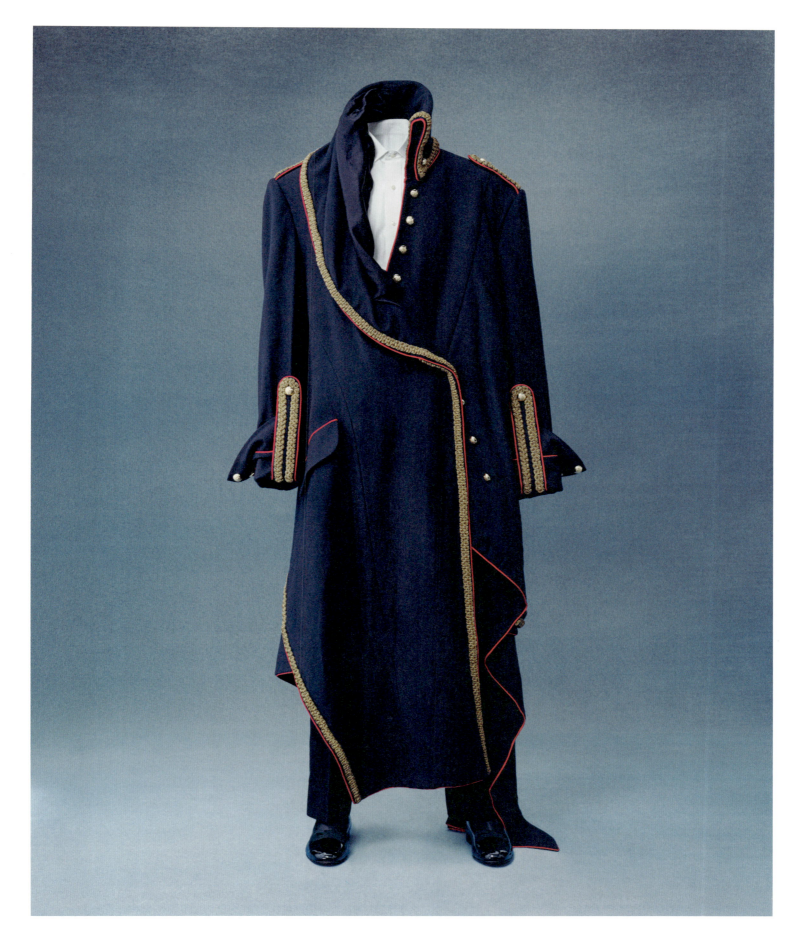

House of Dior. John Galliano. *Coat*, autumn/winter 2000–2001 haute couture

DISTINCTION

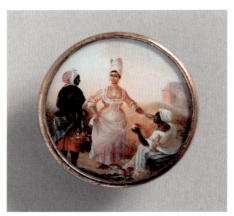
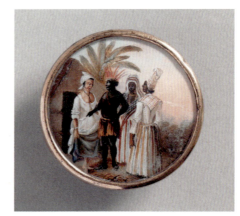
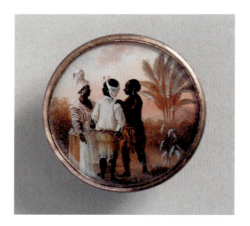
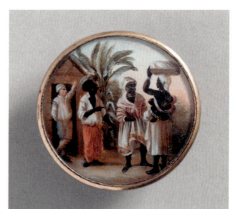

After Agostino Brunias. *Buttons*, late 18th century

DISTINCTION

TOUSSAINT L'OUVERTURE'S COAT BUTTONS

CHRISTINE CHECINSKA

This remarkable set of brass-rimmed buttons opposite, painted by the Italian artist Agostino Brunias or by someone of his school, are said to have once adorned the coat of the Haitian liberator Toussaint L'Ouverture; the claim is intriguing yet impossible to verify. Materially, the buttons are large by contemporary standards, each one an intricately rendered miniature reflecting the eighteenth-century trend among fashionable men for painted-picture buttons. Typical of this genre, the paintings were reproduced on ivory, each protected by a glass dome. However, the buttons' past remains a mystery; the stories surrounding their history captivate the imagination and blur the boundary that exists between myth and fact.

Visual representations of L'Ouverture are numerous and varied, though no portraits of him were completed during his lifetime, and none exist showing him wearing the Brunias buttons. Nicolas Eustache Maurin's 1832 lithograph portrays a resplendent L'Ouverture in full dress uniform, complete with elaborate military jacket and feathered hat, but the painted buttons do not adorn the jacket. However, the work does begin to give us a sense of L'Ouverture as a man of propriety and elegance befitting a military leader. In his 1854 biography of the revolutionary, H. G. Adams describes him both as "an image of God cut in ebony" and, referring to his military achievements, as the "Napoleon of the Blacks." Almost a century later, in *The Black Jacobins*, C. L. R. James writes of the distinction of his carriage, which made a strong impression on those with whom he came into contact: "His step was martial, his manner commanding." L'Ouverture appears to be the embodiment of self-governance. But this begs the question, Why did he choose to decorate his coat with a set of buttons embellished with reproductions of Brunias's "West Indian" paintings?

The complete set numbers eighteen buttons. The vignettes on the faces of the buttons are replicas of paintings commissioned by absentee planters who wanted pictures of their Caribbean properties. Imagery from several islands—St. Kitts, Dominica, St. Vincent, Trinidad, Martinique—appears in these romanticized tropical settings and includes scenes of enslaved individuals washing, dancing, and stick fighting. Depictions of the day-to-day violence of the plantation slavery regime are strikingly absent, and thus, this fictitious, idyllic plantation life is at odds with the recollections of notable formerly enslaved men, such as Olaudah Equiano and Frederick Douglass. Brunias's vignettes instead reference the colonial desire for order and portray the plantation as a site of organized work and bountiful leisure time. Caribs are shown in traditional dress. Female "mulattoes" are clothed in fine madras cloths, silk foulards, billowing skirts, and fitted bodices. Some men wear knee breeches, high-neck shirts, and cutaway-front frock coats. Both male and female figures are often turbaned. Maroons and the Indigenous population wear loincloths, but they appear pacified, surrendering to elaborately dressed British soldiers in scarlet coats trimmed with gold buttons—the implication being that to be dressed is to be civilized and to be naked is to be uncivilized. Brunias fulfilled his commission by visually supporting the argument that plantation life was comfortable and the enslaved were content.

In *The Language of Fashion*, Roland Barthes likens the detail of an outfit to its "soul"; the smallest detail, such as a button, holds the ultimate power of signification. He also suggests that the motivation behind one's appearance is revealed in the detail of one's dress. If this is the case, what is L'Ouverture "signifyin'" by choosing to wear these stereotypical images of happy-go-lucky enslaved people and free people of color? At first glance, it seems rather incongruous that the Haitian leader, formerly enslaved himself, should choose to accessorize his clothing in this way. But is L'Ouverture playing the part of the "signifying monkey," to use a term coined by Henry Louis Gates Jr. in *The Signifying Monkey: A Theory of Afro-American Literary Criticism*? Is L'Ouverture appropriating these ethnographic images to invoke the overturning of plantation slavery in Haiti? Or were these buttons a way for him to denote the paradox of the "dignified slave"?

By affixing these images to the face of his coat buttons, L'Ouverture not only returned the planters' gaze but also committed the Haitian plantation system to the past—as something from a bygone era, something to be commemorated. The myth of ever-merry enslaved people of color, happy and working with song, became fossilized. This recontextualization equates to a radical practice of freedom, a liberatory act. L'Ouverture the enslaved object represented himself as L'Ouverture the human subject. Wearing these particular buttons in this particular moment was both strategy and commentary: He demonstrated that enslaved people know the interconnectedness of being well dressed and being civilized. He both articulated and embodied the paradox of the dignified slave. He challenged and subsequently revised contemporaneous assumptions about Black African men through an elegant choice of accessory. The consequences of the plantation slavery regime—infantilization, feminization, and ungendering—were visibly contested and reversed. He appropriated the power of the European other.

Images of the Haitian revolutionary leaders L'Ouverture, Jean-Baptiste Belley, and Jean-Jacques Dessalines have become symbols of strength, Black autonomy, and elegance. Haiti stood for possibility. When these formerly enslaved Black men entered the global political stage, they were dressed. Through their presentation of self, the Haitian leaders visually announced their status as free—equal to and part of the humanity of all men. This set of intricately painted buttons therefore honors the journey from object to subject, from nakedness and undress to being *dressed*, marking a pivotal moment in the history of Black male style and the democratization of male fashions.

111

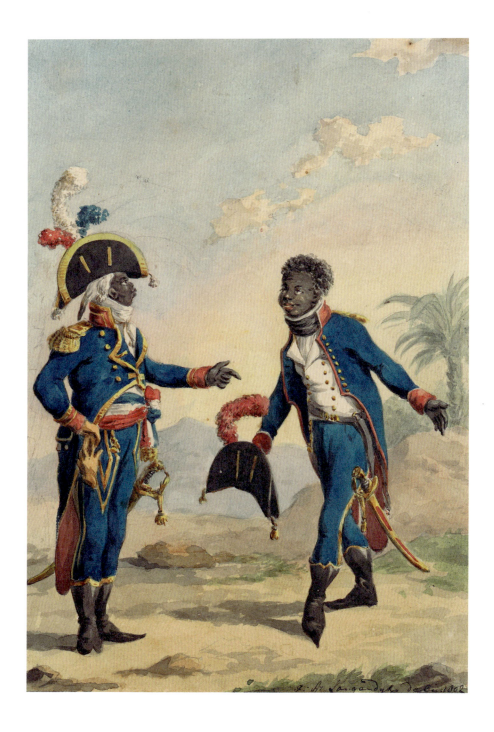

Jan Anthonie Langendijk. *French General and Officer, St Domingo*, 1802

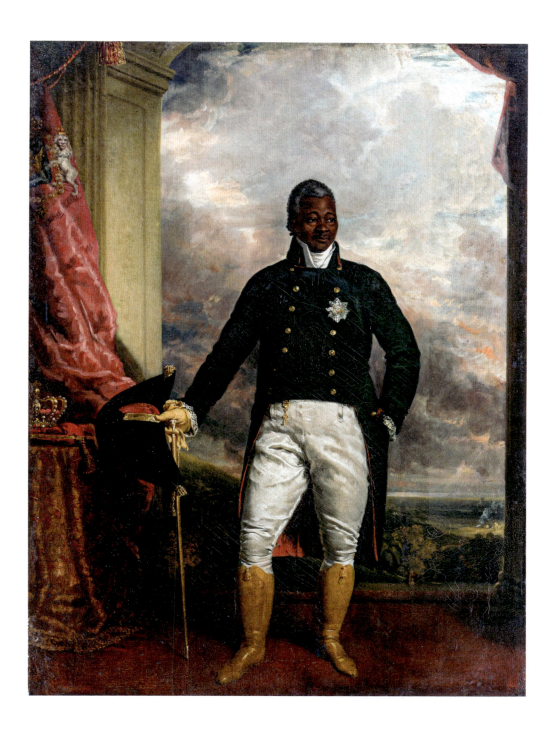

Richard Evans. *Henry Christophe, King of Haiti*, ca. 1816

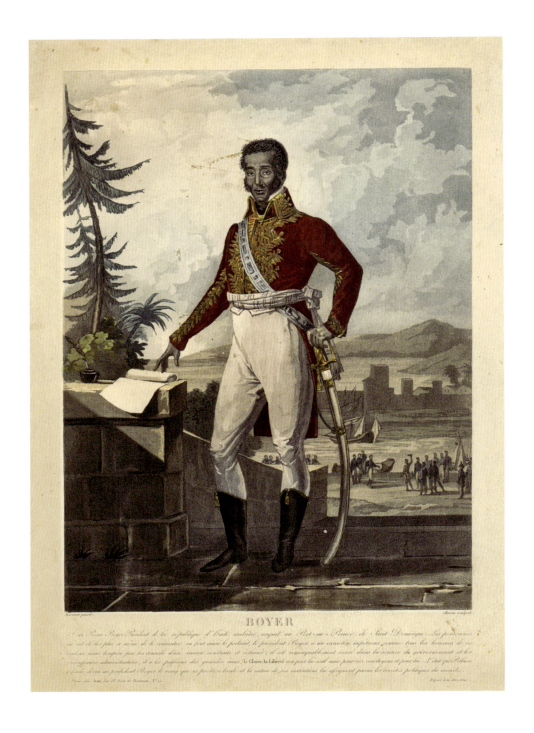

Engraved by Louis François Charon, after a composition by Pierre Martinet. *Boyer*, ca. 1820

Robert Mole. *Sword with scabbard of Faustin I (1782-1867), Emperor of Haiti*, 1850

DISTINCTION

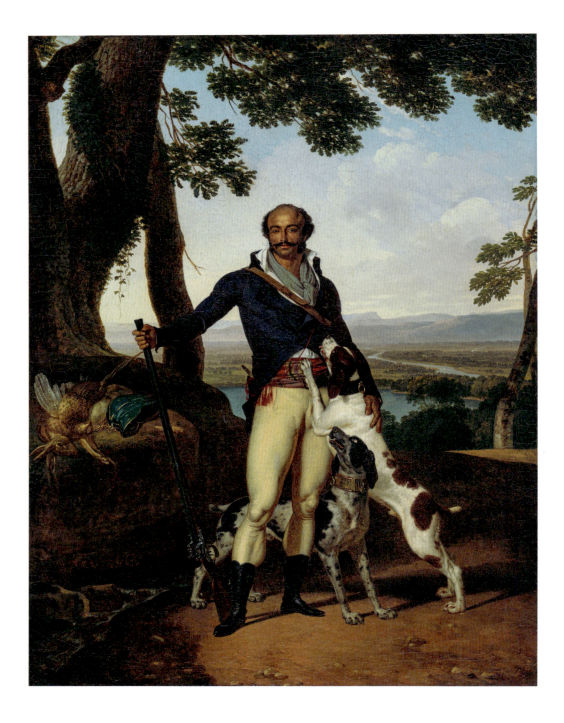

116 Louis Gauffier. *Portrait de Thomas Alexandre Dumas en chasseur*, 1801

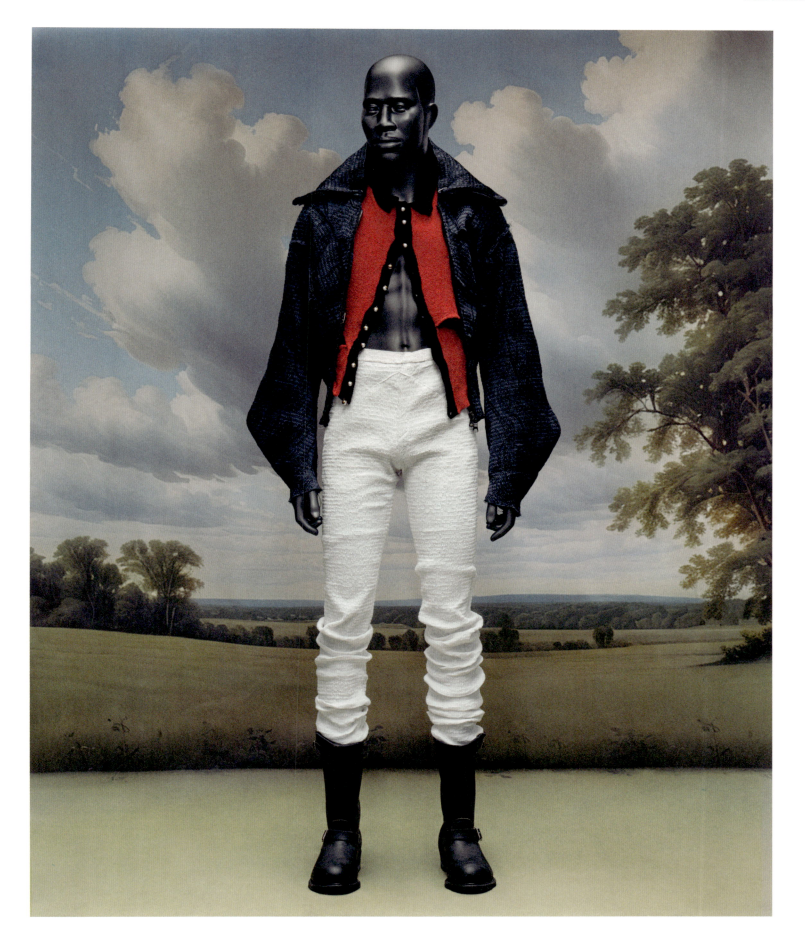

Jawara Alleyne. *Ensemble*, autumn/winter 2021–22

Achille Devéria. *Alexandre Dumas*, 1929

ALEXANDRE DUMAS *PÈRE*

NIGEL LEZAMA

With his impeccable taste and aristocratic detachment, the dandy emerged in France as a cultural touchpoint at the same moment the nation lost its colonial moneymaker following the Haitian Revolution. This event "threatened France's self-perception as an imperial power (with its connotations of racial superiority) and its image of its masculine prowess," according to Robin Mitchell in *Vénus Noire: Black Women and Colonial Fantasies in Nineteenth-Century France*. In turn, French cultural modernity was marked by anxiety over white masculine deficiency, as demonstrated through the malaise of the early nineteenth century, which culminated in the febrile decadence of the fin de siècle. The figure of the dandy embodied this concern, and many French writers', painters', and society figures' adoption of the dandy's style and refinement attempted to mask the perceived failure of nineteenth-century French masculinity. Young dandified men sought to perpetuate the virile mastery of revolutionary and Napoleonic France. Among them was Alexandre Dumas *père*. Son of a heroic multiracial revolutionary general (p. 116) and grandson of an enslaved woman from Saint-Domingue (present-day Haiti), Dumas was a prolific writer and a celebrity due to his literary talent as much as to his extravagant lifestyle. Alongside Victor Hugo and Alfred de Musset, he launched the Romantic movement in French theater in the late 1820s and the 1830s. Thereafter, he rivaled fellow literary dandies, like Eugène Sue, as the most prolific and fashionable novelist in the mid-century, with *The Three Musketeers* (1844) and *The Count of Monte Cristo* (1844–46) ensuring his success in his lifetime and for posterity.

In nineteenth-century France, the Black dandy confronted a different environment than his American counterpart. The French colonial system was such that *cultural* supremacy was allegedly more central to the dandy's performance than racial supremacy. However, this cultural cachet was naturalized as white. For this reason, Black dandyism, like that of Dumas, could be erased, whereas white French dandies, like Honoré de Balzac (an infamously slovenly dresser) and Charles Baudelaire (a man who lived much of his adult life in squalor), were heralded as creators of literary dandyism and dandies in their own right, thereby reinforcing narratives of French cultural—and white—superiority.

Dumas's literary talent was challenged during his lifetime on the basis of his race. As Eric Martone chronicles in *Finding Monte Cristo: Alexandre Dumas and the French Atlantic World*, in 1832 the respected literary critic Charles Augustin Sainte-Beuve reduced Dumas's writing skills to an expression of his natural physicality. The mind-body opposition was a long-standing Eurocentric trope, harnessed to assert a distinction between European intellectualism and African physicality and to naturalize European (that is, white) domination over Africa and Africans. In 1845 Dumas's literary rival Eugène de Mirecourt published an infamous screed against the novelist that sought to discredit him by asserting that his race made his talent improbable, if not impossible: "Scratch the surface of Dumas and you will find the savage," Mirecourt writes in his pamphlet *Fabrique de romans: Maison Alexandre Dumas et compagnie*. Throughout his career, Dumas made no secret of the fact that he wrote with numerous collaborators. Mirecourt argued that because of his race Dumas could not have authored his greatest works; the credit belonged to his collaborators. With the cultural anxiety over white French masculinity simmering, Dumas's literary success needed to be contained so as not to further destabilize French whiteness.

Dumas's personal style was a hybrid of continental panache and exotic flair. While the numerous racist caricatures of the writer often exaggerated his Afrocentric features, they could not refuse his style: pantaloons, waistcoat and frock coat, top hat, and gloves. Because Dumas was a public figure, his likeness was not his own. However, like any cosmopolitan dandy worth his well-polished boots, Dumas understood the importance of self-fashioning.

Thanks to his literary successes, in 1844 Dumas purchased and started construction on an outlandish property in Le Port-Marly, a hamlet near Versailles, turning his life into a work of art. The property consisted of a Renaissance-inspired residence—the Château de Monte-Cristo—and a neo-Gothic writing refuge—the Château d'If—both named after famous locales featured in *The Count of Monte Cristo*. Dumas used these spaces to memorialize his literary successes, display the fashionable and exotic Moroccan, Algerian, and Tunisian luxuries he collected on his travels, and honor his patrimonial lineage. Completed in 1847, the château was the backdrop for an outrageous housewarming party for six hundred guests that July. However, in true dandy fashion, a bankrupt Dumas was forced to sell his property at auction in May 1848.

DISTINCTION

Kennedy. *Cabinet card of Henry O. Flipper*, ca. 1877

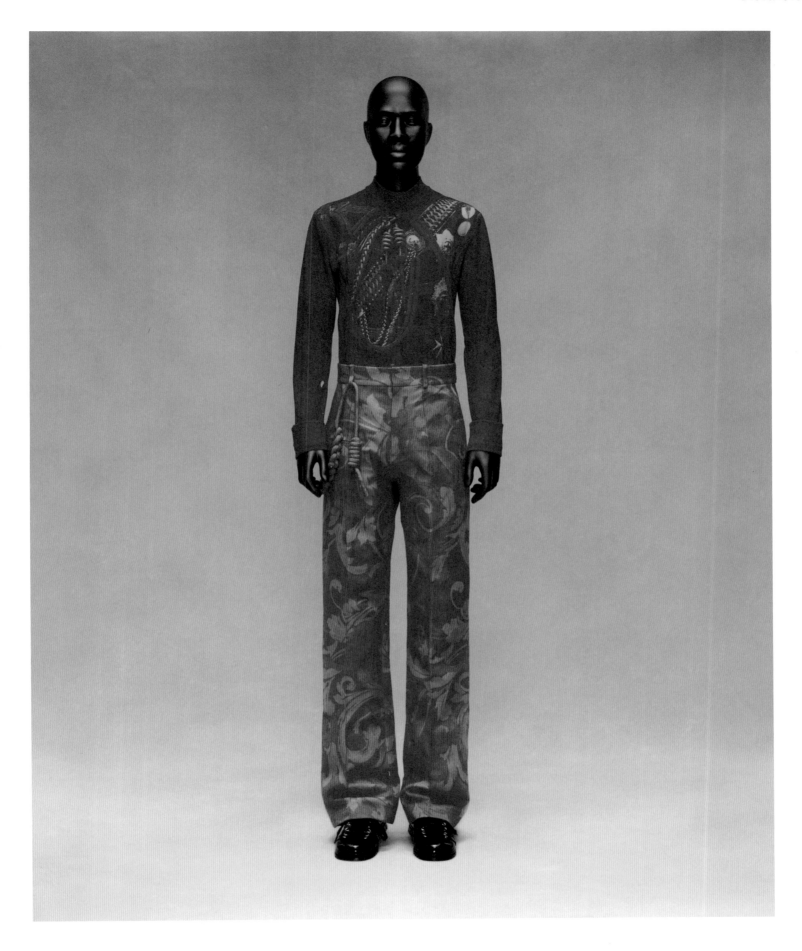

denzilpatrick. Daniel Gayle. *Ensemble*, spring/summer 2025

DISTINCTION

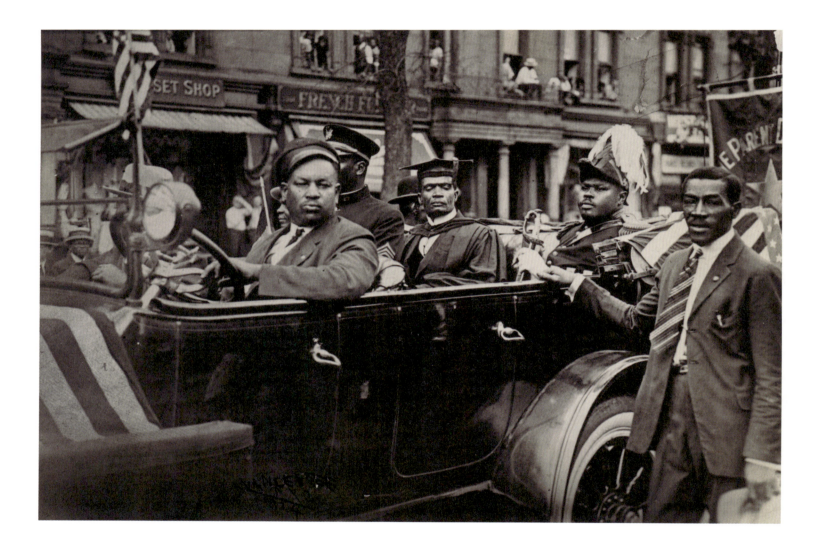

James Van Der Zee. [*Marcus Garvey in a UNIA parade*], 1924

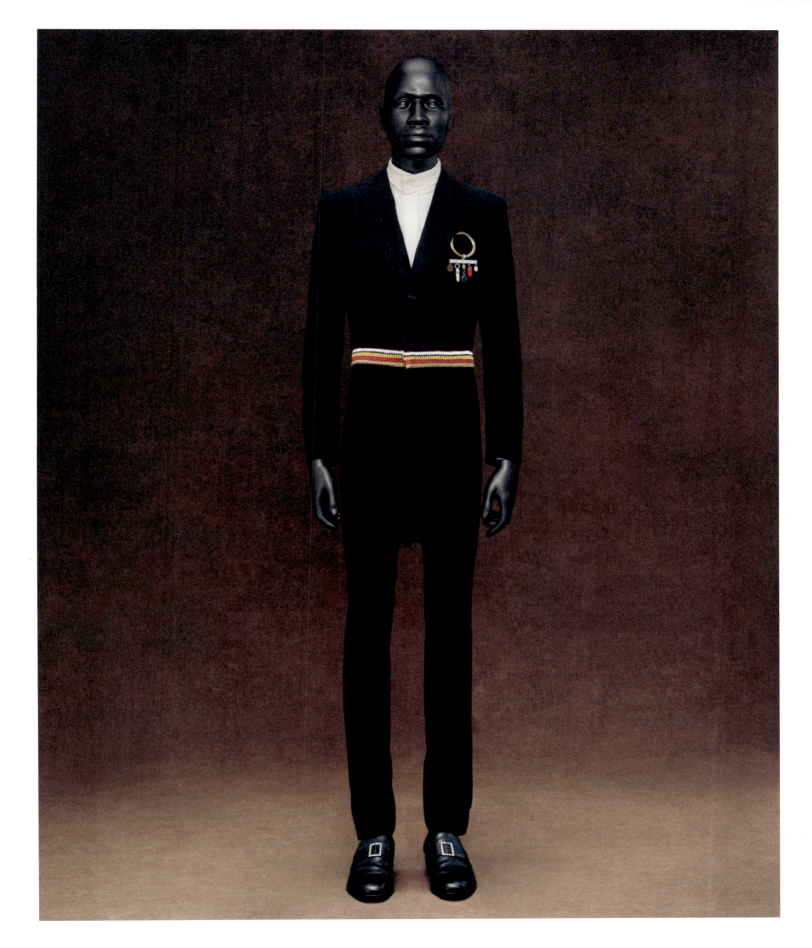

Wales Bonner. Grace Wales Bonner. *Ensemble*, spring/summer 2017

DISTINCTION

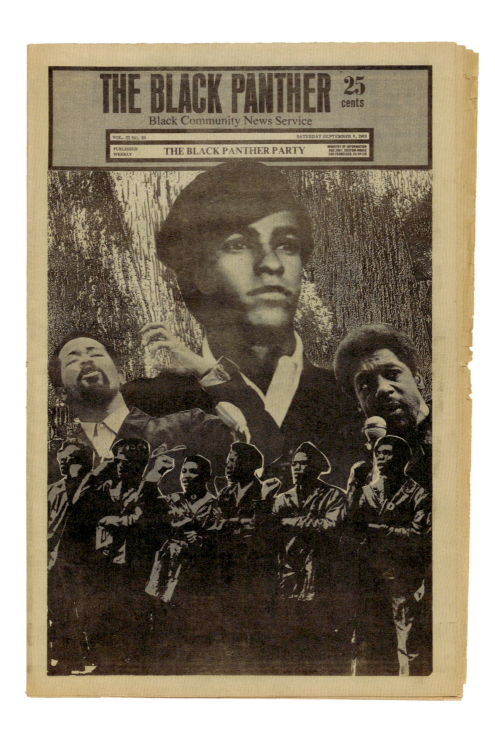

124　　Emory Douglas. Yolanda López. Cover of volume 3, issue 20 of *The Black Panther*, September 6, 1969

DISTINCTION

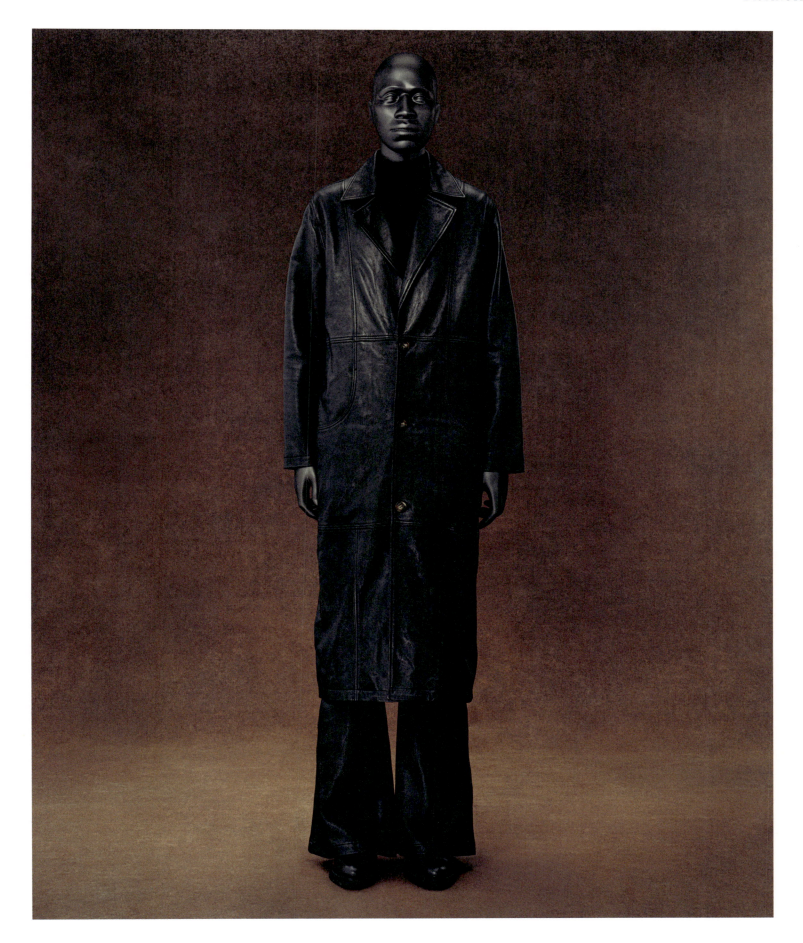

TELFAR. Wilsons Leather. Telfar Clemens. *TELFAR × Wilsons ensemble*, 2024

125

DISTINCTION

Antonio's Manufacturing. *Afro rake*, 1970s
BOTTER. Rushemy Botter and Lisi Herrebrugh. *Afro pick and pouch*, autumn/winter 2021–22

REMEMBERING THE BLACK IS BEAUTIFUL MOVEMENT

TANISHA C. FORD

A photograph taken in August 1968 is arresting. Six unambiguously Black women of the Black Panther Party for Self-Defense stand united at a "Free Huey Newton" rally in Oakland. They wear black shift dresses. Some sport black leather jackets and large hoop earrings. Others have leather belts cinched around their waists. They hold clenched fists in the air while belting out protest chants, their "halo" Afros a symbol of their revolutionary politics. The Panthers fused urban street style with a vision to liberate poor Black folks around the world. Through embodied activism, Panther women and men declared that Black was not just powerful; it was also beautiful.

"Black is beautiful." The Panthers and millions of Black people across the globe used this phrase to communicate that natural hair and melanated skin were sources of pride. Their narratives emphasized the value of Black lives and the joys of being a person of African descent. They rebuilt the Black psyche, healing it from centuries of chattel slavery and settler colonialism that rendered Black people closer to animals than to humans. The Black Is Beautiful movement re-aestheticized Black flesh and, by extension, a politics of style. Clothing and accessories became a second skin to demonstrate one's enlightened Black consciousness. Young Black people remixed sartorial materials. Afros, cornrows, denim overalls, platform shoes, cowrie shells, beaded jewelry, hoop earrings, and dashikis and other African printed garments became massively popular in the early 1970s, when "Black is beautiful" served as a rallying cry across the African diaspora.

Where did the phrase originate? A likely source is Jamaican activist Marcus Garvey and his Universal Negro Improvement Association (UNIA), which promoted Pan-Africanism through its Back-to-Africa movement and calls for Black economic autonomy. Women in the UNIA rejected Eurocentrism—or the idea that Western whiteness and beauty standards were superior. They instead celebrated African beauty in the pages of *Negro World*, the organization's international newspaper. Carlos Cooks, a disciple of Garvey, built the African Nationalist Pioneer Movement (ANPM) in the 1940s and spread the concept of "Black is beautiful" across the Caribbean and in cities such as New York, London, and Paris. In New York, the ANPM hosted the Miss Natural Standard of Beauty pageant, an annual competition in which dark-complexioned contestants appeared with their hair in its natural texture and answered questions that highlighted their Black consciousness.

The Grandassa models, a hip, mixed-gender troupe with ties to the ANPM, made the "Black is beautiful" message popular among the Black Power generation in the early 1960s. Its models were students, activists, and intellectuals, many from Caribbean immigrant families and some recent migrants from the U.S. South who had settled in New York. They had a range of deep brown skin tones and full lips and noses, and they wore their hair in natural styles that were purportedly popular across the African continent. They designed and sewed their own African-inspired garments and headdresses and wowed Harlem crowds with their Naturally fashion shows. "Black is beautiful" and other slogans such as "Think Black" and "Buy Black" appeared on event flyers and other ephemera advertising their shows. Grandassa collaborated with photographers such as Kwame Brathwaite, and jazz musicians, including Abbey Lincoln and Max Roach, performed at their fashion shows. By the mid-1960s, the models' "Black is beautiful" image was circulating in magazines in the United Kingdom, the Caribbean, and East and West Africa, and it appeared on Blue Note Records jazz album covers. They were veritable celebrities.

By the early 1970s, there was no escaping the phrase "Black is beautiful." The Grandassa models. The Black Panthers. Jazz, soul, and funk musicians. College students. Visual artists. Magazines. Films. Commercials and advertisements. "Black is beautiful" was everywhere! For some, the movement's fashions and natural hairstyles showcased political consciousness. For others, this popular aesthetic could be put on and taken off at will. The phrase, the politics, and the aesthetic they cultivated are a piece of history we should never forget.

Today, young people rarely use the phrase "Black is beautiful," even though the sentiment abounds. For the Black Lives Matter movement, hip-hop attire—more than African prints—is the clothing of choice. Ball caps, hoodies, screen-printed T-shirts, skinny jeans and joggers, Jordans, tattoos, box braids with Kanekalon hair in rainbow colors, hoop earrings, and locs (once referred to as dreadlocks) all express Black is beautiful. Black lives are still under assault from police and vigilantes, making the message as urgent as ever. This generation, defining freedom for themselves, has showed renewed interest in the Panthers, Kwame Brathwaite, and Grandassa. Remixing cultural and political messages, younger people are rediscovering the revolutionary impulses of the past.

Disguise

"We sat up all night discussing the plan, and making preparations.
Just before the time arrived, in the morning, for us to leave,
I cut off my wife's hair square at the back of the head,
and got her to dress in the disguise and stand out on the floor.
I found that she made a most respectable looking gentleman."

WILLIAM CRAFT
Running a Thousand Miles for Freedom;
or, The Escape of William and Ellen Craft from Slavery, 1860

Dandyism in the form of race, class, and gender cross-dressing enabled enslaved and free people to express the ways that identity is dependent on—and can be manipulated by—conventions of fashion and dress. For those negotiating the fraught line between enslavement or subjugation and freedom, fashion and dress can be used as a means of both disguise and revelation. "Disguise" emphasizes the ways in which enslaved individuals sometimes appropriated the clothing of their owners or absconded with wardrobes as they imagined liberation or actually journeyed toward emancipation. A myriad of fugitive slave advertisements (p. 132) stress not only the freedom seekers' fondness for dress or their love of fashion and grooming but also the specific grandiosity of the garments they took with them. This attire enabled the self-liberated to pass as free or as white, for women to pass as men, and for men to pass as women. As such, dandyism as a means of disguise destabilizes what we think we know about the relationship between appearance and markers of identity including race, class, gender, and sexuality.

Captive people understood that clothing and dress marked them as an undifferentiated group when they wore standard-issue apparel and as individuals when they were able either to procure their enslavers' castoffs or to make and wear garments of their own choice and design. Some described as "excessively fond of dress" escaped with whole wardrobes of clothing that they used to disguise themselves en route to freedom and to sell in order to fund their journeys and their new lives when liberated. Lathan Windley's *Runaway Slave Advertisements: A Documentary History from the 1730s to 1790* features a 1769 ad posted in Virginia to recover Joe, described as "a genteel and active Fellow, . . . who has always been kept as a Gentleman's waiting Man, his hair comb'd very nicely." Likely traveling north, hoping to make his way to London, Joe had escaped on a fine horse with "a large bundle of Cloaths and other things with him," including "a blue over coat and Breeches, a Lead colour'd Cloth Coat and Vest, with Metal Buttons, and Silver Lac'd Hat, several summer vests, white Shirts and Stockings, of which some are silk."

Even the tattered clothing of those escaping could be distinguished and distinguishing, a sign of the difficulty and profundity of their journeys. Photographed in 1864, after fleeing from the North Carolina plantation where he had been enslaved and finding refuge with Union troops, William Headley (pp. 134–35) bore the marks of his trial. Yet an inscription on the verso of his carte de visite details how even under such harrowing circumstances, Headley's self-styling gave an appearance of confidence and sartorial flair: "His clothes were of many colors and qualities. His cloak consisted of an old cotton grain bag, slit open on one side and raveled which gives the appearance of rich fringe. He appeared perfectly happy and satisfied upon reaching Union lines." Who Decides War's jacket and trousers made of a patchwork of suit remnants—some wrong-side up—suggests improvised and haphazard construction (p. 136). The design appears refined, but close inspection reveals its composite form and loose fit, seemingly signaling the wearer's attempt and failure to conform. In fact, the ensemble was expertly made—designer Everard Best learned the trade from his father, a tailor—and was assembled as commentary on the construction of garments as much as on the construction of the self.

Through an elaborate and strategic act of sartorial disguise, enslaved couple William and Ellen Craft also self-liberated. As recounted in their 1860 memoir, *Running a Thousand Miles for Freedom*, their escape plan in 1848 involved Ellen passing as a white, upper-class "gentleman," with William as her loyal Black male servant. The Crafts saved money to buy the clothes and accessories that formed their disguise;

Ellen, a seamstress, also modified the garments. Nearly recognized by friends of their former enslavers, and stopped a number of times, they finally made it to freedom, only to be forced to immigrate to England to avoid re-enslavement altogether. In addition to gender, dandiacal dress could also disguise class and social status, making its adoption by Black men especially precarious. William's decision to pose as "his Master's" lowly servant while donning a high-quality, dandyish white beaver top hat—not unlike the one on page 139—nearly uncovered the couple's illegal flight. In the memoir, William explains that he risked outclassing himself in dress, as his attire upset white observers' sense of racial-sartorial propriety:

> For the purpose of somewhat disguising myself, I bought and wore a very good second-hand white beaver, an article which I had never indulged in before. So just before we arrived at Washington, an uncouth planter, who had been watching me very closely, said to my master, "I reckon, stranger, you are 'spiling' that ere nigger of yourn, by letting him wear such a devilish fine hat. Just look at the quality on it; the President couldn't wear a better. I should just like to go and kick it overboard. . . . It always makes me itch all over, from head to toe, to get hold of every d—d nigger I see dressed like a white man."

Ib Kamara's black wool "Body Stitch" jackets presented in his spring/summer 2023 collection for Off-White comment on the ability of standardized garments like the suit to conceal the identity and individuality of the wearer. The "Body Stitch" jacket embroidered in contrasting white thread featured here depicts the anatomy and musculature of a man's chest and abdomen (pp. 142–43); its complementary jacket portrays a woman's anatomy.

Just as clothing can disguise, it can also reveal a true self. In the early twentieth century, Ralph Kerwineo (p. 144) and Stormé DeLarverie (p. 145), both assigned female at birth, donned typical male attire as an expression of their nonconforming gender identities; for them, the gesture was as much a means of survival as self-expression. Well known for her role as emcee and the sole male impersonator of the Jewel Box Revue, DeLarverie was a biracial, androgynous entertainer and icon in the lesbian and gay community of mid-twentieth-century New York, performing as a drag king in stylish suits and tuxedos at the Apollo, among other venues. Some believe that a scuffle between DeLarverie and the New York Police Department may have ignited the uprising at Greenwich Village's Stonewall Inn in the summer of 1969. Whether or not this is true, DeLarverie remained a lifelong activist for LGBTQ rights and gender nonconformity. Her debonair masculine style is captured in a 1956 studio portrait by Vicente, in which DeLarverie easefully models an oversize tailored suit, fedora, and pipe. Kerwineo, who had African American, white, and Native American ancestry, made a life as a man in Wisconsin until he was exposed by his female partner, who charged him with infidelity in 1914. At the time, it was illegal to wear the clothes of another gender. The local and national press sensationalized Kerwineo's trial for "disorderly conduct," but his status as an upstanding citizen enabled the case to be resolved without a fine, as long as he returned to living and dressing as a woman. His promise to do so was short lived; a stint in vaudeville allowed him to continue to perform his gender "masquerade." As the *Milwaukee Sentinel* reported on May 5, 1914, Kerwineo said during the trial, "My woman's soul had died and the man's had taken its place."

DISGUISE

Runaway slave advertisement, published in *The New-York Gazette, Or, the Weekly Post-Boy*, October 27, 1763

DISGUISE

FREE STYLING: BLACK AMERICANS FASHIONING FREEDOM

MARY N. ELLIOTT

The very individuals who served the needs of those who held them in bondage cultivated cotton for textiles, crafted beautifully dyed fabric, wove ornate lace, tailored fashionable suits, produced coveted footwear, and styled the hair of their enslavers, understanding the beauty of fashion and its importance in demonstrating power, control, and, more importantly, freedom—freedom they pursued by any means necessary.

Legalized slavery enforced laws that restricted dress and dictated the social standing of enslaved and, in some cases, free Black people. States that maintained such sumptuary laws included Louisiana, Virginia, and South Carolina. South Carolina's 1740 slave code mandated that "no owner or proprietor of any Negro slave, or other slave, (except livery men and boys,) shall permit or suffer such Negro or other slave, to have or wear any sort of apparel whatsoever, finer, other, or greater value than Negro cloth." The limited attire served as a visual cue about the social status assigned to enslaved people. Other laws, known as fugitive slave laws, addressed escape from bondage. The 1850 Fugitive Slave Act required all residents assist in recovering enslavers' human "property," solidifying the nation's position as an enslaving society.

Black self-emancipators took precautions to plan their escapes, including plotting when to flee, determining routes and final destinations, and securing resources to survive the journey and maintain their freedom. Some Black Americans escaped bondage with just the clothes on their backs; others, with wardrobes strategically selected to manifest their liberation. Enslaved people knew clothing could safeguard them from the elements and the environment and serve as a source for potential income through the sale of fine garments. Clothing also functioned as a tool for hiding in plain sight. Without drawing attention, self-emancipated people had to present themselves as being above their dictated social station, relying on their chosen attire, as well as their demeanor, dialect, and vocal cadence, to blend into society as rightfully free individuals.

Enslavers employed various means—bounty hunters, bloodhounds, fugitive slave advertisements (opposite)—to recover freedom seekers. Ads printed in newspapers and posted in the public arena often feature generic stock image illustrations of Black self-emancipators, some well dressed and others in simple clothing. These ads detail the attire, demeanor, physical appearance, skills, and intent of fugitives from slavery. The following ad placed by Braxton Harrison of Charles City County, Virginia, and published on October 8, 1799, is one example:

Five Pounds Reward, FOR apprehending . . . CHARLES, a remarkable black fellow, about 6 feet 2 or three inches high,

. . . Had on when he went off a blue sailor's jacket, oznaburg shirt and overhauls, carried with him a suit of black, also a pale blue coat which is much too small for him; he is a sensible fellow, is very complaisant and submissive when spoken to, and speaks slow . . . he is as black as jet, generously made and as handsome a black man as any in the state weighs I guess 185 lb. is 33 years old, though looks younger. I expect he . . . will endeavour to get to some of the northern states. . . . CHARLES has a variety of clothes, but those mentioned are his best.

In an ad placed in the October 2, 1749, edition of the *Boston Weekly Post-Boy*, an enslaver seeks to capture an enslaved man named Prince. According to the ad, Prince escaped with several items of clothing, including "an old brown Coat. with Pewter Buttons, a double-breasted blue Coat with a Cape, and flat metal Buttons, a brown great Coat with red Cuffs and Cape, a new brown Jacket with Pewter Buttons, a Pair of new Leather Breeches, check'd [linen] Shirt and Trousers, [two] Shirts and Trousers, a red Cap, two . . . Hats, several Pair of Stockings, a Pair of Pumps, a Gun and Violin."

Fugitive slave advertisements shed light on how Black Americans used attire and style to secure and retain their freedom. Some freedom seekers packed tailored clothing made of quality textiles, while others styled and adorned durable materials typical of individuals such as domestic workers and craftspeople. Those who carried a limited wardrobe with them had planned their escapes, selecting their clothing thoughtfully. Others urgently seized the opportunity to escape. Simply consider the depictions of desperate freedom seekers entering Union Army camps wearing tattered clothing (p. 135)—a stark contrast to the illustrated image portraying well-dressed self-emancipated Black Americans Ellen and William Craft (p. 140) who disguised themselves as an enslaver (p. 138) traveling with his enslaved escort.

Being Black in the enslaving nation meant living under constant surveillance, where Black individuals were more often presumed to be enslaved. Enslaved Black people envisioned how they would secure and model freedom. At great risk, Black self-emancipators meticulously planned and executed their escapes, dressing themselves for the journey and for freedom, understanding that their attire provided not only physical protection but also a way to elevate their perceived status. They understood that select garments enabled them to blend into free society and evade capture. It was through their free styling that they asserted their hard-won liberation.

133

William Headley a Contraband from a plantation near Raleigh N.C. arrived at Newberne N.C. on the 20th May 1864. having been six weeks on the road neither sleeping or eating in a house during the time. Two others left with him but were caught by the slave holders Blood Hounds and either killed or taken back. He was weak and nearly famished when he arrived. His clothes were of many colors and qualities. His cloak consisted of an old cotton grain bag, slit open on one side and raveled which gives the appearence of the rich fringe.

He appeared perfectly happy and satisfied upon reaching the Union lines and is now one of the best hands working on Ft. Chase N.C.
June 28 1864

Cabinet card of William Headley (verso, with inscription), ca. 1864

DISGUISE

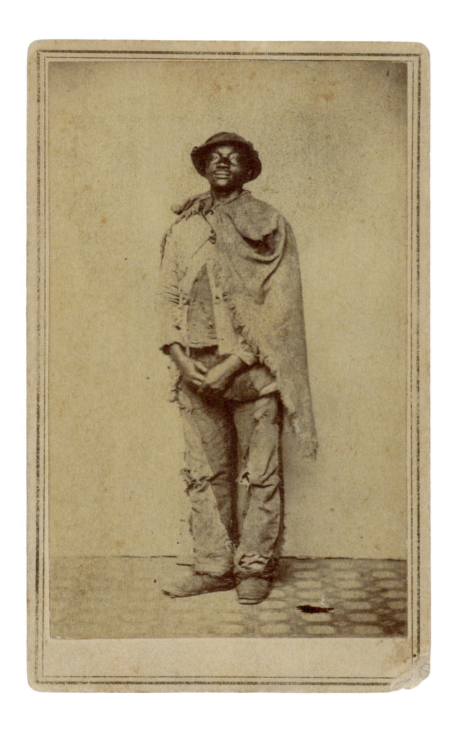

Cabinet card of William Headley (recto), ca. 1864

135

DISGUISE

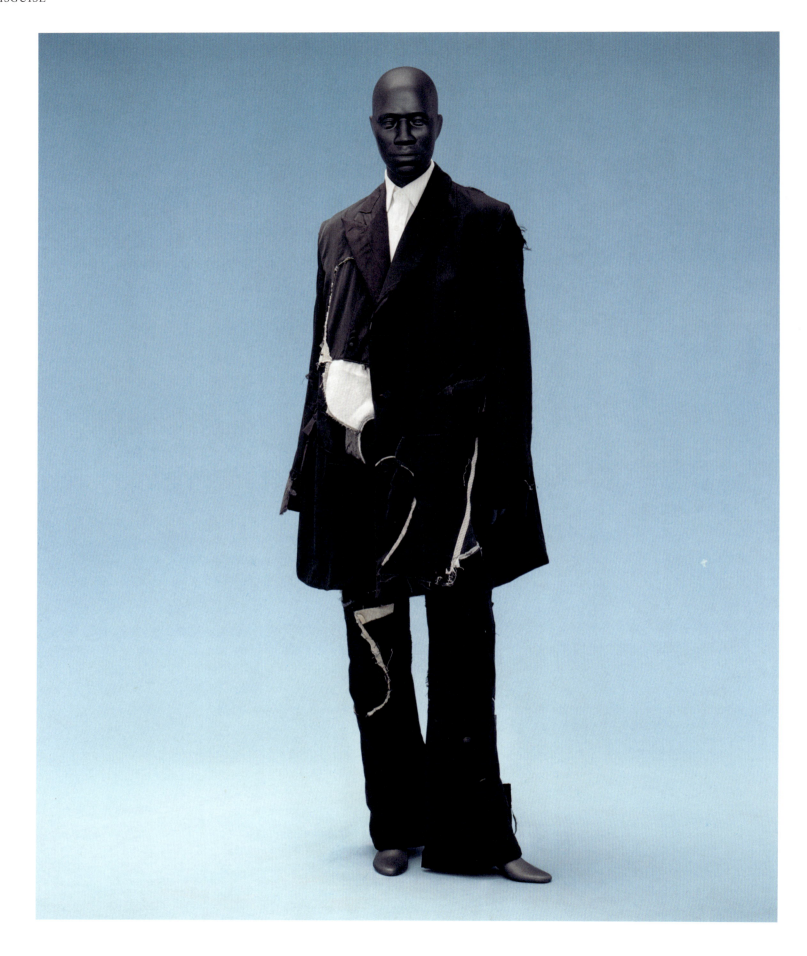

136 Who Decides War. Ev Bravado and Téla D'Amore. *Suit*, autumn/winter 2024–25

A STREET PAVED WITH GOLD: THE CARIBBEAN DREAM

CHARLIE ALLEN

My parents were born on the small West Indian island of Montserrat, which at the time was a part of the British Empire. England's influence was felt in everything on the island: For example, despite the tropical climate, it was imperative that you wore a suit—your Sunday best, so to speak—when going to church or into town. Like many others of their generation, my parents saw England as the mother country, and when England asked for their help in rebuilding the nation after World War II, they heeded the call. With promises of arriving to streets paved with gold, they traveled across the ocean for six weeks in their Sunday best.

Upon arriving, my father went to find work on London's prestigious Savile Row, a neighborhood famous for its bespoke tailoring. He had learned his tailoring skills while still in the West Indies by completing a correspondence course from Tailor and Cutter, a tailoring school and magazine based in London. With every mistreatment or slight, his employers told him, "You should be grateful to even be here." This frustration pushed my father to leave Savile Row and set up his own business in North London.

My parents' work as tailors shaped my own approach to fashion and the trade. They were highly influenced by the magic of the American jazz stars and dandies of the early 1950s, and they insisted everything my siblings and I wore as children be bespoke. I still remember how my school trousers were always perfectly tailored and pressed each week.

By the early 1980s, I was at the Royal College of Art studying in the menswear master's degree program. The suit was my uniform—something that would shield me from criticism. Mostly from wealthier environments, the other students there didn't have to worry about how they were perceived because their race or background didn't prompt constant questioning. But for me, a suit became armor against the judgment and marginalization I faced. It wasn't just about looking good; it was about asserting my place in a world that made strides to make me feel like I didn't belong.

As I began developing my own design signature, I endeavored to combine the traditional elegance and structure of British suiting with comfort. Early on I was inspired by the oversize, sharp cut of Cab Calloway's zoot suits; later, by the softness, drape, and languid movement of Giorgio Armani's deconstructed suits. I wanted my suits to reflect the inner push and pull of my world, so I designed them to be comfortable with features like the dolman sleeve and long, pleated trousers that allowed for more movement and manipulated the physique. They were lighter and more fluid that the British suits tailored in the military tradition.

The many layers of the suit—the cloth, canvas, hair cloth, domet, and lining—are all layered and joined together with stitches. This canvas molds into the figure of the wearer and becomes like a second skin over time, absorbing their body heat, the inner closely woven cloth stitched together to hold the shape. Some traditional military tailors on Savile Row created jackets built with so much structure that they could literally stand on their own. But the more I explored and found my voice, the softer and more deconstructed my suits became. I wanted to highlight the form rather than try to constrict it.

This isn't just a fashion statement; it is a defiant act that remakes the way suits are seen both in the Black community and across British society. The sharp lines and confidence of a Black man in a suit are a way of saying we are here and we will not be overlooked.

For Black men in Britain, the suit has become a powerful expression that goes beyond style; it is a form of resistance in a time of rising racial tensions. Wearing a sharp suit says, "We belong. We are just as good as anyone." It rejects the stereotypes and racism that Black Britons often face, particularly in professional spaces where we are too often made invisible.

The suit embodies both the struggles and pride of the postwar Windrush generation of Black Caribbean migrants who traveled to the United Kingdom as well as the cultural confidence of a new generation of Black Britons. It is a symbol of resilience and self-worth.

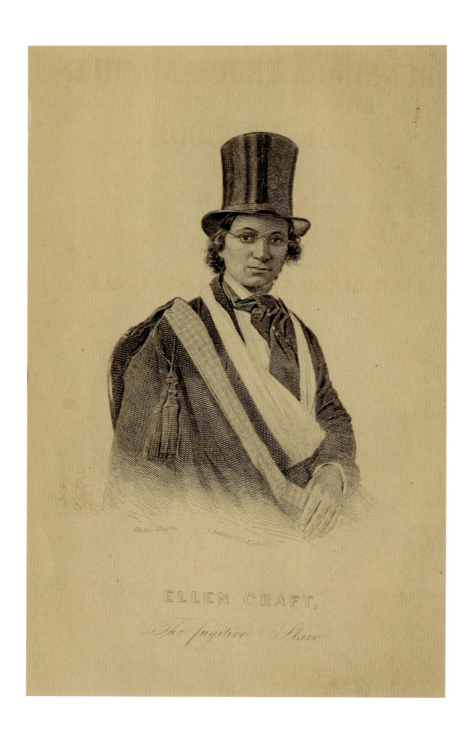

Joseph Andrews. Stephen Alonzo Schoff, after a daguerreotype by Luther Holman Hale.
Frontispiece to *Running a Thousand Miles for Freedom; or,
The Escape of William and Ellen Craft from Slavery* by William Craft, 1860

DISGUISE

Samuel O. Aborn. *Hat*, ca. 1840

139

DISGUISE

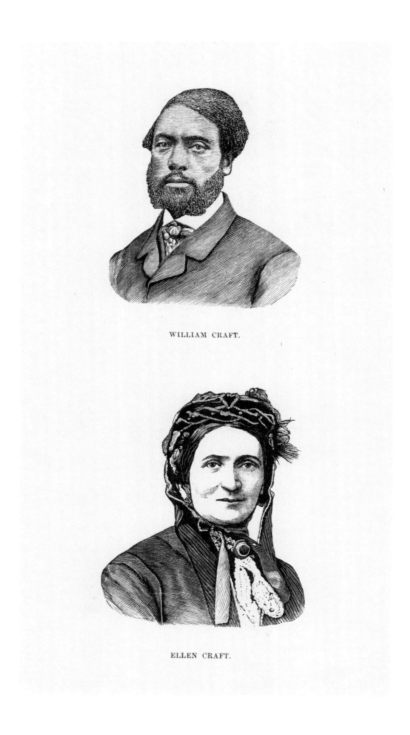

140 *Ellen and William Craft*, published in *The Underground Rail Road* by William Still, 1872

HOW TO CRAFT A DANDY: A SARTORIAL JOURNEY TO FREEDOM

ELIZABETH WAY

The audacious 1848 escape of Ellen and William Craft (opposite) from enslavement illustrates how Black identity was unremittingly complex, liminal, and mutable in nineteenth-century America. As William Craft recounts in his 1860 memoir of the couple's self-emancipation, *Running a Thousand Miles for Freedom; or, The Escape of William and Ellen Craft from Slavery* (p. 138), the wife and husband created a dandy—a chimera fashioned from not only their bodies but also garments, gestures, postures, and words. Christened "William Johnson," this dandy was white, male, well dressed (and therefore elite), and visibly ill, these attributes signaled by a respectable suit on Ellen's "almost white" body and by her crucial accessories, including William as enslaved caretaker. Through Johnson, the Crafts enacted a "crime of fashion"— what Monica L. Miller characterizes in *Slaves to Fashion: Black Dandyism and the Styling of Black Diasporic Identity* as "racial and class cross-dressing that was, as practiced by blacks, a symbol of self-conscious manipulation of authority" to knowingly exploit the expectations of their racist, Southern social environment. They traveled among their oppressors, journeying by train and boat and staying at elite, segregated hotels, from Macon, Georgia, to Philadelphia, passing not into but *through* race, gender, class, and disability, as P. Gabrielle Foreman notes in her 2002 article "Who's Your Mama? 'White' Mulatta Genealogies, Early Photography, and Anti-Passing Narratives of Slavery and Freedom."

The Crafts' memoir identifies Ellen as a "quadroon" lady's maid and seamstress, the daughter of an enslaved mother and their white owner, and William as a Black cabinetmaker who earned wages from his labor. Although William characterizes their enslavement as "not by any means the worst," both experienced painful family separations—circumstances that motivated their escape. To enact their plan, William writes that he bought male garments to clothe Ellen, spreading out his purchases to avoid suspicion, while she made herself trousers. Ellen devised a poultice to tie up her right arm, disguising her illiteracy from hotel clerks and their register books. Another bandage around her head and green spectacles obscured her feminine face, and William cut her hair. As he muses in the memoir, with Ellen now dressed as a rheumatic young planter, William admired the "most respectable looking gentleman" they had styled.

Ellen's body constituted the main scaffold of the dandy disguise, and she was well suited to the role. Miller notes that "the dandy is a figure who exists in the space between masculine and feminine, homosexual and heterosexual, seeming and being." In the Crafts' memoir, William depicts Ellen as a model Victorian lady, timid and fragile, yet determined in her moral righteousness. He explains that Ellen hesitated to don masculine clothes, yet "she saw that the laws under which we lived did not recognize her to be a woman, but a mere chattel, to be bought and sold, or otherwise dealt with as her owner might see fit." Ellen read this race-based rejection of her womanhood—what

C. Riley Snorton pinpoints as the "fungibility" of gender within Blackness—as justification to temporarily embody masculinity, though in an adulterated form.

The bandages and gestures Ellen employed on the journey—that is, her limping and feigning deafness, dizziness, and fatigue—play into nineteenth-century American ideas of the "invalid," conceived as an elite, white, feminine figure who is served by others; in the South, that means served by slaves. Disability studies scholar Ellen Samuels notes in her 2006 essay "'A Complication of Complaints': Untangling Disability, Race, and Gender in William and Ellen Craft's *Running a Thousand Miles for Freedom*" that "the validity of Ellen's racial, gender, and class passing *hinges* on the invalidity of her body" (emphasis added). Any trace of Ellen's femininity within the dandy disguise was obfuscated by disability. Despite this, Johnson remains a sexually attractive figure, further emphasizing Miller's definition of the dandy's liminality. William refers to Ellen-as-Johnson as "he" and "my master," revealing his amused, affectionate, and even erotic perception of his wife's cross-dressing. He accentuates this when a white ticket seller asks him, "'Boy, do you belong to that gentleman?' I quickly replied, 'Yes, sir' (which was quite correct)," and when he describes how "two handsome young [white] ladies" on the train to Richmond develop a crush on Johnson. William jokes, "They fell in love with the wrong chap."

These quips reveal William's role in completing the dandy persona. Miller identifies dandies as "self-styling subjects who" not only "use immaculate clothing" but also "arch wit, and pointed gesture to announce their often controversial presence." William's performance as enslaved caretaker as well as his voice—speaking to ticket sellers, fellow passengers, and hotel clerks—function as essential accessories to the dandy disguise, which would be incomplete and ineffective without his nurturing attention to and explanations of "his master's" condition.

For the journey, William, an enslaved man, is disguised as, well, an enslaved man. Yet, as such, he illustrates the nuances of enslaved people's dress and its perception by taking on a sartorial persona to mirror Johnson's and hide his true identity. He "bought and wore a very good second-hand white beaver [hat], an article," he writes, he "had never indulged in before." William's appearance as dandified, well-treated slave signals Johnson's trust in him—a confidence heavily criticized by white onlookers—and underscores Johnson's vulnerability as an ill man and the overall disguise.

Upon reaching freedom, the dandy disintegrated, reverting to the polyvalent sum of his parts: Ellen and William Craft, now at liberty to fashion self-determined identities. Portraits from 1866 show Ellen dressed in respectable feminine attire and William in a neat hairstyle and smart suit. He crafted a dandified image that echoes the style of other notable Black abolitionists of the era, including Frederick Douglass, Henry Highland Garnet, and Craft's mentor, William Wells Brown.

DISGUISE

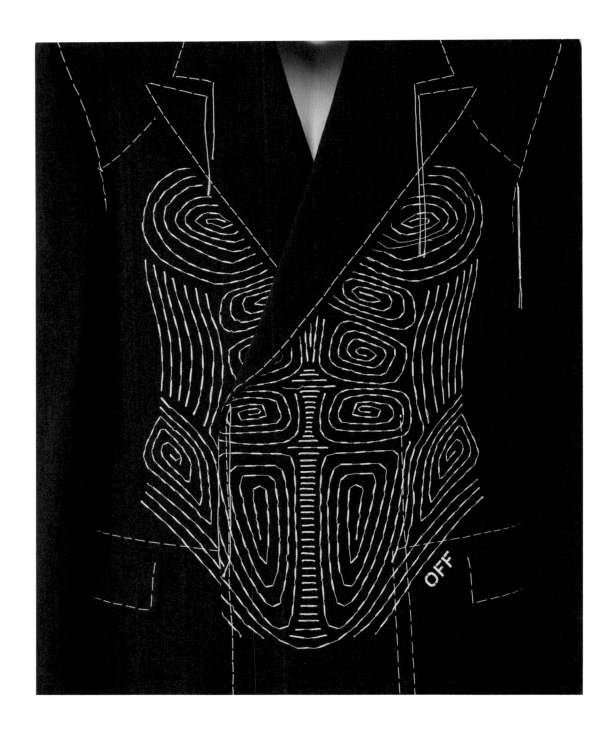

142

DISGUISE

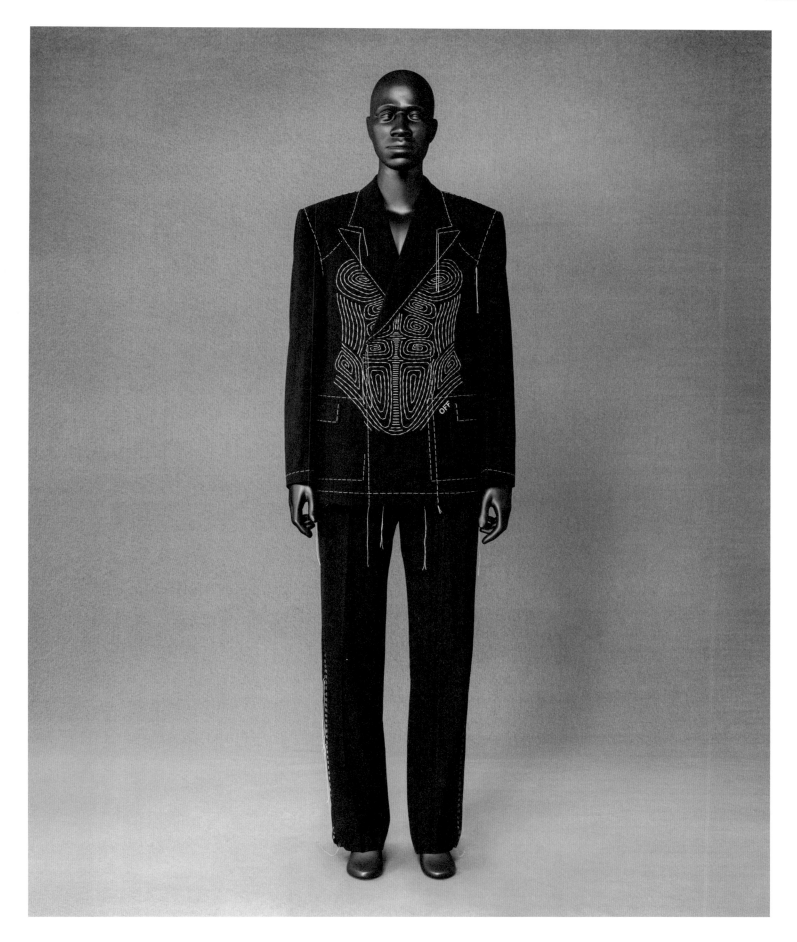

Off-White. Ib Kamara. *Suit*, spring/summer 2023

143

"Thirteen Years a Girl-Husband," published in *The Ogden Standard*, June 13, 1914

Vicente. *Stormé DeLarverié*, 1956

Freedom

———◆———

"I'll tell you what freedom is to me: no fear.
I mean really, no fear . . . like a new way of seeing something."

NINA SIMONE
Nina: A Historical Perspective, 1970

Celebrations of freedom in the early nineteenth-century North often included what we might call "stylin' out": dressing with confidence and panache, and sometimes taking fashionable styles to extremes—traits that came to be associated with the figure of the dandy. "Freedom" explores the anxieties about Black social mobility that coalesced around issues of dress and deportment in the decades leading up to the Civil War, contrasting self-styled images like portraits with caricatures produced around the same time that ridicule the fashions of free Black people in urban centers like Philadelphia, New York, and Boston. At the moment when free and recently emancipated men were beginning to gain social prominence as individuals, so, too, were they stereotyped and satirized en masse; this tension underlies the objects and garments that follow.

From the 1820s, successful Black men, some of whom had been free for generations, adopted bourgeois dress and manners to express their social and political ambitions. Self-commissioned portraits that communicated their wealth, power, and pride showcase their stylish clothing, impeccable grooming, and refined demeanor. These portraits feature well-known businessmen and abolitionists, such as William Whipper (p. 159) and a figure possibly representing James Forten (p. 156), as well as anonymous men of fashion, including the unknown sitter of the so-called *Portrait of a Gentleman* (p. 158). Assured of himself and his position in society, he gazes calmly at the viewer, his arm gently resting behind the chair on which he sits. He marks his prominence by means of fashionable clothing—a fitted coat with high collar and black silk cravat that frame his serene face—topped with a high hairstyle parted stylishly to one side. Thus, he has memorialized his sophistication in this stately image.

At the same time, a new representational regime, the blackface minstrel show, emerged by the 1830s to mock Black individuals' striving and desire for equality and citizenship. Blackface minstrelsy was the most popular form of entertainment in nineteenth-century America, and its stereotypes are an enduring challenge to Black representation today, particularly in the way in which Black men were portrayed as dandies ripe for ridicule. Characters like Long-Tail Blue (p. 152)—named after his blue coat with excessively long tails, a mockery of styles popular in the last years of the eighteenth century—as well as Dandy Jim (p. 153), Jim Crow, and Zip Coon connect masculinity, fashionability, and Blackness in ways that caricature both the Black male body and the Black male as a citizen of mainstream society. Too tight, too long, and too much, Long-Tail Blue's coat derides his aspirations for social ascendence yet also suggests white observers' unease about their own desire for the swagger he elicits. In his eponymous song, first published in 1827, Long-Tail Blue courts a white woman named Sue, declaring, "If you want to win the Ladie's hearts / I'll tell you what to do / Go to a tiptop Tailor's shop / And buy a long tail blue." Sheet-music covers featured images of these characters, specifically targeting urbane Black men, imputing rapacious cunning, criminality, and hypersexuality to them.

The lithograph *Philadelphia Fashions, 1837* from the Life in Philadelphia series by Edward Williams Clay (p. 150) encapsulates an ironic tension between the well-heeled members of the free Black community and attempts to denigrate their hard-earned achievements and elegance. Featuring an extremely well-dressed couple, the male half of which is holding a quizzing glass (p. 151) to his eye, the print includes a dialogue in dialect between the figures:

"What you look at Mr. Frederick Augustus?"
"I look at dat white loafer wot looks at me; I guess he from New York."

Most caricatures in the series examine members of the free Black community with a racist gaze, objectifying and belittling their subjects. This caricature is different, as it is both based on a real person and imagined from another perspective. *Philadelphia Fashions* likely depicts a prominent member of Philadelphia's Black elite, Frederick Augustus Hinton, staunch abolitionist and proprietor of the Gentleman's Dressing Room, a hairdressing establishment. The print reorients the gaze of the other prints in the series: This time the scrutiny is reversed, the Black perspective centered visually even as it is critiqued verbally. Hinton was not a "loafer" at all, but his stature is both mocked and acknowledged here. Similarly, an unexpected critique of white racism is at the center of the cakewalk (p. 174), a high-energy social dance that was famously a feature of the blackface minstrel show. In its later and more well-known form, the cakewalk, performed in blackface for white audiences, mocked Black pretensions to fashionability and gentility. However, the dance originated not on the minstrel stage but, rather, on plantations as a ritual that enslaved individuals invented to playfully and pointedly parody the airs of white slaveholders. In the cakewalk, a caricature of Black society is transformed into commentary on white appropriation of Black expressive culture. With its exaggerated silhouette and whimsical accessories, a spring/summer 2023 ensemble by Virgil Abloh for Louis Vuitton (p. 175) similarly plays with expectations, narrowing the distance between formality and jest.

The exaggerated neckwear adopted by dandies and other aspiring men of fashion from the 1810s reached risible heights by the 1830s, making them ripe for ridicule. Worn over fine linen shirts with high collars and starched muslin ruffles (p. 161), cravats became a sign of the dandy's hauteur, pushing the chin back and causing the wearer to literally look down his nose at the world. A miniature by Jean-Baptiste Sabatier-Blot (p. 164) captures the likeness of Philippe Aime LeGoaster wearing a high black patterned silk cravat similar to the French example on page 165—a fitting pedestal for his somewhat disdainful, pouty visage, bracketed by the face-framing curls fashionable in the 1840s. LeGoaster was one of several wealthy New Orleans *gens de couleur libres* ("free men of color") who parlayed successful tailoring and haberdashery shops into vast real estate fortunes. By 1850 he was the wealthiest free Black man in the city, owning taxable property worth $150,000 in the French Quarter alone. Like many other members of the New Orleans Creole elite, LeGoaster immigrated to Paris, where this portrait was painted, opting for a life as a cosmopolitan "lion"—to use the contemporary French term for a dandy—instead of the fraught existence he encountered as a biracial man in the United States.

The contemporary garments that follow mirror the silhouettes associated with Black dandyism in their most amplified forms. Designers Ib Kamara for Off-White (p. 163), Bianca Saunders (pp. 168, 169, 173), and Louis Vuitton (p. 175) experimented with the traditional elements and signifiers of dandiacal dress and gender through the exaggeration of form and pattern as alleged in the caricature prints: broad collars, an elongated necktie, boldly striped fabrics, and cropped trousers—all features that appear more unconventional than sophisticated. The designs represent new forms of men's dress that defy and mock society's insistence on propriety and a wearer's desire to "get it right." Instead, they encourage play with clothing, pattern, and scale in the service of self-expression.

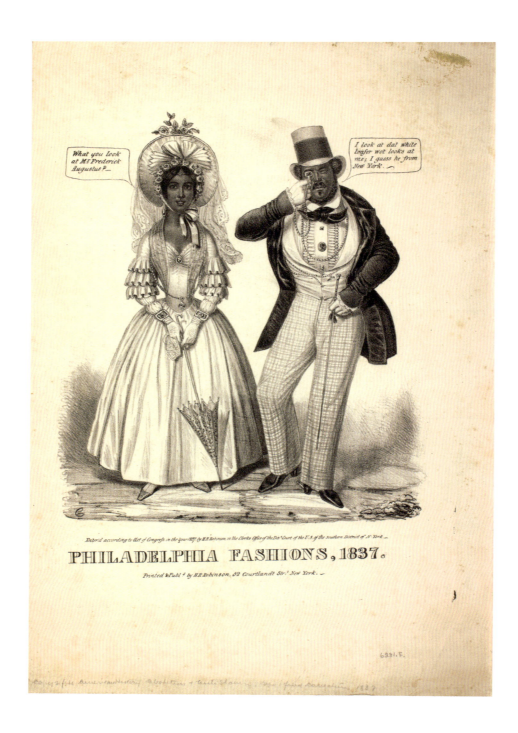

Edward Williams Clay. *Philadelphia Fashions, 1837*, 1837

Quizzing glass. Probably English (second quarter 19th century)

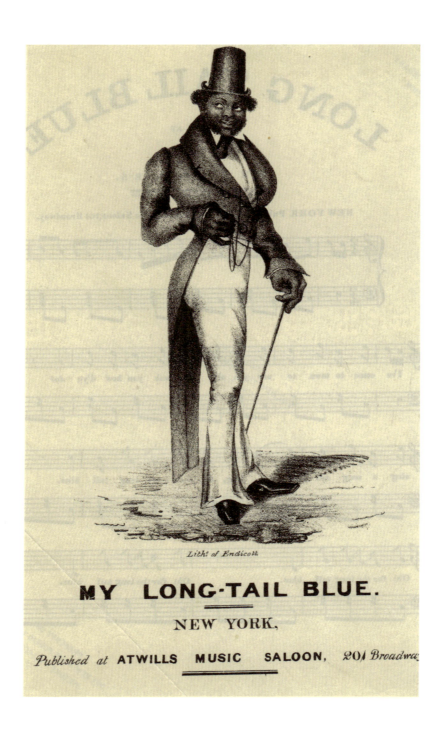

George Endicott. Cover of *"My Long-Tail Blue" sheet music*, ca. 1827

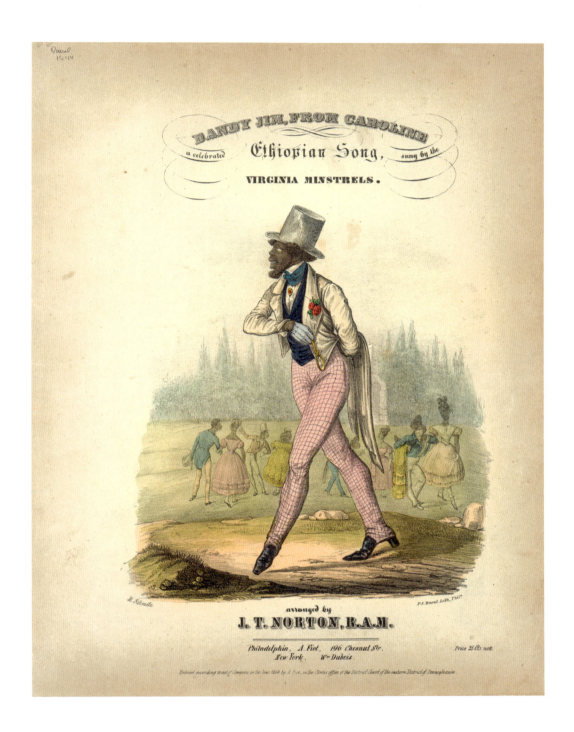

Matthew Schmitz. Peter S. Duval. *"Dandy Jim from Caroline: a celebrated Ethiopian song": sung by the Virginia Minstrels / arranged by J. T. Norton*, 1844

FREEDOM

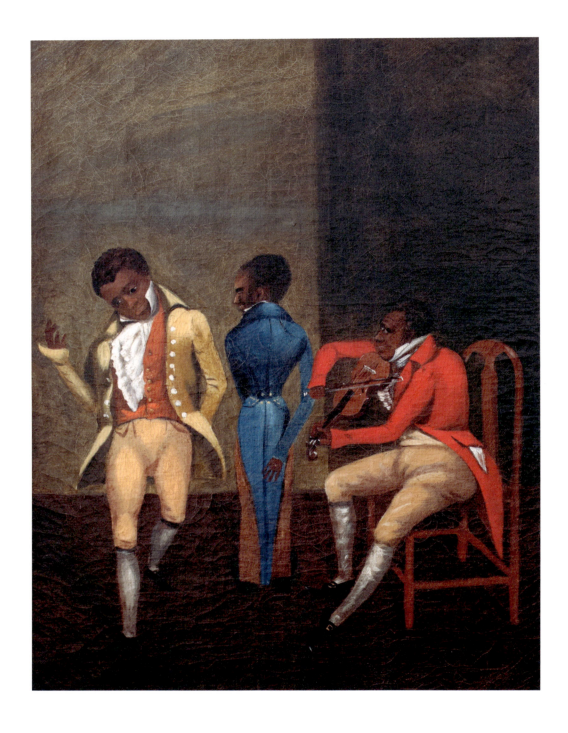

154 Attributed to George Washington Mark. *Untitled [African-American musicians]*, 1838

FREEDOM

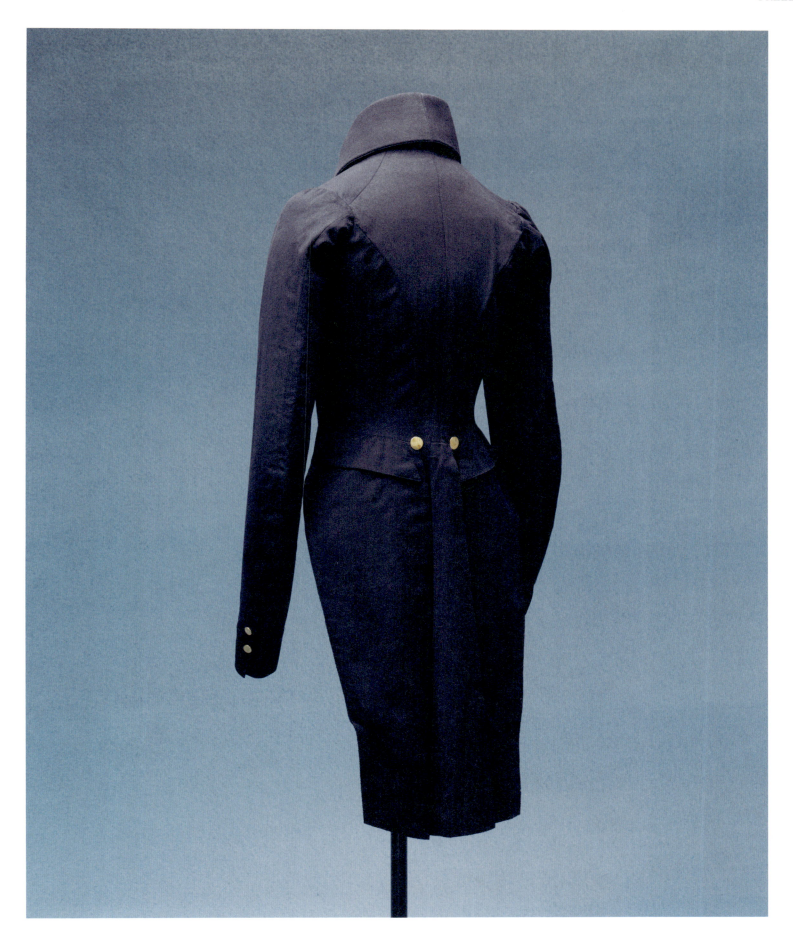

Newton. *Tailcoat*, 1829

Portrait of James Forten. American (ca. 1820)

FREEDOM

THREE JACKSONIAN-ERA PORTRAITS OF BLACK MEN

RICHARD J. POWELL

Frank J. Webb's *The Garies and Their Friends* (1857)—one of the first novels published by an African American—examines the lives of free Black people in the United States. In one passage, readers are introduced to a Mr. Walters, one of the wealthiest Black men in Philadelphia and a character probably based on the real-life Philadelphia sailmaker and abolitionist James Forten (tentatively identified in the portrait opposite). After describing Walters's North Philadelphia mansion and delineating his "commanding figure," Webb shifts his discussion to Walters's clothing. "The neatness and care with which he was dressed added to the attractiveness of his appearance," Webb begins. "His linen was the perfection of whiteness, and his snowy vest lost nothing by its contrast therewith. A long black frock coat, black pants, and highly polished boots . . . complemented his attire." Nowhere in his word sketch does Webb rely on that era's trope of the Black dandy, thereby avoiding its satirical associations and reinforcing the notion that Black male elegance transcended the stereotype's limitations, as seen in several early to mid-nineteenth-century paintings.

As one considers the depictions of Black men in Jacksonian-era paintings of the 1820s through the 1850s, it is important to acknowledge how racial difference reformulated portraiture. No longer constrained by the Western European tradition of a pale, white countenance set against a darker background, the artists who depicted these men grabbed viewers' attention while bringing an untarnished scrutiny to a spectrum of Black physiognomies. Each man's fixed look meets our twenty-first-century curiosity with a modern candor.

That these painters and their subjects conspired to concoct portrayals that cut evocative figures is evident in the man's portrait with a maritime view (opposite). This fastidiously dressed man was probably from New York's free Black community and was painted by the same unknown artist who created a similar portrait of the Albany Line steamboat manager Peter Vogelsang (now in the permanent collection of the National Gallery of Art, Washington, D.C.). The elegant man wears a double-breasted jacket with brass buttons that reiterates his searing gaze. Further accessorized with a white waistcoat, upstanding collared shirt, and four-in-hand necktie, this sitter conveys a gentlemanly demeanor informed by aristocratic airs.

Neither the stark background nor the cultivated but staid attire of a Black man in another portrait (p. 158) reveals much about the sitter. This picture contains none of the fascinating details or biographical tidbits gleaned from the vernacular brass buttons portrait. However, what the unknown portraitist included that animates the subject is a handsome, well-proportioned head with an illuminating expression and a soaring and parted-on-the-side shock of wiry black hair. The image evokes the nineteenth-century Black orator Frederick Douglass's sardonic self-admission in a January 29, 1846, letter to Francis Jackson: "I find I am hardly black enough for british [sic] taste, but by keeping my hair as wooly as possible, I make out to pass for at least a half a negro at any rate." The unknown artist's obvious skill for rendering such physical specificities introduces a welcome academicism and realism that counters the Black subject's recurrent status as a formulaic joke in pre–Civil War visual culture.

Despite appearing as flat as the brass buttons portrait, the painting of the Philadelphia businessman William Whipper (p. 159)—attributed to artist William Matthew Prior—is less one-dimensional and as psychologically layered as the portrait of the elegantly coiffed Black man. Besides tastefully dressing in a gentleman's proper attire, Whipper wears a Masonic gold chain and key on his waistcoat, gold rings on both hands, and a squarish black pin on his shirtfront. Holding a bound copy of one of his self-published pamphlets concerning temperance or the abolition of slavery—his initials prominently displayed on the book's cover—Whipper has neither the ostentatiousness of the vernacular portrait nor the élan of the unidentified man. Instead, the portraitist fused sartorial chic with sobriety and a sympathetic activism, especially through the social reform badge (or mourning brooch) on Whipper's chest. Interpreted through a lens that includes comparable portraits of Black subjects by Prior, *William Whipper* employs the sitter's clothing as more than a nod to fashion. Whipper's wardrobe signals his possession of an aesthetic yet apropos sense of self that, along with his professional duties and mission as a "moral reformer," communicates a conspicuous social position as well as positive propaganda for African Americans, especially in the face of the racial discrimination and outright hostility toward that beleaguered community.

"So you, too, are attracted by that picture," remarks Webb's Mr. Walters to one of his white guests who is mesmerized by his painting of the uniformed Toussaint L'Ouverture, the leader of the only successful slave revolt in the Western Hemisphere. Clearly, an interest and preoccupation with fashionable Black men and their achievements factor into the history of modern portraiture.

157

FREEDOM

Portrait of a Gentleman. American (ca. 1830)

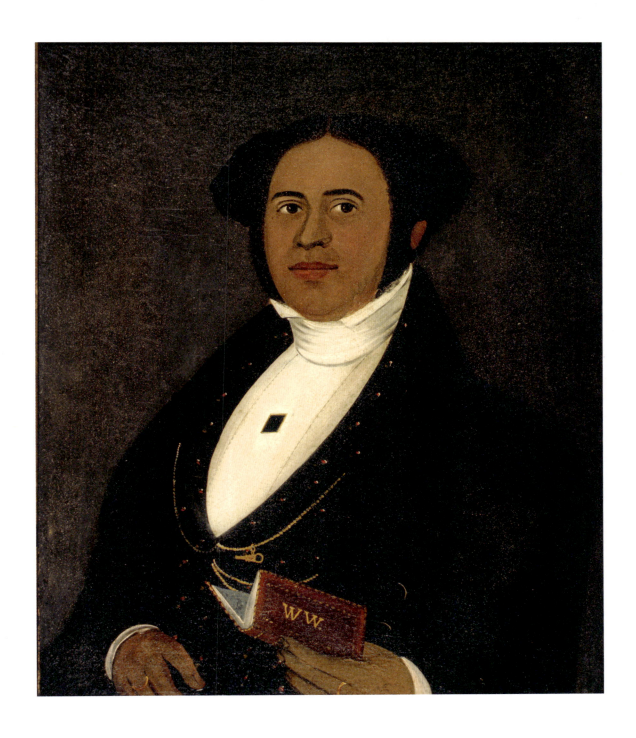

Attributed to William Matthew Prior. *William Whipper*, ca. 1845

William Wood Thackara. William G. Mason.
A New Mode of Perfuming & Preserveing Clothes from Moths, ca. 1819

FREEDOM

Shirt. French (ca. 1800)

George Cruikshank. Frontispiece to *Neckclothitania or Tietania, being an essay on Starchers, by One of the Cloth*, 1818

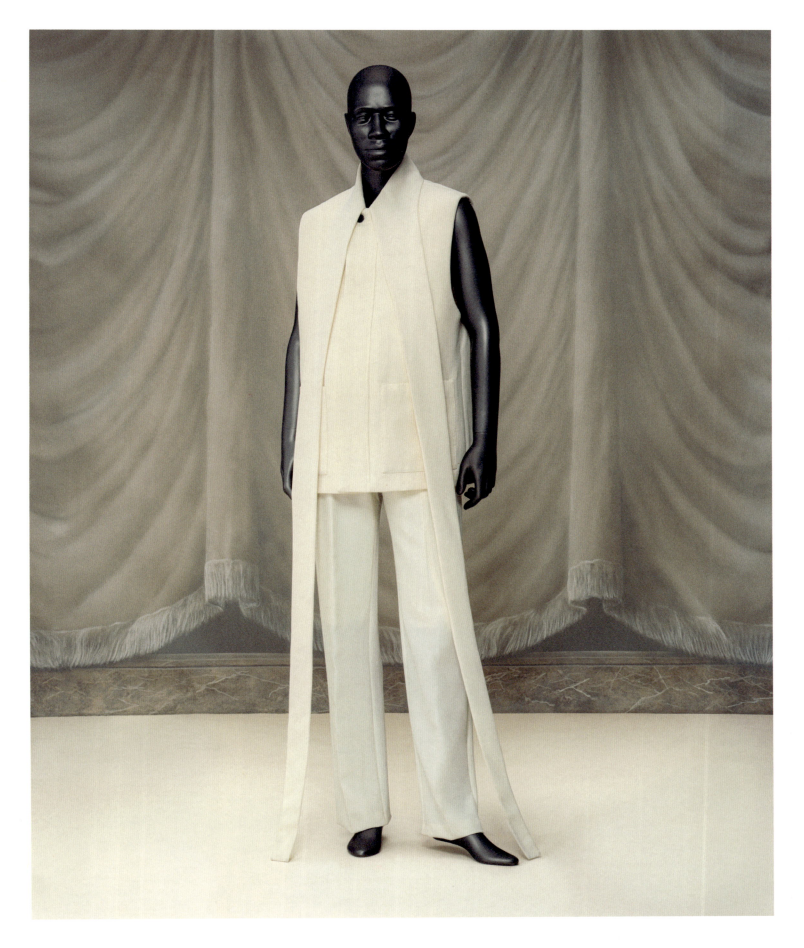

Off-White. Ib Kamara. *Ensemble*, spring/summer 2023

FREEDOM

164 Jean-Baptiste Sabatier-Blot. *Philippe Aime LeGoaster*, ca. 1840

FREEDOM

Clement. *Cravat*, ca. 1850

Life in New York. "Shall I hab the honour of glanting...?" American (ca. 1830)

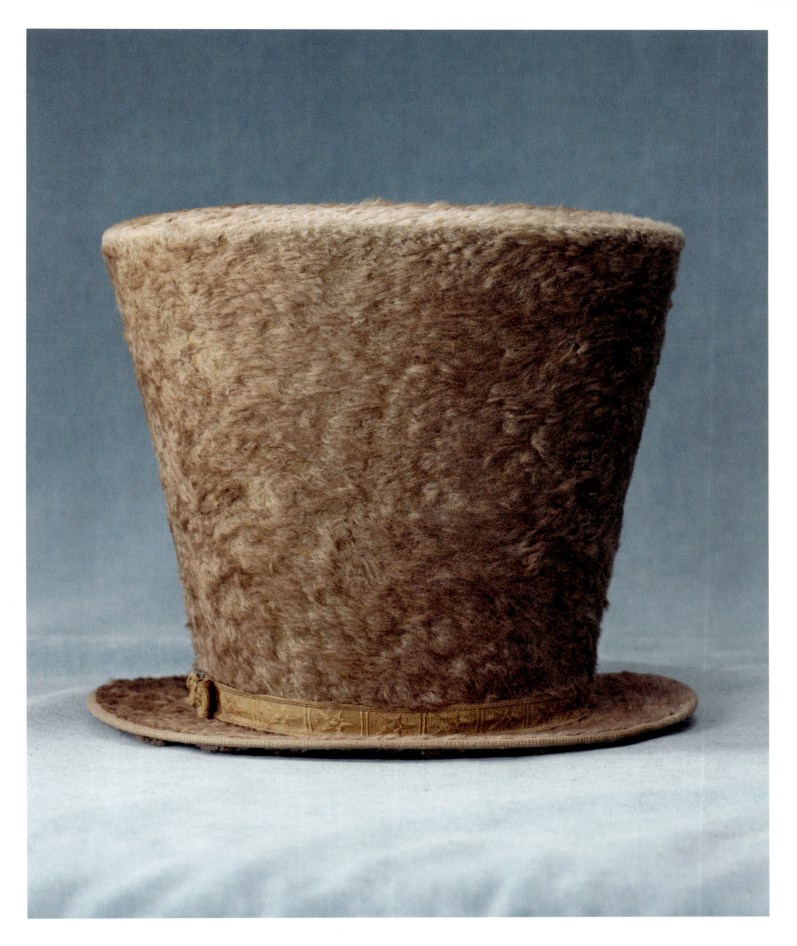

Top hat. American (1830)

FREEDOM

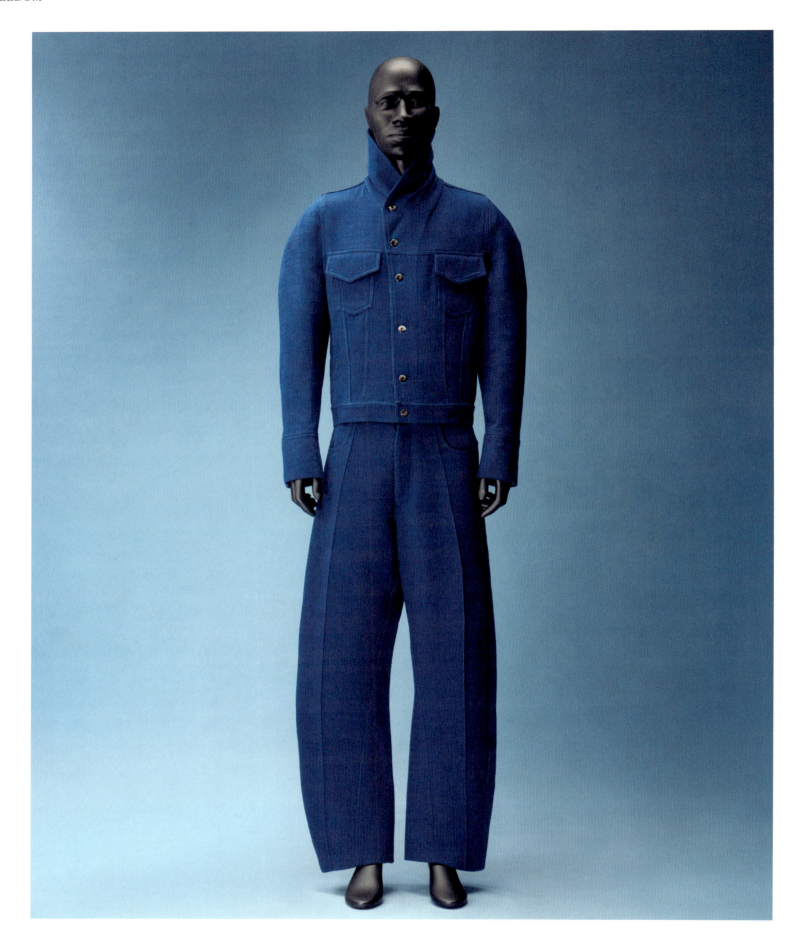

Bianca Saunders. *Ensemble*, autumn/winter 2024–25

FREEDOM

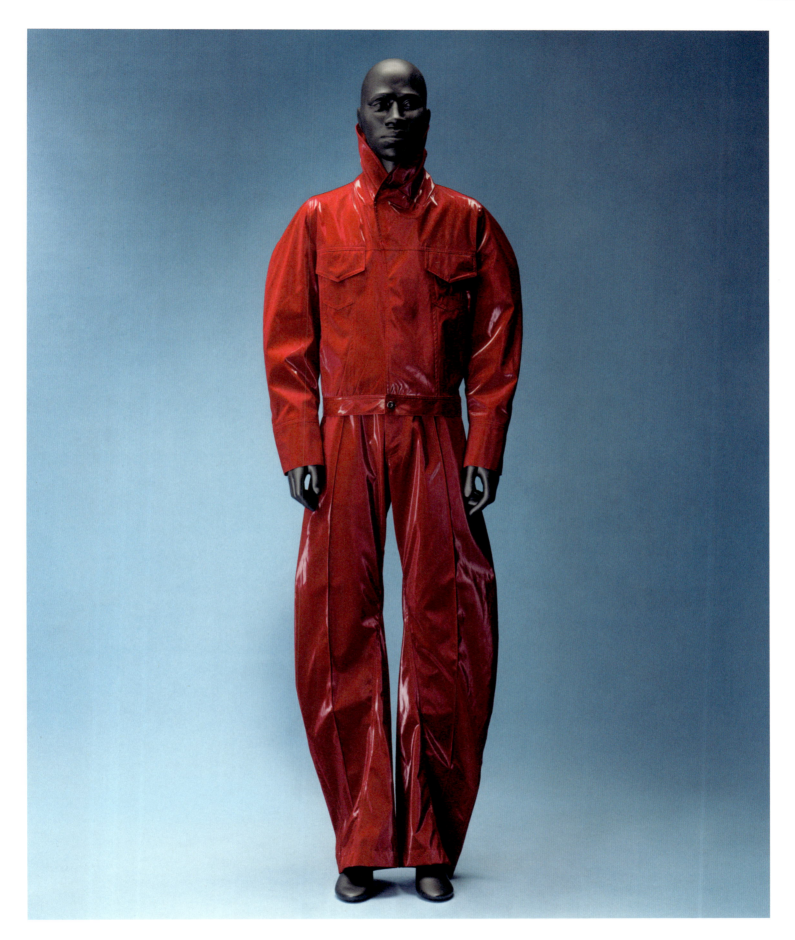

Bianca Saunders. *Ensemble*, autumn/winter 2024–25

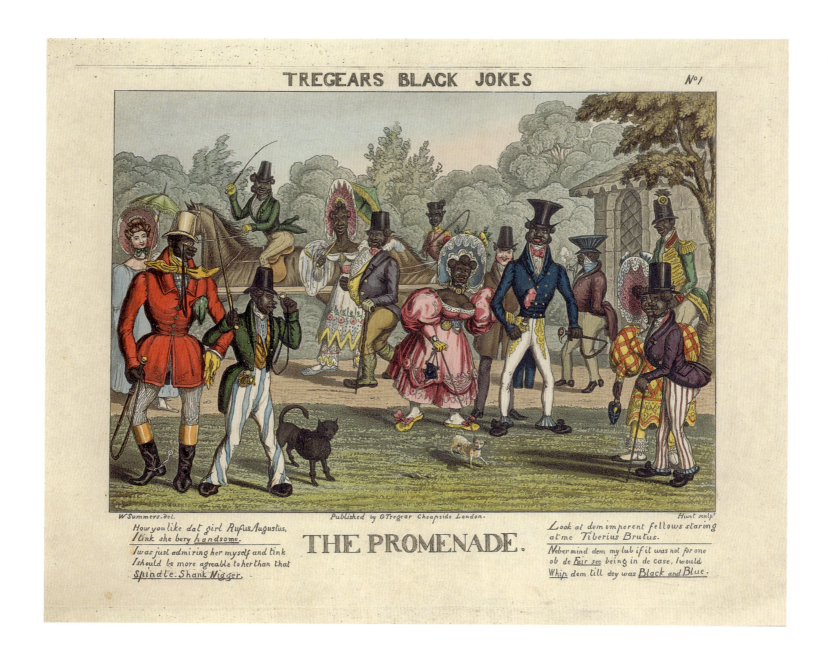

Charles Hunt. *Tregear's Black Jokes: "The Promenade,"* plate 1 from Tregear's Black Jokes: being a series of laughable caricatures on the march of manners amongst the Blacks series, 1834

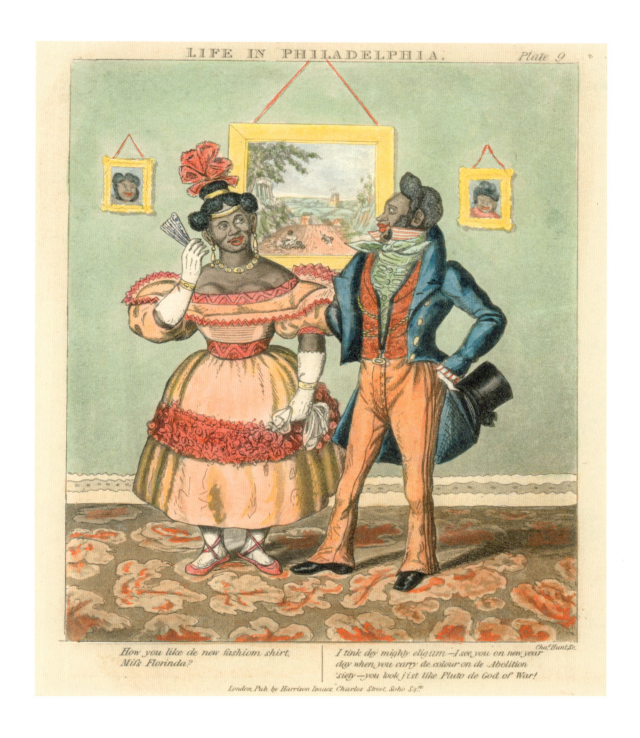

Charles Hunt. William Summers. *Life in Philadelphia*. "How you like de new fashion shirt . . .?," ca. 1831

FREEDOM

172 Winkley & Co. *Trousers*, ca. 1840

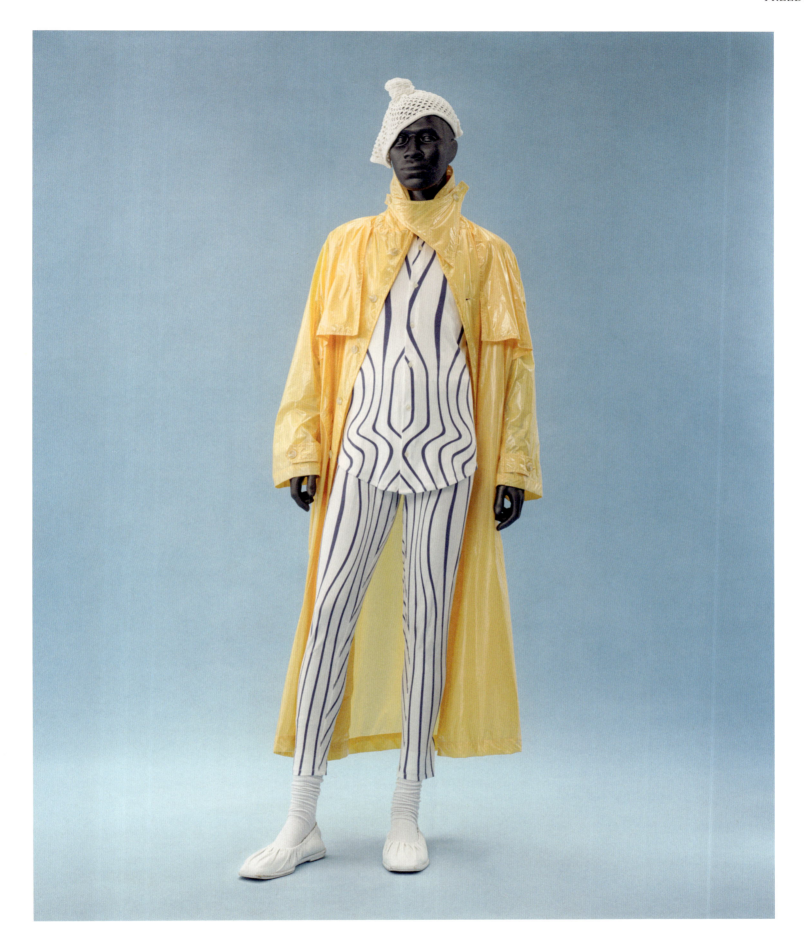

Bianca Saunders. *Ensemble*, spring/summer 2025

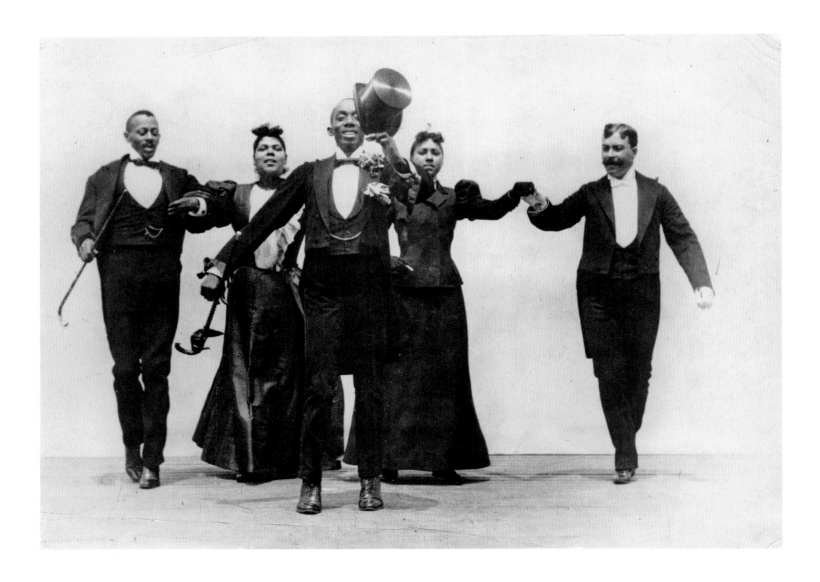

American Mutoscope and Biograph Company. *Dancers Performing the Cakewalk*, 1903

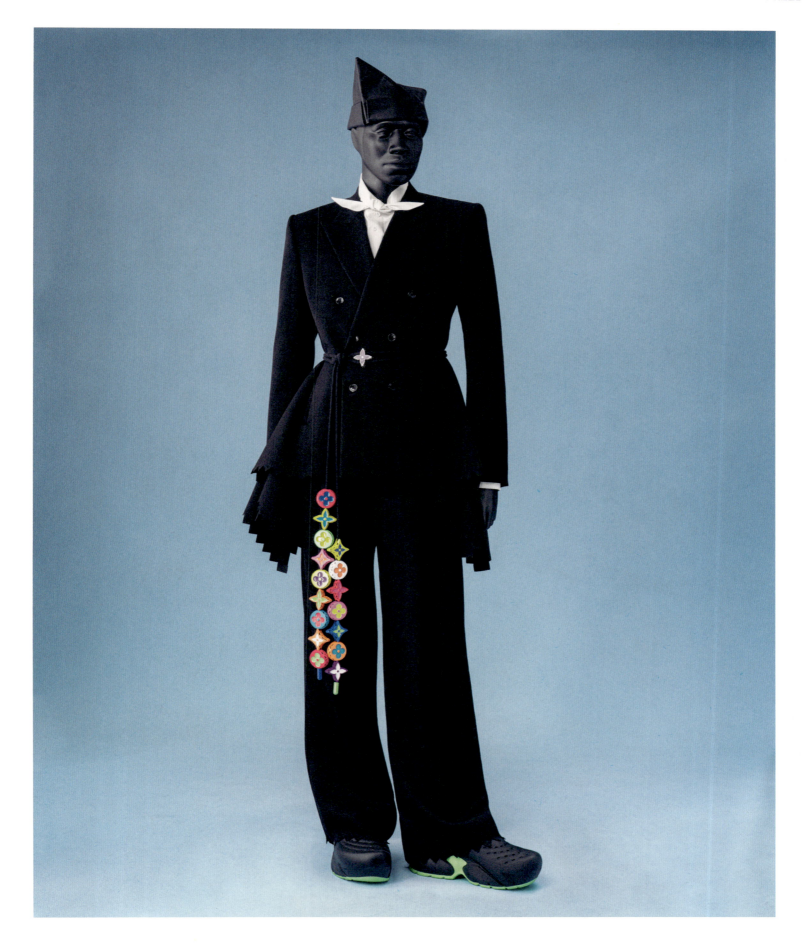

LOUIS VUITTON. Virgil Abloh. *Ensemble*, spring/summer 2023 menswear

Champion

"Have pride in the way you dress, the way you talk,
the way you walk, the way you carry yourself.
Discipline is the thing that makes you a champion."

WALT FRAZIER
"Walt 'Clyde' Frazier Is Still the NBA's Greatest Style God—
and He Knows It," *GQ*, October 6, 2016

Champions are made by determination, perseverance, and self-discipline. Believing in oneself and one's abilities is required for victory, whether or not the struggle for athletic success is individual or collaborative. While dandyism is often thought of as a solitary "sport," it can also unite members of a team or an organization through a uniform that is as stylish as it is utilitarian. Or it can place them in association with other like-styled individuals. Elegant and conspicuously colored, patterned, or accessorized clothing worn by Black athletes is now an indelible part of the entertainment value of sports; as such, this form of Black dandyism distinguishes athletes as both tastemakers and part of the capitalism-sports nexus.

"Champion" examines dandyism in the world of athletics, illuminating not only how success in sports can be a mode of distinction that allows Black men access to style but also how athletics has increasingly influenced men's fashion, shifting emphasis from covering the body to revealing it and reveling in its muscular contours. This history begins in nineteenth-century America, when horse racing relied heavily on the prowess of enslaved Black jockeys. These plantation laborers were known as "race-riders" and often wore so-called jockey silks in their enslavers' colors, which matched the household's livery and signaled their status as property and adept sportsmen. Enslaved riders would have worn garments similar to an ensemble comprising a boldly striped jacket and white buckskin breeches (p. 181), intended for equestrian Colonel William Alston of Clifton and Fairfield Plantations in South Carolina. Apparently never worn, the garments reveal the expertise of the enslaved "plantation tailors" who created them: The jacket is made not from a striped fabric but, rather, of green ribbons meticulously secured to a ground of red satin with small, even stiches.

Skilled as trainers, grooms, and riders, Black jockeys won most Triple Crown victories in the late nineteenth century. Thirteen of the fifteen jockeys in the first Kentucky Derby in 1875 were Black men, but by the early twentieth century, increasingly virulent Jim Crow laws excluded them from the sport. Commissioned to portray prize-winning horses, Swiss-born and Kentucky-based painter Edward Troye also captured the jockeys and trainers who rode and cared for these animals, recording their names and likenesses in a manner unusual for the period. Edward Brown, a prominent jockey and horse trainer, crouches in blue silks in Troye's portrait of the undefeated horse Asteroid (p. 180), created in the midst of the Civil War. Born into slavery, Brown won the Belmont Stakes as a jockey and the Kentucky Derby as a trainer, eventually becoming one of the most successful turfmen of the nineteenth century. "Brown Dick," as he was universally known, earned great wealth and, as he grew older, a gentlemanly reputation due to his success; as the Louisville *Courier-Journal* noted, "Brown Dick is never happier than when with his hat doffed, he is leading [women and children] from stall to stall and answering their absurd questions with gentlemen courtliness worthy of a wigged and ruffled cavalier."

Troye's painting also depicts Ansel Williamson holding the horse's reins; he trained the first Kentucky Derby winner, ridden by Black jockey Oliver Lewis. While racial politics of the time defined these men as property and, later, as second-class citizens—part of an un-individuated or nameless population—their hard-earned athletic prowess gave them access to the tools and materials for individual expression and recognition. Some riders, like Jimmy Winkfield (p. 182), had great success at home and abroad. Winkfield was the last Black jockey to win the Kentucky Derby, taking the crown twice (in 1901 and 1902) before immigrating to Russia and then France, riding to victories in both countries. He had his own stables outside of Paris until he was forced to flee back to the United States during the Nazi occupation.

In the late nineteenth and early twentieth centuries, boxer Jack Johnson lived an extraordinary life in which his success provided fame as well as notoriety, affording him avenues to fashionability not readily available to others. Always pushing the boundaries of race, in 1910 Johnson, the "Galveston Giant" and first Black Heavyweight Champion of the World, famously knocked out boxer James Jeffries, known as "The Great White Hope," which led to riots across the country. He broadcast his success as a connoisseur of clothing,

cars (p. 190), and controversy, wearing elegant ensembles (p. 189) and driving a white Mercedes-Benz upholstered with leopard skin, all while provoking the ire of the press and public with his three marriages to white women. Not shy of displaying his impressive physique in the ring (p. 188), Johnson promoted physical exercise and a healthy diet while cultivating a public persona as a man of extravagant style. As he wrote in his 1927 autobiography (later republished as *Jack Johnson Is a Dandy*), "The possession of muscular strength and the courage to use it in contests with other men for physical supremacy, does not necessarily imply a lack of appreciation for the finer and better things in life." Johnson's attention to his physique mirrors contemporary desires to display physical beauty through clothing that accentuates a rigorously toned body, a desire reflected in the work of designer Saul Nash, whose garments not only celebrate the physical results of athletic practice through body-conscious construction but also respond to its technical needs in their pliable, porous materials (p. 193).

Muhammad Ali, known as "The Greatest," followed in Johnson's footsteps in terms of challenging racial regimes and social hierarchies. Born Cassius Clay, he abandoned his "slave name" when he joined the Nation of Islam and became a conscientious objector to the Vietnam War. His career as a boxer is unparalleled; fights known as the Rumble in the Jungle (1974) and the Thrilla in Manila (1975) are among the most memorable in boxing history. Ali married his civil rights activism with style, promoting his boxing prowess as much as his personal beauty through trash talk and rhyme, saying, "I'm so pretty I can't hardly stand to look at myself!" In their satiny texture and black-and-white color scheme, the Everlast shorts (p. 195) Ali favored act as a trademark as well as a nod to the formalism of the tuxedo. Ali also enjoyed bespoke suits, ordering his first from luxury tailor Harry Helman on London's renowned Savile Row in 1966 (p. 194). He was inspired to do so by friend and legendary photographer Gordon Parks, declaring, "I'm a gentleman now. I have to look like one."

Like Black jockeys and boxers before them, Black basketball players have also used the sport in which they dominate to gain fame and wealth, endorsing products like sneakers that have become enduring symbols of style and status. Legendary New York Knicks basketball player Walt Frazier is one of the sport's first style icons and sportswear entrepreneurs. Like Johnson, Frazier was known for his love of luxurious furs (p. 196) and cars, and he was one of the first athletes to develop an original shoe design with a sportswear brand. Still in production, the 1973 Puma "Clyde's" (p. 197) reference Frazier's ability to steal the ball from opponents on the court, as the name alludes to notorious bank robber Clyde Barrow. The "Clyde's" paved the way for later commercial collaborations, including Nike's "Air Jordan" line, named for Chicago Bulls champion Michael Jordan and introduced in 1984. The famed NBA tunnel—the walkway from the arena entrance to the locker room—today functions as a runway: Players entering the arena have traded traditional sportswear for clothes by both established luxury brands as well as up-and-coming Black designers. Players like LeBron James and Dwayne Wade have long-standing relationships with design houses and are often labeled best dressed not only in the league but, more broadly, in the world of fashion.

Contemporary Black designers respond to the unique relationship between sports and fashion through historical investigation and experiments with form. Tremaine Emory's designs for Denim Tears concentrate on the stories and figures of the African diaspora. His 2024 "T.G.B.J." ("The Great Black Jockeys") collection (p. 186) adapted the traditional patterns of racing silks and the popular motifs of equestrian fashions to provoke appreciation for the sport's diversity and complex origins. Other designers, including Saul Nash and Emeric Tchatchoua of 3.Paradis (pp. 198–99), elevate the status of sportswear by converting objects from the gym and the playing field into elements of the men's suit—white towel as shawl collar, basketball net as bejeweled vest. The designs draw parallels between sportswear and formalwear, highlighting the evolution of dandiacal dress in fashion and alluding to the potential benefits—and costs—of athletic success.

CHAMPION

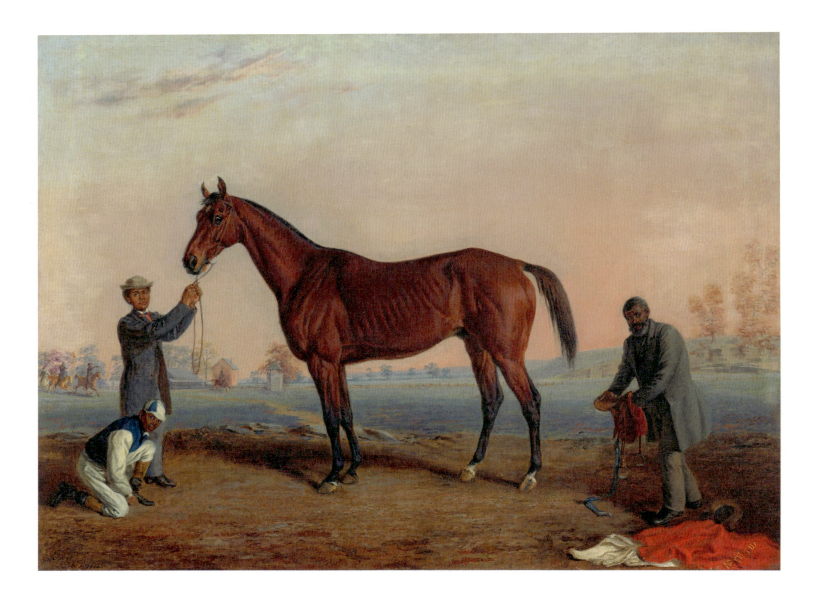

180 Edward Troye. *Ansel Williamson, Edward Brown, and the Undefeated Asteroid*, 1864

CHAMPION

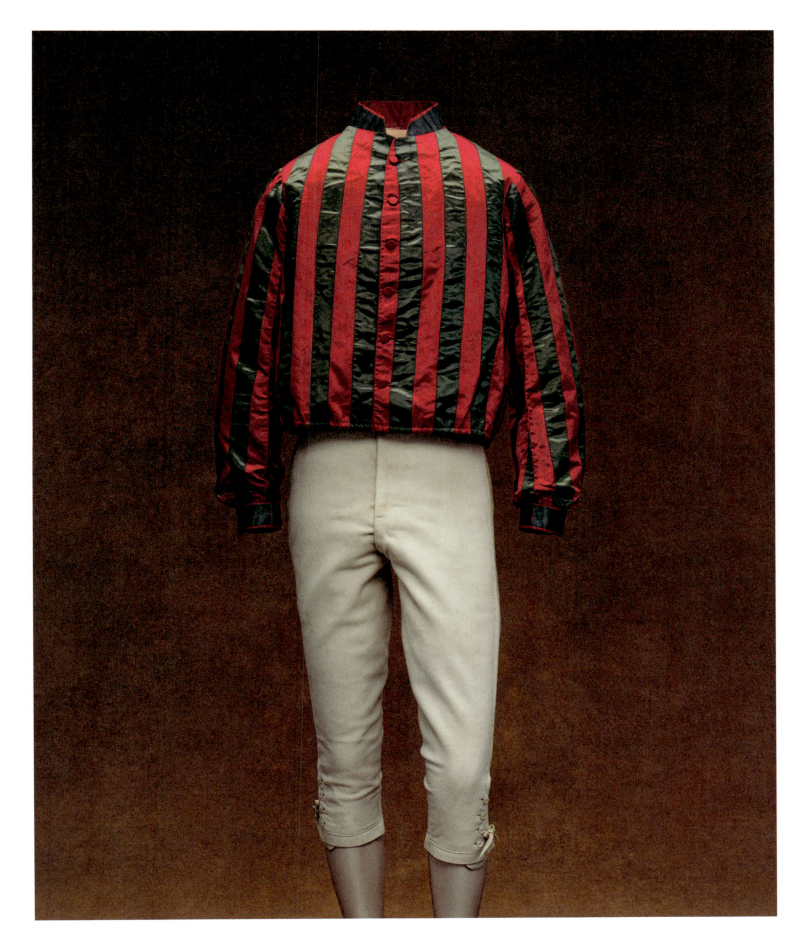

Jockey suit. American (1830–50)

CHAMPION

Charles Christian Cook. *Jimmy Winkfield*, ca. 1902

WIN WIN

ANDRÉ 3000

Sports and style have always cheered each other on. How can anyone not champion the competitive colors, distinguished graphics, utilitarian-turned-personal fits, individual modifications, and the collective power of team uniformity?

Through their personal style, sports stars have historically had an open line of communication with the fashion world. Michael Jordan's longer-than-usual shorts. Florence Griffith Joyner's vibrancy. Andre Agassi's electric attitude. Allen Iverson's injection of cornrows and neighborhood style into basketball and those watching. Mike Tyson's all-black minimal look. It's as if these style choices gave them a superpower advantage in competition. They looked cooler, so this must have made them feel and perform with confidence. These athletes would begin to carry this expressiveness at all times. Even in their civilian clothes, they displayed something of themselves. Their signature "in-game" style eruptions would start to appear off the court and field and go on to influence designers, photographers, visual artists, and musicians alike. This sports-to-art feedback loop continues to hum.

In the music video for the Outkast song "Hey Ya!," you will notice a trio of background singers dressed in stylized polo-player garb. While planning and creating the look for this shoot, I had a wishful casting idea: With my fingers crossed and being very wide eyed, I actually reached out to Ralph Lauren's office and asked if Mr. Lauren wouldn't mind playing the Ed Sullivanesque TV show announcer at the start of the band's performance. No, I didn't know him at all, but he had been a part of my life for years, and I thought it would just be rad to see him there in that space. He kindly declined the offer and I totally understood.

What Ralph didn't know was, during that time period, I was reading anything I could find about him and sifting through archival images of his clothing. He and musicians Sly Stone, Jimi Hendrix, Sun Ra, Eric Dolphy, Thelonious Monk, Miles Davis, Slick Rick, Prince, Kraftwerk, and George Clinton and his bands Parliament and Funkadelic were all influential style pillars to me. It may be a wonder to some how Ralph could sit in style company next to Hendrix, but what I noticed in all of these people was a common rebel, dreamer, world-builder spirit, and I identified with that. Creating the world you would like to see is important. It might inspire an onlooker to build their own.

If you asked any Black person from my early middle school days who their favorite designer or fashion force was, they would probably answer, "Ralph Lauren." Now, looking back, I'm not even sure if I knew what a designer was, but I knew this brand name produced these rich, colorful clothes that made me feel better. For me and most of my peers, RL was the pinnacle of style and our introduction to dressing. In my hometown of Atlanta, kids who had never played polo—much less even ridden a horse—would come to public school wearing riding boots and blazers! Across town, there was a group of kids called the Stray Cats, and their trademark look consisted of big wild hair, tartan pants, mesh Polo shirts, custom Rit-dyed Tretorn canvas sneakers, and actual tennis rackets zipped inside vinyl cases slung across their backs. Their girlfriends had finger-waved hairstyles and wore tennis skirts, tennis sweater-vests, and thick white socks with Air Jordan 4s before streetwear had reached puberty. These people had never played tennis. They were just kids dreaming in clothes. They somehow made it look more alive than reality. Ralph taught us how.

After years of self-styling, drawing, and designing my own clothing pieces and costumes for stage performances, I wanted to try my hand at my own public fashion offering. In 2006 I started working on the Benjamin Bixby brand. These would be some of the best times of my life. Even considering the hardships and lessons learned, I would do it all over again. And I will.

CHAMPION

184 John C. Hemment. *Isaac Burns Murphy*, ca. 1891

Isaac Burns Murphy at Salvator's Clambake, 1890

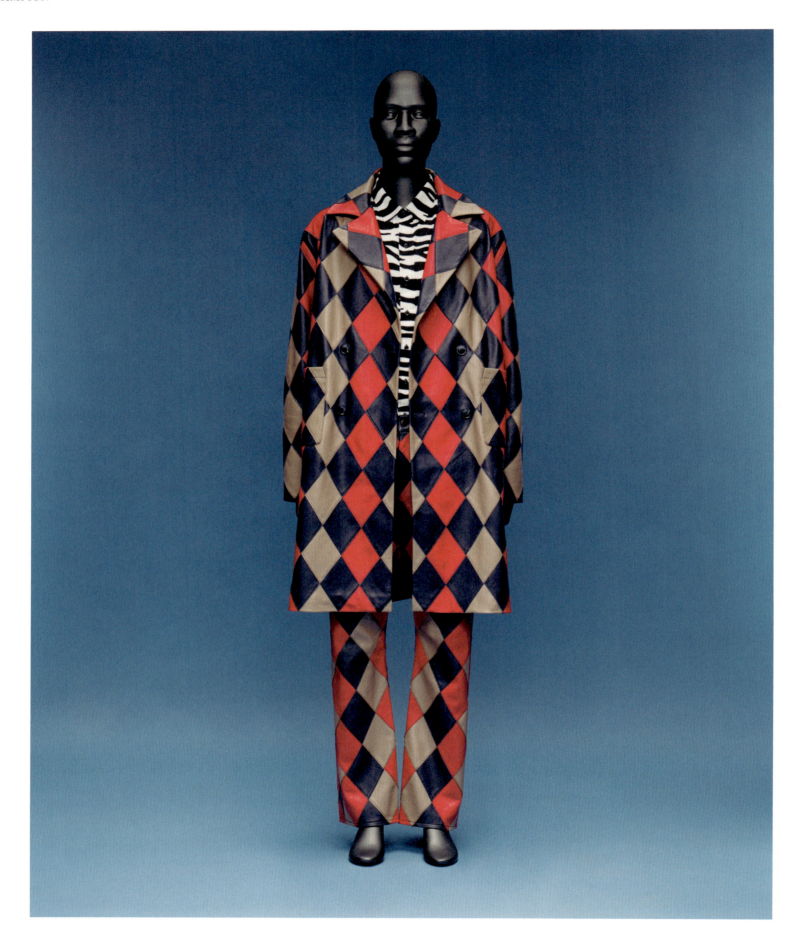

Denim Tears. Tremaine Emory. *"T.G.B.J." ensemble*, 2024

BLACK JOCKEY

TREMAINE EMORY

Black American culture is no stranger to whitewashing. Throughout this nation's history, the cultural contributions of Black individuals across the arts, sciences, and sports have been overlooked—and in many cases erased entirely—to reshape contemporary perceptions. As a result, the significance of Black artists, scholars, and athletes has been heavily diluted, painting a distorted truth of Black Americans' past. The Black athletes of horse racing have fallen victim to such cancellation. During the nineteenth century, the sport was considered one of the nation's most popular, with the Kentucky Derby heralded as the most prestigious of the stakes. It was here, on Louisville's world-renowned Churchill Downs racecourse, that Black jockeys mastered the sport, earning a reputation as some of the greatest horsemen in the world. From the Kentucky Derby's inaugural race in 1875 to the early twentieth century, when the participation of Black riders would dwindle as a result of Jim Crow laws and mounting racial tensions, Black Americans would reign supreme on the racetrack. During the sport's first three decades, more than half of the derbies were won by Black men—the first Kentucky Derby winner, Oliver Lewis, being one of thirteen Black jockeys among the event's fifteen riders. Despite their enormous contributions to horse racing during its infancy, Black jockeys, their rich history and legacies, would be forced to the background as the sport flourished and became a staple of American culture.

Ardent in our desire to explore and uncover Black America's forgotten and erased histories, we at Denim Tears bring equestrianism—namely, derby racing—and the African American jockeys who dominated the sport into focus with the launch of the "T.G.B.J." ("The Great Black Jockeys") collection (opposite), inspired by Edward Hotaling's book *The Great Black Jockeys*, an extensive profile of the Black American jockeys prominent from the early 1700s to the turn of the twentieth century. An illumination of a poignant yet overlooked era in America's illustrious sporting past, the "T.G.B.J." collection is a defiant refusal to accept the erasure of Black jockeys and their accomplishments, offering instead a take rooted in history yet declaring the timelessness of what it means to be a champion. Achieved with reverence for the significance of the cultural contributions made by Black riders, the collection spotlights the sport's most prominent athletes, drawing attention to the first eleven Black jockeys to compete in the Kentucky Derby—Oliver Lewis, William "Billy" Walker, George Garrett Lewis, Babe Hurd, Isaac Burns Murphy (pp. 184–85), Erskine Henderson, Isaac Lewis, Alonzo "Lonnie" Clayton, James "Soup" Perkins, Willie Simms, and Jimmy Winkfield (p. 182)—all the while honoring the eclectic style synonymous with the stakes race. While equestrian sports' extravagant fashions contribute to the ensembles' color scheme, the collection's foundations are based on a reference-rich palette, allowing for a capsule wardrobe that reaffirms the legacy of America's Black jockeys' power.

Denim Tears's impassioned commitment to illuminating and illustrating overlooked moments in Black American history through a contemporary cultural lens has defined the label's expressions across mediums, having understood that access to knowledge is imperative to delivering these stories to the public. This access was granted with the establishment of our first brick-and-mortar store, African Diaspora Goods, in March 2024. Encompassing Denim Tears's sartorial explorations and articulations of the African diaspora as well as Black American history and culture, the flagship's intentions far exceed a traditional storefront; instead, African Diaspora Goods also serves as a cultural hub and resource library.

Beginning with friendship, mutual respect, and understanding, this intent was achieved collaboratively. As founder, I worked with Theaster Gates, an artist and professor who has dedicated much of his career to the importance of archiving Black cultural forms to enable accessibility and remembrance. Although a deeply personal reflection of my life, as it alludes to my parents' video store, my experiences of over a decade in retail, and Denim Tears's chronology, African Diaspora Goods keeps my and Gates's shared values close to heart. Within, a library 1,500 books strong features literature on the history of the arts of Africa. Curated by Lee and Whitney Kaplan, owners of the California-based Arcana: Books on the Arts, the body of writings echoes the sentiments of a brand universe deeply rooted in educating on and celebrating the cultural contexts that inform it; as I have said, "You don't get Denim Tears without the knowledge in the books."

CHAMPION

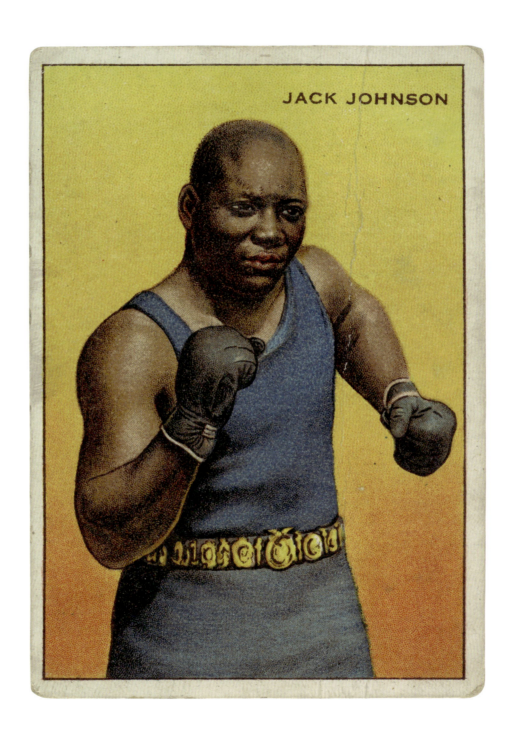

Honest Long Cut Tobacco. Miners Extra Tobacco. *Jack Johnson*, from *Series of Champions (T227)*, 1912

188

Boxer Jack Johnson of Galveston, Texas, 1908

Jack Johnson Driving an Automobile, Chicago, IL (detail), 1910

FASHION AS A VEHICLE FOR SELF-EXPRESSION

LEWIS HAMILTON

Since I was young, I was forced to conform—from my daily routine down to what I wore. My routine was rigid. And because I was the only Black kid on the racing track, there was no one like me to look up to.

It wasn't until later in my career that I found the courage to push beyond the boundaries I had been confined to for so long and to transcend the preconceived notions that attempted to limit whether, or how, I could navigate spaces where I, like many Black people before me, had historically felt marginalized. I started to express myself more creatively, especially through fashion. Finding my identity through how I dressed was a huge positive change in my life.

Monica L. Miller's book *Slaves to Fashion: Black Dandyism and the Styling of Black Diasporic Identity* emphasizes how Black people have historically used clothing as a form of protection and self-expression—as a way not just to make a statement but to show resilience, to shield ourselves from hostility and carry ourselves with pride. Dressing and expressing who we are allows for another part of each of our identities to come through.

The connection between fashion and self-presentation for our culture runs deep. It challenges perceptions of who people think we are and empowers us to stand out and feel confident, particularly in the face of adversity. It allows us to have ownership over our own identities—how we see ourselves and how we see each other—and to combat preconceived notions with humanity and dignity through what we wear.

I know the power of representation and how fashion can be a vehicle to help push diversity forward and celebrate our differences. I've always been passionate about uplifting Black creatives and amplifying our underrepresented voices. With *Superfine*, I'm excited to celebrate Black history and show that inclusion and creativity go hand in hand.

James Van Der Zee. *Untitled [Boxer]*, 1924

Saul Nash. *Ensemble*, autumn/winter 2023–24

CHAMPION

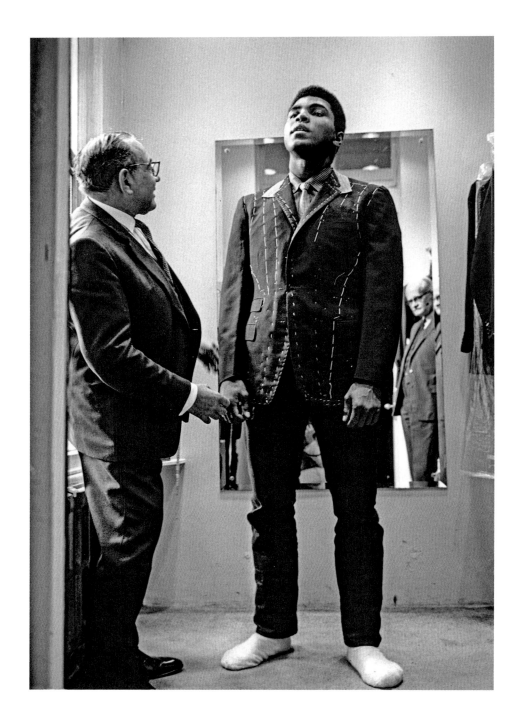

Thomas Hoepker. *World heavyweight champion Muhammad Ali is fitted for a new suit, London*, 1966

Everlast. *Shorts worn by Muhammad Ali*, 1972

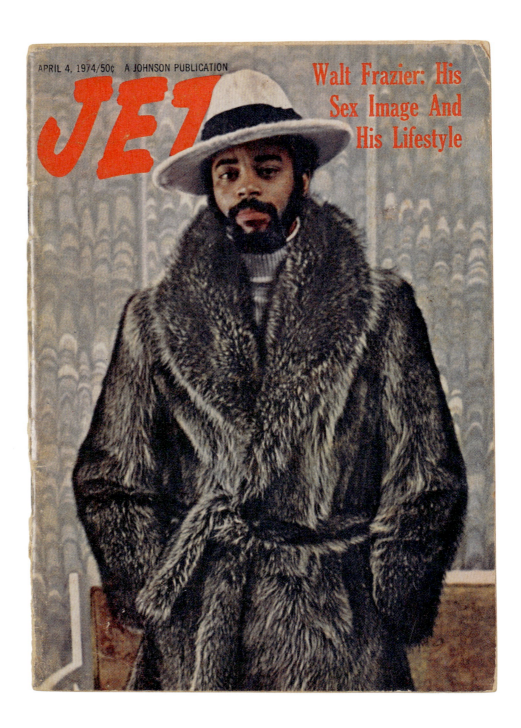

Cover of *Jet*, April 4, 1974

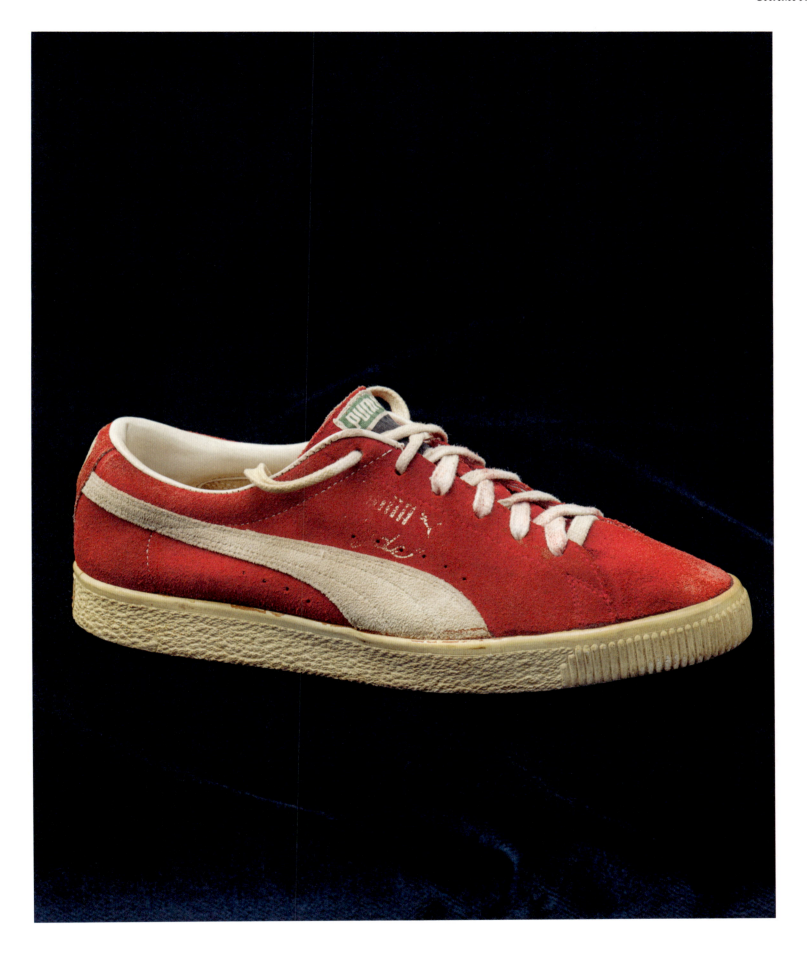

PUMA. *Clyde's*, 1970s

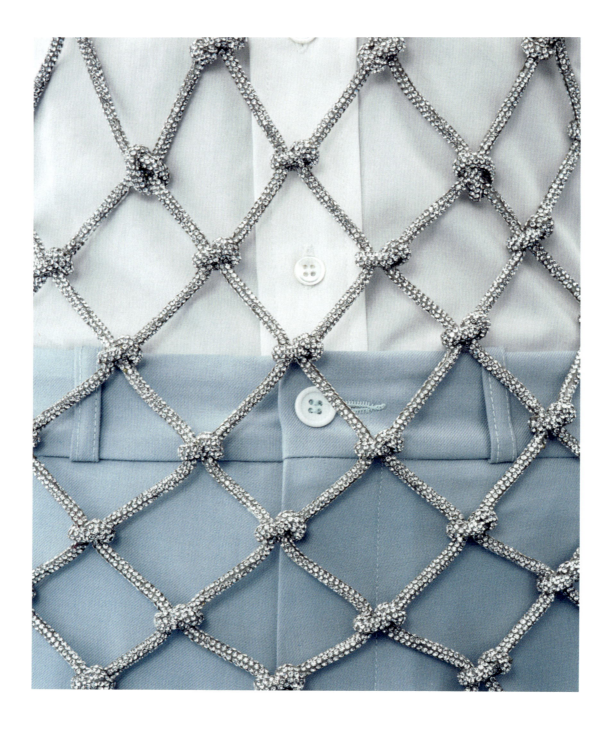

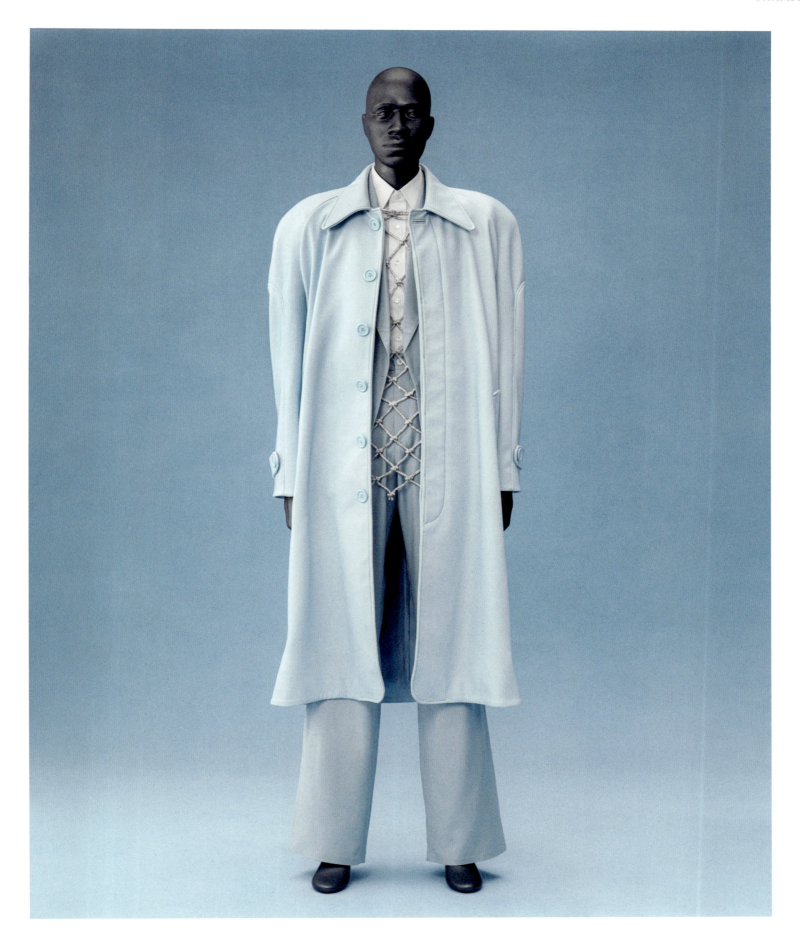

3.PARADIS. Emeric Tchatchoua. *Ensemble*, spring/summer 2024

Respectability

———— ❧ ————

"True enough, we think a man is wanting in the upper story,
who invites attention to his fine clothes; but a man is wanting, both in
the upper and lower story, when he pays no attention to his dress.
The times are hard—yes, the times are hard, very hard with us;
money is scarce, and the demands upon us are unusually pressing;
but the respectability and dignity of colored Americans must be upheld."

FREDERICK DOUGLASS
"There Is Something in Dress," *Frederick Douglass' Paper*, May 25, 1855

Activism and propriety went hand in hand for abolitionists and early "race men" like Benjamin Banneker, Frederick Douglass, and W. E. B. Du Bois, exceptional men who, in one way or another, took on the responsibilities of representing their race. Political and cultural leaders have long understood dress and grooming as tools of power and distinction. "Respectability" examines the sartorial styling of these men who dressed in bespoke, tailored garments to assert that they should be "treated as they were dressed," as Du Bois writes in the novel *Dark Princess* (1928).

While the image of Benjamin Banneker on the cover of the 1794 edition of his almanac (p. 204) is likely idealized, it nevertheless reflects his confidence in his own talents and his desire to be treated with respect. A freeborn self-taught mathematician, surveyor, and astronomer, Banneker used his prodigious intellect to issue a highly esteemed almanac based on his astronomical calculations. Forced to defend his scholarship against suspicions that an individual of his race was not capable of such scientific accuracy and rigor, Banneker nevertheless published *Pennsylvania, Delaware, Maryland, and Virginia Almanac* from 1792 to 1797 in twenty-eight different editions. Ardent desegregationist and publisher of Frederick Douglass's newspaper the *North Star*, William Cooper Nell remembered Banneker's self-presentation in his *Coloured Patriots of the American Revolution* (1855), one of the first histories of Black people by a Black author, writing:

> When I was a boy, I became very much interested in [Banneker], as his manners were those of a perfect gentleman; kind, generous, hospitable, humane, dignified and pleasing, abounding in information on all the various subjects and information of the day, very modest and unassuming. . . . His head was covered with a thick suit of white hair, which gave him a very venerable and dignified appearance. His dress was uniformly of superfine drab broadcloth, made in the old style of a plain coat, with a straight collar and long waist-coat, and broad-brimmed hat.

Banneker was "smart" in more ways than one, as were many other accomplished Black men of his time, and he used his dress—the modest "drab" wool three-piece suit of the respectable Quaker—to amplify and reinforce the perception of his intellectual gifts.

Abolitionist, writer, and statesman Frederick Douglass—the most photographed man of the nineteenth century—also exuded dignity. His elegant self-presentation was as important as his righteous rhetoric; he combined forceful arguments for citizenship and civil rights with a confident, elegant appearance, grounded in sober black suits and a signature shock of curly hair, worn parted to one side in Romantic fashion when he was young and combed back into a regal mane as he aged. Like his fellow abolitionist Sojourner Truth, who famously sold images of herself to support her cause, Douglass used photography to broadcast his message insisting on equality and pride. In the epigraph that introduces "Respectability," Douglass applies the language of fashion to describe the importance of changing the typeface of his eponymous newspaper's title. By calling for a more refined font, he demonstrated his understanding of the power of image, style, and elegance as it pertained to all aspects of "representing" his race. His own sophisticated self-fashioning is evident in items from his wardrobe, such as a black jacket (p. 207) and a white shirt bearing his monogram (p. 206).

One of the best-dressed and most educated Black men in turn-of-the-century America, W. E. B. Du Bois wore bespoke suits to teach the world about Black pride and progress and to insist on civil and human rights. The first Black man to earn a PhD from Harvard University, Du Bois was a sociologist, historian, and Pan-Africanist who promoted Black respectability to the world not only through his own refined dress (p. 208) but also by carefully curating imagery of what he considered proper dress for upstanding Black men. He compiled hundreds of images for a display at the 1900 Paris Exposition, and his Exhibition of

Negroes included portrayals of clean-cut men in crisp suits and ties, portraits similar to the ones he used throughout the pages of *The Crisis*, the magazine Du Bois founded in 1910 as the official publication of the National Association for the Advancement of Colored People. A 1911 receipt from Du Bois's London tailor (p. 209) documents his attention to dressing like a refined gentleman, including his order for a tailed morning jacket and matching "fancy" worsted wool trousers. In his autobiography, he records celebrating being awarded a fellowship to Europe with the purchase of a "delectable" new, expensive shirt.

In the cases of Banneker, Douglass, and Du Bois, as well as the men featured in "Freedom" and the sportsmen spotlighted in "Champion," tailoring was key to their ability to communicate respectability. This was true for both wearers and makers. Wearing a bespoke suit served to mark a particular form of arrival; creating one had a similar connotation. Tailoring traditions were often passed down within families in the African diaspora. And since the late nineteenth century, students could also learn these techniques as part of their education at Historically Black Colleges and Universities (HBCUs), as seen in the 1899–1900 photograph of Hampton University students at work (p. 212), an image also shown at the 1900 Paris Exposition.

HBCUs have been essential to the creation of a progressive Black vanguard since emancipation; they are centers of Black life, culture, and fashion, as well as incubators of a specific collegiate style with its own codes of respectability. Although no longer a student—he had already graduated from New York University with a bachelor's degree in 1923 and from Columbia University with a master's degree in 1927—Harold Jackman became "a college lad" for artist Winold Reiss in his 1924 portrait (p. 216). Reportedly Harlem's handsomest man, Jackman is rendered wearing a classic three-piece gray suit with a patterned red tie and pocket square, elements of the urbane pupil's wardrobe at the time. Howard University and Morehouse College have particular reputations as bastions of scholarly excellence and Black style. Howard professor and artist Loïs Mailou Jones portrayed one of her students in the more casual garb of the postwar undergraduate—a leather jacket over a blue Oxford shirt, again with a red patterned tie—in her 1946 watercolor *A Student at Howard* (p. 220), an assemblage echoed by Skepta in his spring/summer 2025 collection for Mains (p. 221). *Life* magazine highlighted Howard's campus style (p. 218) when they featured its students in a photo essay in the November 18, 1946, issue, saying, "It takes the Howard freshman practically no time to acquire the universal collegiate look. And although Howard students are as clothes-conscious as every other U.S. undergraduate, they generally dress better. This is because Howard's energetic physical education department encourages the students to read fashion magazines, and constantly reminds them of their posture, hair, and general appearance. It is also because Howard undergraduates have less money to spend and therefore invest it more wisely." As an homage and extension of this history, creative director for Ralph Lauren's Polo brand James Jeter, a proud Morehouse College graduate, conceived a capsule collection for the label between 2019 and 2022 (p. 219) inspired by the collegiate suits and sportswear worn at Morehouse from the 1920s through the 1950s.

For iconic fashion editor, stylist, and writer André Leon Talley, the cut of a suit was part of its symbolic power; he knew that he could infiltrate and change exclusive spaces when well clad in a bespoke ensemble. In his memoir *The Chiffon Trenches*, Talley explains that the cut of the suits by Madison Avenue tailor Morty Sills was modeled on those worn in the 1940s by Jack Bouvier, father of Jacqueline Kennedy and Lee Radziwill. "Respectability" features one of Talley's favorite suits by Sills (p. 214)—an example for Talley and others of his ascension to the halls of success—and finishes with a classic 1980s suit and overcoat by designer Jeffrey Banks (p. 215). Banks founded his namesake brand after designing for Ralph Lauren and Calvin Klein and describes his design practice as "masculine, classic, but classic with a twist—either through color, fabrication, or both." The quintessential, well-made suit silhouette endures as a form of pride, protection, and camouflage for Black men.

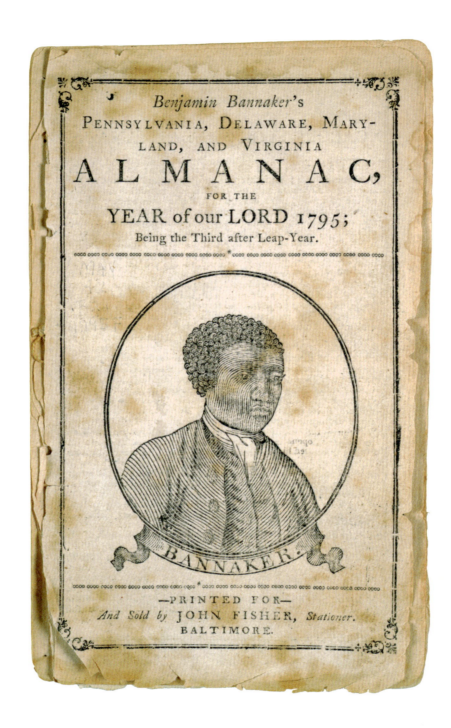

Front cover of *Pennsylvania, Delaware, Maryland, and Virginia almanac, for the year of our Lord 1795* by Benjamin Banneker, 1794

RESPECTABILITY

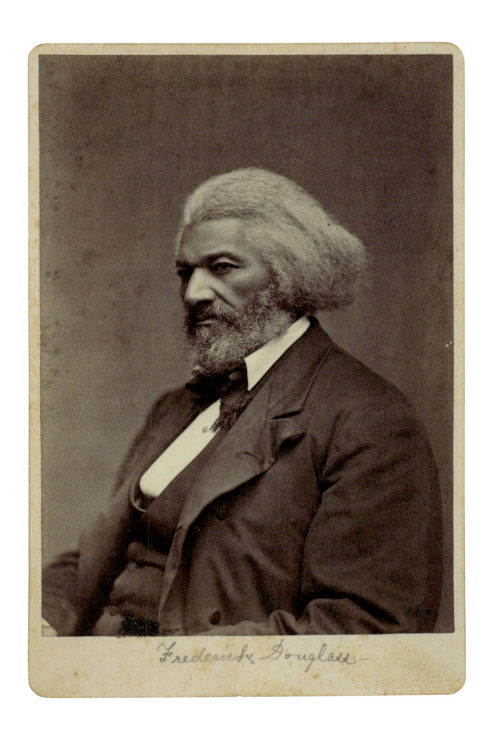

George Kendall Warren. *Frederick Douglass*, 1876

205

Philip T. Hall. *Shirt worn by Frederick Douglass*, late 19th century

RESPECTABILITY

Tailcoat worn by Frederick Douglass. American (late 19th century)

207

W. E. B. Du Bois at Paris International Exposition, 1900

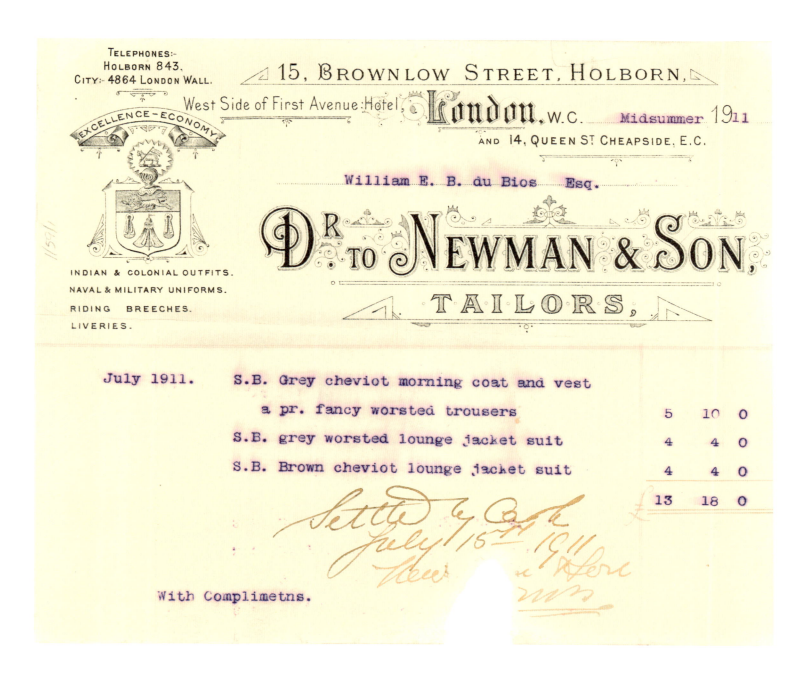

W. E. B. Du Bois' receipt from Newman and Son Tailors, July 1911

[*Young African American man, head-and-shoulders portrait, facing slightly right*].
Probably American (1899–1900)

FROM THE TALENTED TENTH TO THE PARIS EXPOSITION:
W. E. B. DU BOIS AND SARTORIAL ACTIVISM

DENISE MURRELL

W. E. B. Du Bois is venerated for his articulation in *The Souls of Black Folk* of a double consciousness within the Black American psyche, "this sense of always looking at one's self through the eyes of others" when confronted with fellow Americans' overtly racialized gaze, shaped by prevailing stereotypes. At the turn of the twentieth century, "race men" like Du Bois gave meticulous attention to a mode of sartorial self-styling intended to convey dignity and aesthetic refinement. The trend was rooted in a precarious confidence that the wearer would be "treated as he was dressed"—as the protagonist in Du Bois's novel *Dark Princess* remarks—therefore gaining a societal acceptance that transcended race and advanced the cause of racial uplift. As Du Bois broadened his activist interests to align the Black American civil rights movement with the international African diaspora's anticolonial revolution, the aesthetics of his attire evolved to reflect a transatlantic worldview shaped by his trajectory from college student to international activist-intellectual.

In 1890 Du Bois graduated from Harvard University with a degree in sociology, adding a second degree to one awarded in 1888 from Fisk University, a premier Historically Black College and University (HBCU). During his years at Fisk in Nashville, Tennessee, the Massachusetts-born Du Bois experienced his first encounter with the harsh racism of Jim Crow segregation. At that time, he began to theorize his role as a member of an emergent "college-bred" Black elite characterized as the talented tenth, to use a term coined by Henry Lyman Morehouse, namesake of the HBCU Morehouse College, and popularized by Du Bois. In *The Philadelphia Negro*, Du Bois describes this newly minted activist-intellectual as one "who is, or ought to be, the group leader, the man who sets the ideals of the community where he lives, directs its thoughts, and heads its social movements."

Like his HBCU-educated peers, Du Bois embedded the idealistic values of his student years in his choice of attire, as seen in numerous portraits by unnamed photographers. The young sitters invariably wore suits that conveyed an understated dignity; a dark jacket buttoned up to a pristine white collar manifested the conventional propriety of selfless community leadership. But Du Bois often projected a debonair individuality with small details—a precisely folded pocket handkerchief and slicked-back curly hair with a rakish off-center part—indicative of his close attention to self-presentation. These features, in combination with a contemplative pose, amount to a nuanced portrayal of a charismatic, erudite young thought leader poised at the forefront of an emerging racial uplift movement.

Du Bois noted that more than half of the talented-tenth elites were educators, and by the year 1900, he was settled into a position as a professor of sociology at Atlanta University, another prominent HBCU. During the intervening decade, after years of research that included a fellowship at Friedrich Wilhelm University (now Humboldt University of Berlin), he had become the first Black American to receive a PhD from Harvard. During his international travels, he gained awareness of a European version of racism forged by oppressive colonial rule, and he formed close associations with Black European artists and writers who sought an end to empire. These experiences led to his July 1900 participation in the First Pan-African Conference in London.

Just a few months later, Du Bois presented the extensive Exhibition of American Negroes at the 1900 Paris Exposition. As Jacqueline Francis and Stephen G. Hall note in their introduction to *Black Lives 1900: W. E. B. Du Bois at the Paris Exposition*, this pathbreaking profile of Black American life was remarkable for the finely honed aesthetic display of scientific data, juxtaposing colorful infographics that charted statistics covering many facets of economic, demographic, and social conditions with bound volumes presenting hundreds of black-and-white photographs depicting "Negro Types" from all walks of life. Photographs of Du Bois during the exposition reveal a sartorial portrayal of his transformation from emergent student-activist immersed in the early years of the American civil rights movement to eminent transatlantic activist-intellectual. If his earlier styling choices were typical of his cohort of students on the brink of activism, the Paris portrait (p. 208) conveys the cosmopolitan aspect of his international stature. Images from the Paris exposition shown in Francis and Hall suggest that his jacket and vest situate his attire within the realm of the three-piece suits favored by many of the HBCU students featured in the exposition albums.

But the light-colored pants, and especially the tall black silk top hat, place Du Bois in the sartorial domain of the formal day or evening attire of the European upper classes, as depicted in contemporaneous works of literature and political critique as well as the paintings and photographs of Edgar Degas, Henri de Toulouse-Lautrec, and their Impressionist peers. In contrast, the Library of Congress collection of exposition photographs that capture Du Bois's Black American cohort indicates their choice of headwear by the prevalence of bowler or derby hats and fedoras.

Du Bois drew this blend of elite male sartorial self-styling from the conventions of his long-standing talented-tenth cohort as well as those of his more recent Black and white European allies, thus reconciling the dual American and international aspects of his activist-intellectual persona.

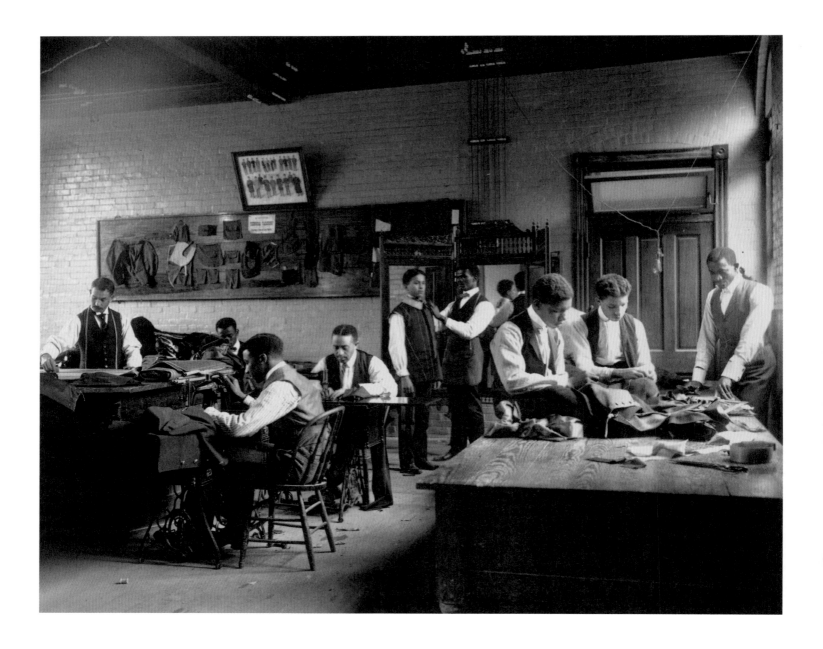

Frances Benjamin Johnston. *Tailor boys at work*, 1899-1900

RESPECTABILITY

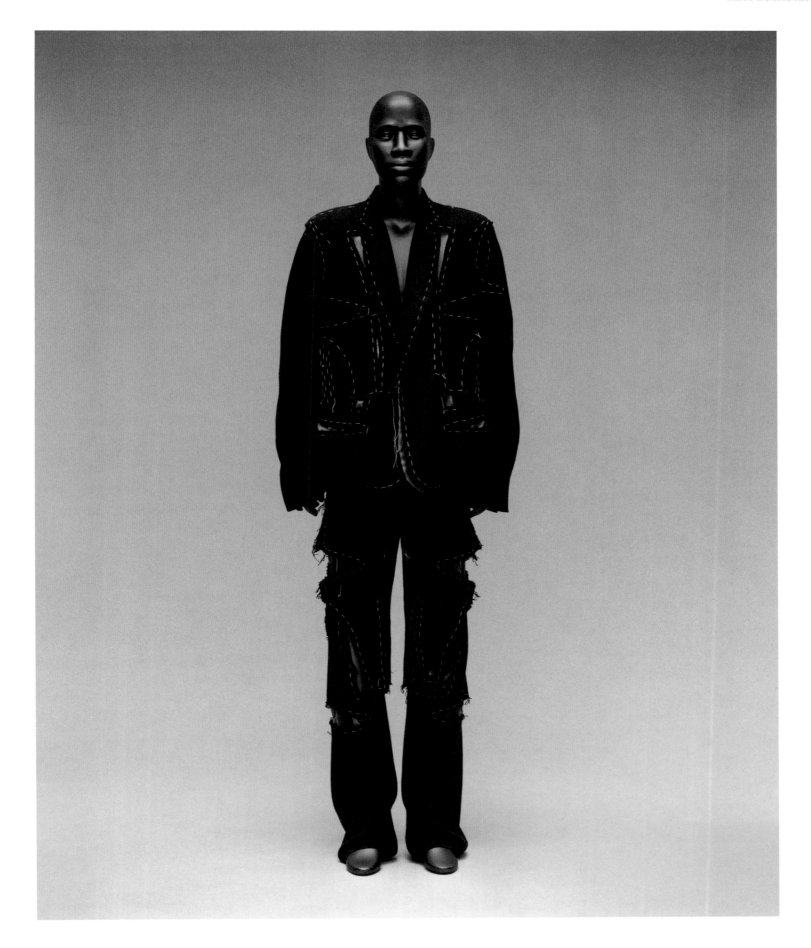

Who Decides War. Ev Bravado and Téla D'Amore. *Suit*, spring/summer 2024

RESPECTABILITY

Morty Sills. *Suit*, 1986

Jeffrey Banks. *Ensemble*, ca. 1980

RESPECTABILITY

216 Winold Reiss. *A College Lad*, 1924

FINDING MY FASHION SENSE IN HARLEM HISTORY

MICHAEL HENRY ADAMS

Because I'm an architectural and social historian and love the aesthetic of an earlier time, I've been criticized as being reactionary and wanting to turn back the clock to, so to speak, make fashion great again. No way. My mission is to live today in the best way possible, always seeking equality and ever greater perfection. But with attire, as with anything else, Malcolm X said it best in his 1963 speech "Message to the Grassroots": "Of all our studies, history is best qualified to reward our research."

Due to privations and dehumanizing mischaracterization, the art of dress has always interested most Black people. In his *Music on My Mind: The Memoirs of an American Pianist*, Willie "the Lion" Smith discusses how for some it was a preoccupation. He offers fascinating observations about the lengths taken and expense incurred by Black theatrical artists—for example, the vaudeville troupe Williams and Walker and their wives— to secure the finest and most original wardrobes obtainable. For esteemed jazz musicians such as Duke Ellington or Luckey Roberts, ordering suits with matching spats and contrasting linings could be even more exacting.

Even in the uppermost echelons of Black society, economic parity with white societies was nonexistent, so Black communities relied on every expedient available to "look good." So long as the garments were immaculate, many saw no shame in wearing secondhand clothes. Early in her career, the singer Marian Anderson, who was a seamstress herself, made many of her own gowns. She wasn't alone. Not disclosing the identity of your talented tailor or dressmaker—who could be your mother—was common.

Black appreciation of inventiveness as well as respect for high-quality clothes and accessories were often savagely lampooned in mass media, where the press also encouraged such ridicule by others. Very often, though, Black people had the last laugh: When white dancers Vernon and Irene Castle appropriated the ragtime craze popularized in the United States by the Black performers George and Aida Overton Walker, the white couple disseminated Black culture around the world, assured of their exploitation's benevolence to advance the race—a practice not unfamiliar today.

In ol' New York, as nowhere else, those we admire most can sometimes be befriended. So by example and with encouragement, a rich diversity of role models, including the performers Eartha Kitt and Bobby Short and the historian David Levering Lewis, have contributed to my personal style.

The evolution of this collaborative process started long ago. After much pleading, I was just eleven when my great-grandmother gave me her brother Frank's gold watch. At thirteen, thanks to the superb Akron, Ohio, public library, I discovered photographer James Van Der Zee. Not as art but as a record, his work is among the marvelous illustrations in the catalogue for The Metropolitan Museum of Art's *Harlem on My Mind* exhibition. It changed my life. I'd reached a critical impasse because of the way the Black Consciousness movement was impacting fashion. I might be proud, and Black might be beautiful, but I didn't care to dress like Shaft or to emulate *Super Fly*—to look just like everyone else. These striking Harlem images date from the 1920s through the 1960s. Whether set in houses, churches, and clubs or on broad boulevards, they showed me something important, something profound. They helped me realize that I didn't have to dress like everyone else.

As stylish and dapper as anyone ever was, in any time, anywhere, beautifully attired, elegant and poised, these men were, as was said, "as fine as they want to be." Beyond question, they were authentically Black. By the time I was in college—just about the time I finally came out—I learned that many of the most notable and talented among them were gay, too, just like me. Traveling back in time, I found myself. I wanted to dress like philosophy professor Alain LeRoy Locke and like Harold Jackman (opposite), the handsomest man in Jazz Age Harlem. Those with lots to teach about sartorial splendor included sophisticated singer Jimmie Daniels, who briefly dated prominent architect Philip Johnson; Eddie Manchester, who worked as a Fifth Avenue tailor and a "high-class" pimp on the side; acclaimed sculptor Richmond Barthé; advocate Bayard Rustin; journalist Edward Perry; and activist Huey P. Newton.

I wanted to be inspired by Langston Hughes, our acclaimed writer and poet, not as he looked when he was embarrassed as an usher in the poet and novelist Countee Cullen's wedding because his rented morning dress was noticeably fading, but as self-possessed and smart, as he appears in Winold Reiss's 1925 pastel *Langston Hughes*. I aspired to the standard of photographer Marvin P. Smith; he looked as sharp as a tack, every day, be it wearing a striped sailor's shirt from Marseilles or a white tie.

Letters, diaries, paintings, and photographs show that all of these men were concerned and careful about both the way they comported themselves and the way they dressed. It was a point of pride that defied stereotypes and influenced trends. Like me, they never wanted to be perceived as just like everyone else. Expressing individual tastes, they wanted to "represent," to look and to be the best that they could.

I want that too.

RESPECTABILITY

Alfred Eisenstaedt. *Howard University students*, 1946

RESPECTABILITY

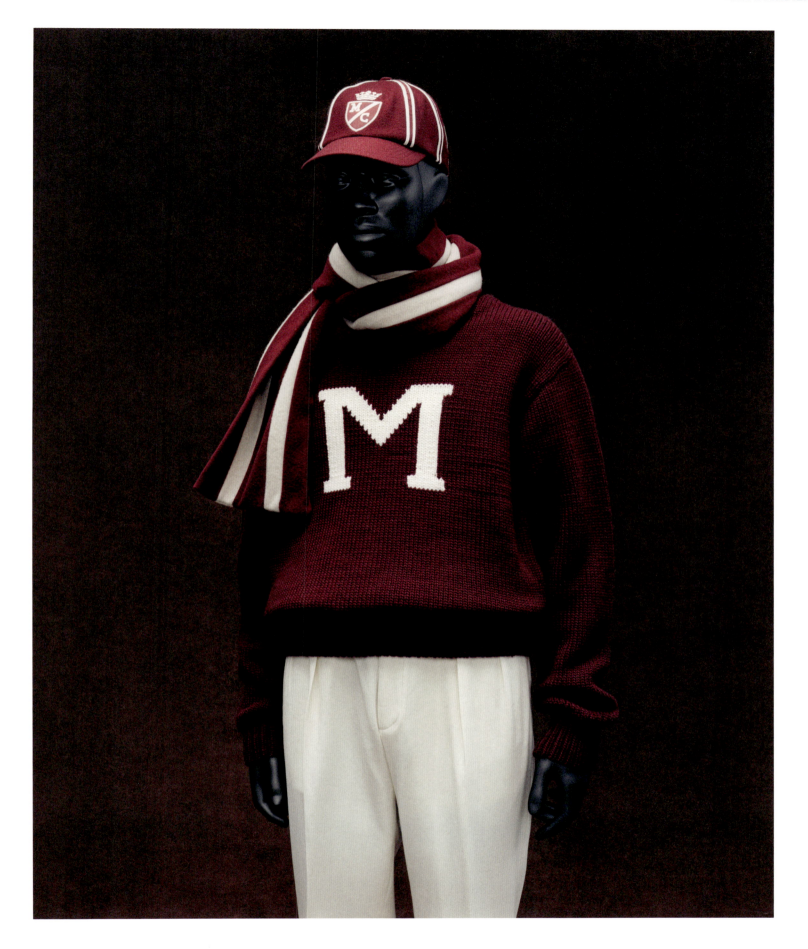

Polo by Ralph Lauren. Ralph Lauren Purple Label. *"Morehouse College" ensemble*, 2019–22

RESPECTABILITY

220 Loïs Mailou Jones. *A Student at Howard*, 1946

RESPECTABILITY

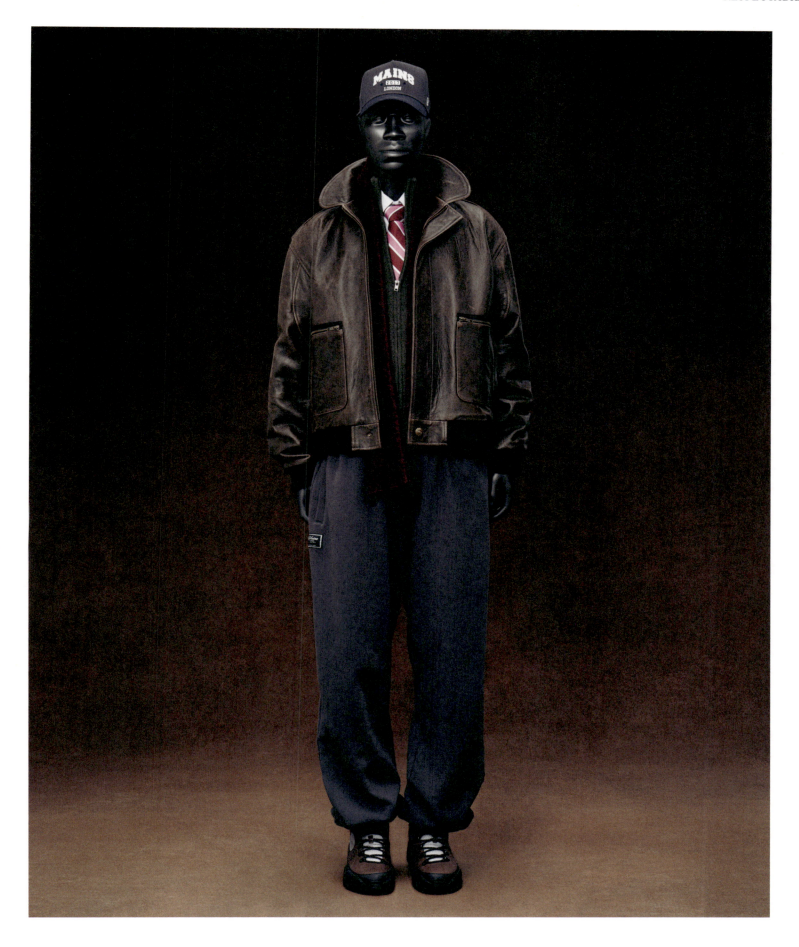

Mains. Skepta. *Ensemble*, spring/summer 2025

221

Jook

"All night now the jooks clanged and clamored.
Pianos living three lifetimes in one. Blues made and used right on the spot.
Dancing, fighting, singing, crying, laughing, winning and
losing love every hour. Work all day for money, fight all night for love."

ZORA NEALE HURSTON
Their Eyes Were Watching God, 1937

In her 1934 essay "The Characteristics of Negro Expression," Zora Neale Hurston describes "the jook"—a "Negro pleasure house" full of communal music, dance, and joy—as an integral facet of Black American expressive culture. Jook (or juke) joints, speakeasies, and cabarets were places where exuberance was artistically conveyed and embodied. Patrons and entertainers dressed in refined and racy ways; they were "lookin' good" for themselves and each other. In these spaces, avant-garde fashion often aligned with a desire to push boundaries of race, gender, class, and sexuality by dressing in fine, flashy clothing. "Jook" encapsulates the word's status as both a noun and verb, investigating its evocative power as a conceptual mode of uninhibited joy. It features the zoot suit and the tuxedo, investigating their sometimes subversive relationship to vivacity and refinement, respectively.

Throughout the 1920s, Mexican artist Miguel Covarrubias documented and celebrated emerging figures who defined the Harlem Renaissance. Working primarily for *Vanity Fair* magazine, he portrayed entertainers, dancers, nightlife denizens, and stylish men and women. In the drawing *Harlem Dandy* (p. 226), Covarrubias emphasized the angularity and exaggerated proportions of the titular subject's suit, cut in the latest style—with broad shoulders, oversize peaked lapels, and contrasting collar—paired with a jauntily cocked fedora, obscuring one eye while highlighting the sideways glance of the other. Unlike in his other caricatures from the same period, here the artist included several background elements that add texture and contrast, situating the dandy within the graphic architectural milieu of 135th Street in central Harlem, near so-called Strivers' Row, home to many successful Black professionals. For Covarrubias, style, attitude, and self-assurance seem to define the Harlem dandy as a "type."

Signifying on their minstrel-stage counterparts, Harlem dandies ruled the streets of uptown New York; 125th Street and Lenox Avenue were new runways for people to strut and saunter as they populated the city in the wake of the Great Migration, which saw rural Black Southerners move to the urban centers of the North and West. The Harlem Renaissance witnessed an explosion in nightlife and entertainment venues, among them the Savoy Ballroom, which opened in 1926. Home to the Lindy Hop and other energetic social dances, the Savoy's dance floor was also a site of sartorial innovation, where clothing developed to respond to the requirements of increasingly athletic moves. The "drape" suit of the 1930s, with wide shoulders and voluminously cut trousers to facilitate dancing, gave way around 1940 to the even more exaggerated zoot suit, with its dramatically long jacket, nipped waist, and ballooning trousers, pegged at the cuff (pp. 229, 230, 231).

Zoot suits required a surplus of fabric to create the sharp-shouldered, oversize shape that amplified the wearer's silhouette and gleefully emphasized a turn on the dance floor. Worn by "hepcats" like the young Malcolm X (then Malcolm Little) and jazz musician Cab Calloway, the zoot suit was a symbol of transgression, joy, and youth, particularly for marginalized ethnic groups; although pioneered by Black men, zoot suits were enthusiastically adopted by men of diverse racial and cultural backgrounds, including Italian, Filipino, Mexican, and Japanese Americans, as well as women. Malcolm X recalls the purchase of his first zoot suit in his autobiography:

> I was measured, and the young salesman picked off a rack a zoot suit that was just wild: sky-blue pants thirty inches in the knee and angle-narrowed down to twelve inches at the bottom, and a long coat that pinched my waist and flared out below my knees.
>
> As a gift, the salesman said, the store would give me a narrow leather belt with my initial *L* on it. Then he said I ought to also buy a hat, and I did—blue, with a feather in the four-inch brim. Then the store gave me another present: a long, thick-linked, gold-plated chain that swung down lower than my coat hem. I was sold forever on credit.

In the run-up to World War II, the zoot suit's excess fabric was expensive and considered wasteful. As such, the suits defied mainstream social mores and were the subject of highly publicized riots in Los Angeles in 1943, when young Mexican American youth clashed with U.S. service members critical of their attire. Flamboyant in both materials and presentation, zoot suits challenged perceptions of masculinity and sexuality, infringing upon what was considered acceptable as an expression of modern, youthful, urban identity,

particularly for marginalized ethnic groups. Contemporary Latine designers such as Willy Chavarria (p. 234) and Raul Lopez for Luar (p. 235) take up the history of the zoot suit and its excessive proportions, designing ensembles that recontextualize the look for the twenty-first century. In a personal essay published June 20, 2023, as part of the *New York Times* Big Ideas series, Chavarria explains the significance of the zoot suit and its history on his work, specifically his use of proportion: "[The suit's] incredible aesthetic moved me deeply, not only because of its ability to take up space through silhouette and style, but also because of its capacity to make powerful political statements primarily through visual means. Zoot suits somehow managed to articulate who their wearers were or had the potential to be, albeit in contradictory ways for the diverse bodies wearing them and the general public." Lopez's and Chavarria's zoot suit–like silhouettes emphasize the garment's intersectionality: its ability to cross racial and ethnic boundaries by forming radical subcultures united by fashion across time and space.

These subcultures generated both sartorial and linguistic innovations, both of which were deeply intertwined; accompanying youthful fashion and the growth of jazz was a new vocabulary of hipness and coolness—a jook-related slang. Musician and writer Dan Burley covered Harlem culture for the *New York Amsterdam News* in the 1930s and 1940s and became known especially for his Back Door Stuff column, which he sometimes composed entirely in jive, Harlem's heavily encoded street slang. In 1944 he published *Dan Burley's Original Handbook of Harlem Jive* (p. 232), a study of "what's being put down," as he called it, that was translated into many languages and saw multiple editions, as readers were eager to learn the latest lingo. In it he explains the origins and use of jive, characterizing it as "language made vivid, vital, and dynamic," complementing his discussion with essays, parodies of Shakespeare, and anecdotes in its distinctively energetic lexicon.

Jive was a language for those in the know, ensuring that only members of a community of like-minded individuals would understand its meaning—especially important during the age of Prohibition and speakeasies, when illegal activity took on a veneer of elegance. Likely modeled on infamous Harlem numbers runner Casper Holstein, Covarrubias's *The Bolito King* (p. 236) associates Holstein with the lottery game played with a small ball (*bollito*), not only emphasizing gambling's value to the communal spirit of the jook but also suggesting that attaining an elegant life in Harlem was akin to playing a game of chance. Joe Casely-Hayford's ca. 1989 silk shirt embroidered with playing cards (p. 237) exploits the ace of spades as an aesthetic device as well as a symbol of sport and victory: One might say that the cards speak to the combination of luck and skill that afforded Casely-Hayford a career as one of the first prominent Black British menswear designers.

Like the zoot suit, the tuxedo is provocative and multifaceted: Worn by service workers and the well-heeled at formal functions and by entertainers and musicians onstage, it can act as both a uniform and a garment that distinguishes its wearer as special. In his seminal 1989 film *Looking for Langston*, Isaac Julien fantasized about the sexual politics of the Harlem Renaissance, staging pivotal scenes of queer sociality in an underground speakeasy full of tuxedo-clad men and women who dance and sway (p. 238). Their tuxedos enable them to pass each other anonymously while still feeling a sense of connection and belonging, critical for an individual's ability to survive and thrive. When worn by provocative women like the lesbian blues singer Gladys Bentley (p. 240), famous for her bawdy same-sex-loving lyrics and white top hat and tails, or performer Joséphine Baker (p. 242), who embraced menswear as part of her play with sexuality and gender on- and offstage, the tuxedo can be a savvy vehicle for communicating a sharp-edged androgyny and unapologetic sex appeal. Once concentrating on womenswear, Brandon Murphy for Brandon Murphy Collection now designs primarily menswear. His double-breasted white tuxedo (p. 241), with an elegant shine reminiscent of Bentley's, is part of his effort to inspire people to "dress however you want and become anyone you want." Inspired by the Hollywood glamour of the film industry's early years, an interpretation of the tuxedo by Maximilian Davis for Ferragamo (p. 239) combines a sharply tailored silhouette in black wool with a top of soft white transparent fabric. A panel of the fabric drapes over the shoulder from an opening at the wearer's chest. The ensemble thus merges elements of masculine and feminine dress to convey elegance as well as transgression.

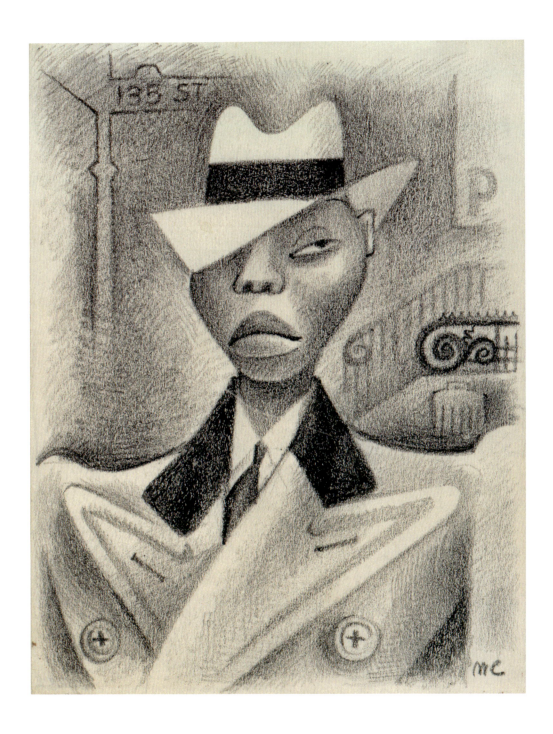

Miguel Covarrubias. *Harlem Dandy* [*African American man (head & shoulders) wearing a hat with tilted brim*], ca. 1930

ON THE ZOOT SUIT

DANDY WELLINGTON

Rebels, thugs, hoodlums—all of these were used to describe those who wore the zoot suit. Indeed, modern historians and writers have since used such language to reference the distinct dressers who wore the style during the late 1930s and early 1940s. But are these descriptions accurate? Were those who donned these garments rebels?

The exact origin of the zoot suit is unclear, though it may have been created by comedians like Dewey "Pigmeat" Markham and Lincoln Perry (known as Stepin Fetchit) who frequented the Chitlin' Circuit, a network of live performance venues for Black performers dating back to the 1930s. Regardless of its origin, the zoot suit would come to represent a new youth subculture driven by Black people in the Northeast and made infamous by Mexican Americans in the West. And despite how it was perceived by the greater (largely white) society, at the heart of this unique style phenomenon was jazz.

By the late 1930s, the musical genre of jazz was being dominated by a new "swing" sound. Bolstered by national radio broadcasts like NBC's *Let's Dance,* which debuted with Benny Goodman's orchestra, the swing era was born and the sound of big bands ruled the airwaves, drawing young people to the music. In Harlem nonsegregated venues like the Savoy Ballroom and Small's Paradise were temples of swing, attracting patrons from across New York City to see some of the hottest big bands in the country. Erskine Hawkins, Chick Webb, Teddy Hill, Count Basie, Cab Calloway, and others filled dance floors with well-dressed youth who brought the music to life in fits of pure joy. At the Savoy Ballroom, innovative dancers like Frankie Manning and Pepsi Bethel—who wore loose-fitting suits when dancing with fellow Lindy Hoppers Frieda Washington and Norma Miller—would swing out and somersault to the music in their stylish clothes. Having invented many of the swing dance movements and "air steps" connected to this new rhythm, they'd Lindy Hop and Eagle Rock, Shim Sham and Shortie George in ballrooms and at breakfast dances all over Harlem. As the music's popularity continued to grow beyond Harlem, so too did the slang and style of its most prominent Black musicians.

In 1938 Calloway released *Cab Calloway's Cat-ologue: A "Hepster's" Dictionary,* the first dictionary published by an African American, in which he codified jive, the slang of the day. He mentioned the zoot suit within those pages, describing it as "overexaggerated clothes." In the 1942 song "A Zoot Suit (For My Sunday Gal)," the garment is described as having "a reet pleat / And a drape shape, and a stuff cuff." This lyrical description aside, thanks to Calloway's colorful zoot-suited appearance in the 1943 film *Stormy Weather,* the style's popularity grew among many jazz fans and would become the style of dress he was most known for. The suit consisted of an over-draped, wide-shouldered, peak- or notch-lapel jacket worn with matching high-waisted, wide-legged trousers featuring a tapered cuff at the ankle. The ensemble often included a dress shirt, neckwear (a bow tie or a long tie), a pair of dress shoes, and a wide-brimmed fedora. Elements of this bold style became a mainstay among some Black jazz musicians like Lester Young, and it gained popularity with fans as the musicians toured the country. Soon the zoot suit wasn't just being worn by young Black New Yorkers but integrated into the personal style of Mexican, Japanese, and Filipino Americans as well as some Italian and Jewish American youth.

Personal style can be a courageous expression of self—an ambitious quest to articulate one's individuality through clothing. At times it can intersect with community, but at its core, it remains singular in its practice. Zoot-suiters embraced this new form of sartorialism in response to the happiness, culture, and fellowship associated with jazz. It was not adopted in opposition to but in celebration of this new swing rhythm and the musicians who created it.

Yet as the United States entered World War II, print media across the country launched a likely uncoordinated but consistent campaign objecting to zoot-suiters. First written about as a fad, the zoot suit now regularly featured in negative stories in such newspapers as the *New Orleans Item-Tribune, New York Post,* and *Dallas Morning News,* the articles often including the zoot-suiters' race or the word *gang.* Racialized stories and political cartoons about the garment and its wearers increased in the wake of the 1942 Office of Price Administration's rules on wartime rationing of wool and other textiles, sparking further opposition within white society to the seemingly rebellious and unpatriotic zoot-suiters. For non-white youth, it was personal style. But in a racist society, is an act of personal style rebellious? What does it mean when your effort to exist or to seek delight is seen as disobedience?

Mexican Americans, who were surely accustomed to racism following the Undesirable Aliens Act of 1929 and Mexican repatriation through the 1930s, were now on the receiving end of much of this racialized hostility. In response, they continued to wear the zoot suit not only as an expression of personal style that connected them to the jazz community but as a form of sartorial defiance. The resulting unrest, known as the Zoot Suit Riots—a series of Los Angeles–based conflicts between U.S. service members and Mexican American youth that began after a group of sailors claimed to have been attacked by Mexican American zoot-suiters—would forever label the garment as contrary and its wearers as hoodlums. Their potential place in history was obscured by a morass of sensational media, bigotry masquerading as patriotism, and a political system to provide it cover. This is not to say that before the subsequent riots that spread across the country there wasn't a spirit of rebellion behind the wearing of the zoot suit. But first and foremost, the zoot suit was an aesthetic celebration of style, community, and joy.

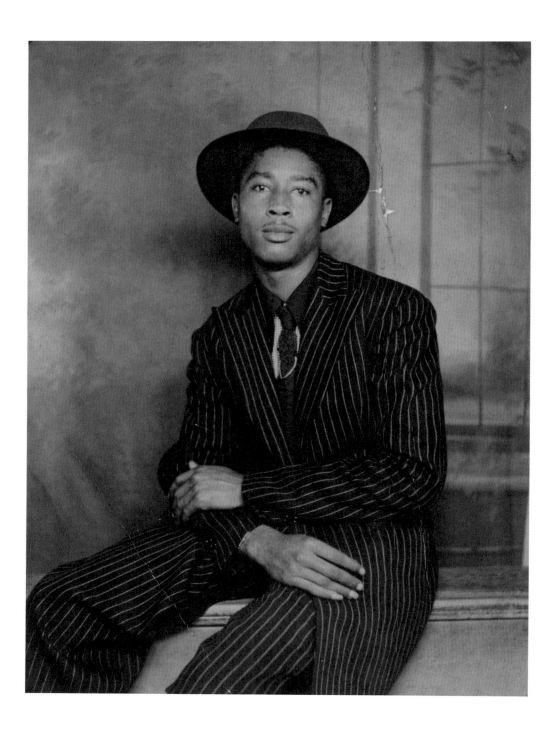

[*Studio portrait*]. American (1940s–50s)

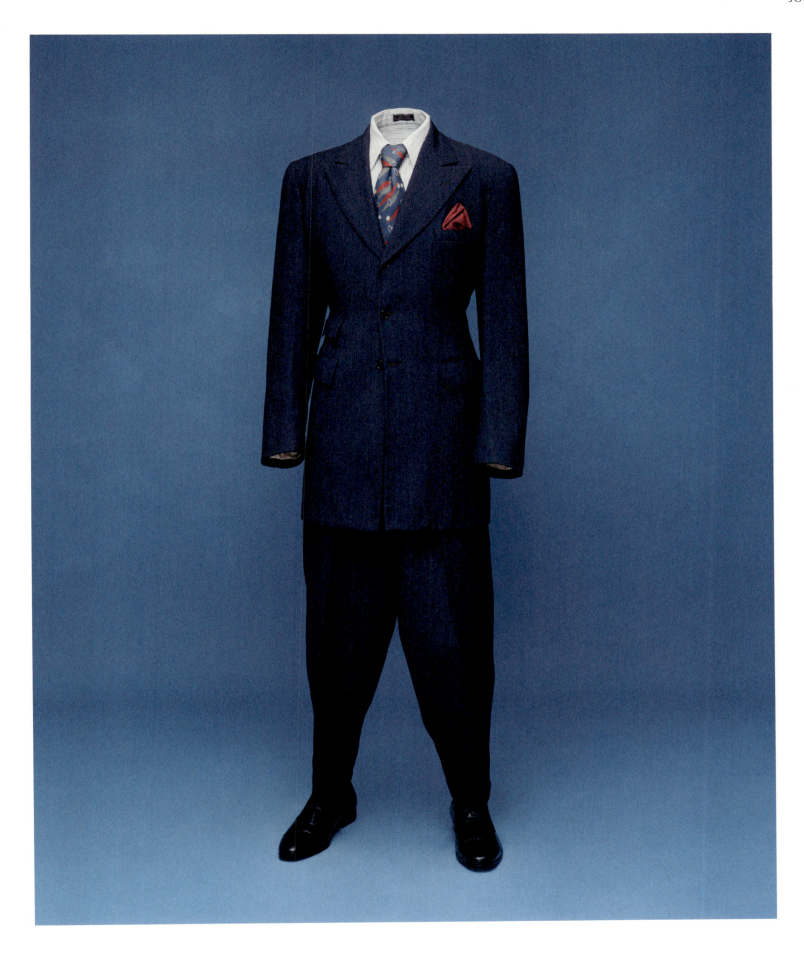

Zoot suit. American (1940s)

Charles Henry Alston. *Zoot Suit*, ca. 1940

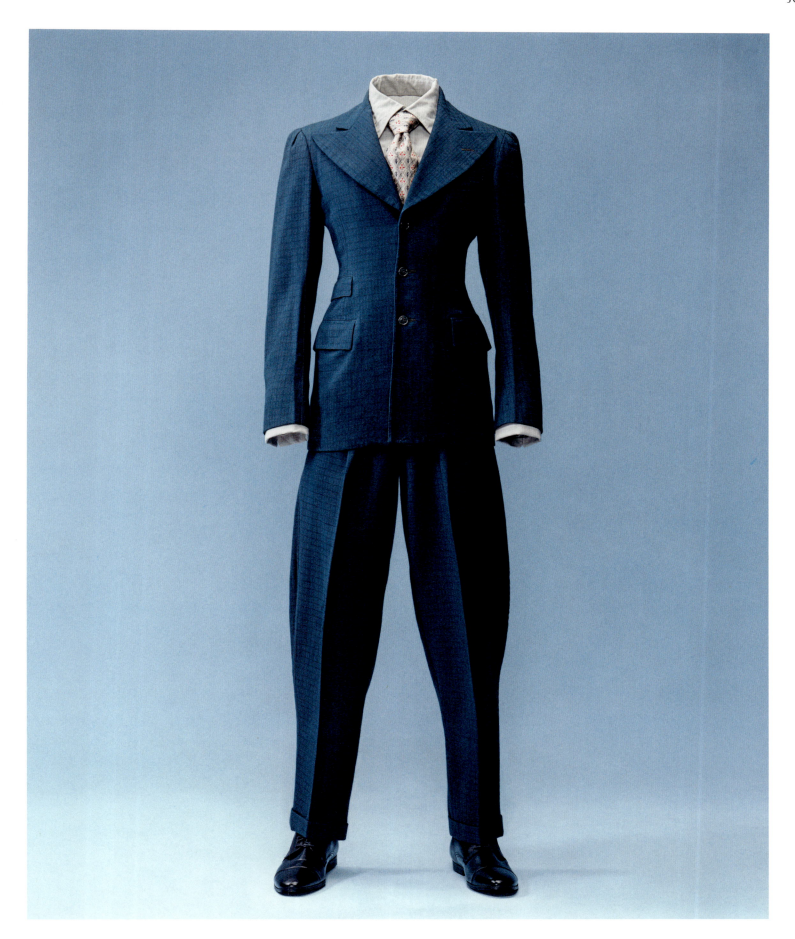

Progress Tailoring Co. *Zoot suit*, 1940–45

Melvin Tapley. Cover of *Dan Burley's Original Handbook of Harlem Jive* by Dan Burley, 1944

JIVE: VOCABULARY AS STYLE

BRENT HAYES EDWARDS

In Black culture, style has been measured as much by how you talk as by what you wear or how you move. By the mid-twentieth century, the rapidly shifting, hugely influential vernacular known as jive radiated through American culture as the defining index of cool. The explosion of the commercial recording industry in the 1920s made blues and jazz the first truly national popular musical forms, transforming stars like Bessie Smith, Louis Armstrong, Duke Ellington, and Ethel Waters into international celebrities. And crucially, the qualities associated with Black music—astonishing inventiveness, rhythmic drive, and unruffled aplomb—came to be defined by criteria that emerged from the culture itself. According to Black musicians, the greatest artists possessed not only technical virtuosity and interpretative sensitivity but also "swing," which historian Albert Murray described in a 1989 talk on Ellington as "equilibrium under the pressure of all tempos and unforeseeable but not unanticipated disjunctures."

Unpredictable and effervescent, the guild's idioms—used by musicians offstage and after hours to goad rivals as well as express mutual admiration—became emblems of style that could be adopted and paraded just like a porkpie hat or wingtip shoes. On "Heebie Jeebies," his first major hit in 1926, Armstrong both played cornet and sang on a record for the first time, though he famously abandoned the lyrics and "started to Scatting" (as he recounted in a 1951 *Esquire* article), singing an infectious rhythmic succession of nonsense syllables. His friend the clarinetist Mezz Mezzrow explains in his 1946 memoir *Really the Blues* that the record "took all of Chicago by storm," as "you would hear cats greeting each other with Louis' riffs when they met around town—*I got the heebies*, one would yell out, and the other would answer *I got the jeebies*, and the next minute they were scatting in each other's face. Louis' recording almost drove the English language out of the Windy City for good."

To put it another way, Armstrong's insouciant phraseology recast the language, blowing English in an entirely new direction. And the music's fresh verbal idioms quickly became the dominant paradigms of modern style. As anthropologist Zora Neale Hurston puts it in her 1934 essay "The Characteristics of Negro Expression," the African American "has made over a great part of the tongue to his liking and has had his revision accepted by the ruling class." For Hurston, this influential linguistic renovation "arises out of the same impulse as the wearing of jewelry and the making of sculpture—the urge to adorn."

A few Harlem Renaissance novels include glossaries of slang, like the "Introduction to Contemporary Harlemese, Expurgated and Abridged" in Rudolph Fisher's 1928 *The Walls of Jericho*. In the 1930s swing era, as the idioms specific to Black urban culture in Chicago and Harlem spread nationally, linguists, jazz journalists, and gossip columns—including Billy Rowe's Notebook in the *Pittsburgh Courier* and Dan Burley's Back Door Stuff in the *New York Amsterdam News*—documented the quickly changing currents of the vernacular. But the first stand-alone lexicon was prepared by a musician closely associated with the new style: singer and bandleader Cab Calloway. Calloway published *A "Hepster's" Dictionary* in 1938, explaining in the foreword to the 1944 edition that the compilation started as a "glossary of words, expressions, and the general patois employed by musicians and entertainers in New York's teeming Harlem," with terms derived from that milieu (*the joint is jumping*, or *orchestration*, meaning "overcoat"). But within a few years, "jive talk" had become "an everyday part of the English language," as evidenced by the familiarity of such neologisms as *chick, dig, pad, square, mellow, in the groove, have a ball*, and *hip*. In 1944 the poet Langston Hughes encouraged Burley to publish his own compendium, *Dan Burley's Original Handbook of Harlem Jive* (opposite), which was followed by a parade of other such reference works, including the singer Slim Gaillard's 1946 *Vout-o-Reenee Dictionary*, a mixture of "jive talk" and "bebop" with foreign words and a personal argot he called "Gaillardian."

These jive dictionaries promise access to an insider lingo, cracking "a secret inner-circle code" that "brings those in the know closer together," as Mezzrow observes. And even as Burley insists that jive is a "language in motion" that cannot be captured since expressions are continually being "tried and discarded, accepted or rejected," he nonetheless calls his handbook a "guide," a set of tools the reader can use to join the club.

The Original Handbook of Harlem Jive traces the roots of the word *jive* to the English *jibe* ("to taunt, to scoff, to sneer—an expression of sarcastic comment"), and Burley emphasizes that the code is equally a critique of the norms and assumptions of the dominant culture, only adding to its allure. For Mezzrow, jive talk is a way of "mocking . . . the idea that words are anything but hypes and camouflage." In its inspiring flights, its delight in the sheer pleasures of sound (*yackety-yak, bebop, hootchy-kootchy, honky-tonk*), and its penchant for figurative gems (*I got my rug beat* to mean "I got a haircut"; or *Are your boots laced?* to ask, "Do you understand?"), jive encapsulates the rebellious invention at the heart of Black music, providing an exhilarating arena for creative self-fashioning.

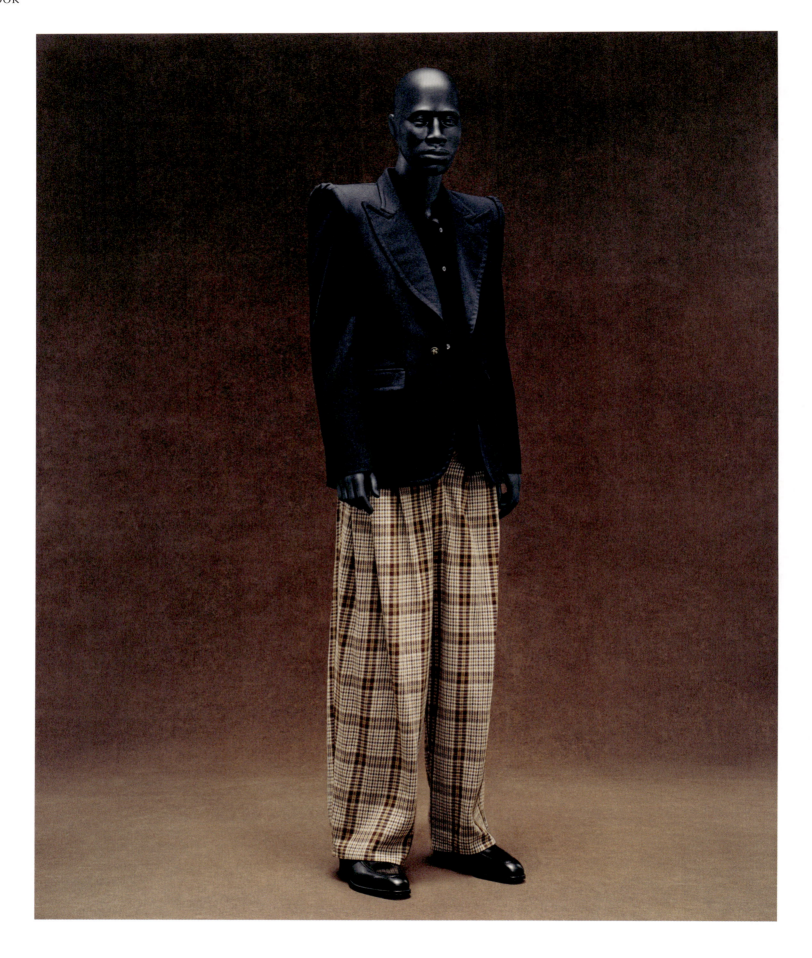

Willy Chavarria. *Ensemble*, autumn/winter 2024–25

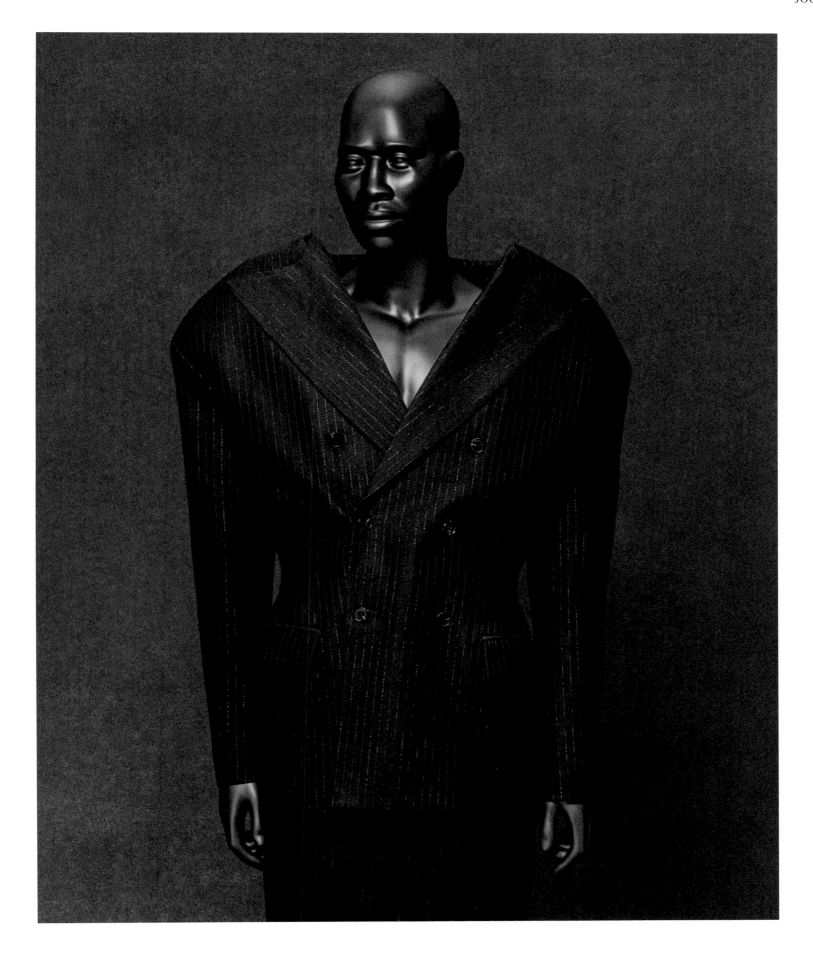

LUAR. Raul Lopez. *Suit* (detail), autumn/winter 2024–25

Miguel Covarrubias. *The Bolito King*, published in *Negro Drawings*, 1927

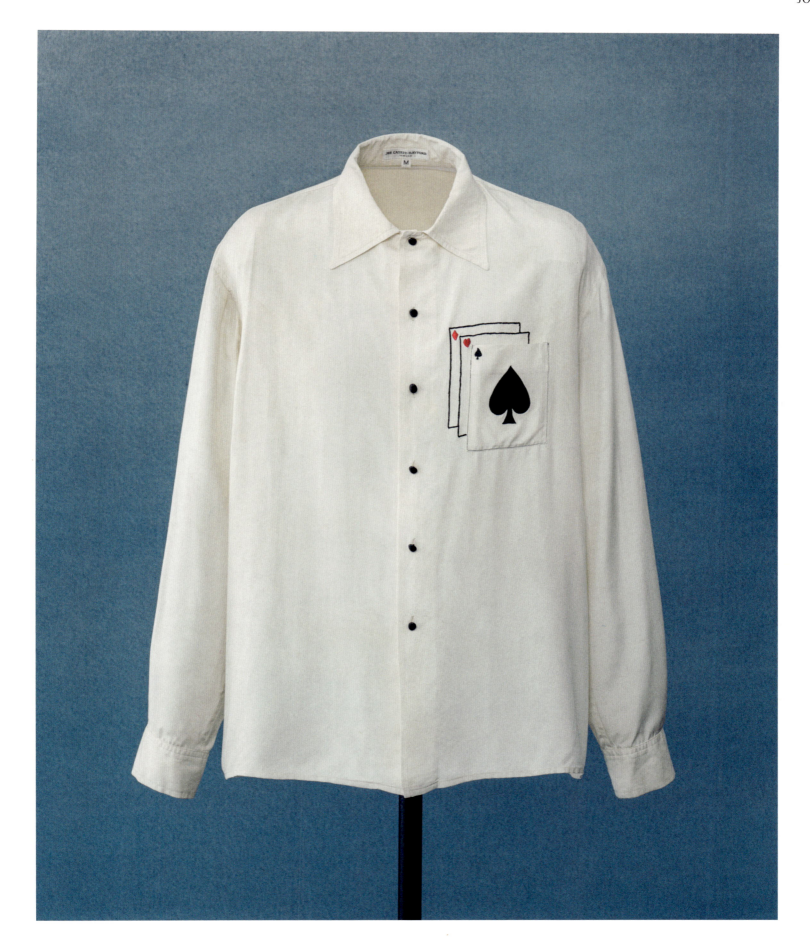

Joe Casely-Hayford OBE. *Shirt*, ca. 1989

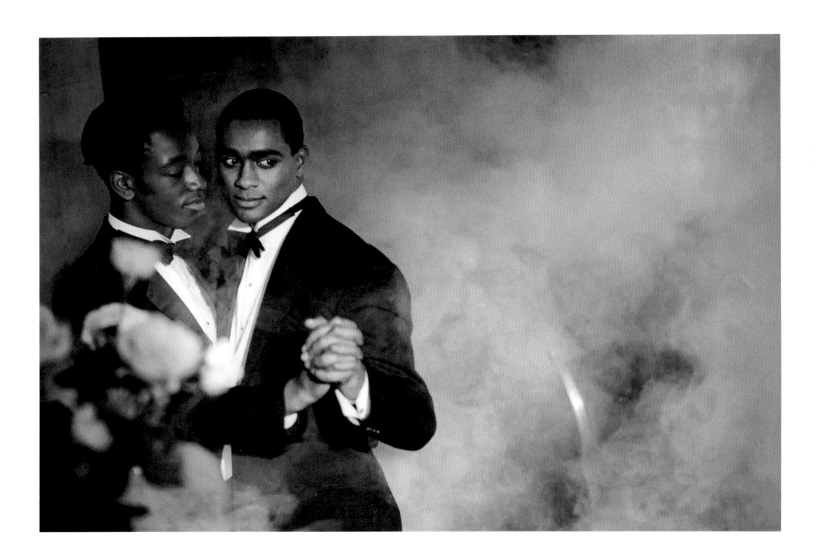

Isaac Julien CBE RA. *Pas de Deux No. 2 (Looking for Langston Vintage Series)*, 1989, printed 2016

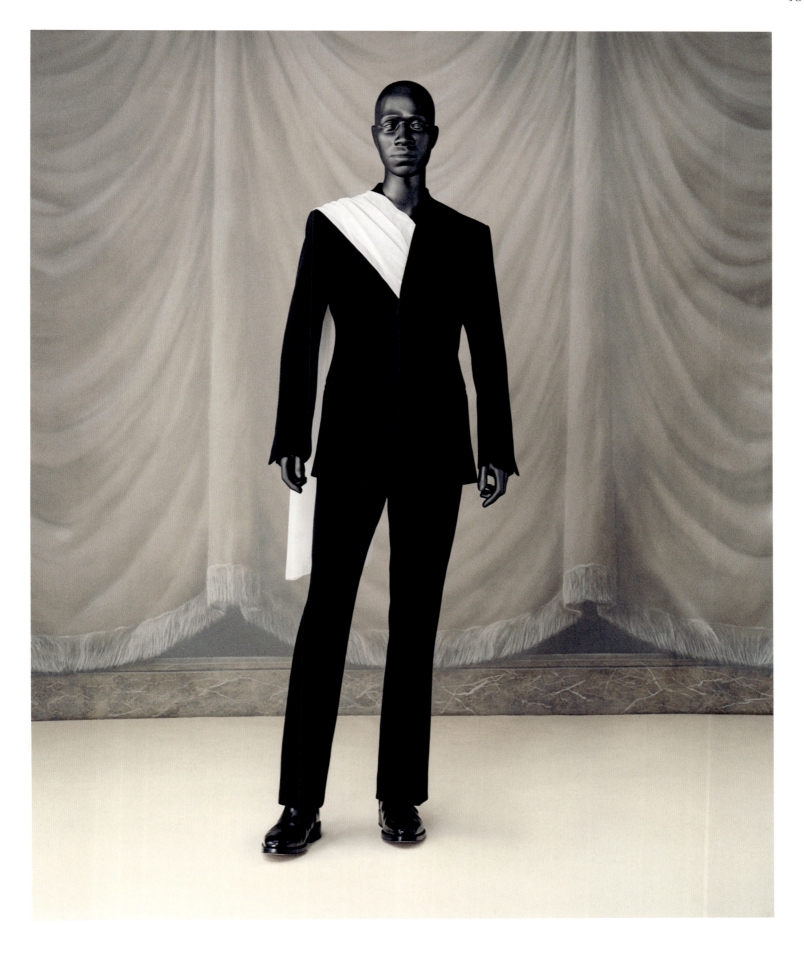

Salvatore Ferragamo. Maximilian Davis. *Ensemble*, spring/summer 2023

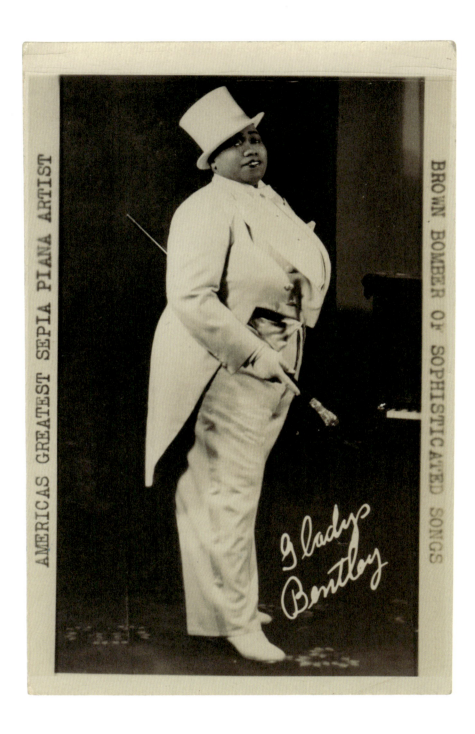

Gladys Bentley: America[']s Greatest Sepia Piana Artist—Brown Bomber of Sophisticated Songs, 1946–49

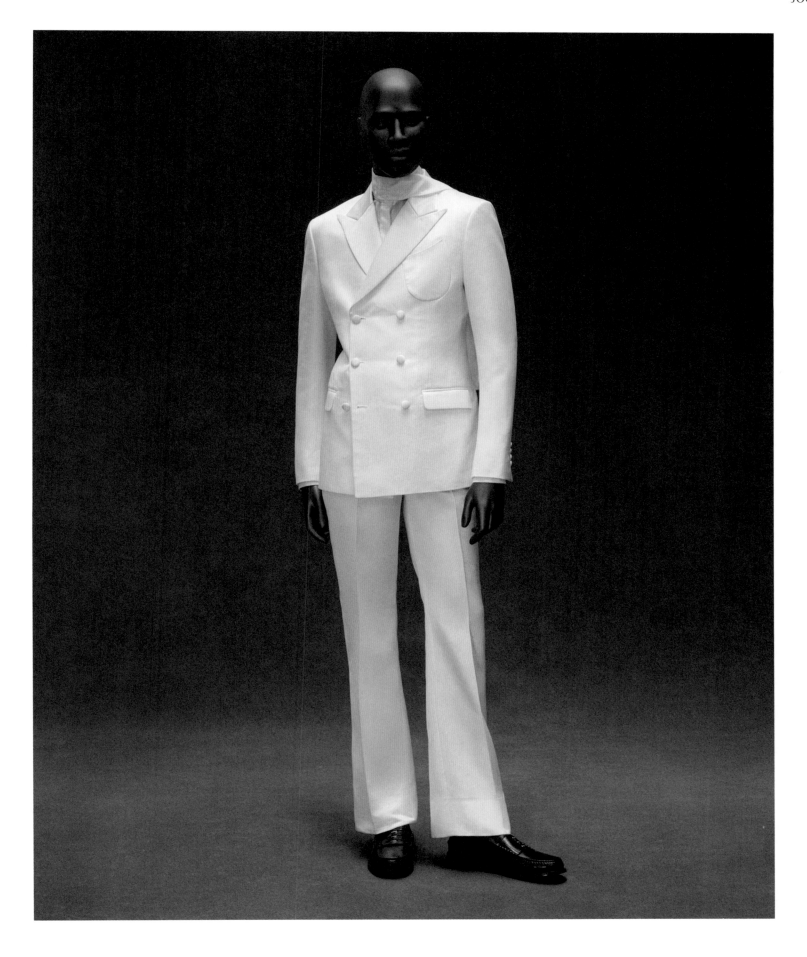

Brandon Murphy Collection. Brandon Murphy. *Ensemble*, autumn/winter 2020–21

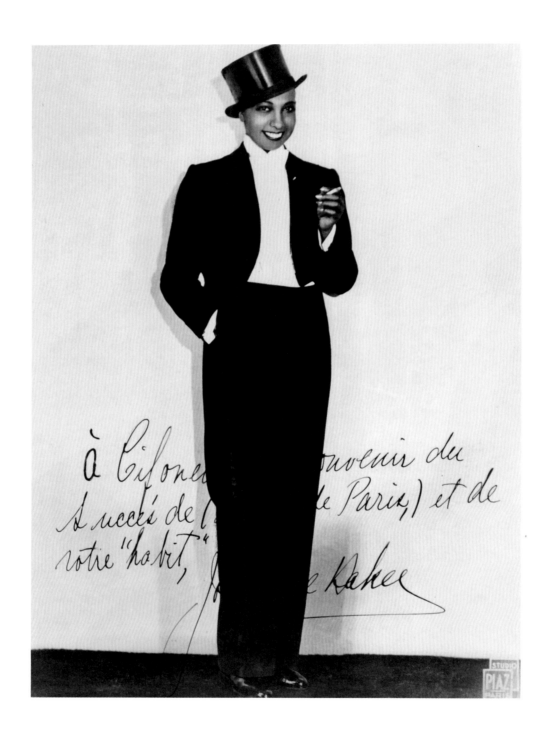

Teddy Piaz. *Inscribed and autographed photograph of Joséphine Baker*, ca. 1932

"LA BAKER" AND "LA BENTLEY": SUITS, SYNCOPATION, AND SUBVERSION

KAI TOUSSAINT MARCEL

The early twentieth-century explosion of Black-led entertainment produced queer supernovas like Joséphine Baker and Gladys Bentley. Their audacious yet elegant style and radical expressions of individuality helped define Harlem Renaissance modernism and expand collective conceptions of performance and identity. Their visibility defied easy categorization, eliciting anxiety but, more presciently, engendering new possibilities for negotiating hegemonic constructs about race, class, gender, and sexuality that reverberate even a century later. In their wake are artist-androgynes such as Grace Jones, Prince, and Janelle Monáe, in whose work Baker's and Bentley's genderful spirit of seductive disruption lives on.

Even under the auspices of New Negro progressivism, which sought to update old and imposed racial paradigms, the colonial imposition of the gender binary remained consistent. Men and women seeking to engage in a post-emancipation politics of racial uplift were still expected to participate in a distinctly bifurcated fashion. Although movement leaders such as Frederick Douglass and W. E. B. Du Bois endorsed suffrage and greater employment opportunities for women, repressive attitudes about dress and desire remained and were further complicated by questions of queerness. Despite the palimpsestic pressures of cisheteronormativity from Black and white society alike, "La Baker" and "La Bentley," as they were called in the media—sometimes in admiration, sometimes in jest—sought greater expanses onstage and off, rejecting the inurement of conformity with their signature humor and high style.

In true dandy fashion, Baker's and Bentley's meticulous use of clothing was central to the construction of their images and identities. Both shared a well-documented love of fine clothes and appropriated luxury tailored menswear into their stage and personal wardrobes. Whereas Baker is less remembered for her masculine dress, Bentley, who *Women's Wear Daily* described in 1936 as the "zenith of sophistication," became most associated with it. Her white top hat and tails ensemble (p. 240) has been exalted as her signature costume, though she boasted in *Ebony* in 1951 of several similar "tailor-made" ensembles in multiple colors, including "two black, one maroon, and a tan, gray and white," each featuring matching shoes and canes. Baker's and Bentley's garments not only functioned as an index of their accumulated star power and hard-won prosperity, but more profoundly, they heightened the entertainers' abilities to shape-shift and use their own bodies in a choreography of haptic signification.

Onstage and off, bedecked in their finery and with radical chic, they performed an in-real-time embodied social deconstruction. With every syncopated, temeritous gesture, they played with and collapsed the many binaries—male/female, white/Black, rich/poor, sophisticated/savage, respectable/decadent, heterosexual/homosexual, pious/desirous—that endeavored to place them in static, subaltern categories. In demonstrating the porosity between these alleged opposites, they undermined the categories' authority as hierarchical devices. In their respective acts, they deployed exaggeration, role reversal, and parody, burlesquing and manipulating society's closely held ideals into humorous effigial oblivion. Their queer departures from Victorian and New Negro respectability politics demanded audiences see the inherent performativity—and absurdity—of conservative ideals entrenched within social normativity and their darker abject inverses.

The portrait of Baker on the opposing page was captured in the early 1930s by the fashionable Parisian photographer Teddy Piaz. At once both soignée and subversive in silk satin and wool barathea, Baker appeared in print in this sophisticated "cross-dress" on a series of widely circulated postcards publicizing her hit revue *La joie de Paris*. The three-hour extravaganza, which *The Afro-American* reported as featuring a cast of one hundred performers, including two separate orchestras, premiered on December 17, 1932, at the Casino de Paris. Just the year before, the then only twenty-five-year-old Baker made box-office history there in her sold-out revue *Paris qui remue*. Among the cavalcade of background performers in *La joie de Paris* was a twenty-two-piece Black male jazz ensemble that, in one of the forty-five featured tableaux, swung and swelled to the beat of Baker's baton. Here, in her Geminian multiplicity, she seamlessly cast off her showgirl shimmy dresses and banana skirt to embrace the role of besuited bandleader. It is likely in this capacity, occupied by jazz men like Cab Calloway and Duke Ellington, that Baker wore the pictured evening suit.

Elegantly accessorized with a silken top hat worn over equally reflective brilliantined hair, Baker collaborated with French-Italian tailor Arturo Cifonelli to fashion this full-dress suit—the more formal antecedent of the tail-less tuxedo. The highly sought-after tailor, who made Baker's suits for personal and professional use, had arrived in the city from Rome in 1926. Moving the family firm with him—first to the rue de Courcelles and later, in 1936, to the rue de Marbeuf, where the atelier still stands—Cifonelli retained the favor of local and international mondains, including international film stars Cary Grant and fellow fashion renegade Marlene Dietrich. Baker hungrily embraced couture and bespoke tailoring, wanting only the best—trunks upon trunks of it. In 1951 AP reported on her $250,000 stage wardrobe—over $3 million today. In *Josephine: The Hungry Heart*, her laundress, Madame Buechels, said of her sartorial fastidiousness, "She was odious when it came to her laundry, especially the shirts she wore with her [tuxedos] and her top hat. . . . The girls had to restarch and re-iron her shirts until they satisfied her, she was very demanding." While it is unlikely that the pictured suit is extant, the inscription on the photograph, which continues to live in the Cifonelli atelier today, is a testament to its creation. The dedication reads, "à Cifonelli en souvenir du succès de la joie de Paris et de votre 'habit,' Josephine Baker" (to Cifonelli in memory of the success of *la joie de Paris* and of your "suit," Josephine Baker).

Heritage

———◗———

"Heritage is so complex that we have to be simple.
And we have to consider ourselves global.
It takes a lot of courage to do that."

MAYA ANGELOU
"A Way Out of No Way," *African American Lives 2*, February 6, 2008

Fashion may bridge gaps in African diasporic history, as clothing and dress can tell personal stories and explore familial lineages essential to building self-confidence, community, and a sense of belonging. On the African continent and in the diaspora, Black dandyism has a long history of hybridizing Western tailoring and traditional forms of African dress. Designers and wearers also take inspiration from African textiles, fabrics, and silhouettes, relating them to their personal heritage as well as to the circumstances of their forced and chosen migration and travel. "Heritage" explores the multiple ways in which diasporic histories and connections to Africa are represented as engaged acts of cosmopolitanism in photography, fashion design, and personal styling, arguing that Black fashion defines and is defined by diverse modern Black identities.

Cultural exchange and negotiations of political and social hierarchies during the time of enslavement, colonialism, and imperialism were displayed on the body in outfits that remixed clothing traditions in fashionable, unpredictable ways. In an early 1890s photograph, an older man wearing traditional dress and a top hat sits regally, holding a slim staff (p. 248). He is attended by a young man sporting a Western suit jacket and pants, protectively bearing a thicker stick. We know little about the sitters, the circumstances in which they were photographed, or even the location in which the picture was taken. Nevertheless, the contrast between the stiff black top hat and the gentle folds of the older man's draped cloth stands out as a visual signifier of a potential cultural clash, even though the man and his attendant seem completely at ease. Possibly taken in Congo or Angola, another photograph from around 1890 depicts young men elaborately dressed in similarly hybridized outfits: They wear Western suit jackets, accessorized with pocket watches, on top of draped, patterned African textiles (p. 249). They, too, hold delicate walking sticks, a gesture to African tradition as well as to Western dandy iconography. Perhaps "house boys" to colonizing Europeans, these men show us that they are living and working between cultural divides, negotiating the relationship between Western traditions of dress and their modern African identities, and vice versa.

Decolonization movements also encouraged people of the African diaspora to sartorially signal their political support and cultural resonance with Black and African liberation and style. A photograph of a ninety-one-year-old W. E. B. Du Bois and his granddaughter in New York from 1959 (p. 250)—two years before he relinquished his American citizenship and settled in Ghana—features Du Bois in a Western suit with a long kente cloth expertly draped over it. In this image, Du Bois manifests his past, as an organizer of Pan-African congresses and a decades-long advocate for decolonization, and his future on the African continent, as a Ghanaian citizen and editor of the *Encyclopedia Africana*. Although he died two years later, Du Bois relished his time in Ghana, where he was far from the racism and anti-Communist McCarthyism then rampant in the United States. "I have returned so that my remains may mingle with the dust of the forefathers," DuBois reportedly said at the time, considering this immigration to Africa as a moment of completion, an honoring of the sacrifice of his ancestors. Virgil Abloh's similarly hybridized autumn/winter 2021–22 ensemble for Louis Vuitton (p. 252) comprises a tailored white Western suit with a branded "kente" blanket encircling the wearer. Like Du Bois, Abloh was inspired by his heritage, basing this garment on a photograph of his Ghanian grandmother. This ensemble announces to the world the multiplicity of his identity and his influences as an American designer of African descent then newly appointed as artistic director for one of the world's most celebrated French design houses.

Since the 1960s, when much of Africa was decolonizing and new native leaders took office, Black people in the diaspora have donned clothing with African motifs and themes as a point of pride and connection. In a 1977 self-portrait that he titled *Slick* (p. 254), Barkley L. Hendricks contrasted his impeccably cut double-breasted, flared-leg white suit with a brilliantly colored kufi (p. 255), a knitted cap worn by African men who are religious and community leaders. The cap pops against the suit and Slick's warm brown skin, as the titular subject embodies the epitome of cool by expressing pride in being of African descent. For both Hendricks and André Leon Talley, fashion was a part of identity formation, an aesthetic arena for play, and

an expression of a connection to Africa—or any number of other allusions, as evinced by the 1975 Polaroid of Talley as a Brown University graduate student (p. 260). His improvised outfit of a draped striped textile, also accessorized with a kufi, presages a caftan custom crafted for him by Nigerian designer Patience Torlowei (p. 261). Thus, African regality can be claimed even by people separated from the continent by hundreds of years. As Du Bois explains in his 1940 autobiography, *Dusk of Dawn*, "Africa is of course my fatherland. Yet neither my father nor my father's father ever saw Africa or knew its meaning or cared over-much for it. . . . Still my tie to Africa is strong."

Designers of African descent often reference their diverse heritages and personal journeys in their designs; in addition, they take inspiration from and amplify forgotten or overlooked histories of Black people the world over. In so doing, they honor the multiplicity of people in the diaspora who have found liberation and transcendence through dress, style, and fashion. Grace Wales Bonner, a contemporary British designer of Jamaican descent, cites American writer and Black nationalist Amiri Baraka (p. 256) as an influence. Baraka adopted Afrocentric dress and a new name in the late 1960s to assert the value of African heritage. In his seminal 1970 book *In Our Terribleness*, he creates a new lexicon of cool specific to the Black experience, writing, "Our terribleness is our survival as beautiful beings, any where [*sic*]. / Who can dig that?" Wales Bonner's autumn/winter 2019–20 ensemble (p. 258) mixes a classic, if oversize, white dinner jacket with a knitted hat—reminiscent of a rastacap or tam—featuring the collection's title, "Mumbo Jumbo," taken from cultural theorist, musician, and writer Ishmael Reed's 1972 novel of the same name. Considering "writers as oracles," the collection comprised a mélange of classic American collegiate styles and references to West Indian spiritualism, such as voodoo, in the form of "talismanic jewellery," like the shell, coral, and feather brooch adorning the jacket here, to "imbue varsity dress with an atavistic magic, weaving a sacred thread to the animist traditions of West Africa and the Caribbean," according to show notes. The show notes add that we must "honour the ancestors. Honour the lineage."

French Cameroonian designer Emeric Tchatchoua of 3.Paradis describes his collections as "highly personal, emotive and affective journey[s]" in an artist statement on his label's website. His most recent work features a collaboration with artist Johanna Tordjman, who grew up with him in the Paris suburbs. Reimagining photographs Tchatchoua took on a recent trip back "home," these ensembles—like the red and orange checked short suit (p. 263) and the hand-painted beige duster (p. 262)—highlight fabric design and representational motifs inspired by the people and colors of Cameroon. Saying that he represents the "in-between" of the African diasporic world and Western fashion, Samuel Boakye of Kwasi Paul similarly ingrains his Ghanaian background and his upbringing in the Bronx and Queens into his designs. Fusion and heritage are important to him as the son of an immigrant mother who attended the Fashion Institute of Technology; in fact, Kwasi Paul, his label, hybridizes his parents' names, just as his designs connect their histories, as seen in a 2023 ensemble (p. 264).

Jacques Agbobly's Togolese heritage and their nonbinary identity inspire, as their website notes, the "vibrant colors, artisanal materiality, and visionary silhouettes" of their clothing. "Growing up in Togo, my grandmother rented part of her home to seamstresses and tailors, and I saw myself in that," they told *Vogue* in 2022. Their clothing celebrates their African ancestry and their family tree: One ensemble (p. 265) features a printed pattern reminiscent of the nylon "Ghana Must Go" bags carried by refugees expelled from Nigeria in the 1980s, while the hand-beaded denim jacket and trousers with pendant crystals (p. 267) evoke the earrings their aunts wore to Sunday church services. As exemplified by his beaded UGG moccasins (p. 266) from his "Black Seminole" capsule collection, Tremaine Emory of Denim Tears also designs with the intention of spotlighting diversity within Black communities, including his own Indigenous background. The inspiration contemporary designers take from African heritage can be general and imagined, or more specific and personal; nevertheless, in every case it fuels innovation formally and conceptually as it honors those who came before.

HERITAGE

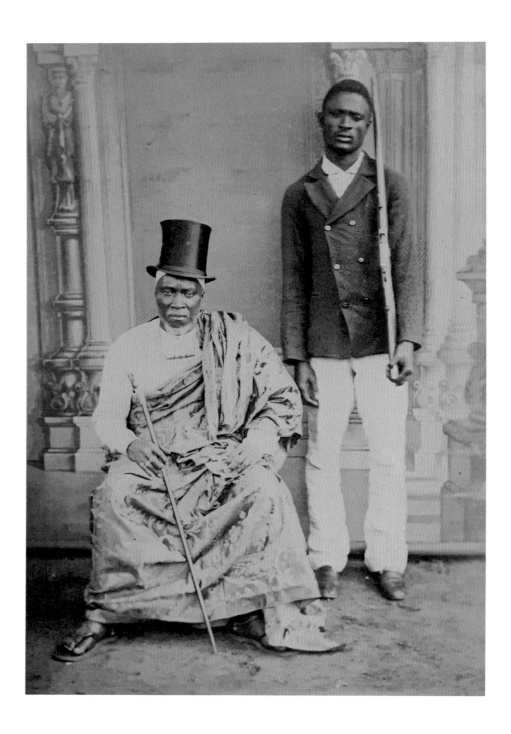

248　　　　　　　　　　Neils Walwin Holm. *Untitled [Portrait of two men]*, 1890–92

HERITAGE

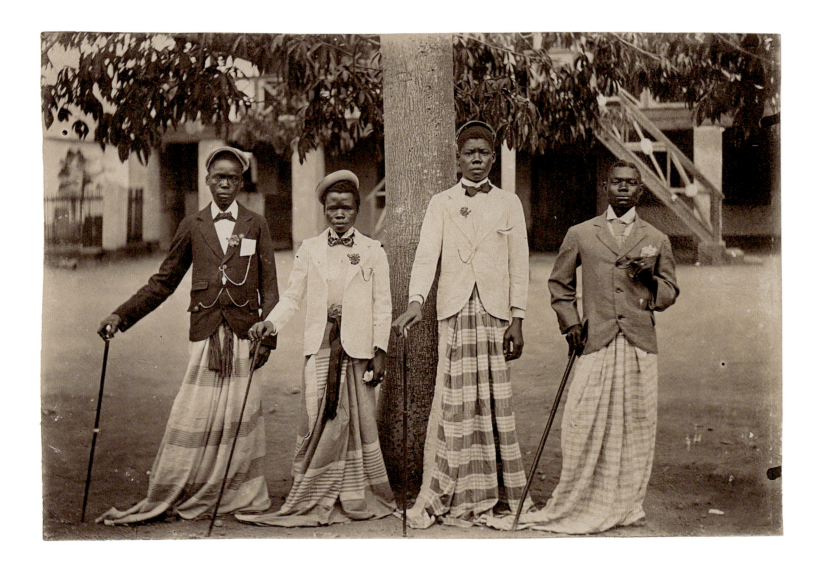

Untitled [*Portrait of four young men*]. Possibly Congolese or Angolan (ca. 1890)

HERITAGE

W. E. B. Du Bois and Du Bois Williams, July 1959

HERITAGE

DU BOIS IN KENTE

DEBORAH WILLIS

As captured in photographs, W. E. B. Du Bois's sartorial sense has always intrigued me. Pictures of the noted dandy reveal his signature style and his undeniable love of fashion. In his studio portraits as well as images of him as editor in the *Crisis* magazine office, at ceremonies on stages, and in meetings, he is often dressed in a suit—sometimes just a vest and a tie—holding a formal pose. One of the earliest photographs of Du Bois shows him wearing a topcoat, a high-collared shirt, and a Victorian black top hat as he stands in the doorway of Nadar Studio, one of the most noted Parisian photography galleries. He was in the city to promote the opening of his Exhibition of American Negroes at the 1900 Paris Exposition. Today, I imagine Du Bois's closet as "ever present"—that is, he could revisit his closet year after year and always find the ideal item of clothing; he was aware of the fashion of the time. As a sociologist, scholar, "race man," and Pan-Africanist, Du Bois considered the dressed body as a response to stereotypical perceptions of Black men and Black masculinity.

The color photograph opposite is a small personal snapshot of Du Bois. *W. E. B. Du Bois and Du Bois Williams* shows the dandy wearing kente, a cloth that dates back to twelfth-century Ghana and is viewed as a signal of ancestral and cultural pride inspired by a diasporan connection to African heritage. In her article "Fashion Statement or Political Statement: The Use of Fashion to Express Black Pride During the Civil Rights and Black Power Movements of the 1960s," Mary Vargas explains that "kente first captured the attention of African Americans in 1958 when Kwame Nkrumah, the first prime minister of independent Ghana, wore the cloth to meet with President Eisenhower at the White House." Du Bois's closet housed items that focused on sartorial modes of Black masculinity that joined Western and African forms of dress, as exemplified in this image by his white collared shirt overlaid with the colorful kente. He proudly stands adorned and wrapped. One hand holds the cloth close to his body, and a red knotted tie highlights the white collared shirt.

Sporting his signature vandyked beard—here, white with age—Du Bois posed for this photograph with his granddaughter in 1959 on the anniversary of Ghana's independence. At the invitation of Nkrumah, Du Bois moved to Ghana in 1961 and was buried there upon his death in 1963. The picture references the history of his conscious effort to embody pride, heritage, Black masculinity, and Pan-Africanism through dress. Wearing the festive Ghanaian cloth clearly indicates that Du Bois's sense of dandyism and his commitment to style remained throughout his life.

HERITAGE

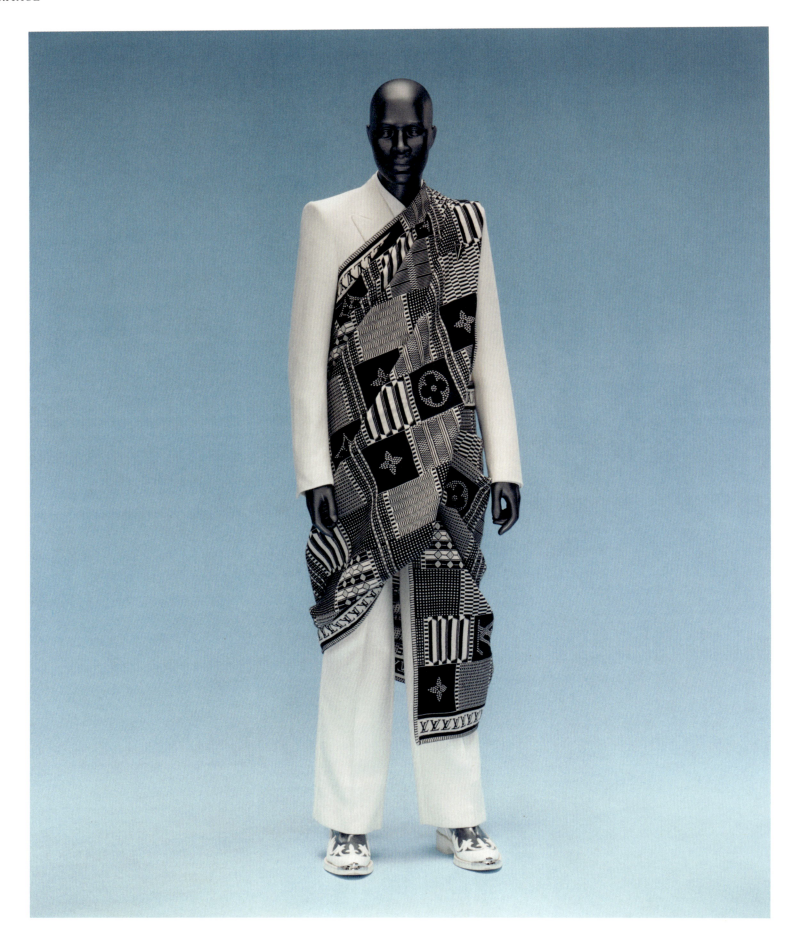

252 LOUIS VUITTON. Virgil Abloh. *Ensemble*, autumn/winter 2021–22 menswear

THE FABRIC OF OUR LIVES

GABRIELLA KAREFA-JOHNSON

Many first encounter kente as a meandering bridge to a distant concept of Africanness—it is an essential construct of the diaspora, yet its locus is not popularly known. Still, it has endeared itself to the collective as a beacon of Blackness, a symbol of home. It belongs to us, and we can wear and share it, as long as it remains *ours*.

Kente, a traditional artisanal cloth born in Bonwire, Ghana, was developed for this very purpose: to connect its wearer to who they are and to signal that lineage to observers. Traditionally, the cloth held a spiritual significance, with a nod to some measure of wealth. But what then when it travels from the hands of traditional weavers to the looms of a luxury French fashion house where the myriad symbols in its patterns are no longer markers of identity and are, instead, distilled down to *just* signifiers of status and wealth? How can one draw a starker line between reclamation vis-à-vis symbolic subversion and the relinquishing of ownership or concession to capitalist systems that seek to profit from pillaging Black and African culture? These are the questions posed in Virgil Abloh's autumn/winter 2021–22 menswear collection for Louis Vuitton—a cultural collage in which sharp Western suiting is wrapped in the soft folds of kente cloth bearing the brand's signature logo where traditional prints and patterns would otherwise exist (opposite).

Abloh's work in this collection exemplifies a collaboration between two ideological projects: the dismantling of a Eurocentric and white supremacist ruling aesthetic, and a repossession of a collective African visual identity diffused, but not diluted, across the diaspora. Presented on a stage considered to be the definitive institutional authority, the work ratifies Africa's largely unrecognized impact on global fashion and makes way for a future in which *our* visual culture, in all of its richness, complexity, and diversity, holds as much power, cultural capital, and gravitas as that of a single brand logo.

A Ghanaian American, and the first Black male creative director at a heritage French luxury house, Abloh was uniquely equipped to embark upon this project—to invite fashion's children of the African diaspora to engage in excavating our own identities as well as exploring and ultimately harnessing the power in what, within fashion's Eurocentric context, is our otherness. As a fashion editor of West African, Caribbean, and Black American descent, I have often felt lonely in my Blackness. Thus, in the African tradition of call and response, I was drawn to be in conversation with Abloh's work when given the assignment of styling poet Amanda Gorman for the May 2021 cover of American *Vogue*.

On the cover, Gorman wears a Louis Vuitton kente-cloth blanket as a dress, cinched around the waist by a wide belt. One goal of this look, and perhaps of Abloh's collection in general, was to aid in building a contemporary canon for us, by us, reflective of us. What hopefully would follow is a more authentic expression of Blackness, one that supplants fashion's previous interpretations of Africana—hollow attempts full of fraudulent facial markings and fabrics. The kente is American fashion because Blackness is American.

At the time of the sitting, Gorman was an exceptionally young Black American poet, fresh from reciting her work "The Hill We Climb" at President Joseph Biden's inauguration. She addressed a nation in violent fissure—fractured by racism and bruised by a rhetoric of hate spewed from the highest office in the land to the street corners of the smallest cities. She was tasked with uniting us through the reclamation of language—hijacking the tools of the oppressor to liberate the oppressed and paint a picture of who we could be. Gorman both represented the future and bore the burden of healing the past. So much of that pursuit is alive in the kente looks in Abloh's Louis Vuitton collection. It exists in the very history of kente's fabrication, whereby the eighteenth-century African artisans deconstructed luxurious European wovens, like French and Italian silks, as they made their way through Ghanian ports on colonial trade routes. Once isolated from their original fabrics, these threads were reworked to weave vast and varied tapestries of African identity, a reversal of colonial cultural theft and a genius reverse engineering of fashion itself.

Initially, the visual dissonance in Abloh's Louis Vuitton look on the page opposite demands an investigation of stylistic hierarchy: We clamor to identify which speaks the loudest, the three-piece white suit or the kente. Sit with the question and, ultimately, a harmony between the two is revealed, and friction gives way to complement. The seemingly disparate pieces balance each other quite satisfactorily; they hold the same weight. The unifying objective of Abloh's project and his legacy in fashion become clear.

The fact that kente has historically been used interchangeably as a barometer of socioeconomic status and as a sacred spiritual symbol perhaps illuminates the plain truth that a luxury label is not a deserving deity. The logo is not the dream. In it, we will not find our future. The limitless swag of Black style, on the other hand—now that is eternal, future building, and indeed worthy of worship.

HERITAGE

Barkley L. Hendricks. *Slick*, 1977

254

HERITAGE

Skullcap. Probably American (ca. 1968)

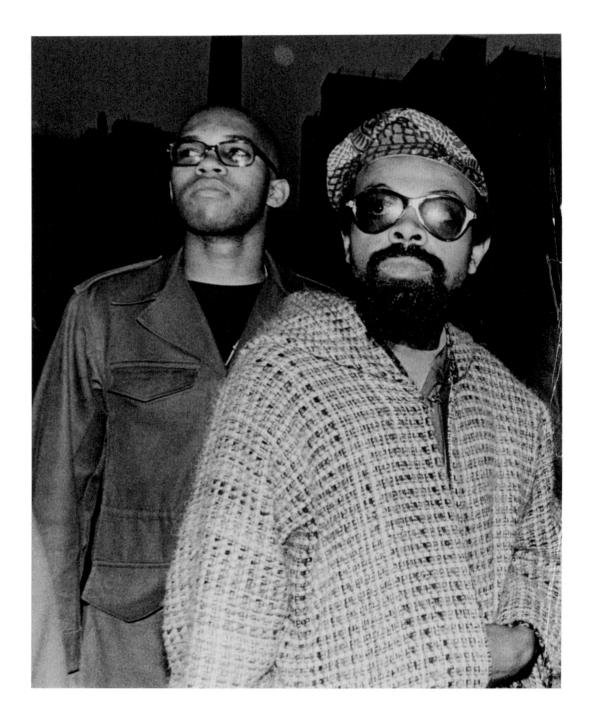

Amiri Baraka wearing sunglasses. Probably American (1967)

HERITAGE

"EVERYTHING'S FOR REAL": RECOLLECTIONS OF BLACK STYLE

GRACE WALES BONNER

In Our Terribleness (Some Elements and Meaning in Black Style), a collaboration between radical poet Amiri Baraka (opposite) and the photographer Billy Abernathy, remains a shining and resilient record of Black style. The book combines Abernathy's stirringly elegant depictions of Chicago's Black community in the 1970s with Baraka's consciousness-raising poetry. Embedded within mirrored pages and jazz riffs in the poet's verse is the majestic and powerful statement "everything's for real." It is an idea that I carry forward like the Akan people's mythical bird Sankofa, a symbol for learning from the past to create the future. Everything's for real—a mantra that serves as a call to action—now defines my understanding of style and my philosophy for design. What I aspire to create in its purest form is real on many levels: It is real because it means something; it is real because it comes from history; and it is for real because it is rooted in true style created by originators.

My search for meaning in Black style began as a search through ancestry to reveal beauty and complexity over time and across traditions of expression. Some elements can be traced to what I experienced in my father's study: early memories of his improvisation on the grand piano; the vast library celebrating Romantic poets, fine arts, and Caribbean poetry; the elegant militancy of a portrait of Malcolm X; and a grand poster of *Rhapsodies in Black: Art of the Harlem Renaissance*, an exhibition curated by David A. Bailey at London's Hayward Gallery in 1997.

I elaborated on these early pillars, seeing the Harlem Renaissance come to life through the lens of Isaac Julien's *Looking for Langston* (1989) (p. 238)—definitions of beauty, tenderness, and grace forever situated there. This tenderness also extends to how I look to connect with people through the clothing and images I create. Julien's depiction of the character Beauty—in the finery of a tuxedo and draped in sheets—recalls the homoerotic visions of fashion photographer George Platt Lynes. Reminiscent gestures are reflected, too, in the strands of pearls and extended fingers of dancer Geoffrey Holder in flight and the elemental dress of James Baldwin—his regal jewelry, pastel-toned denim, and seductive brown leather.

The radical expression I observed in Baraka's work is also defined by photographs of the Black Panthers and by blaxploitation films—namely, *Sweet Sweetback's Baadasssss Song* (1971) by Melvin Van Peebles. I witnessed a rebel spirit in the jagged cool of the characters in *Rockers* (1978) and Beth Lesser's dancehall

photography. I feel a deep connection to a style that values heritage; there is something sweet in the appreciation of the crisp shirting and fine leather sandals that I saw worn by musicians Augustus Pablo and Bob Marley—but powerful, too, in their wearing of clothes with a presence and a dangerousness that created new glittering potential for future style. In the archive, I saw invention and evolution; righteous embodiment; artists in motion, resisting, forever creating fresh stylistic pathways for new generations alongside free and expansive ways of being. These individuals were for real, their style a mirror of who they were and a reflection of what they could offer the world.

The figure of the Black intellectual was an ever-present guide. New dreams were found in writers Ben Okri and Ishmael Reed, as well as Steve Cannon, publisher of the literary magazine *A Gathering of the Tribes* who always wore Ray Charles–style sunglasses on his face and glorious beads around his neck. David Hammons presides as the artist-as-shaman in talismanic cloth, his dress the reflection of a wondrous soul. Ishmael Reed once told me that clothing was as significant to Black cultural traditions as drumming. His 1970s masterpiece *Mumbo Jumbo* provided further inspiration to enjoy hybridity, historical irreverence, and play. Immaterial ideas like polyrhythm, time travel, and the spirit certainly could be other important elements to consider.

Through endless journeys that continue to unfold each day, I realize that I have been searching for Black princes. From the biblical Magi and seventeenth-century statesman Malik Ambar to André Leon Talley. I saw princes in the poignant characters of *The Black House* by photographer Colin Jones; they remained dignified, crafting beauty from the debris of their surroundings. Shining reflections of light.

Tupac wore a crown of diamonds on his ring. Biggie wore the crown too. I always loved André Leon Talley's appreciation for finery and the best the world could offer; he must have understood his majesty in Charvet shirts, velvet Manolo Blahnik shoes, and pastel alligator coats. I think about him often—his extraordinary clothes—as well as the role of a tailor creating something from nothing, weaving threads, conjuring magic. The best of Black style emanates from a soulfulness resounding in the way a person embodies clothing, bringing "invention into existence" (Frantz Fanon, *Black Skin, White Masks*)—like Jean-Michel barefoot in paint-splattered Armani pinstripes, sitting in his tenderness, waiting patiently for the crown. Boom, for real.

HERITAGE

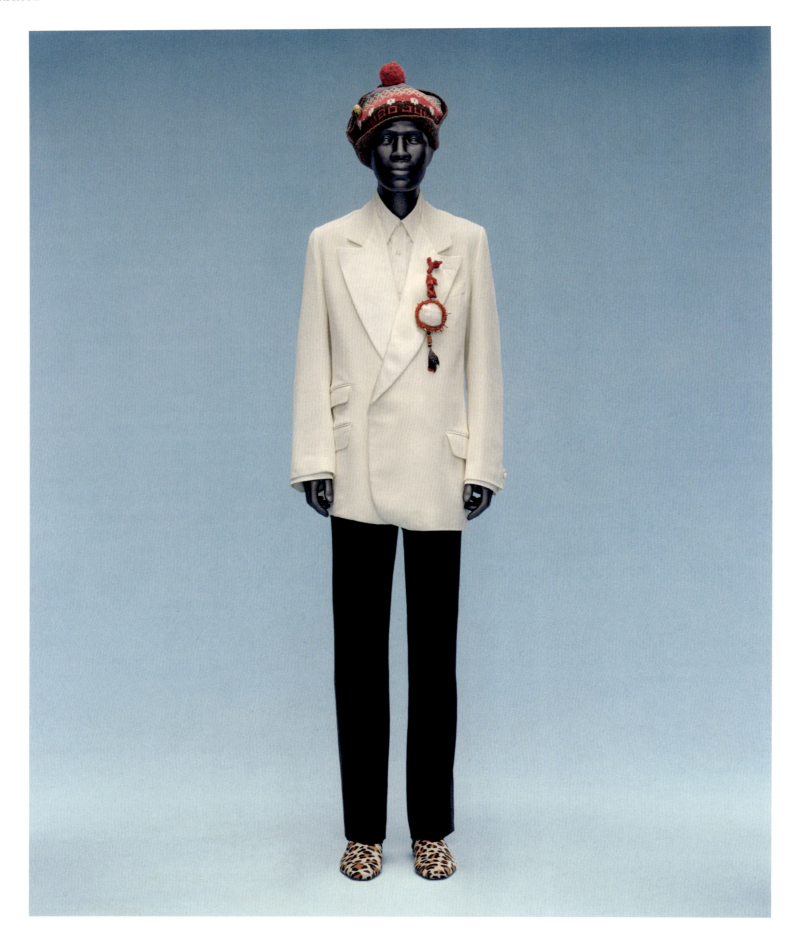

258 Wales Bonner. Grace Wales Bonner. *Ensemble*, autumn/winter 2019–20

HERITAGE

DECLARATIONS OF INTENT: BIANCA SAUNDERS AND GRACE WALES BONNER

CAROL TULLOCH

Great events persist beyond their happening.

—Homi Bhabha, *The Location of Culture*, 1994

The designers Grace Wales Bonner and Bianca Saunders use material to comment on visibility, demonstrating a sentiment Homi Bhabha applied to literature in a talk at the British Library, broadcast on BBC Radio 3 on May 28, 2019: Cultural tenets are "about the pre-moment of rights, the moment before the right gets formulated . . . where the passion and the solidarity and the community begins to come together to make a claim. This is precisely where the role of narrative becomes visible in shaping the individual and collective agents of freedom. . . . Narrative can be picturesque, narrative can be imagistic, narrative can be abstract, [the] imaginative will to liberty, to narrate."

The Wales Bonner and Bianca Saunders labels are part of the arts that provide nuanced iteration of these concerns and desires. These "agents of freedom" have channeled their inheritance of the distinct aesthetic of Black style at home in Britain, the African diaspora, and worldwide. Through their practice, Saunders and Wales Bonner have articulated fashion narratives that include the adversities and significance of difference. Their fashion design chronicles how the world has been, as it is, as it should be.

Every element worn presents, represents, and imprints who we are and what has informed that becoming. It is a materialization of personal narrative. Wales Bonner and Saunders have always known this. The knowledge has been passed down across the arts and with lived experience through generations of the African diaspora. These women "search for a language of [their] own," to borrow a comment from Bhabha's talk. And through the electricity of collaboration with culture makers, they expand the possible fashion narratives to connect and give witness to the diaspora.

Their first collections began within the vortex of Black British culture and style, referencing the everyday practices of post–World War II West Indian migrants and their descendants whose styles helped them engage with the adventure, opportunity, fear, and excitement of a new place and new horizons. The legacy of each generational contribution results in a swirl of memories. The two designers have articulated how shards of personal and group memory, private archives and cultural references—music, literature, art, social interaction, "the pedestrian," domestic interiors, hotels—in turn trigger individualized memories for those who are part of that heritage. For example, the Adidas × Wales Bonner red mesh "Samba" trainers feature white crochet accents that trigger memories of the crochet doilies my mother used to decorate her dressing table; her ornate cosmetic glass containers were encircled by a crochet edge. Likewise, the titles of Saunders's menswear collections mark her steadfast material commentary on Black masculinity—her first collection, "Personal Politics" from autumn/winter 2018–19, the manifesto.

These designers exercise past-present-future interconnectedness, a marker of aspects of Black British style and identity that reaches back to the sorrowful days of enslavement and that has flowed ceaselessly into the arts now. The heritage of diasporic style narratives that Wales Bonner and Saunders feed into their fashion designs contributes to possible new individualized, styled bodies and results in followers who wear their designs and share that history, creating their own fashion narratives. Simultaneously, the garments still play a part in the dissemination of the designers' philosophy even when the clothing is worn by those who do not participate in this inheritance. The revered international position these two women have within the fashion industry further imprints their concerns and social purpose on all who engage with their designs. Taste as visibility.

259

HERITAGE

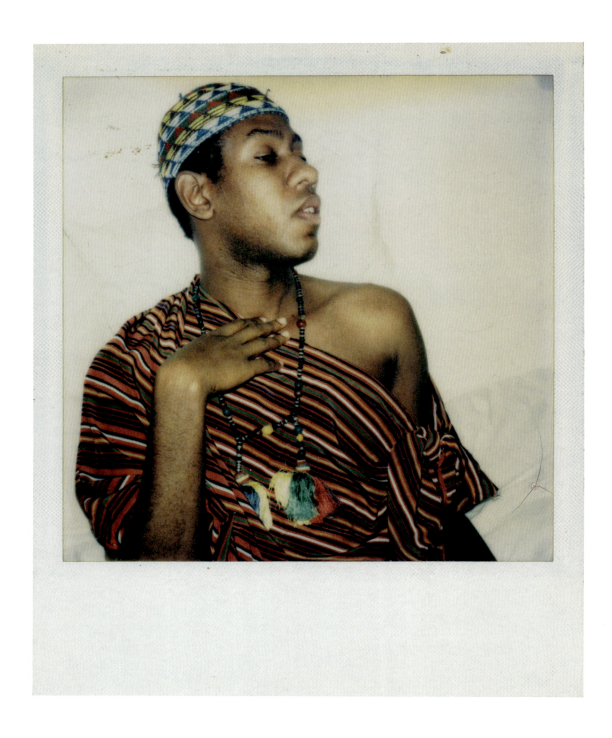

Reed Evins. *André Leon Talley*, 1975

HERITAGE

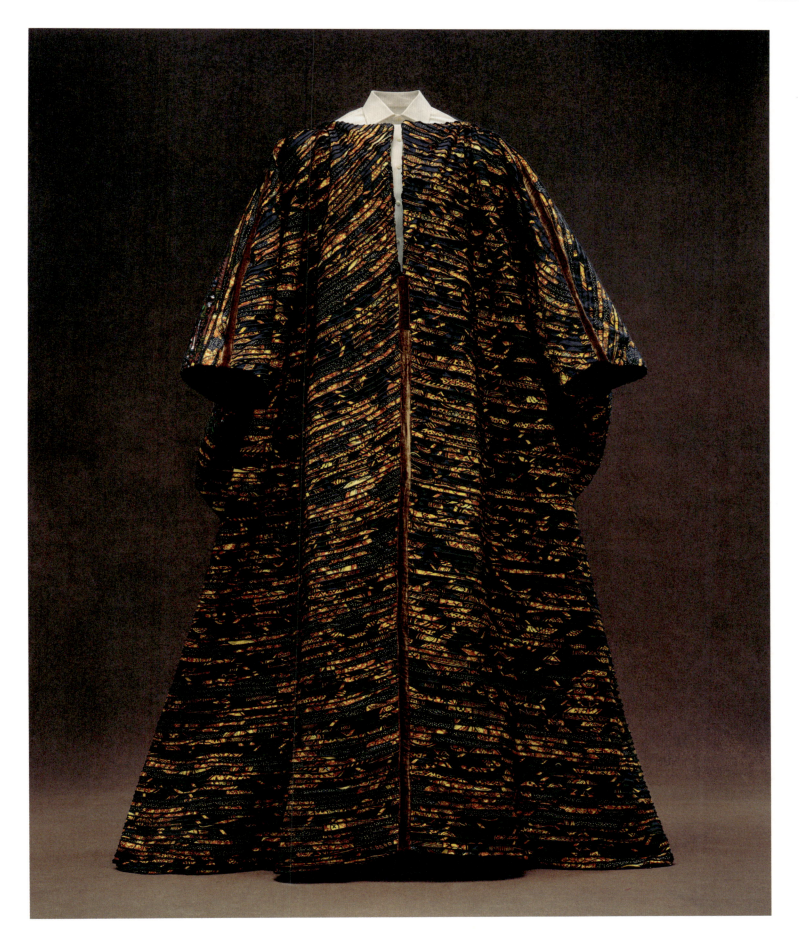

Patience Torlowei. *Caftan*, ca. 2020

HERITAGE

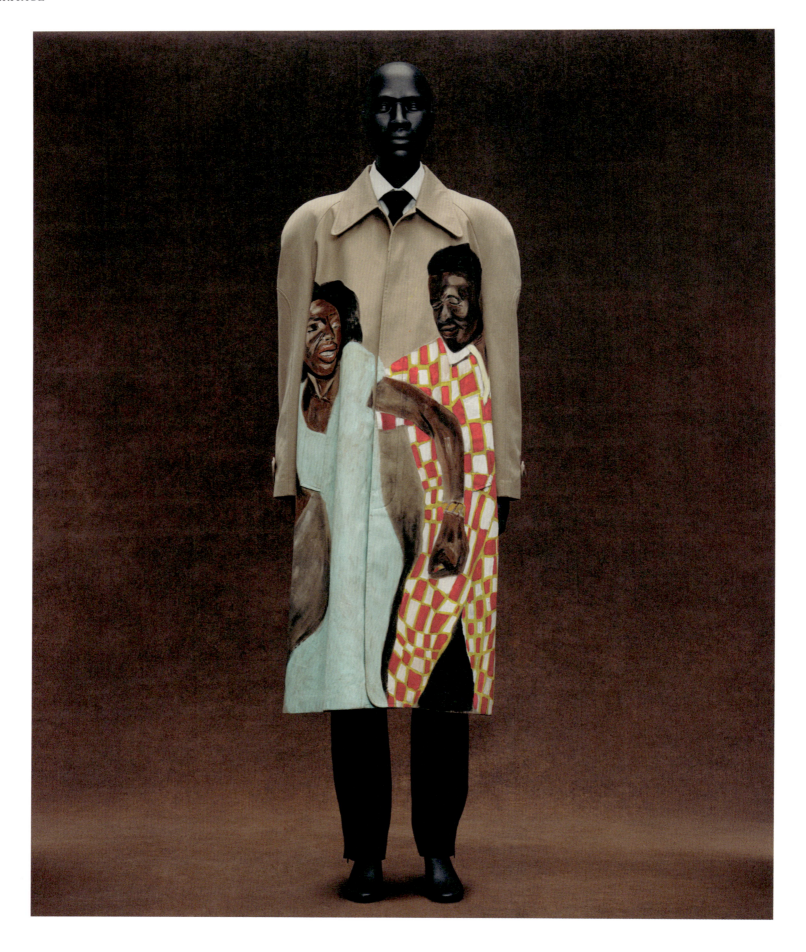

3.PARADIS. Emeric Tchatchoua. *Ensemble*, spring/summer 2025

HERITAGE

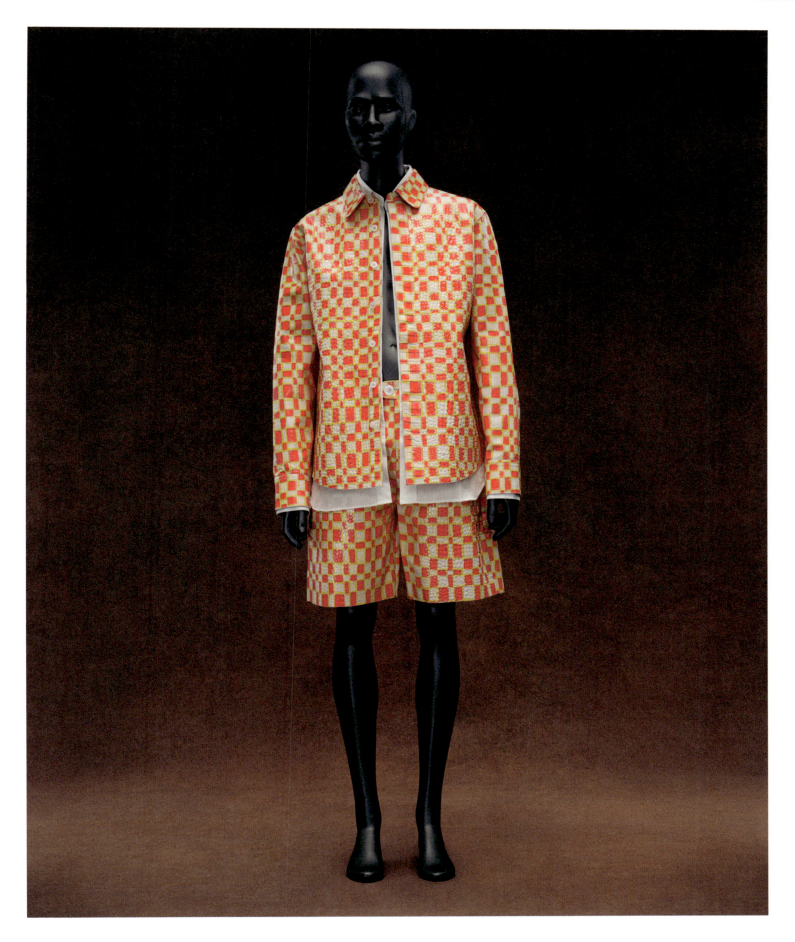

3.PARADIS. Emeric Tchatchoua. *Ensemble*, spring/summer 2025

263

HERITAGE

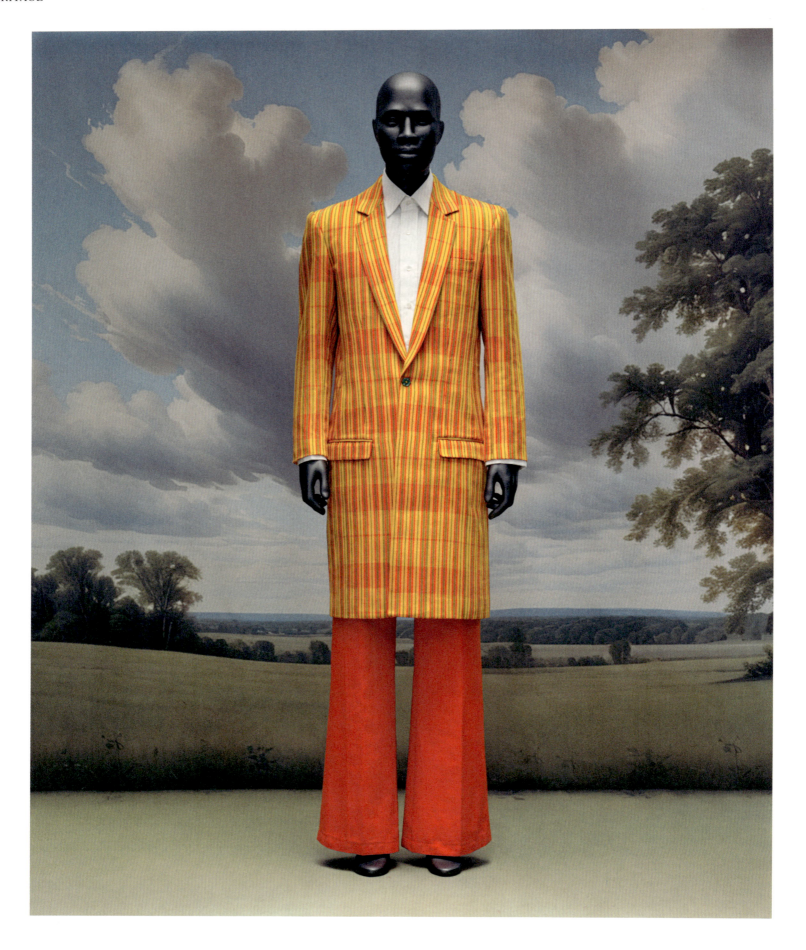

264 Kwasi Paul. Samuel Boakye. *Ensemble*, 2023

HERITAGE

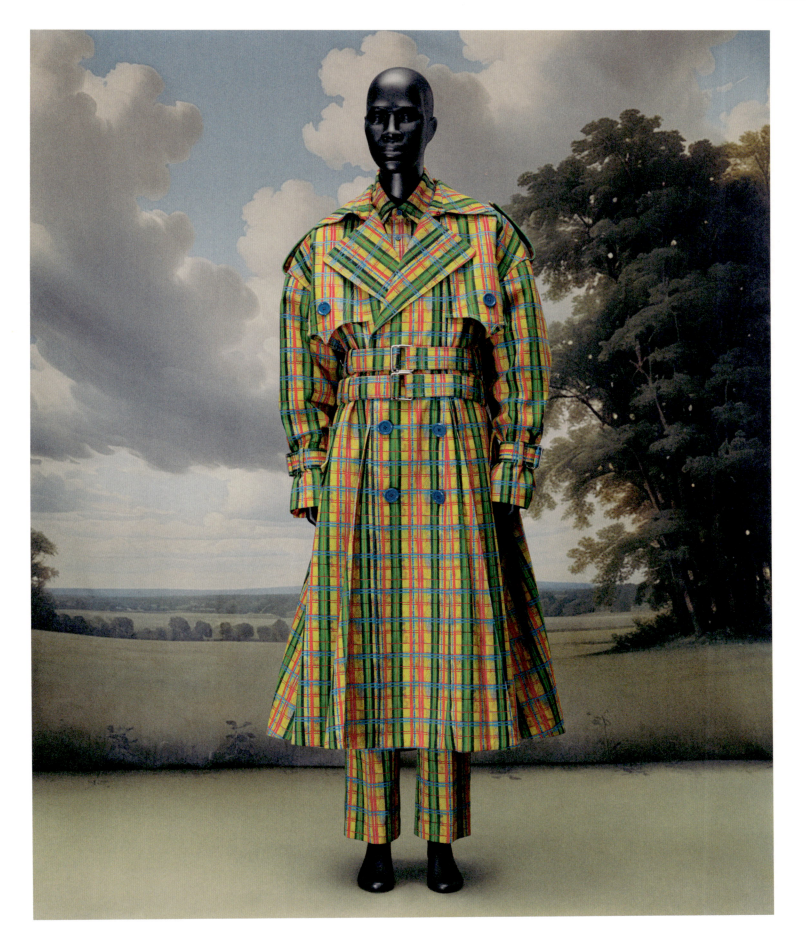

Agbobly. Jacques Agbobly. *Ensemble*, 2024

HERITAGE

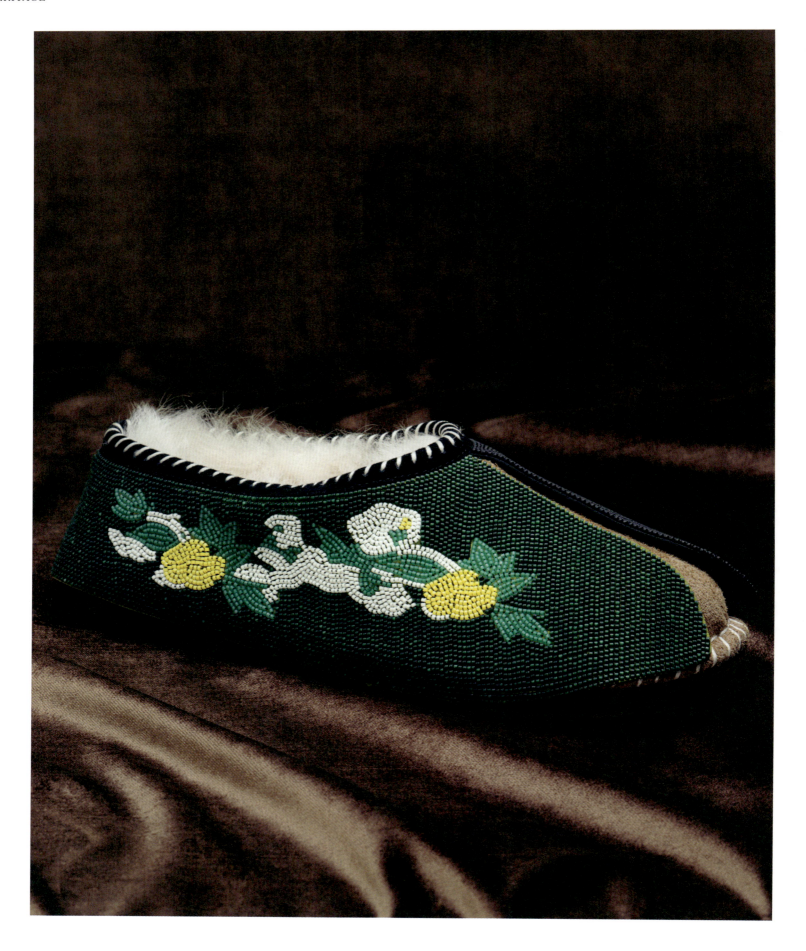

266 Denim Tears. UGG. Tremaine Emory. *"Tasman Onia" slippers*, spring/summer 2022

HERITAGE

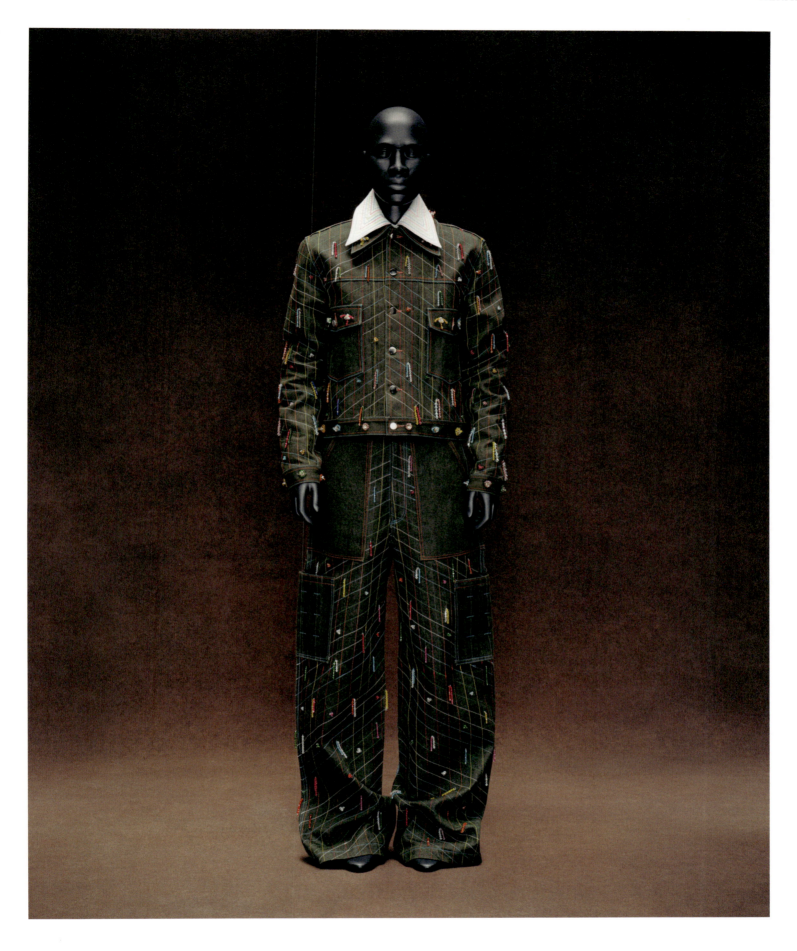

Agbobly. Jacques Agbobly. *Ensemble*, 2023

267

Beauty

"Beauty is not a luxury; rather it is a way of creating possibility in
the space of enclosure, a radical art of subsistence,
an embrace of our terribleness, a transfiguration of the given.
It is a will to adorn, a proclivity for the baroque,
and a love of *too much*."

SAIDIYA HARTMAN
*Wayward Lives, Beautiful Experiments: Intimate Histories of Riotous
Black Girls, Troublesome Women, and Queer Radicals*, 2020

In 1968 the poet Nikki Giovanni wrote "Beautiful Black Men" in praise of what she saw as a flourishing of Black male beauty. Later appearing in "The Black Male," a 1972 special issue of *EBONY* magazine, the ode applauds these "outasight" men for the ways in which they take up space, amplifying self-possession and pride. For Giovanni, this "new breed" of men could be identified by the chic spectacularity of their fashion and grooming: Their "fire red, lime green, / burnt orange / royal blue" clothing and their Afros intensify their desirability and ability to seduce observers. Saying, loudly and affirmatively, "i wanta say just gotta say something / bout those beautiful beautiful / beautiful outasight / black men," she touts the "brand new pleasure" that she and others take in admiring their confidence and the sheer fabulousness of their style and attitude.

In response to the civil rights and Black Power movements and the sexual liberation and gay and lesbian rights movements of the late 1960s, Black men converted their previous social invisibility into a form of radiance that relied on hypervisibility, pride, and flash. This cultural confidence and interest in self-regard allowed for experimentation with atypical modes of masculine dress. With a focus on exposure and aliveness, "Beauty" transitions between historical and contemporary garments that either radiate light or are saturated with color. The attire features drapery, lace, ruffles, and sequins, emphasizing Black dandyism as a mode of dress that approaches and appropriates "the feminine"—sometimes aggressively—as part of its transgressive power. This apparel challenges norms of masculinity, including gender identity and sexuality, in its reinforcement of an "excessive" self-display.

Just as Giovanni's poem anchors "Beauty," so does the iconic Prince Rogers Nelson, who changed the face of fashion. Heels, lace, ruffles, sequins, and color characterize Prince's wardrobe across the many eras of his career and style. These elements embellished his stage wear and personal dress, enhancing the sensuality and sexuality of his bohemian persona, genre-defying music, and virtuoso performance style. Racially ambiguous, gender nonconforming, and sex-positive, Prince used dress to disrupt expectations and push the boundaries of identity and musicianship. In the early part of his career, particularly during the monumental success of his album and film *Purple Rain* (1984), lace-ruffled shirts (p. 274) worn with high-collared, beautifully and closely cut tailcoats became a signature look—a New Romantic version of early nineteenth-century dandyism filtered through the intervening 1960s English dandy. Given that lace conceals and reveals due to its open weave, simultaneously exposing the skin and encasing the body, these shirts functioned as both armor and a provocation for Prince. Feminine and frilly, they enabled him to exude a fierce, somewhat ironic vulnerability.

When used as the fabric for a garment, rather than merely as trim or embellishment, white lace affords a sensual perspective on embodiment, just as it connotes regality, innocence, and purity. Kenneth Nicholson's spring/summer 2019 ensemble (p. 276) pairs wide-legged white trousers with a white lace shirt that features an extended lace volant falling from the left hip, softening the traditional silhouette and evoking both romance and melancholy. In an interview for *Metal* magazine, Nicholson discusses his desire to push boundaries in his designs, saying, "I don't mean to imply that there should never be a uniformity across gender expression[;] on the contrary where all things take on identical expressions we cut ourselves short, and with it lose the diverse array of beauty that can only be found in the richness of collective complexities." For his 2019 graduate collection for Central Saint Martins, Martinique-born and Paris-raised designer Marvin Desroc explored the limits of "gender and blackness," as he recounts to *i-D* magazine. An ensemble from this collection (p. 277) includes a rendering of the nude male chest in meshwork lace, veiling and revealing the musculature (and skin tone) of the wearer beneath, juxtaposing this delicacy with an almost aggressive, oversize bow belt: "The more ridiculous it is, the more I love it, hence these stupid

bows," Desroc explains. Ultimately, his creations are a means of reflecting on his own upbringing, desires, and fears, and are a vehicle for emancipation; as he told *AnOther* magazine in 2020, "I allow myself to live and feel freely, and then observe where those emotions are coming from." His collections are, in his own words, "empathic, honest and nostalgic."

While costume design is often used to play up certain aspects of a performer's personality or add theatricality to the performance itself, for some—like Prince, Sylvester, and Earth, Wind & Fire in the 1970s and 1980s—costume was a constitutive element of their identities as both people and performers. In the late 1970s, "Queen of Disco" superstar Sylvester hit the charts with his LGBTQ anthem "You Make Me Feel (Mighty Real)," bringing his joyous, liberatory message to the world. He never shied away from expressing his own truth as a gender-nonconforming, gay Black artist who dressed in typically masculine or feminine clothing based on how he felt each day. Designed by Pat Campano for Sylvester around 1980, a graphic black-and-white jacket overlaid with shimmering sequins (p. 278) reflects the entertainer's androgynous fabulousness: The suit jacket is both traditional and subversive, its oversize square shoulders recalling not only the tuxedo and zoot suit—icons of hypermasculinity—but also contemporary female ensembles built with massive shoulder pads. Its bold pattern and sparkling embellishment lend further touches of femininity, its flash transforming its formality, its glitter emphasizing its glamour.

In the 1980s, Earth, Wind & Fire similarly used clothing to emphasize their genre-defying musical message of exuberance and vibrancy. Recalling his and collaborator Louis Wells's work for the band in the 1970s, costume designer Vaughn Terry told *Women's Wear Daily* in 2018, "the lights would go down, you'd rip some tuxedos off them and underneath would be glittery clothes." As a group, Earth, Wind & Fire's "beautiful black men" wore nearly every trend that redefined men's fashion from the 1970s to the 1980s: leather and suede, sequins, beading, fringe, and fur, all in a shiny rainbow of colors, as seen in a 1978 photograph of the group by Bruce Talamon (p. 280). A funkiness in dress, music, and dance became part of the band's identity, complementing their performances of "Let's Groove" and "Boogie Wonderland," among many other hits. Taking a cue from another sensual musical tradition, Edvin Thompson of Theophilio is inspired by his native Jamaica's dancehall music scene. Named the 2021 American Emerging Designer of the Year by the Council of Fashion Designers of America, Thompson insisted in *W* magazine in 2023 that his designs are "sexy and sophisticated at the same time," asserting, "I wanted to help build a bridge from my country to the world [with my garments]." His ensembles in multicolor snakeskin leather (p. 281) and blue and green sequins (pp. 282, 283) channel dancehall rhythms and the music's celebrations of bodily pleasure.

"Beauty" closes with pieces that embody the energy of another long-standing provocative, performative, gender-inclusive, and community-building music and dance tradition: Ballroom. French Haitian photographer Chantal Regnault captured the Ballroom community in the 1980s and 1990s, when some of its most iconic innovators, including members of the Pendavis family, were achieving mainstream notice. Her 1990 photographs of Avis Pendavis at Red Zone (p. 284) and the Grandest March Ever at an AIDS benefit at the Palladium nightclub (p. 286) showcase the fierceness and dynamism of performers for whom excessive and elegant gender-transformative fashion provided passage to other, more inclusive and loving worlds, especially during the AIDS crisis. LaQuan Smith's spring/summer 2025 ensemble (p. 285) comprising a bright chartreuse "transparent trench coat" over silk pajama pants floated down the runway, achieving a liberating sashay, while Botter's spring/summer 2023 suit jacket (p. 287) features slits that allow it to transform into a halter top, showing off the shoulders to elicit, as Giovanni's "Beautiful Black Men" proclaims, "the same ol danger / but a brand new pleasure."

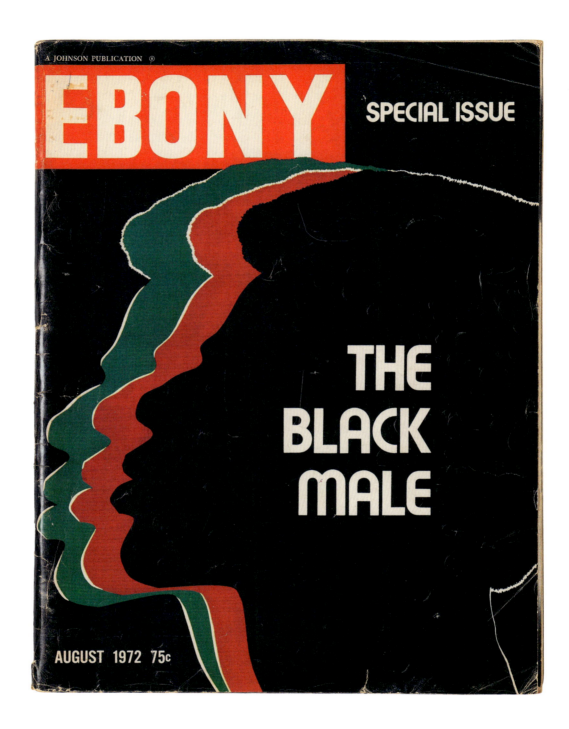

Cover of *EBONY*, August 1972

BEAUTY

THE POWER OF FASHION EDITORIALS IN BLACK MEDIA:
A LEGACY OF CELEBRATION AND INNOVATION

MARIELLE BOBO

Fashion editorials in Black media have long been a vital force in celebrating Black identity and artistry. At a time when mainstream publications largely excluded Black creatives and narratives, Black-owned outlets not only offered representation but elevated Black culture with unmatched innovation. These platforms have used fashion as a form of self-expression and pride, creating visual stories that resonate deeply within Black communities and shape broader cultural narratives.

As a Haitian American woman and a longtime fashion editor, I've seen firsthand how these editorials have impacted our understanding of self-presentation and racial pride. During my tenure as editor in chief and senior vice president of programming at *EBONY* and as fashion director at both *EBONY* and *Essence*, I witnessed the transformative power of these stories. Fashion in Black media has never just been about clothes; it has been a declaration of identity, a reclamation of how Black people see themselves and how they want to be seen.

Since its founding in 1945 by John H. Johnson, *EBONY* has set the gold standard for celebrating Black excellence. Through its monthly publication and its groundbreaking *EBONY* Fashion Fair, the magazine has democratized luxury fashion, bringing couture to Black communities across the globe. Eunice Johnson, cofounder of *EBONY* and the visionary behind the Fashion Fair, traveled to Paris to purchase haute couture designs for the legendary runway shows. The shows brought the exclusivity of high fashion directly to Black audiences, demonstrating that these communities deserved to be at the center of the luxury-fashion conversation.

A lesser-known yet equally impactful part of *EBONY*'s legacy was its dedication to Black men's fashion. From the 1980s through the 2000s, *EBONY* produced issues specifically focused on men and in 1985 launched *EBONY Man* (*EM*), a standalone magazine devoted to showcasing Black men as icons of sophistication and modernity. One standout is the August 1983 suiting editorial titled "Urban Casuals & Classics," styled by Llewellyn Jenkins, which explores polished suiting. It isn't just about style; it redefines Black masculinity, challenging stereotypes and positioning Black men as arbiters of elegance and power. Working for *EM*, photographers like Keith Major created stunning visuals that portrayed Black men in dapper looks, adding dimension to their representation in media.

In my own life, *Vibe* magazine served as a cultural touchstone during the 1990s and early 2000s. Its pages felt like an authentic reflection of my world, blending high fashion with the swagger of hip-hop culture. For the first time, I saw my friends and myself represented in the editorial content—images that paired couture with the irreverent creativity of Black youth. Visionaries like Michaela Angela Davis, Emil Wilbekin, John Moore, Memsor Kamarake, and Rajni Jacques revolutionized fashion storytelling by bridging luxury and streetwear, creating narratives that were aspirational yet deeply relatable. Seeing then-senator Barack Obama on the cover of *Vibe*'s 2007 "Special Juice" issue was a defining moment of effortless coolness: Wearing a crisp button-down, sleeves rolled up, he gazes at the sleek watch on his wrist beneath the bold cover line "It's Obama Time."

In addition to *EBONY* and *Vibe*, publications like *Trace*, *Uptown*, *Essence*, and *Honey* further expanded the boundaries of Black fashion. Photographers such as Matthew Jordan and Barron Claiborne and stylists like Agnes Cammock and Freddie Leiba used these platforms to create visually arresting work, showcasing the ingenuity of Black style. These individuals laid the groundwork for today's generation of Black photographers, stylists, and editors who are now shaping mainstream fashion imagery.

One *Trace* editorial that profoundly impacted me is a 1997 menswear story shot in Jacmel, Haiti, by Haitian-born photographer Marc Baptiste. For me, as a Haitian American woman often yearning for representation that celebrates both my Black and Caribbean heritage, this editorial was transformative. Baptiste's imagery showcases the vibrant beauty of Haiti in tandem with high fashion, offering a rare, aspirational portrayal of my cultural roots. It is a reminder that our stories, too, can occupy the space of luxury and artistry.

While it's heartening to see more Black creatives being tapped by mainstream outlets today, it's crucial to acknowledge the foundational role of Black media. Such outlets provided opportunities for visionaries to publish their work at a time when they were often excluded elsewhere. By celebrating Black culture in its full complexity and beauty, Black media has not only documented trends but also fostered a legacy that continues to inspire.

As *EBONY* marks its eightieth anniversary in 2025, we reflect on the profound impact it and similar publications have left behind. These platforms have illustrated that fashion transcends mere clothing; it's a powerful form of cultural preservation and self-expression. As I grew up, these editorials shaped my understanding of identity, pride, and possibility. They showed me that Black style isn't just a mirror of who we are but a bold proclamation of who we aspire to become.

BEAUTY

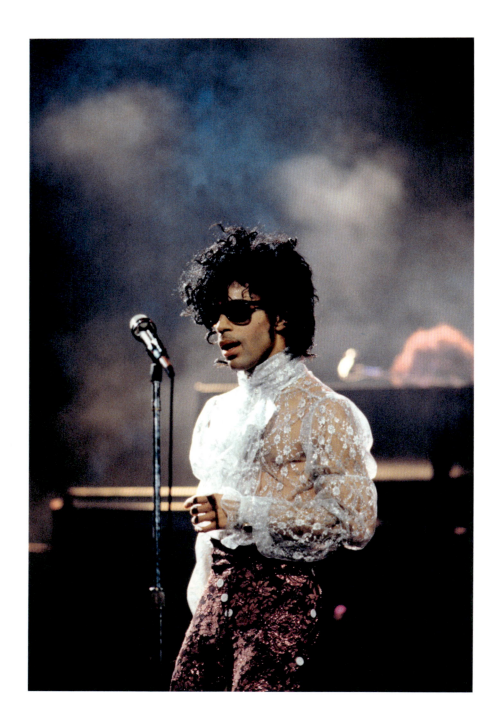

274 Ebet Roberts. *Prince performing on stage—"Purple Rain" tour*, 1985

BEAUTY

ON PRINCE AND LACE

MADISON MOORE

It's the lace blouse that spoke a thousand words: a sheer, long-sleeved cream moment made of an opulent vine-and-leaf pattern, punctuated by pearloid buttons and a fierce high collar, all anchored by three layers of ruffles cascading down the front of the blouse while blue jeweled cufflinks sewn onto the sleeves add even more drama to the look. He has on the matching pants and heels too. Taken together, the ensemble says, "Baby, I'm Prince. *Get into it.*" On November 20, 1984, Prince wore this garment at the Capital Centre in Landover, Maryland, as part of the 1984–85 Prince and the Revolution *Purple Rain* concert tour. During a riveting, acrobatic thirteen-minute encore performance of "Baby I'm a Star," a sweaty Prince unbuttoned the blouse and then snatched it off completely, conveying sex appeal while turning a very demure shirt from a delicate material connoting wealth and royalty into an accessory or prop that buckles and struggles under his pressure.

Over the course of his performance career, Prince Rogers Nelson demonstrated an unyielding affinity for ruffles, sequins, furs, eyeliner, flowers, heels, and lace. YouTuber Chanta-nh8et commented on the 1984 live video performance of "Baby I'm a Star," concluding, "Prince was the only man that could walk into a room wearing lace, makeup and high heels and steal every woman in there." Indeed, as a young queer kid growing up in Saint Louis, desperate for modes and models of Black queerness to emulate and save me from the tyranny of homophobia and bad outfits, I found an opening in Prince's affection for lace and heels.

Prince was a highly visible Black artist who embraced gender play through fashion at a time when there was a broad cultural fear of Black gay men during the onset of HIV. This kind of "fabulous masculinity"—as fashion theorist Ben Barry describes in "Fabulous Masculinities: Refashioning the Fat and Disabled Male Body"—is a kind of remixed masculinity where non-normative male bodies create outfits that "articulate new understandings of masculine embodiment." When I think back on why Prince resonates with me so much as an artist, I realize that it is because I loved that he could be so flamboyant and still

be considered heterosexual. Not that I dreamed of being read as straight, but getting called a "sissy" or worse every day does get exhausting after a while. What Prince taught me at a young age was that it is possible to use fashion to agitate the false tensions, boundaries, and binaries between masculinity and femininity, inciting dandyish gender play through dress. If Prince could get away with it, maybe I could too.

Such an embrace of fashion is a form of dissent, "a social practice that mounts a critique against the hierarchies that order society," as Monica L. Miller notes in *Slaves to Fashion: Black Dandyism and the Styling of Black Diasporic Identity*. This dissent lies at the heart of the history of the Black dandy, where Black dandies contort, hack, remix, chop, screw, and most importantly *test* the perceived edges of identity. For Miller, the Black dandy is a figure who thrives in the indeterminable intersections "between masculine and feminine, homosexual and heterosexual, seeming and being," simultaneously reifying and challenging identity at the flip of a cream lace blouse.

Make no mistake: Prince was *fabulous*, to use the term I apply to queer acts of dress that endorse over-the-top gender play through style as a way to direct the gaze and stretch, expand, and question the limits of binary gender. Anyone can "be" fabulous, but the practice and currency of fabulousness has a more pointed meaning when it is done by those who sit at the margins of society: Black folks, queer folks, trans folks, poor folks, Latine folks, working-class folks, and so on.

The beauty of Prince and his practices of Black stylization lies in how he negotiated the ambiguity of identity one lace blouse at a time. The chase for this obliqueness is why practices of fabulousness typically embrace sumptuous materials like lace, sequins, and fur and accessories like heels and costume jewelry. All of these items, in some way, are larger than life and must be seen—*demand* to be seen—while lending value to bodies that are regularly devalued. Prince teaches us that, for the Black dandy, style and beauty are an important means of seizing some form of personal agency, even if just for a little while, in a world that insists on your erasure.

275

BEAUTY

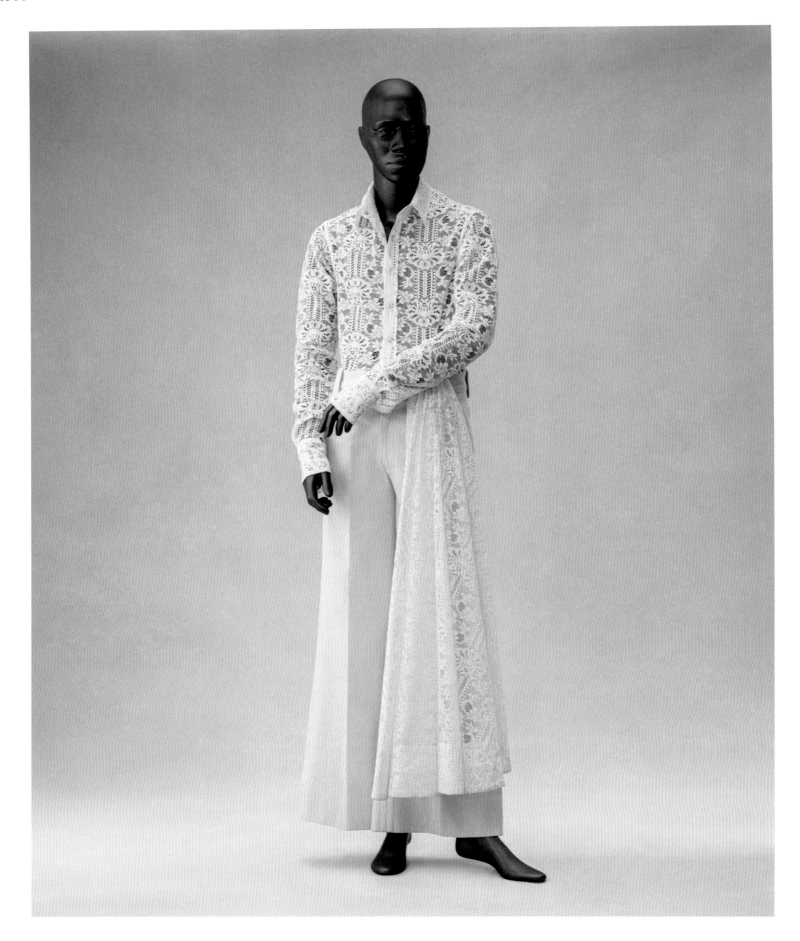

Kenneth Nicholson. *Ensemble*, spring/summer 2019

BEAUTY

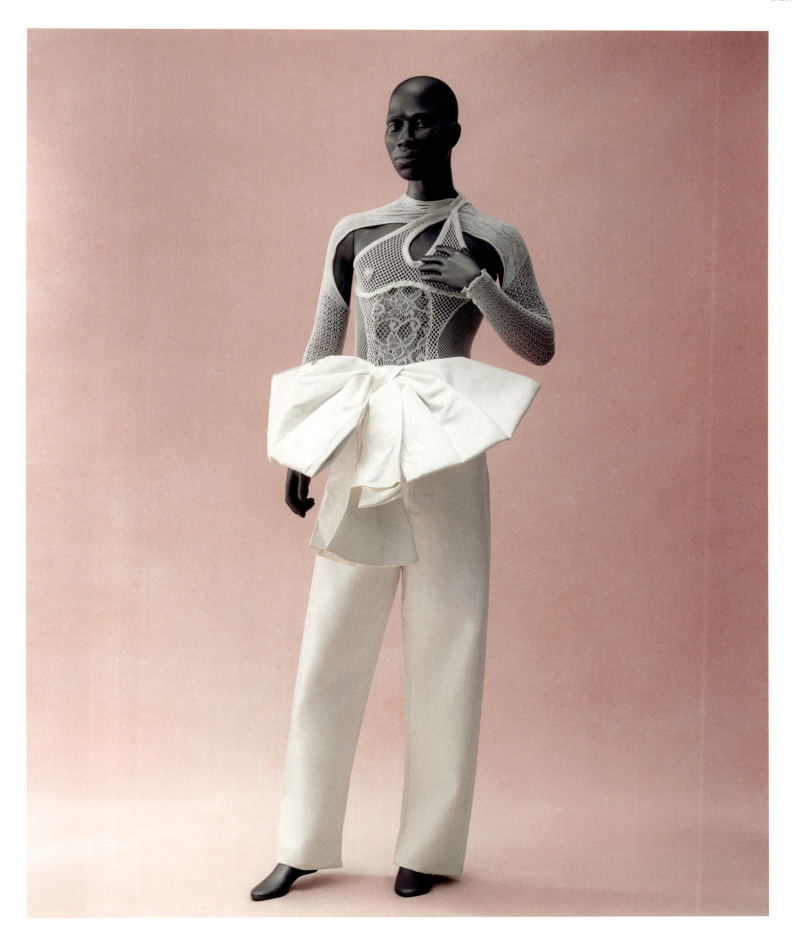

Marvin Desroc. *Ensemble*, 2019

277

BEAUTY

Pat Campano. *Jacket worn by Sylvester*, ca. 1980

BEAUTY

SEQUINS AND CEREMONY: THE RADIANT SYLVESTER

KIMBERLY M. JENKINS

Workin' on my feet in the disco heat / Dancin' through the night 'til / mornin' light shines on me
Again, music makes me dance / Dance, dance, dance

—Sylvester, "Dance (Disco Heat)," 1978

Radiance relates to an object's emission of light or heat, and in 1970s San Francisco, Sylvester James was an eminent source of radiance. In the disco era, his father's namesake was better known simply as "Sylvester," the mononym emblematic of his gender fluidity. Never to be confined to one gender, Sylvester's style shifted freely between masculine and feminine silhouettes. The BBC documentary *Queens of Disco* suggests that he fashioned himself by "working" gender as a daily negotiation, employing materials, colors, textures, and archetypal objects—wigs, suits, dresses, makeup, sequins—that signified either male or female. Resisting the binaries that sought either to categorize him as a "drag queen" or to satisfy the societal expectations of his Black, male, soul-music counterparts, Sylvester's self-fashioned presence revealed the tensions, paradoxes, and amorphous nature that the constructs of race, gender, and sexuality thrust upon him.

Sylvester's relationship with clothing, hairstyling, and accessories evolved into his embrace of androgyny while a member of the San Francisco–based theater troupe the Cockettes, the experience deepening his exploration of performance and stage presence according to Nastia Voynovskaya in "How the World Caught Up to Sylvester." Upon his departure from the company, Sylvester pioneered a sound and vocal styling as well as an aesthetic that could not be defined, though clearly rooted in Black Church gospel and soul music, as examined by Joshua Gamson in *The Fabulous Sylvester: The Legend, the Music, the 70s in San Francisco*. Sylvester introduced the transcendent characteristics of Black gospel to audiences who were unfamiliar with the rapturous call-and-response nature of a religious service, in which the pulpit and the choir provide a blend of didactic and riveting theater for the congregation. He would sometimes say, "We had service," after stirring his audience into a fervor during an ecstatic performance, borrowing the phrase from the Black Church, where it denotes the completion of a collective worship. Not unlike a preacher or a choir, Sylvester acted as a conduit for transporting the audience to the realms of liberation and bliss, using the alchemy of his signature falsetto to ride and ascend over the grounding, pulsating rhythm of his more dance-oriented tunes.

I really believed for a certain time that I was Josephine Baker. In my attitude, in my everything, I was Josephine Baker.
—Sylvester, in Joshua Gamson, *The Fabulous Sylvester*, 2005

In perfecting his stage presence, Sylvester chose costumes and a comportment that embodied the tradition of Black women performers he admired, such as Joséphine Baker and Patti LaBelle, as observed by Gamson as well as David Masciotra in "Queen of Disco: The Legend of Sylvester." (Masciotra notes that Sylvester performed

LaBelle's song "You Are My Friend" at San Francisco's War Memorial Opera House for the recording of his live album, *Living Proof*.) The singer had a penchant for Old Hollywood glamour. His wardrobe wove contemporary garments and accessories with vintage finds. Matthew S. Bajko's 2019 article in the *Bay Area Reporter* recounts how, by the 1980s, Sylvester began collecting suits and jackets from the sought-after San Francisco–based designer Pat Campano, who had gained fame for his detailed costumes for the theater and entertainment industries—the Supremes being among his clients a decade prior. Frequently featuring sequins, beads, silks, and organdies, Campano's work elevated and animated Sylvester's flamboyant performances, which demanded luminescence and texture for maximum impact. Profiling the exhibition *Queer California: Untold Stories*, Bajko describes how sweat stains mark all of Sylvester's archival pieces, a testament to the labor and physical exertion of an entertainer who prioritized giving the audience a spectacle, delivering ecstasy at the mercy of the unbreathable materials.

Sylvester's wardrobe acquisitions testify to his keen attention to quality and representation. The GLBT Historical Society holds a collection of his meticulously crafted suits. Gradations of hot pink cover one example; gradations of blue, another; both could be a play on the conventional colors assigned to gender. And the black-and-white sequined jacket opposite suggests an interplay of racial consciousness. Like other garments by other designers of the time, the 1980s archetypal silhouette of this Campano jacket situates Sylvester's sartorial sensibility alongside fellow sophisticated Black music icons like Phyllis Hyman and Luther Vandross. These artists balanced the masculine angularity of their silhouettes with the feminine luminosity of sequins and bold colors.

Sylvester used fashion objects and the act of fashioning as a mode of self-determination, carving out a space for himself to survive and thrive amid occasional alienation from the Black (traditional) community and the (predominantly white) gay community. He incorporated sequins and glitter with masterful intent—unavoidable, undeniable, and unyielding. In "Sylvester 'Mighty Real': A New Generation Looks to the Late 'Disco Queen' as a Role Model," Tony Bravo notes how the sound of jangling jewelry preceded Sylvester's entrance, and he took up space through the wingspan of a kimono or a broad fan of feathers, his eventual exit perhaps leaving behind a trail of shimmer. The 1970s and 1980s sociopolitical landscape—in comparatively safe havens like San Francisco—enabled Sylvester to experiment with what liberation looked, felt, and sounded like. The bridge that disco offered into the 1980s allowed androgynous dress and presentation to enjoy freedom of expression with provision, thanks in part to the fabulous Sylvester. The sun would set on his life before the end of the decade.

279

BEAUTY

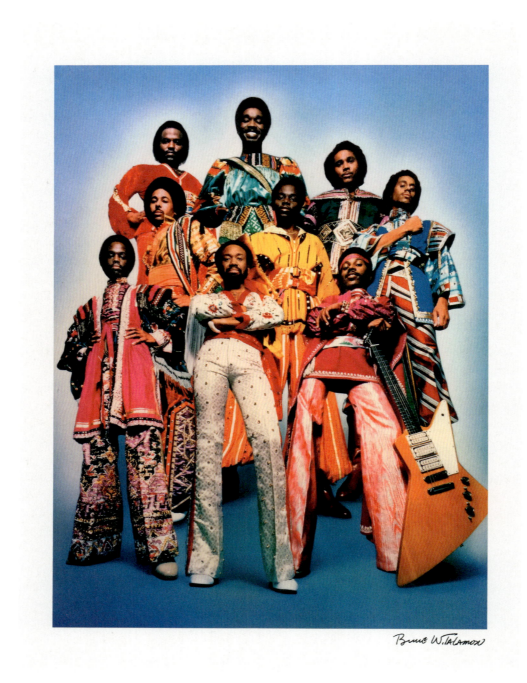

280 Bruce Talamon. *Earth Wind and Fire*, 1978

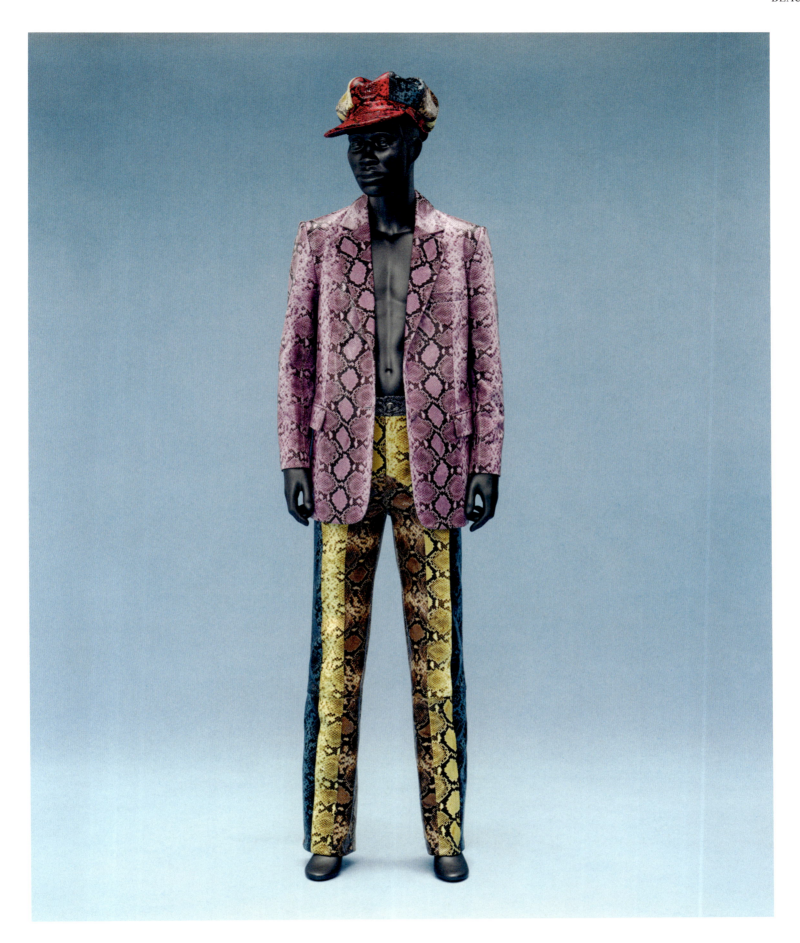

Theophilio. Edvin Thompson. *Ensemble*, spring/summer 2024

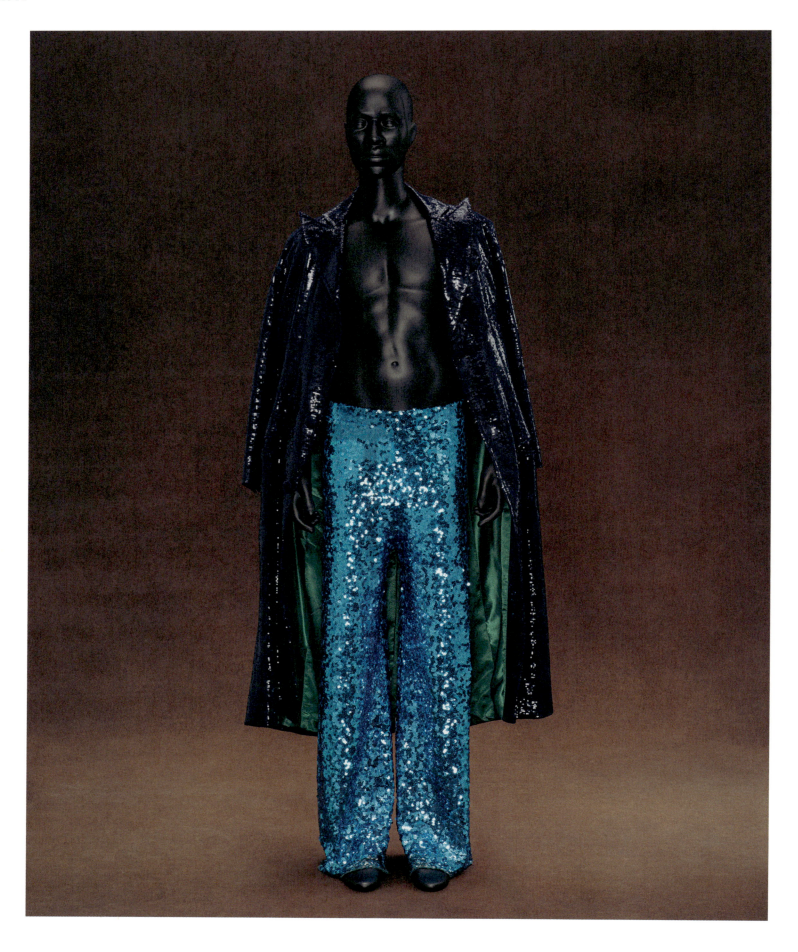

Theophilio. Edvin Thompson. *Ensemble*, spring/summer 2025

BEAUTY

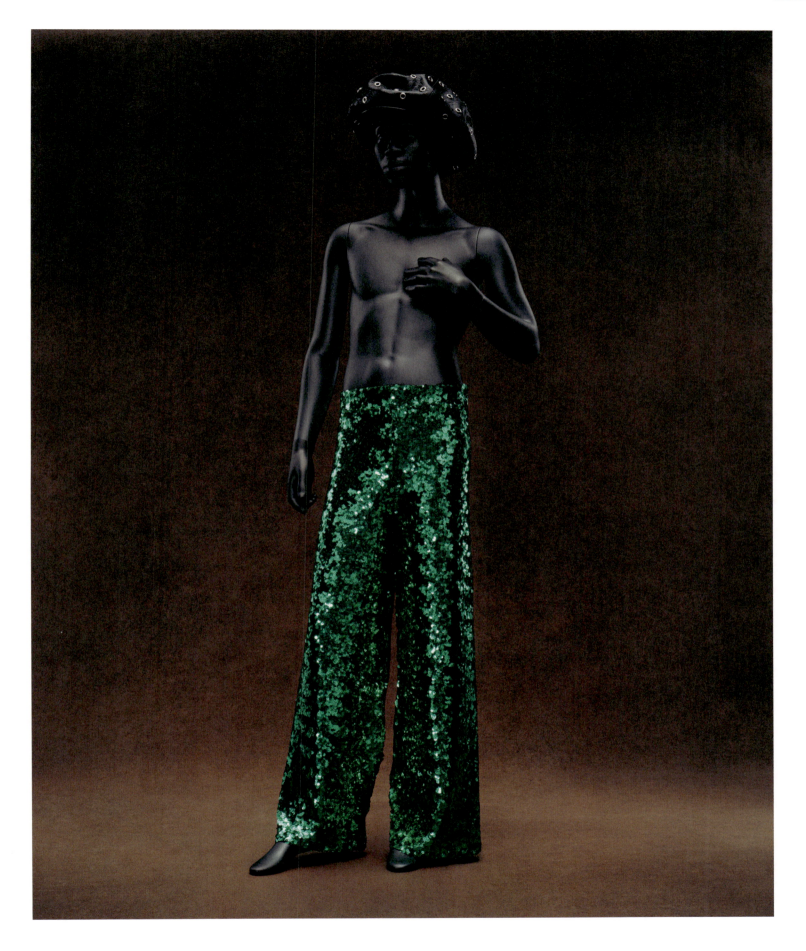

Theophilio. Edvin Thompson. *Ensemble*, spring/summer 2025

BEAUTY

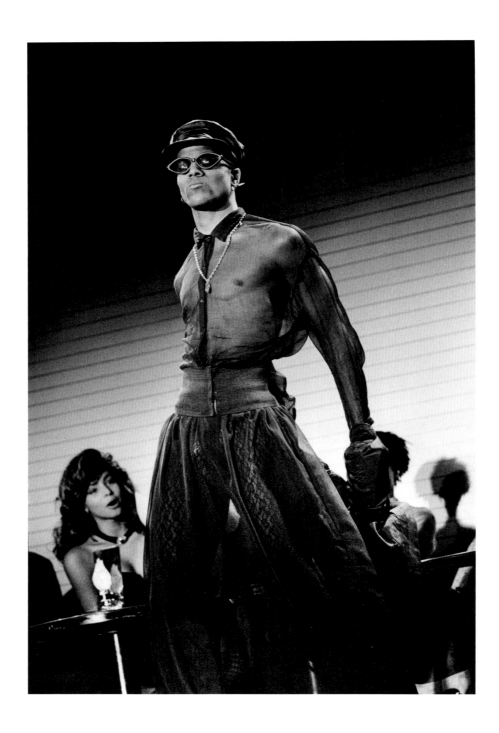

Chantal Regnault. *Avis Pendavis Ball, Red Zone*, 1990

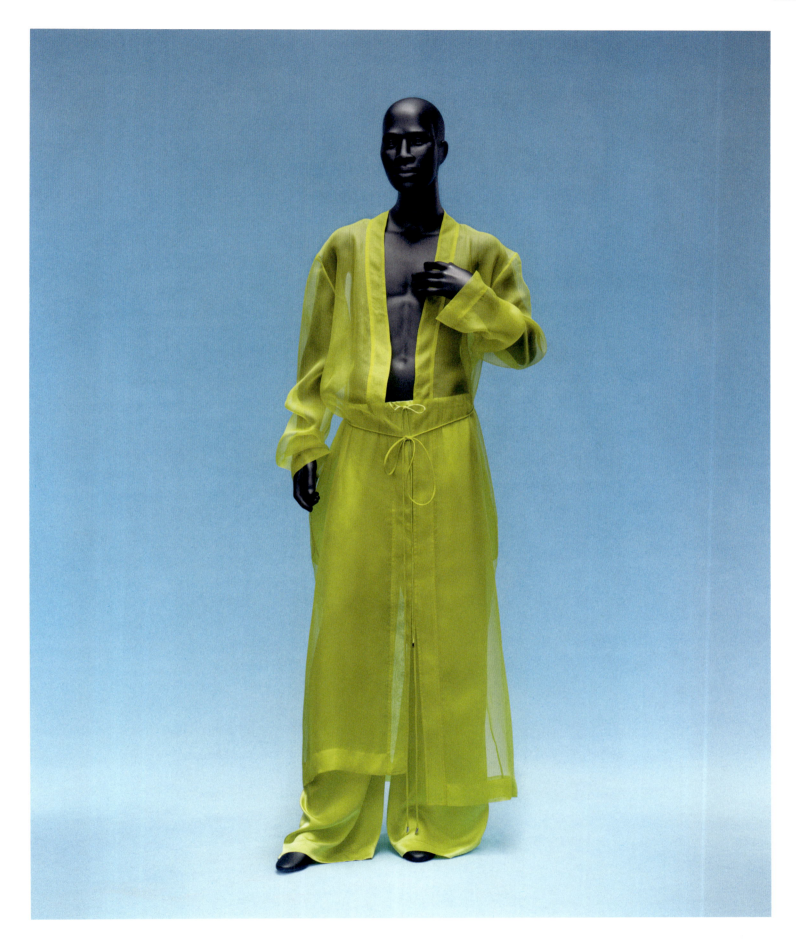

LaQuan Smith. *Ensemble*, spring/summer 2025

BEAUTY

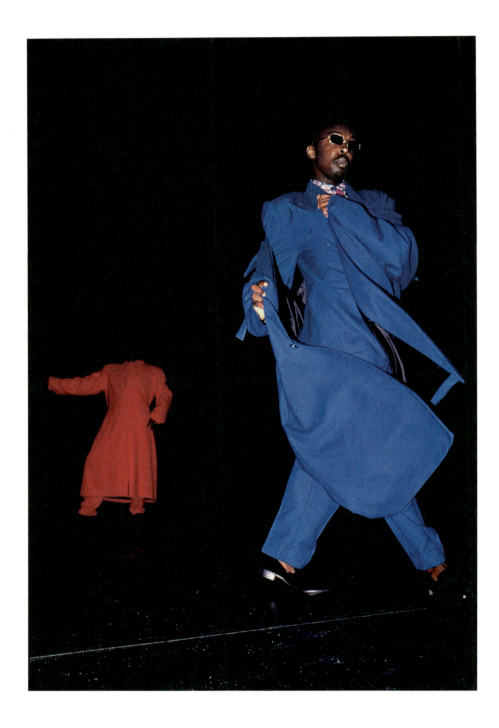

286 Chantal Regnault. *Grandest March Ever Aids Benefit, Palladium 1990 Darryl Overness*, 1990

BEAUTY

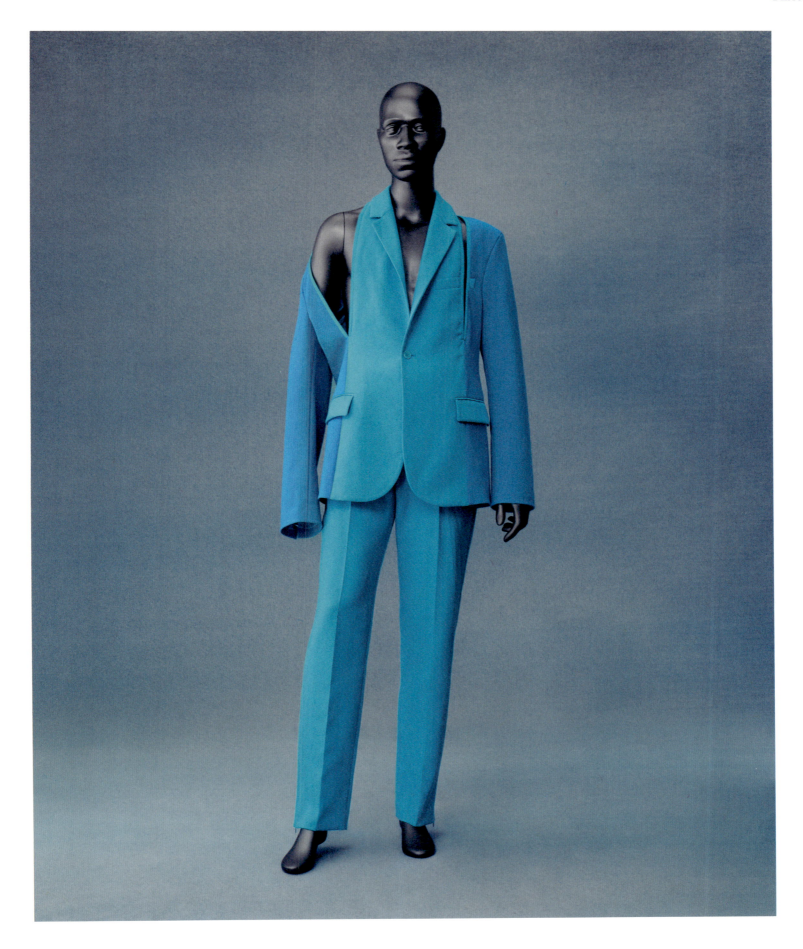

BOTTER. Rushemy Botter and Lisi Herrebrugh. *Suit*, spring/summer 2023

Cool

—◦—

"Being rebellious and black, a nonconformist, being cool and hip and angry and sophisticated and ultra clean, whatever else you want to call it— I was all those things and more."

MILES DAVIS
Miles: The Autobiography, 1989

The turn to exquisitely styled casual dress in the 1960s, 1970s, and 1980s revolutionized fashion. Black designers and wearers were at the center of redefining how people dress and show up—as themselves—to work and play. Resisting authoritative norms of dress, they donned khaki, knitted cardigans, tracksuits, and denim, which came to manifest the art of being unbothered and dexterous. This easeful form of Black dandyism sartorially communicates "cool," an undefinable concept that one recognizes when one sees or experiences it. This cool pose relies on the creation of a mood or atmosphere, in which fashion, accessories, posture, and gait come together, attracting notice and producing desire.

"Cool" begins with the Kariba suit, which replaced Western suiting as official formal dress in Jamaica in the early 1970s. A lightweight two-piece suit, worn without a shirt and tie, the Kariba (or Kareeba) was designed by couturier Ivy Ralph and "liberated" Jamaican men from "the tyranny of jacket and tie," per a March 24, 1976, *New York Times* article. Made for the Caribbean climate, the shirt (p. 293) was an element of decolonization and a symbol of independence. Jamaican prime minister Michael Manley (p. 292) and members of his People's National Party adopted the Kariba for governmental and formal occasions, including Manley's 1976 visit (in a black Kariba) with Great Britain's Queen Elizabeth II. Available in both bright and dark colors, long and short sleeves, as well as formal and "sport" versions, Karibas also became popular in other Caribbean and African nations.

While perhaps not intending to buck fashion norms, President Barack Obama wore a tan suit in August 2018, igniting controversy by seemingly tapping into anxieties about political authority and comfort. He appeared, to some, nonchalant and perhaps overly at ease. Presidential candidate Kamala Harris reignited this debate when she wore a tan pantsuit to the Democratic National Convention in August 2024, in a nod to Obama and another groundbreaking candidate and fan of the pantsuit, Hillary Clinton. British Jamaican designer Bianca Saunders's tan suit from her autumn/winter 2022–23 collection (p. 294) exemplifies her desire to make "tailoring relevant to men in a casualized world," as Sarah Mower notes in a January 19, 2022, review for *Vogue*. The jacket is cleverly structured as a pullover with concealed press buttons and expresses what Saunders describes as the "comfort, and feeling at home" that drive her design practice.

The 1965 Watts Rebellion might seem like an unlikely moment in fashion history. And yet, as photographed for *Life* magazine by Bill Ray (p. 298), young Black Watts residents in 1960s America nevertheless showcased an emerging effortless style. Images from the July 15, 1966, issue, taken to mark the previous year's events, feature stylish young men idly hanging out due to chronic unemployment while anticipating further confrontations with racist police. Media coverage of this and other signal moments in civil rights history brought Black style to a wider audience, creating both curiosity and fear. But here, expertly positioned as if in a fashion editorial, Watts residents wear colorful cardigans, slim trousers, jeans, porkpie hats, and sunglasses that evoke the tailored but casual aesthetic of iconic jazz musicians of the 1950s and 1960s, such as John Coltrane and Miles Davis, who embodied midcentury American cool. Davis, in particular, epitomized the mid-1950s laid-back "Ivy style," wearing Brooks Brothers garments like tailored blazers (sometimes in seersucker or madras), khaki pants, and button-down Oxford shirts with Bass Weejuns loafers. Even though many Black people at the time "adopted the style in order to be perceived as acceptable in the eyes of the mainstream," as Graham Marsh and Jason Jules note in *Black Ivy: A Revolt in Style*, these individuals instead gave "the style an edge and attitude that it would have otherwise lacked."

It is a look that endures, as seen in a luxurious version by Virgil Abloh for Louis Vuitton from autumn/winter 2021–22 (p. 299). Grace Wales Bonner also reinterpreted the classic aesthetic in an

iteration evoking the more tailored style of Coltrane: Her two-tone, brown wool patch-pocket suit (p. 301) is an homage to the lover's rock music scene created by Afro-Caribbean youth in 1970s South London (p. 300). In show notes, she declares that lover's rock aficionados "are defiantly elegant in their swagger and eclectic in expression. Hippie sensibilities. Conservatism of dress rejected. Identity performed with chest-up pride."

A Great Day in Hip Hop, Harlem, New York (p. 304), Gordon Parks's 1998 remix of Art Kane's 1958 photograph *Harlem* (p. 296), depicts the hip-hop community at the height of its power and popularity, celebrating the spectrum of cool defined by Black musicians from the mid to late twentieth century. The bespoke jacket made for Jam Master Jay of Run-D.M.C. by Dapper Dan (p. 305) encapsulates some of the defining elements of hip-hop style that emerged in the genre's ascendance in the 1980s: The fashion reconceptualized cultural symbols, like luxury brand logos, by imbuing them with a slouchy, casual edge. Dapper Dan's Harlem boutique at 125th Street and Madison Avenue was the center for 1980s cool during the golden age of hip-hop. "I was just creating what we liked. I never thought of myself as an artist, or in any fashion-industry terms," Dapper Dan declares in his memoir, *Dapper Dan: Made in Harlem*. Nevertheless, he designed sportswear that came to represent an era. DJ Kool Herc's fly denim ensemble (p. 302), also a signature of hip-hop fashion, is echoed here in Bianca Saunders's spring/summer 2023 denim ensemble (p. 303). True to her aesthetic, Saunders "takes a generic template" like a denim suit and reworks it until "all the oldness and ordinariness is wiped clean away and replaced with her relaxed, but never sloppy, sense of dressing smartly," as Sarah Mower explains in a June 22, 2022, *Vogue* article.

Along with the denim suit, the iconic tracksuit replaced the three-piece suit as "casual formal" wear for young urban folks in the 1980s and 1990s. Street-style photographer Jamel Shabazz's images from the 1980s (p. 308) document the ubiquity, relaxed elegance, and colorful impact of the garment. Even fashion trailblazer André Leon Talley enjoyed the fit and function of the tracksuit, owning several versions by Juicy Couture embroidered with titles like "Emperor" (p. 307), "Tsar," and "King of the Universe." Pelle Pelle brand leather jackets with bold, often polychrome pieced and embroidered designs graced the shoulders of hip-hop legends and stylish urban men in the 1980s and 1990s. In 2025 Who Decides War designers Ev Bravado and Téla D'Amore collaborated with Pelle Pelle, paying tribute to the label's function as a streetwise archive of Black history by embossing coats (p. 306) with what they call "our Mount Rushmore": portraits of Martin Luther King Jr., Barack Obama, Frederick Douglass, and Malcolm X.

The colorful, contrasting striped polo or rugby shirt (often by Ralph Lauren) is also recognized as a hip-hop staple, forming a 1980s analog to the button-down shirt so popular in the 1960s as a symbol of fashionable casual cool. Hip-hop artist and Lo Life founder Thirstin Howl the 3rd's 1999 song "Bury Me with the Lo On" requests, "Aiyo son make sure that my casket / Is filled with the fantastic, polo classics." The rap commemorates the Lo Lifes, a group of Brooklyn teens infamous for boosting (or stealing) 'Los (or Ralph Lauren Polo shirts) in the 1980s. Howl captured the Lo Lifes' outlaw exuberance in his music and collection of portraits from the era (p. 310). An updated "couture" version of the polo (p. 311)—oversize and sculptural, with raw-edged appliquéd stripes—is a signature garment for Rushemy Botter and Lisi Herrebrugh of Botter. The shirt demonstrates their commitment to "realistic dressing" both in terms of style and sustainability, as the vibrant blue color alludes to our connection to the ocean and the climate crisis. Riffing off of these now-canonical easeful looks, contemporary designers have elevated them to high fashion while still preserving their ability to communicate cool composure.

COOL

Michael Manley, Prime Minister of Jamaica, 1972–1980 and 1989–1992

Ivy Ralph OD. *"Kareeba" shirt*, 1970s

COOL

294 Bianca Saunders. *"Pull Over" ensemble*, autumn/winter 2022–23

TAILORING PERCEPTION: POWER, IDENTITY, AND OBAMA'S TAN SUIT

AMY SHERALD

In a world where the fabric of identity intertwines with the threads we wear, President Barack Obama's choice of a tan suit on August 28, 2014, became a cultural flashpoint, igniting discussions that transcended the realm of fashion. The uproar surrounding that seemingly innocuous outfit—an ensemble that echoed the sartorial choices of his predecessors like Ronald Reagan and George H. W. Bush—revealed deeper tensions between formality and informality, particularly within the context of Black dandyism. Here, the act of dressing became a profound statement of self-perception and societal expectation.

Historically, the presidency has often been a stage for the most formal of wardrobes, where power is cloaked in dark suits and crisp ties. Yet this aesthetic has evolved, particularly during the cultural revolutions of the 1960s, 1970s, and 1980s, driven by a desire for authenticity over rigidity. As Monica L. Miller poignantly notes in *Slaves to Fashion: Black Dandyism and the Styling of Black Diasporic Identity*, fashion is not merely about clothing; it is a manifestation of one's identity and a reflection of cultural narratives. Obama's tan suit, an emblem of leisure and a departure from convention, was interpreted as a challenge to long-standing norms, inviting scrutiny into the intersection of race, representation, and image making.

The response to Obama's outfit was about not merely the suit itself but the symbolic weight it carried. While previous presidents had donned similar garments without a second thought, Obama's choice was dissected through a racial lens, revealing the ways in which Black bodies are often policed in spaces of power. To wear a tan suit as a Black man in the highest office of the land was to flirt with the boundaries of what is deemed "presidential." Congressman Peter T. King's condemnation of the suit as indicative of a "lack of seriousness" underscored how the sartorial choices of a Black president were scrutinized under a microscope of racialized expectations.

This tension between formality and informality resonates deeply within the legacy of Black dandyism, a movement that celebrates the art of self-presentation and the defiance of societal constraints. The leisure suit, emerging from a historical context of resistance to rigid norms, embodies a spirit of unbothered elegance. It is a garment that speaks to the dexterity required to navigate spaces that often attempt to box individuals into narrow definitions. In this way, Obama's tan suit became a canvas onto which the complexities of race, identity, and representation were painted.

As I reflect on my own work, the use of color in my portraits serves as a visual dialogue about race and representation. The hues I choose are deliberate; they speak to the beauty of Black skin while challenging the often monochromatic narratives imposed by society. In this light, Obama's choice of a lighter suit can be seen as a reclamation of space—a celebration of the multifaceted identities within the Black experience. Just as I strive to capture the essence of my subjects through grisaille, Obama's suit became a medium through which to explore the nuances of Black representation in a predominantly white institution.

The tan suit served as a reminder that fashion, like art, is steeped in cultural significance. It challenges the viewer to reconsider preconceived notions of authority, seriousness, and identity. A portrait of John Adams in a tan suit hangs in the National Portrait Gallery, a testament to the historical continuity of such choices. Yet, when viewed alongside Obama's attire, it becomes evident how the interpretation of similar garments shifts dramatically depending on the wearer's race.

In an era where casual formality began to redefine the landscape of fashion, Obama's tan suit emerged not just as a style choice but as a bold statement of ease and authenticity. It encapsulated a moment where the complexities of race, identity, and power converged, reminding us that fashion is an act of self-definition—one that can either constrain or liberate, depending on who wears it and how they choose to show up in the world.

COOL

Art Kane. *Harlem*, 1958

LIKE GODS: JAZZ MUSICIANS, AGENTS OF FREEDOM AND COOL STYLE

ALPHONSO D. MCCLENDON

A distinct way of performing, behaving, and dressing emerged through the art of jazz musicians who honed their skills in Alabama, Louisiana, Mississippi, Texas, and other locales at the turn of the twentieth century. With roots severed from West Africa and the West Indies, these griots created a uniquely American rhythm that emanates freedom of expression, struggles for humanity, community bonding, and narrations of life. The music, born of hardship, gained immense popularity and spiritual devotion by reflecting life's delight and sorrow through sound. Jazz musicians fused the music and self-presentation to reject the marginalization of Black people and promote their modern dandy status. Dizzy Gillespie, an American trumpeter and composer, summarizes the universality of the music developed in New Orleans in his autobiography *To Be, or Not . . . to Bop: Memoirs.* He explains, "It shares the rhythmic content of African music, music of the Western Hemisphere and various lands of the East, and has merged this rhythm with European harmonies, the soul of the slaves, the blues, and the spirituals to create jazz."

In *Treat It Gentle,* American soprano saxophonist and clarinetist Sidney Bechet emphasizes the essence of the music, declaring that musicians were showing the community how to be happy: "There's a pride in it, too. The man singing it, the man playing it, he makes a place[,] . . . the place he's been looking for." The dynamic intersection of a people confronting racism and inequality, the creation of an American art form, and the act of dressing the body yielded a symbiotic relationship between music and fashion, imparting influential identities and showmanship. There is a designation of supremeness in this music. Louis Armstrong, an American trumpeter, vocalist, and bandleader, articulated the divine regard of a jazz musician in early 1920s Chicago. In selected writings compiled in *Louis Armstrong, in His Own Words,* he emphasizes that they "were treated and respected just like—some kind of a God." Continuing this theme, in a 2010 interview with this author, writer and jazz musician Michel Fontanes noted the impression of Black American musicians in Paris after World War II: "They were considered in France as Gods."

JAZZ SHOWMANSHIP

Musicians contested the hardships of racial segregation with being well dressed in organized groups with elite names like the Superior and Original Tuxedo Orchestras. From the late 1800s to the 1920s, standards of formal dress—mandarin collars, fully buttoned coats, regimental stripes, suits, bow ties, and caps with emblems—signified structure, cohesiveness, and authority. These African American and Creole marching bands, brass bands, and orchestras with artistry and refinement challenged racial constructs and blurred the lines of class difference. They often performed for whites-only audiences, and their formal dress, grooming, and conduct regulated by the bandleader provided nearness to the privilege and wealth not accessible to them.

MODERN DANDY

Subsequently, the music got hot, birthing the Harlem Renaissance and the Jazz Age. This wild, swinging, and unapologetic syncopated rhythm became influential and popular American music from the 1920s to the 1940s. Jazz performers projected a new attitude and visual of Black success and liberation, expanding the culture globally. Armstrong, Bechet, Benny Carter, and others exported jazz culture and aesthetics to London, Paris, and Copenhagen. Dandified jazz men and goddess-like songstresses were surreptitiously observed by white society and worshipped by Black Harlem, Philadelphia, Chicago's South Side, and Kansas City. The polished identities of Duke Ellington and Count Basie, American pianists and composers, were presented in media and on film and screen, countering negative Black representations that still thrived.

COOL STYLING

From the 1940s to the 1960s, widespread appropriation of jazz characteristics bred contempt, and a modern sound developed, accompanied by a hip attitude, an intellectual and defiant manner, and a cool way of being. Jazz withdrew from popular tradition into a realm of specialization. Performers adopted casual styles on stage, donning leisure suits and long-sleeved knitted polos. In smoky nightclubs, musicians adorned themselves with berets, fitted jackets, slim neckties, narrow trousers, pointed-toe shoes, and sunglasses. The mature jazz dandy in possession of these new sartorial sensibilities challenged the fragmentation of modern music, the erosion of celebrity status, and the reduction of earnings.

ENDURING JAZZ AESTHETIC

Over decades, jazz artists flourished with unimaginable technical skill and produced accentuated fashion transformations, often at their own peril. In a November 1956 interview with Mike Wallace for *Night Beat,* the American jazz singer Billie Holiday declared, "We try to live one hundred days in one day and we try to please so many people . . . sing this way and sing that way . . . and eat all the good foods and travel all in one day and you can't do it." The exhaustion of wielding virtuosic newness and combating cultural, social, economic, and political oppositions had its toll. What endures alongside the elegance and suave resistance of Louis Armstrong's tuxedo, Duke Ellington's tilted top hat, Charlie Parker's glen plaid suit, and Dizzy Gillespie's goatee and horn-rimmed eyeglasses are the extraordinary rhythms, harmonies, melodies, vocals, foot tapping, and finger snapping of living, creating, and expressing freedom and improvisation fueled by human adversity.

COOL

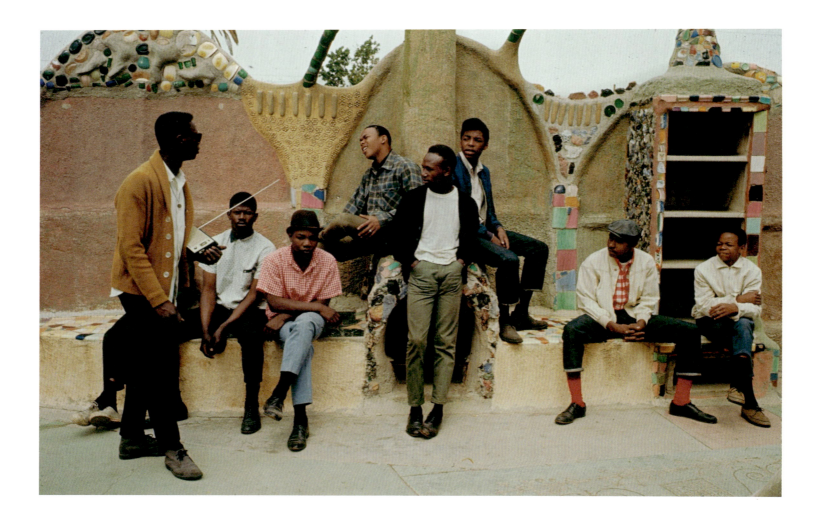

Bill Ray. *At the Watts Tower*, 1966

COOL

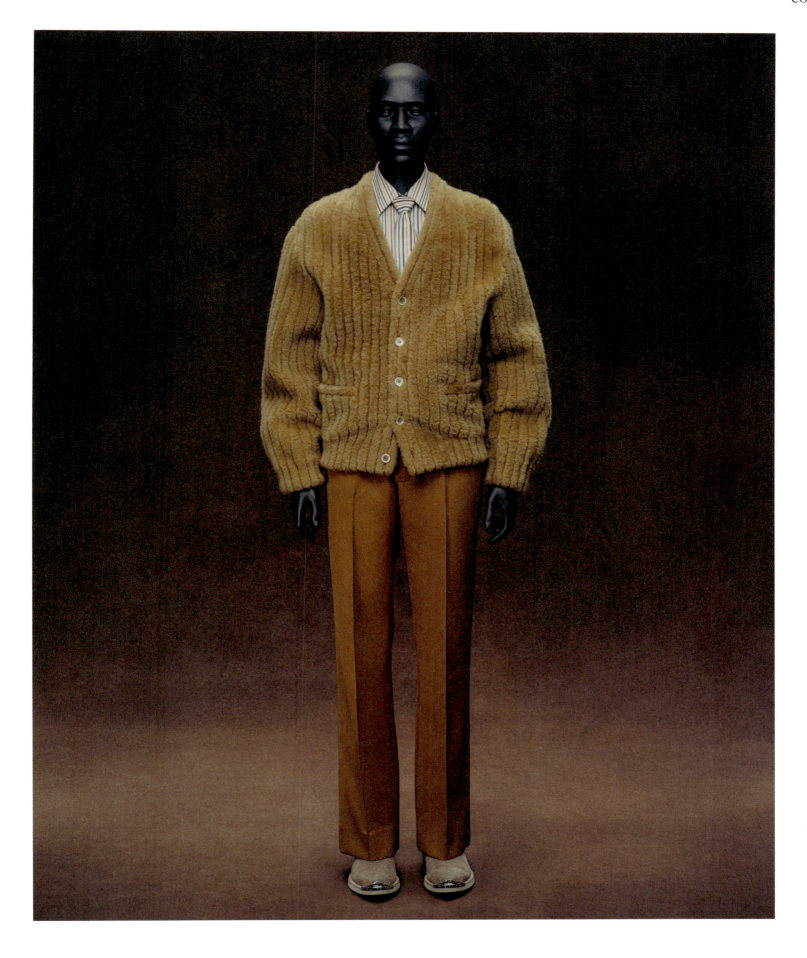

LOUIS VUITTON. Virgil Abloh. *Ensemble*, autumn/winter 2021–22 menswear

COOL

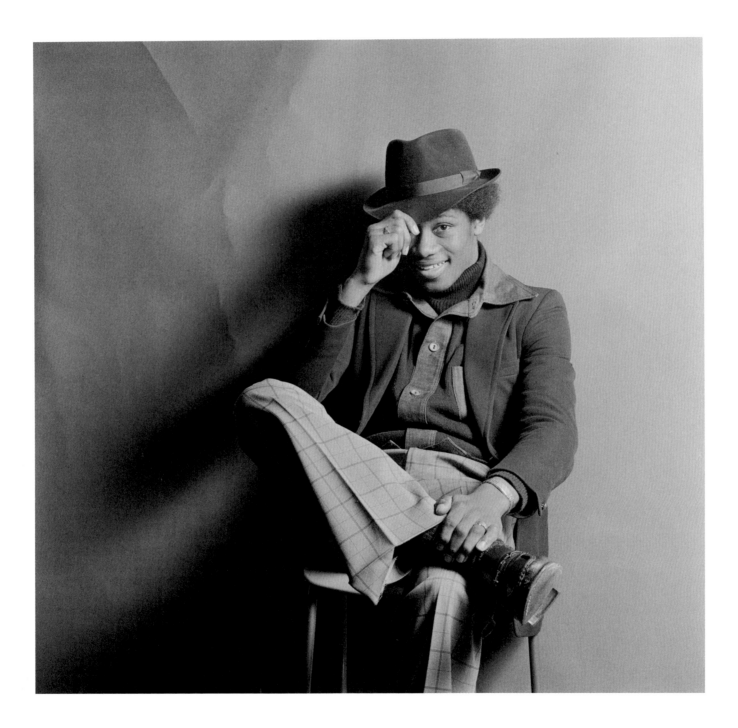

John Goto. *Untitled*, from Lover's Rock series, 1977

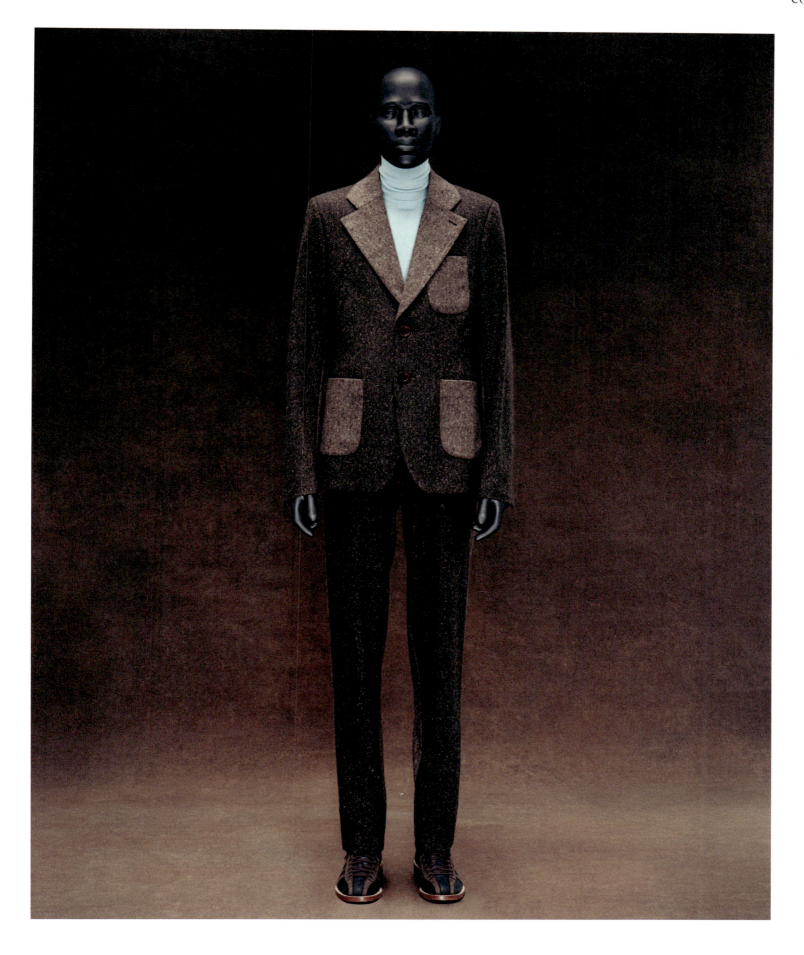

Wales Bonner. Grace Wales Bonner. *Ensemble*, autumn/winter 2020–21

COOL

DJ Kool Herc. American (ca. 1985)

Bianca Saunders. *Ensemble*, spring/summer 2023

COOL

304 Gordon Parks. *A Great Day in Hip Hop, Harlem, New York*, 1998

Dapper Dan of Harlem. Daniel Day. *Jacket worn by Jam Master Jay aka Jason Mizell*, 1987

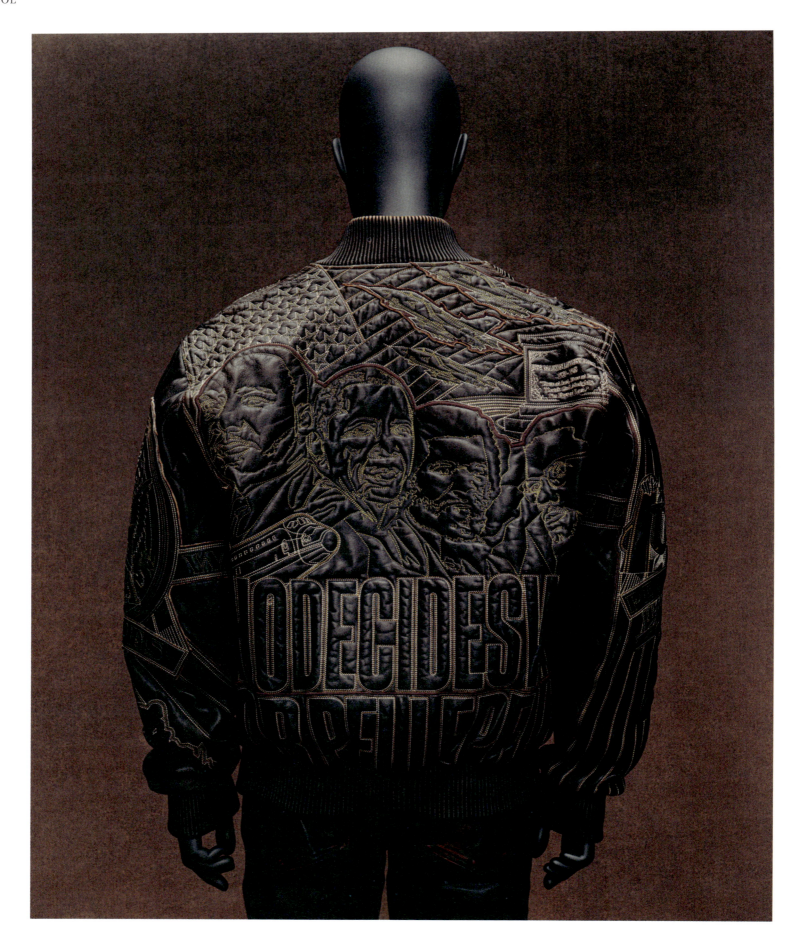

COOL

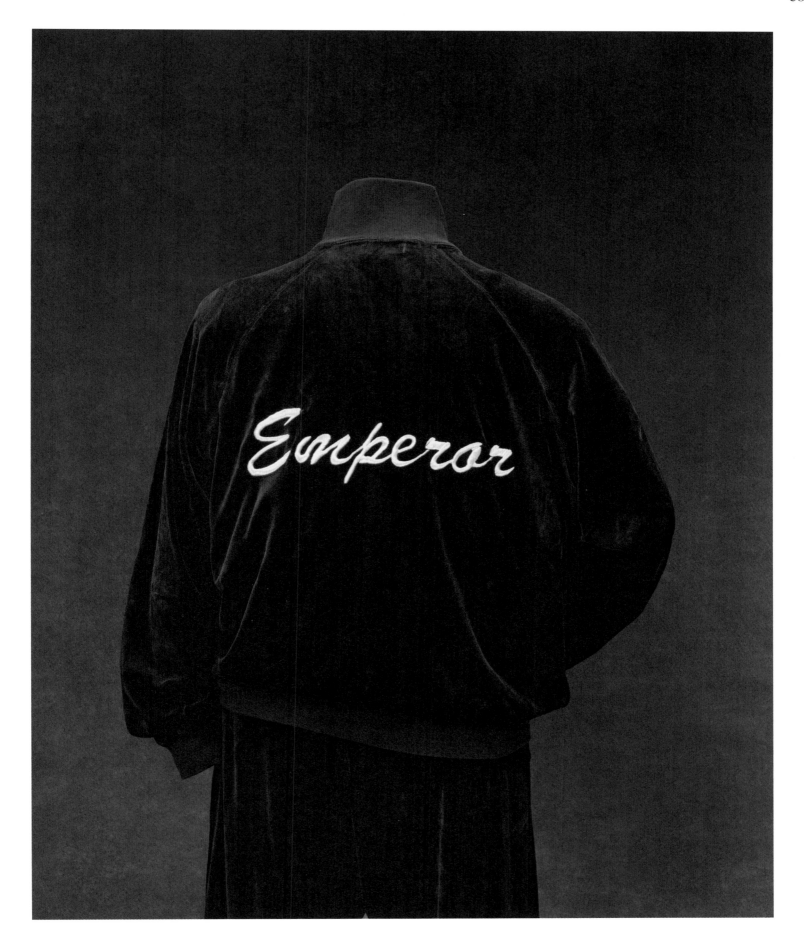

Juicy Couture. *Tracksuit*, ca. 2004

COOL

308 Jamel Shabazz. *Untitled*, three photographs from Back in the Days series, 1985

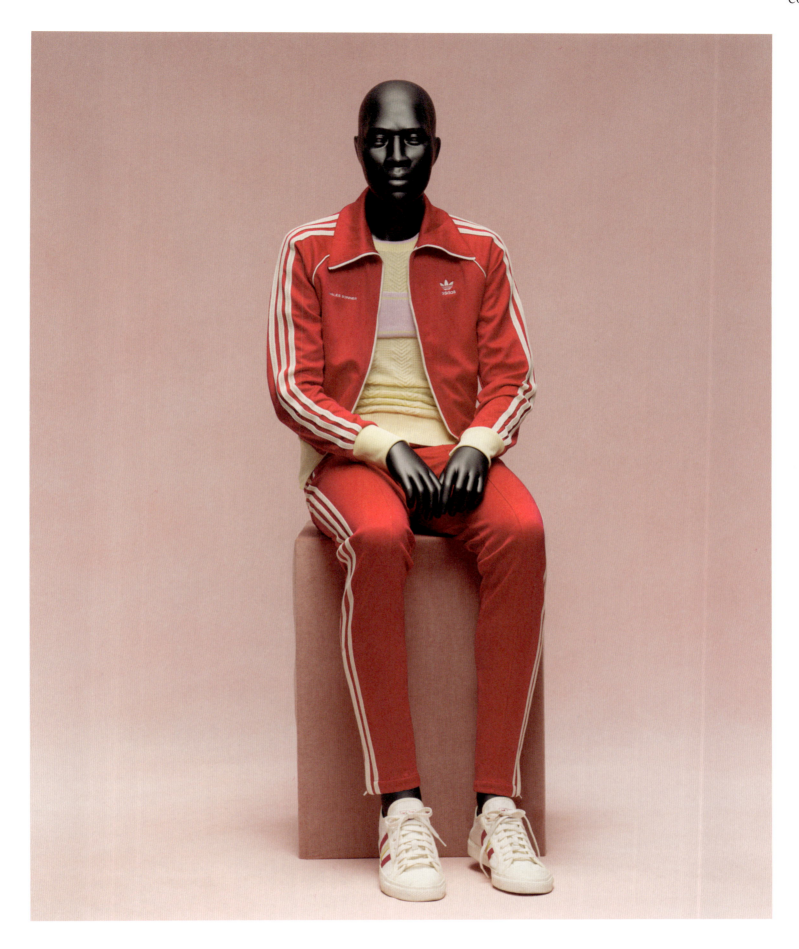

Wales Bonner. Grace Wales Bonner. *"Adidas Originals" ensemble*, spring/summer 2021

Thirstin Howl the 3rd. *Flexin' on the Deuce*, 1987

COOL

BOTTER. Rushemy Botter and Lisi Herrebrugh. *Ensemble*, spring/summer 2022

Cosmopolitanism

"In the world in which I travel, I am endlessly creating myself."

FRANTZ FANON
Black Skin, White Masks, 1952

COSMOPOLITANISM

Migration and movement, whether forced or chosen, imagined or actual, has transformational power. "Cosmopolitanism" focuses on travel—the crossing of borders literally, figuratively, and imaginatively—between and within Africa and its diaspora. Breaking down geographic and symbolic boundaries, those practicing dandyism claim habitation and home across borders and barriers. In their clothing and manner, they visualize membership in an interconnected, sophisticated, cosmopolitan Black diasporic world. The style and stylization that results from this broadening of consciousness is represented by contemporary designers for whom symbolic and actual flight enable forms of liberating transcendence.

The passports of writers, activists, and dandies W. E. B. Du Bois and James Baldwin open "Cosmopolitanism." The father of Pan-Africanism, Du Bois traveled to Europe to participate in the 1900 Paris Exposition, to continue his education, and to organize Pan-African congresses, arguing for African and Caribbean liberation from European colonialism. His 1921 passport (p. 316) was issued for his travel to the British Isles, France, Italy, Switzerland, and Belgium at the time of the Second Pan-African Congress. These meetings were important to Du Bois personally as well as philosophically; as a representative for Black Americans seeking civil and human rights, he made connections there that were essential to the creation of a diasporic consciousness that manifested in both his politics and style throughout the twentieth century. As NAACP literary editor Jessie Fauset reports in the organization's magazine, *The Crisis*, "What can be more fascinating than learning at first hand that the stranger across the seas, however different in phrase or expression, yet knows no difference of heart? . . . We felt our common blood with almost unbelievable unanimity."

Baldwin likewise chose a life of travel and movement abroad that informed and fueled his work. Relocating first to Paris in 1948 to escape American racism and homophobia and to develop himself as a writer, Baldwin achieved a "critical distance" from the United States that influenced his fierce, principled critique of American race relations; he spent the rest of his career between the United States and France, Switzerland, and Turkey. His passport (p. 316), issued on August 2, 1965, alludes to a heady and pivotal time in his life. Based in Turkey from 1961 to 1971, Baldwin had an extremely productive decade there, writing some of his best-known works, including *The Fire Next Time* (1963). Baldwin traveled to the United Kingdom to promote *Another Country* (1962) in 1965 and to debate conservative thinker William F. Buckley Jr. at the Cambridge Union in one of the most important intellectual discussions on race and racism ever held. His cosmopolitanism could be seen not only in his writing but also in his personal style: Although he wears a suit and slim tie in the passport photo, he was also lauded for a more dandiacal look that often featured large sunglasses and open-neck sweaters worn with a scarf tied jauntily around the neck.

Aspiration is a major part of the story of cosmopolitanism in the African diaspora; paying homage to the successes and stylish dreams of one's ancestors can also be a way to promote worldliness as an indelible part of Black life. Paris-based artists' collective Air Afrique—which includes founder and author Lamine Diaoune, film director Djiby Kebe, and photographer Jeremy Konko, among others—takes its name from the storied Pan-African airline, established by eleven decolonized African countries and dedicated to intra-African travel. Operating from 1961 to 2002, Air Afrique was famed for its classy and colorful midcentury style; the eponymous collective uses archival material from the airline, including the stamps issued by the airline's participating countries (p. 318) and historic luggage (p. 321), to inspire its designs. Their imagery is echoed in 2025 collaborations with Pharrell Williams for Louis Vuitton (p. 319).

The possibility of international or intercontinental travel had a profound effect on psyches in liberated African nations, as Sanlé Sory's photographs (p. 320) demonstrate. In the 1960s and 1970s, his Studio Volta Photo in Bobo-Dioulasso, Burkina Faso, provided a way for people to explore even when it was beyond their means: Aspiring travelers packed their bags and imaginatively hopped on Air Afrique, depicted on a backdrop in his studio. As he told the *Guardian* in 2017, "the aeroplane backdrop was particularly popular with young people who couldn't afford to travel. It gave them a chance to experiment, to escape

their ordinary lives and play with elements of the modern world." This play was serious and sophisticated, a part of reimagining new connections and desires in the decolonizing 1960s.

In 2018 Ghanaian American Virgil Abloh, trained architect and the designer at the label Off-White, was appointed artistic director of Louis Vuitton menswear, becoming the first person of African descent offered this position at the French luxury house, which necessitated a move to Paris. At Louis Vuitton, Abloh's design practice was informed by and infused with his own experience as the son of African immigrants to the United States and as a multi-hyphenate artist who traveled back and forth between Europe and America. In his autumn/winter 2021–22 show for Louis Vuitton titled "Ebonics," Abloh explored the creation of a new language for his work in the wake of the Black Lives Matter movement, reflecting on the power of archetypes and identities across cultures. Emphasizing his own African heritage throughout the collection (p. 252), Abloh played with the transformational power of travel and movement for Black masculine identity formation. The men on Abloh's runway were ready for literal and symbolic transport, as in the opening look from the collection: a wool overcoat secured with airplane-shaped buttons, complete with red leather passport holder in the breast pocket (p. 323). In his show notes the next year, Abloh continued to highlight the diversity and cosmopolitanism of his practice, providing a map marking the birthplaces of his models and their parents (p. 322). Knowing where he was going was indelibly linked to the diverse places Abloh was "from."

For Savile Row tailor and fashion designer Ozwald Boateng (p. 324), *The Road to Paris*—the video announcing his first runway show in 1994—was definitive in the development of his cosmopolitanism. Like Abloh, he regularly crosses between cultures and continents, as his family also hails from Ghana. In Paris Boateng brought British tailoring to a global audience but in his characteristic way: a precise fit and silhouette made in bright colors using bespoke designed fabric in recognition of Congolese Sapeurs, a subculture of dandiacal men who influenced his practice in the 1990s. In 2019 he traveled to Harlem's Apollo Theater to stage "A.I."("Authentic Identity"), what his website describes as an "immersive" fashion show featuring "African design touches combined with nods to the Harlem Renaissance." And a 2022 suit in his "tribal"-patterned silk (p. 325)—signifying, according to Boateng, "a renewed ideal of Africa at home and abroad"—offers its wearer a sense of reconnection between England and Africa, remixing Western and Afro-diasporic fashion and style to define cosmopolitanism for diasporic communities.

Just as clothing can embody the hopes and dreams of arrival, owning luxurious accessories that enable travel can also facilitate a sense of achievement. When André Leon Talley walked through the airport, he was proud of how his matched, monogrammed set of Louis Vuitton luggage visualized his success (p. 326). The purchase of these cases epitomizes his journey from a modest home in the American South to the runways of the world's fashion capitals. Well known for his branded vegan leather Shopping Bag— popularly called the "Bushwick Birkin"—Telfar Clemens has also traveled a long way from his Liberian immigrant background to being named 2021 Council of Fashion Designers of America Accessories Designer of the Year. In 2024 Telfar introduced the Carry Bag (p. 329), made in deluxe leather. While it still features the brand's famous embossed logo, this bag exemplifies Telfar's earned "quiet luxury."

"Cosmopolitanism" closes with two contrasting ensembles from Labrum London's collection titled "Designed by an Immigrant: Journey of Colours," which designer Foday Dumbuya describes as "an exploration of human movements and migration" in a February 22, 2024, *Elle* article. Born in Sierra Leone and raised in London, Dumbuya is heavily influenced by Boateng's success and makes it his mission to showcase "British tailoring [and] West African flair," per the label's motto. A wool jacquard coat patterned with passports, immigration documents, and visa stickers documenting his father's emigration (p. 328) is followed by a more conceptual ensemble composed of airline boarding passes printed on draped fabric strips assembled into a garment equal parts protective and scrappy (pp. 330–31). According to the brand, this collection "pays tribute to the inspiring stories of immigrant artists who overcame adversity and made significant contributions to the arts and fashion world." These ensembles embody both the potential heaviness and transcendent possibilities of movement across the globalized world.

COSMOPOLITANISM

 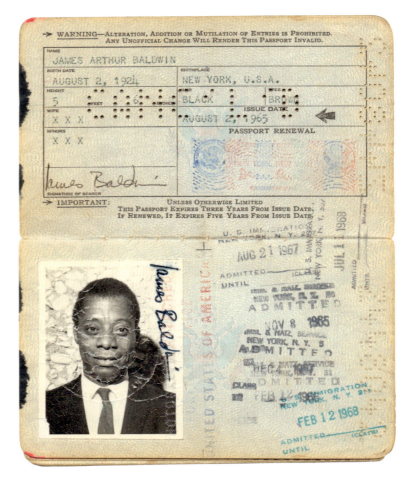

Passport of W. E. B. Du Bois, July 22, 1921
United States passport belonging to James Baldwin, August 2, 1965

COSMOPOLITANISM

SINGULAR BEINGS, MAGNIFICENT STRANGERS:
THE AFRODIASPORIC TRAVELER AS DANDY

EKOW ESHUN

Before traveling to the Swiss mountain village of Leukerbad in 1951, James Baldwin (opposite) was warned that he would be a "sight" for the locals. He went anyway, spending months alone in a place where a Black person's presence was a conspicuous novelty. "I remain as much a stranger today as I was the first day I arrived," he writes in his essay "Stranger in the Village," noting, "The children shout *Neger! Neger!* as I walk along the streets."

The experience of being made other and alien as a Black traveler was not unique to Baldwin. Martinican political philosopher Frantz Fanon spoke of the humiliation of being pointed out in postwar France by a white child with the words, "Look, a Negro!" And back in 1897, in "Strivings of the Negro People," civil rights leader W. E. B. Du Bois coined the term *double consciousness* to describe the "peculiar sensation" of living as a Black person physically within and psychologically outside white society: It is "this sense of always looking at one's self through the eyes of others, of measuring one's soul by the tape of a world that looks on in amused contempt and pity." For Du Bois, double consciousness was the defining criterion of Blackness, bitter testament to the way that Black lives were doomed to oscillate between hypervisibility and invisibility, perpetually victim to the white gaze.

Baldwin first swapped American bigotry for Europe's more socially tolerant environment in 1948. With what he described as "the fury of the colour problem" behind him, he cultivated a new sense of sophistication, surmounting the provincialism of a village like Leukerbad by fashioning himself cosmopolitan, as he explained in the essay "The Discovery of What It Means to Be an American." The 1970 documentary *Meeting the Man: James Baldwin in Paris* captures the writer as elegant and self-possessed: He wears a black puff-sleeve shirt and silver medallion while holding court before a group of admirers in artist Beauford Delaney's studio; he walks along the Seine in a brown suede coat and black toque hat, a scarf flung loosely over his shoulder. This is Baldwin the dandy, as poised in appearance as he is in words, wielding personal style as a means to liberate the Black body from objectification, even though greater visibility risked heightened vulnerability. As he acknowledges in the film, "I'm aware that I, and people I love, may perish in the morning but . . . if you live under the shadow of death, it gives you a certain freedom."

Conjured thus, Baldwin exists within a lineage of Afrodiasporic travelers, each wielding style, deportment, and the knowing self-regard of the dandy as part of a greater struggle for visibility, agency, and emancipation. We might think of the young Du Bois in this context. In David Levering Lewis's "W. E. B. Du Bois: Biography of a Race, 1868–1919," Du Bois

describes being inspired in Germany by the "beauty and elegance of life that permeated [his] soul"—a contrast to "the narrowness and colour prejudice" he had known in the United States. As a student in Berlin in 1892, he adopted the distinctive elements of his personal style—a cane and gloves and a carefully trimmed goatee—that he maintained through the rest of his life.

Likewise, as captured in a June 22, 1948, photograph, the three Jamaican immigrants on the deck of the *Empire Windrush* are dressed showily, in broad-shouldered zoot suits and hats. A silver bracelet glimmers on one wrist. Another man flashes a watch and a signet ring. Their arrival that day at Tilbury docks symbolizes the start of mass emigration from the West Indies to Britain. Caribbean immigrants were often met with condescension upon arrival in Britain, their vivid fashions taken as a sign of their naïveté. This, as the scholar Stuart Hall argues in "Reconstruction Work: Images of Post-War Black Settlement," is a reading to be refused: "These are not country bumpkins, or indigent cousins 'from the Tropics,' or primitives just swinging down from the coconut trees." Their choice of clothes and the confidence with which they wore them signaled a determination to be seen on their own terms. "These people have just survived the longest, hardest journey in their lives: the journey to another identity. They mean to survive. The angle of the hats is universally jaunty, cocky. Already, there is *style*."

More than half a century later, the travels and travails of such men have become a resonant subject for fashion designers. Virgil Abloh themed his autumn/winter 2021–22 Louis Vuitton menswear show around Baldwin's "Stranger in the Village." Grace Wales Bonner's autumn/winter 2023–24 collection was also inspired by Baldwin, as well as by other "rebel sojourners" like Fanon and the Martinican poet Aimé Césaire. The same season, Foday Dumbuya's Labrum show drew from novels such as Samuel Selvon's *The Lonely Londoners* in homage to Windrush-era African and Caribbean migrants, their status as wayfarers represented in one case by a model wearing a hat in the form of a suitcase.

Each collection proposes the knowingness and sophistication of the dandy as the governing condition of Blackness instead of the anguish of double consciousness—a syncretic sensibility founded in "the juxtaposition between dream and reality that comes with migration," as Dumbuya's show notes describe, and in the spirit of "singular beings, magnificent strangers, ever-soaring in art and life," as Wales Bonner put it. Or, as poet and performer Saul Williams says while trekking through a snowy Alpine landscape in an ankle-length black coat and broad-brimmed hat in *Peculiar Contrast, Perfect Light*, the film that accompanied Abloh's show, "I am no stranger anymore; the world is love to me."

Air Afrique stamps, 1960s

COSMOPOLITANISM

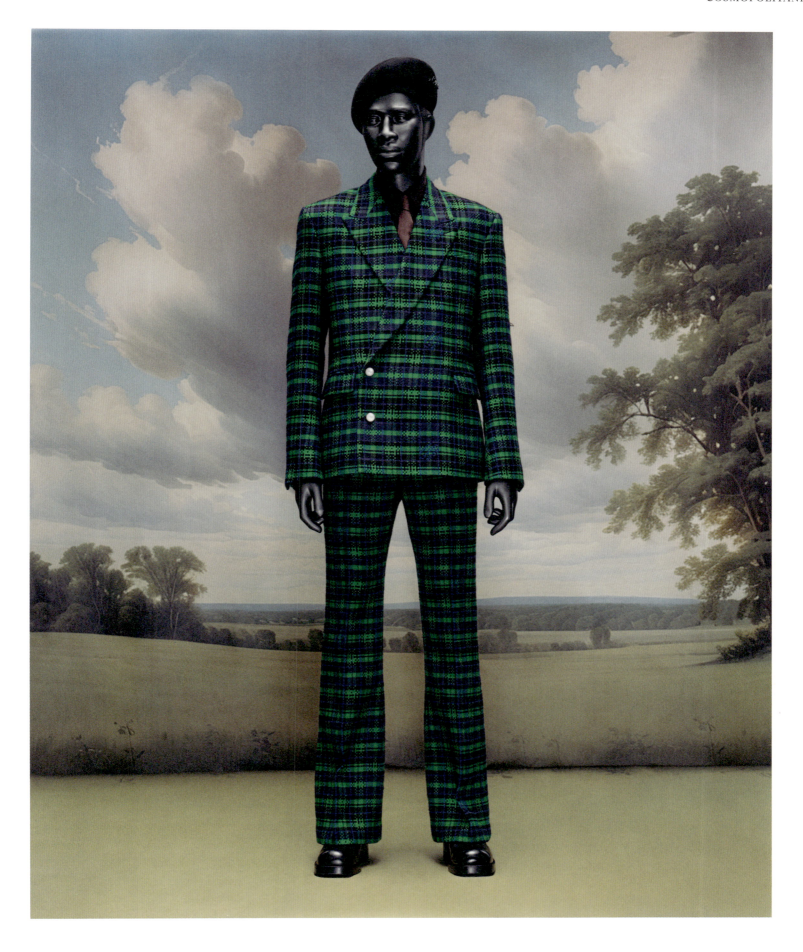

LOUIS VUITTON. Pharrell Williams. *Ensemble*, spring/summer 2025 menswear

COSMOPOLITANISM

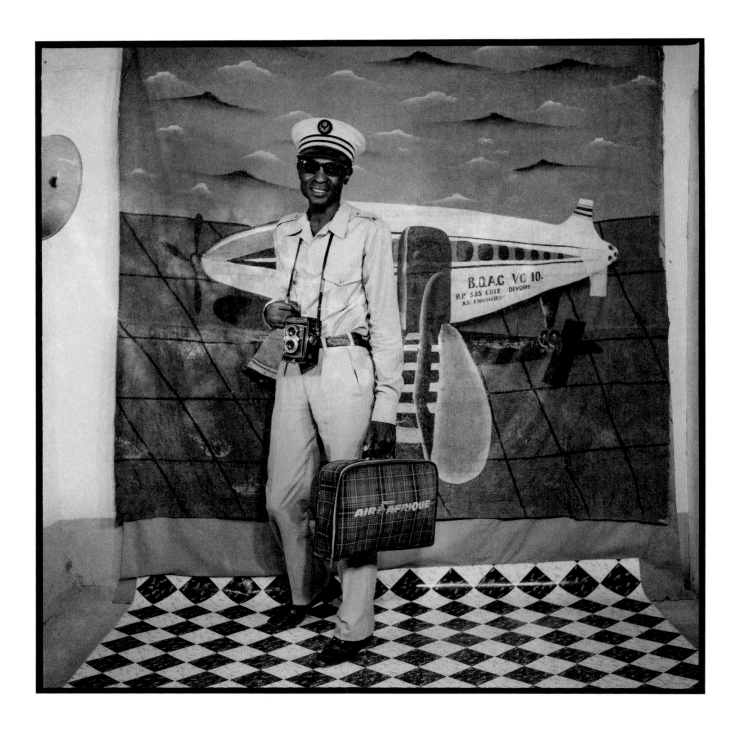

Sanlé Sory. *Air Afrique, Nous Voilà!*, 1979

Air Afrique. *Bag*, 1970

COSMOPOLITANISM

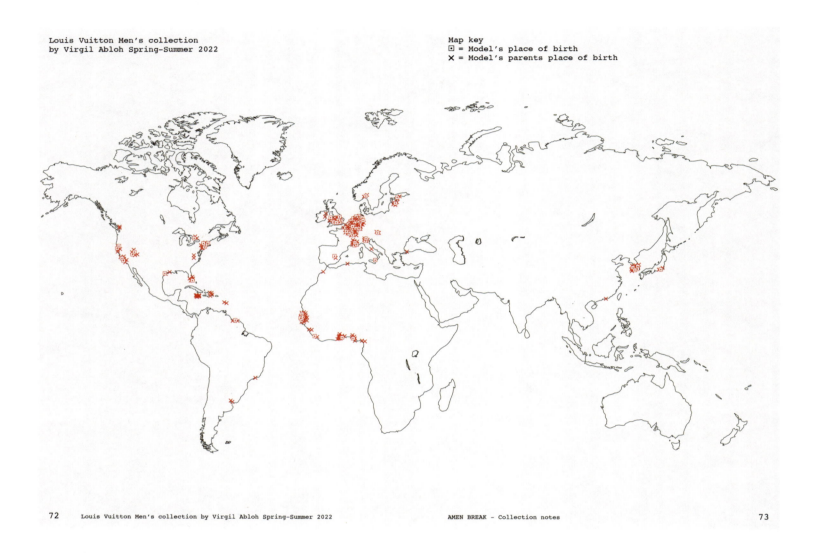

LOUIS VUITTON. Virgil Abloh. *"Amen Break" show notes*, spring/summer 2022 menswear

COSMOPOLITANISM

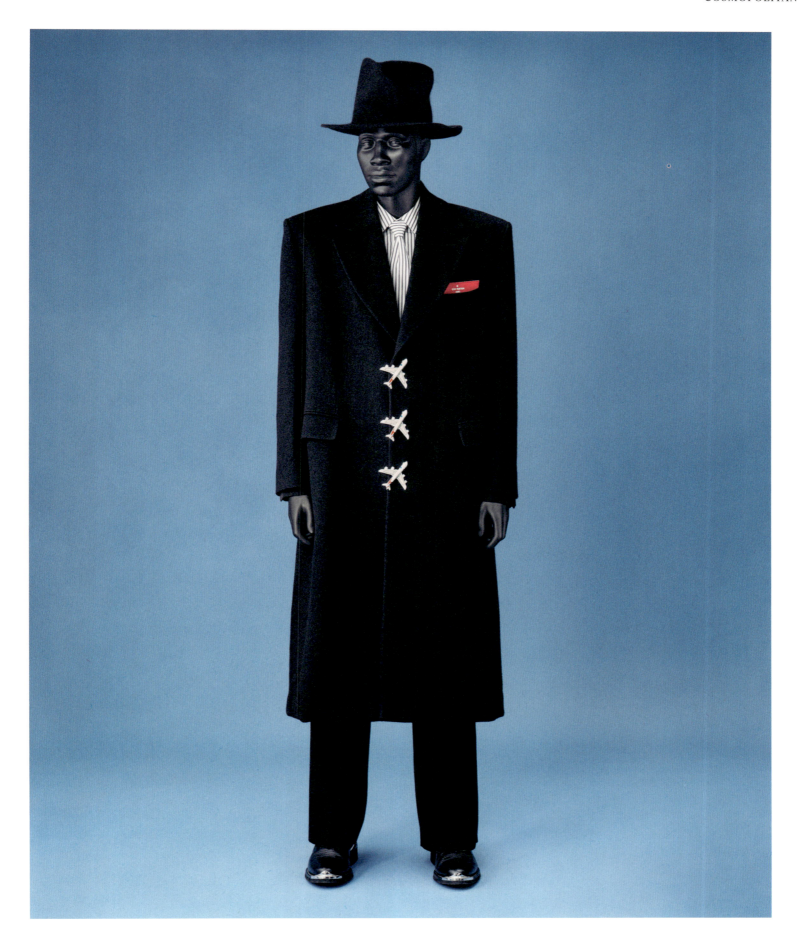

LOUIS VUITTON. Virgil Abloh. *Ensemble*, autumn/winter 2021–22 menswear

COSMOPOLITANISM

Tom Stoddart. *Ozwald Boateng walks along Savile Row (at Vigo Street), London, England*, 2009, from Johnny Walker's Walk with Giants campaign

COSMOPOLITANISM

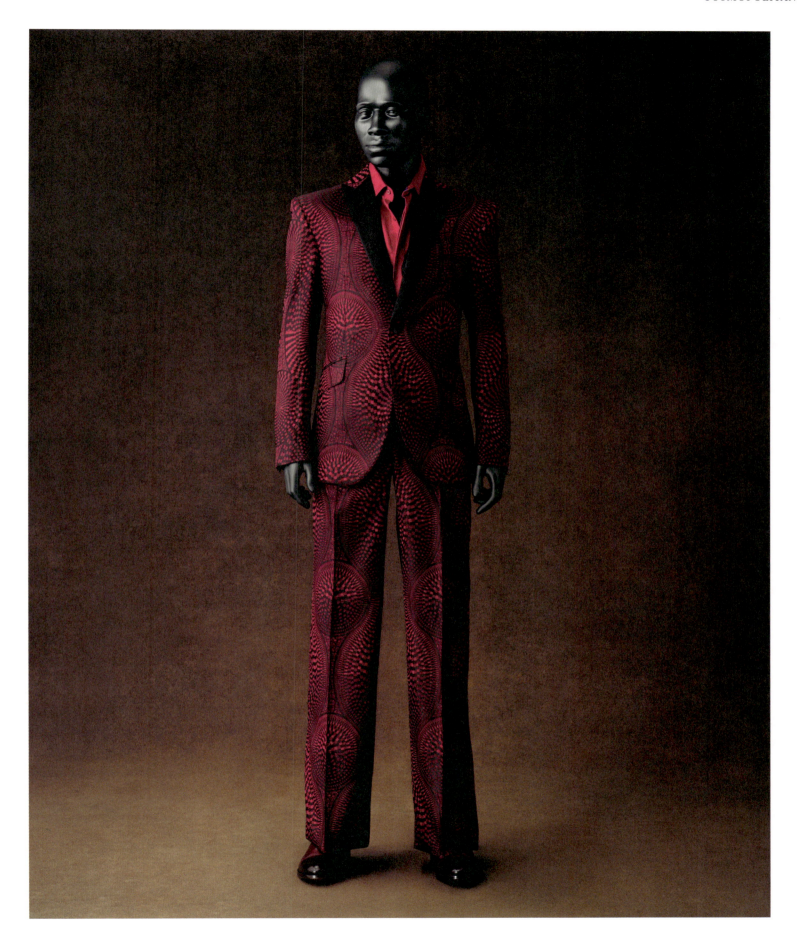

Ozwald Boateng. *Ensemble*, 2022

325

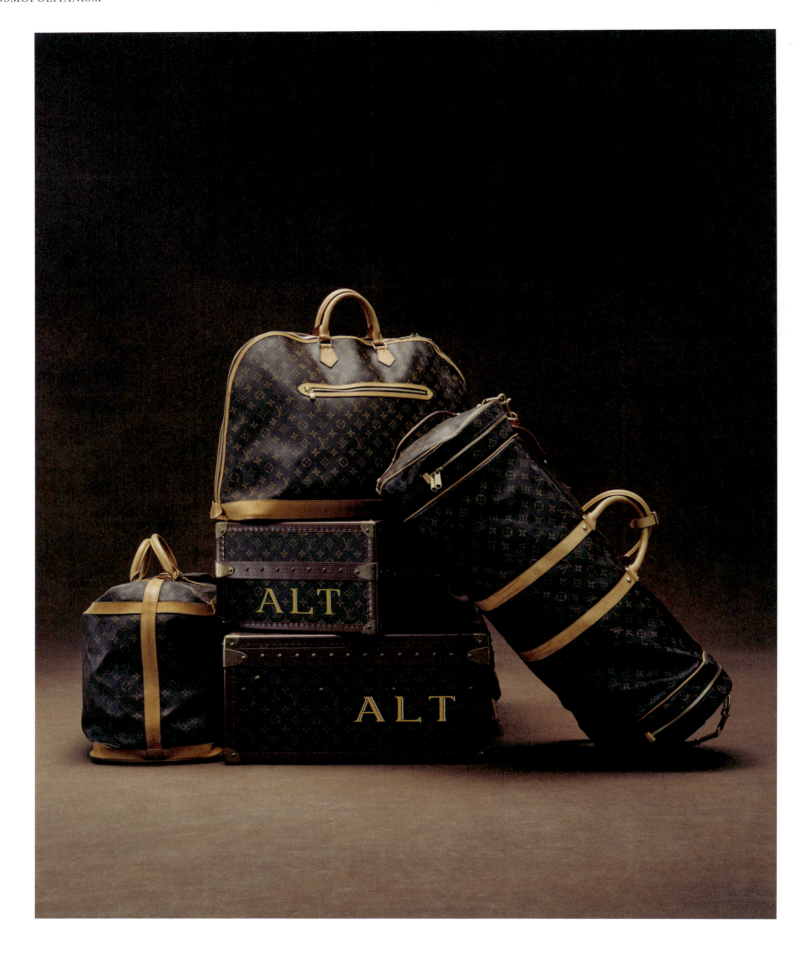

LOUIS VUITTON. *Suite of luggage owned by André Leon Talley*, ca. 1990 and 2004

BECOMING ANDRÉ: OBJECTS OF DISTINCTION

JASON CYRUS

Built on wood frames and trimmed in monogrammed leather, Louis Vuitton trunks are potent symbols of wealth and travel. In their 2010 book *Louis Vuitton: 100 Legendary Trunks*, Pierre Léonforte and Éric Pujalet-Plaà emphasize the historical and cultural importance of these sought-after items to the history of the luxury industry. An air of mystery and promise surrounds Vuitton trunks, beckoning the viewer to imagine their contents and destination. This dual sense of imagination and historical connection encapsulates the personal resonance of André Leon Talley's suite of luggage (opposite).

In the nineteenth century, the wealthy employed professional packers and trunk makers to ensure their possessions were prepared for travel with the utmost care. Louis Vuitton was one such skilled tradesman, mastering the art of preparation and preservation. Similarly skilled was Talley's grandmother Bennie Frances Davis, a member of the caretaking staff at Duke University. In his writings, Talley recalls the meticulous manner in which Davis used intricate folding and layers of tissue paper to pack their luggage. Such an act went beyond practical preparation; it was a powerful reinforcement of African American value. Amid the racist oppression of the Jim Crow laws governing Talley's Southern upbringing, Davis's insistence on presentation and maintenance was subversive. Many years later, Talley encountered a similarly rigorous commitment to self-presentation among the fashionably wealthy. This connection across race, class, and economic means would form Talley's driving aesthetic perspective.

Talley's Vuitton luggage also represented escape. Images of such cases piled high invoked the romance of travel, far away from the conservative upbringing of his youth. In the 2018 documentary *The Gospel According to André*, college friend Yvonne Cormier recalls the moment she first met Talley during orientation at Brown University: "[André] introduced himself to me and asked me how many pieces of Louis Vuitton luggage I owned. I said none. He said, 'Darling, you need them when you cross the ocean on the QEII!'" In her 2018 *Garden & Gun* article, Julia Reed reports that Talley would buy his first set of Louis Vuitton luggage with money earned as a teaching assistant at Brown.

This acquisition was an important step in realizing the fashion icon he would later become. A photograph of a young Talley by Arthur Elgort from the 1970s exemplifies his burgeoning dandyism. The image shows him well attired in suit and tie, clutching a piece of Louis Vuitton luggage. Each of these sartorial codes recalls the European dandy. However, Talley's invocation of these tropes took a subversive turn. His luxurious self-presentation and accessories sent a powerful message about the value of African American identity, one that countered the prevailing image of Blackness as destitute, impoverished, and unworldly. Talley's Vuitton pieces can be read in a similar vein.

The luggage was also a sign to himself and others that he had finally made it within high fashion. In a 2018 interview for the Canadian Broadcasting Corporation, Talley remembers his early days of becoming: "I arrived in Paris to be the editor of *Women's Wear Daily* at [a] very young age in 1978 in January. I arrived with thirteen pieces of unmatched luggage . . . When I arrived with thirteen pieces of unmatched luggage, I was an insecure person. I was afraid, I didn't know what I was getting into. . . . I will say now I have about fifty pieces of matched Vuitton hard-side suitcases at my home in North Carolina." André Leon Talley had become the successful vision he imagined for himself.

His Vuitton cases later became a portal through which many in the wider world encountered him. Much like his grand capes, Talley's Vuitton luggage became part of his iconography. In 2008's *Sex and the City: The Movie*, Talley's monogramed Vuitton makes a scene-stealing cameo. Naturally, Talley plays himself—well dressed and in command of a fictional *Vogue* photo shoot. Once again, he cradles in his lap a piece of Vuitton luggage, his name clearly legible across the surface of the monogrammed canvas. At this moment, Talley's dandified style and pronouncements were arguably as publicly recognizable as the Vuitton case he carried.

Yet what was widely perceived in the press as an attention-grabbing form of dress was, in fact, Talley's armor and moral code. In Reed's article, Cormier explains, "Even then, André just thought it was good manners to look wonderful." In the 2007 documentary *The September Issue*, Talley arrives for his tennis lesson sporting a diamond watch and dripping in Vuitton accessories. Talley narrates the scene: "It is all a part of the life of me, being who I am. I have to get up and approach life with my own aesthetics about style." This strategy concealed the deep pain and personal trauma Talley writes openly about in his 2020 autobiography, *Chiffon Trenches*. The wear-resistant surface of his Vuitton luggage, simultaneously adorned in the company's luxurious monogrammed leather, can be read as a metaphor for André's own sense of style—a meticulously crafted sartorial expression meant both to edify the wearer and to protect him from hardship. He would inspire many others to do likewise.

The afterlife of Talley's Vuitton luggage would become a testament to this legacy. The cases were among the most sought-after items in the public auctions of Talley's effects after his passing in 2022. For many, these items were totems of his style. Many saw themselves in his extroverted, flamboyant dandyism, which gave them the courage to be fearlessly themselves. Through them, Talley's potent dandyism lives on.

COSMOPOLITANISM

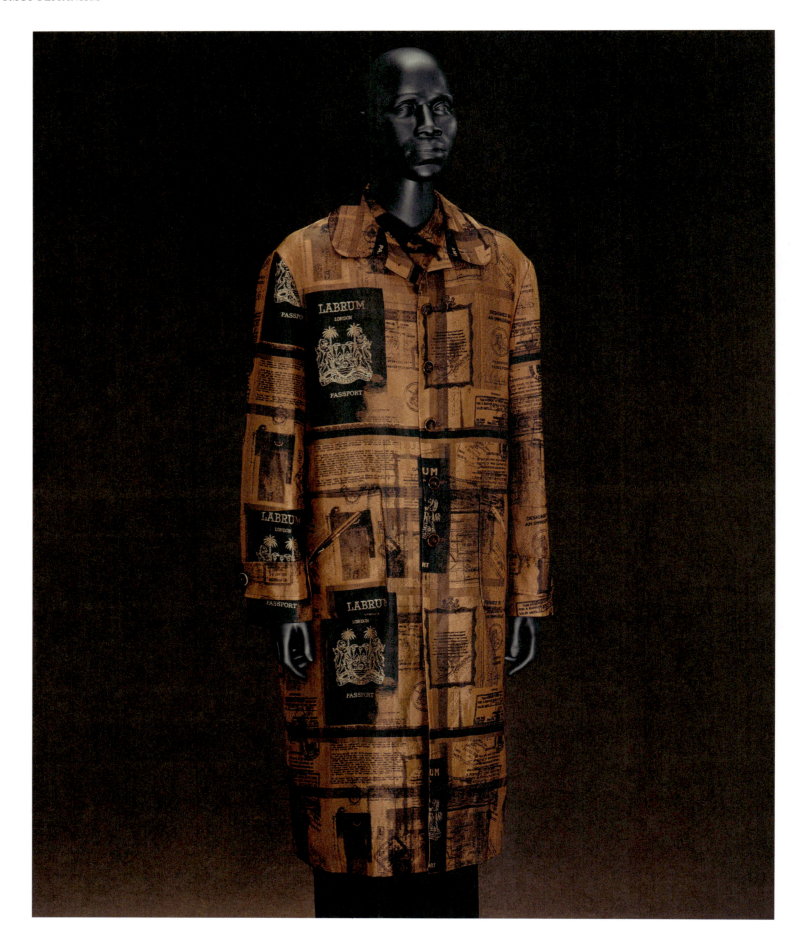

LABRUM London. Foday Dumbuya. *"Maya Angelou Passport" ensemble*, autumn/winter 2023–24

TELFAR. Wilsons Leather. Telfar Clemens. *TELFAR × Wilsons Leather Carry Bags*, 2024

COSMOPOLITANISM

COSMOPOLITANISM

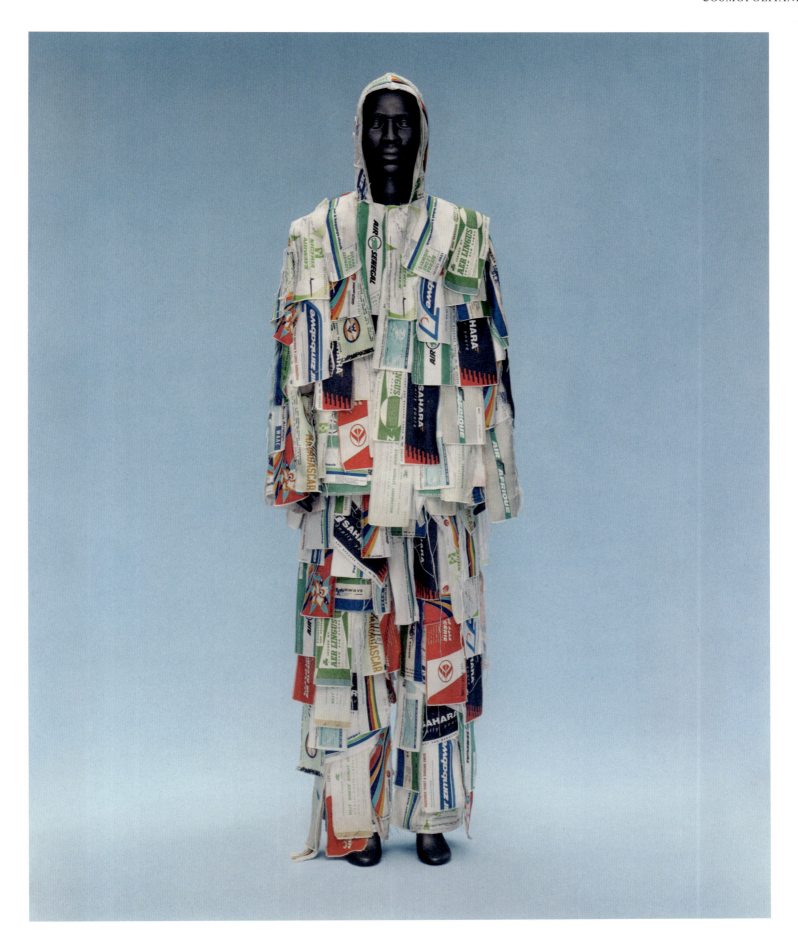

LABRUM London. Foday Dumbuya. *Ensemble*, autumn/winter 2024–25

331

Epilogue

In this epilogue Iké Udé, an artist, an aesthete, a free thinker, and a dandy himself, presents a dandy's way of life. In the Igbo tradition of *njakiri* (or teasing banter) and proverbs, his "Sartorial and Aesthetic Sympathies" proffer a set of witty aphorisms as principles through which the style is lived. "Kofi: The Sartorial Frame," an excerpt from a longer study of the dandy and aesthete Kofi, sets these principles in motion, enabling the protagonist to philosophize and chart unconventional modes of being with a radical laissez-faire attitude within the messy contemporary world he finds himself in. Like the two-faced Roman god Janus, or the pharaonic Egyptian god Thoth before him, Kofi reconciles a binary, concurrently looking back into the past as well as forward into the future for wisdom and guidance. His story is a timeless treatise on culture, art, aestheticism, dandyism, cosmopolitanism, modernity, and the vagaries of life in general.

SARTORIAL AND AESTHETIC SYMPATHIES

IKÉ UDÉ

1. Style is always as timeless as tomorrow, because style is triumphantly unfashionable beyond the purview of fashion.

2. Elegance, arrived at by unhurried, deliberated omissions of certain parts of an ensemble, aces anything in comparison with a redoubtable sartorial quotient.

3. Numerically, today's fashion is always younger than tomorrow's fashion. As time goes by, 2025 becomes younger than, say, 2099. Yet, counterintuitively, we think and regard fashions of 2025 as older than ones of 2099.

4. Suppleness of sartorial elegance is the lyricism in a best dressed.

5. For the dandy-artist, to be half-understood is awful; to be nearly understood, horrific; to be perfectly understood, not an option; but to be respected, he'd nonchalantly give an inexact raincheck, if that, if the mode of respect is reciprocal.

6. In the absence of a sartorial Magna Carta for lack and want of sophistication, the dandy's role as an arbiter elegantiae is preciously incalculable.

7. There are some so-called "fashion statements" that'd tempt an extremely sensitive dandy to walk out a plane in mid-flight.

8. To be clothed with attitude, informed by thoughtfulness, glossed over with easy charm, garnished with dainty details and with a whiff of seraphic grace, served with loveliness is always a winning recipe.

9. The unique narcotic joy derived from being well dressed is only equaled by its harmlessness.

10. The best prêt-à-porter suit is a millimeter short of perfect; the average tailored suit, a millimeter too perfect.

11. The sartorial narrative is rarely linear; instead, the sartorial arc is a nonlinear narrative, fraught with surprising twists and turns. Thus, its saga continues, beyond anyone's life span.

12. The first casualty of style is obvious effort.

13. Sense and sensibility are the embryo of style.

14. We are jolly when we feel good, a touch cock of the walk when we look good, and in peaceful bliss when the mirror returns the compliment.

15. Some clothes look great in photographs but don't even come close to being tolerable in real life. Buyer beware.

16. A three-way mirror can inspire confidence or invite horror.

17. The best sartorial eloquence reveals itself, almost like a whispered-verse composition.

18. We all know about the dramatic purchase of color in an outfit. Often under sung is that arched drama of the silhouette, which denotes perfect fit and subtly brings sexy back with a benign wink and nod.

19. Receipts for good manners, self-confidence, mellifluous voice, a walk with a feline grace, and that *je ne sais quoi* are all priceless, intangible attributes that enhance one's sartorial delta.

20. When the presence of a style becomes tantamount to an atmosphere, stoked and charged with potent emotional import, you are possibly looking at a momentous, spellbinding sartorial fourth wall, or more.

21. The honnête homme, or gentleman, is the symbol of practiced bourgeoisie respectability, affectations, or piety. An astute fashion dissident, the dandy symbolizes his own sovereignty of mind, aristocracy of elegance, served with a disarming wit, for good measure.

22. Fit and posture are not only key but force multipliers of an elegant ensemble.

23. The dandy makes poems out of dressing, songs out of elegance, and philosophy out of attitude.

24. Contagious attitude, subtly refined to its purest degree, often has supreme escalatory dominance in matters of style.

25. Overdressing betrays sartorial economy and is the Hail Mary of the sartorially challenged.

26. The look of shoes is one thing, but the truly sublime pleasures of wearing shoes reside in their voluptuous interiors, luxuriously lined to tenderly protect and snuggly hug the feet as we sit, stand, strut, or languidly saunter about with no agenda, no regrets.

27. The boutonniere is the musical cherry topping off an outfit, thus imbuing and switching it up with the musical equivalents of the aria, the sonata, the impromptu, the overture, the rhapsody, the Afrobeats, and that passion-inflamed flower, the harmonious chromatic embodiment of beauty, form, and function.

28. The dandy doesn't necessarily wear clothes; instead, dressing denotes quick wit, infectious attitude, and redoubtable chic.

29. When one's swag is precariously standing on stilts, the ensemble is conceited—a capital red flag.

30. The saving grace of the classical suit is that it offers a grand sweep of elegance with such economy.

31. DISGUST! We have this word to infinitely thank for. But for our sense of disgust or the disgusting, so hardwired in us, we wouldn't have the guardrails to distinguish between the repulsive and attractive, between the vulgar and tasteful, between the abominable and admirable, between the déclassé and genteel.

32. It is painful, perhaps immeasurably painful, to behold a personage absolutely gorgeous, yet a disaster in one poignant detail.

33. Fit and correct posture aside, there is a sartorial harmony, music like, achieved by employing a shared chromatic framework of subtly varied hues of the same color within an ensemble.

34. Clothes are like a map. The body, a terrain. The map mustn't be confused with the terrain. When these two meet, the reality check is often more disastrous than we admit.

35. The dandy is a sartorial assassin—fluent in big arrow glamour in concert with uncannily subtle but huge, elegant interventions, using smaller arrows.

36. It is sublime when the delectable curves, edges, and penumbra of knowledge are subtly expressed when dressing the body.

37. To find the grandeur in the quotidian and monotony of life via dressing is a dandiacal alchemic feat.

38. What narcotic savor, the caresses of a silk collar shirt on the neck. What scandalous sweetness, as the hands slip through the near-haughty sleeves of a dry-cleaned cotton shirt. What delicious shiver, what reverie, what dream, still, as the legs find their ways through the incorrigible, communicable, suave sensations of cashmere trousers, or one's aroused cheeks repeatedly dabbed, with such tenderness, on the sleeves of a velvet jacket. These are but a few of the 1,001 pleasures of dressing.

39. Style is as much the idealization of the imperfect *Homo sapiens* as it is the exaltation of the beast.

40. Sartorial eloquence has bulletproof charms that even enemies or detractors can't resist.

41. The mirror, for the dandy, is an objective observer. At times the same mirror plays a sartorial devil's advocate to ensure purity of elegant style.

42. A multiheaded hydra, a gossamer apparition—the sartorial fog of dressing may be foggier than the fog of war.

43. In a sense, elegance is the exaltation of common sense in a seamless fashion and singular style.

44. In matters of best dressed—rule number 1: fit, posture, and inherent aplomb are key. Rule number 2: Never forget rule number 1.

45. The salient import of a sartorial detail is the spectacularly outsize exquisite magnificence that it brings to the table, compared to its minuscule size.

46. Water is life and the sartorial deity of clothing and hygiene. Without water, we are FILTH, condemned in perpetuity to dress in disgustingly unwashed clothes, so decidedly unholy, a pig would blush in our presence with a straight face.

47. In the fabric sphere, we go to cotton for its dignified practicality and demure chic; silk and velvet, for their pleasurable, luxurious tactility and sensual chic; wool, for its warmth, agreeable roughness, and earnest, pragmatic, shaggy chic; organza, for its oh diaphanous dreamy weightlessness.

48. Continual cultivation of beauty and perfection of style is a war of attrition, with limitless kill zones.

49. If an arbiter elegantiae is envied, held in contempt, accused of snobbery, or subjected to off-color gossips, you can be sure such an individual is guilty of a job well done—perhaps, too well done.

50. Behold the most powerful or richest person in the world; behold, still, the most beautiful, handsome, or stylish person in the world; add to this list the most brilliant scientist, intellectual, designer, entertainer. Alas, when they open their mouths, it's a bombshell, a traumatizing bombshell of bad breath or halitosis. It turns out that there's more to style than meets the eye. Lest we forget, bromhidrosis or reeking body odor is the notorious twin of halitosis.

51. The sartorial pyramid has three levels: at the base, the fashionista who unwittingly clamors for every latest thing; at the middle, the bourgeoisie gentleman who dresses for respectability and dictates of decorum; at the apex, the dandy-aesthete who judiciously employs clothes-plus as artistic medium to signify his *great refusal*, his radical philosophical bent and aesthetic sympathies, with dispassionate attitude, to boot.

52. If Hathor or Aphrodite is the goddess of beauty and love, the dandy is surely her gallant knight in shining armor.

53. The full power and beauty of clothing are unleashed when smartly worn, but impotent otherwise.

54. If the body is fashionable or fashionable enough, fashion won't exist.

55. While at it, let us emulate the poplar for its soaring, stately elegance, proudly erect posture, and resilience; the flowering plants and flowers alike, for their cheerfulness, their unwavering beauty, and for giving us the blueprint to invent perfume.

56. When the beauty instinct is pleased, there isn't a note more needed in an outfit.

57. Most people are closet narcissists; their false modesty to look like an "average Joe or Jane" is the creepiest type of vanity—a remarkable low in narcissism.

58. There are two types of skins: the one that nature gave us, the epidermis, and the one that we wear on it. Clothing is our culture-skin, one of the major markers of culture, civilization, and a sophisticated, assuaging shield against barbarism and primitivism.

59. Do not dress to expectations; do not seek approval; only obey the mirror.

60. Style is not just about form and substance. It's also about the luxurious deliberation of intelligence in the face of boundaries.

61. There's wisdom in the folly of dressing and folly in the wisdom of dressing. What fun, what wizardry, and what a conquering paradox.

62. Regardless of nationalities, the global African brothers, above all else, have the pulse, the limitless stylistic wherewithal in sartorial lingua franca. Conversely, the same excellence is needed in the STEM and finance fields for profound power and lasting agency. If not, all that swag hangs by a thread, vulnerable to myriad indignities, or far worse.

KOFI: THE SARTORIAL FRAME

A dandy and aesthete, Kofi saw that dressing ennobled the body, as the nobility of dress dignified the unfashionable body. As far as Kofi was concerned, there were clear distinctions between individualized style and trendy seasonal fashion offerings that were always changing, in flux, directionless, even gimmicky, disposable. For him, fashion was a prescriptive system of appearance that tells one when, where, or how to pose in the latest thing, rather than how to be. Style, on the other hand, was a philosophy, an attitude of dressing and being that shunned fashion trends and, as such, was a mode of individual sovereignty, a mode of fashioning a unique identity and an expressive individualized splendor.

Regardless of what was trending, he preferred Edwardian menswear, especially its fitted and graceful silhouettes that appeared limned from all angles. The period's shirt styles, neckties, as well as its shoes, sock-garters, were all a thing to behold and long for. Kofi's adherence to this sartorial style freed him from the tyrannical, shrill seasonal fashion system, so he made time to pursue his other loves and passions.

Fabric-wise, natural fabrics were preferable. He was particularly partial to cotton and organic fabrics in general. For spring, cottons, cashmere, fine light-weight wools; for summer, all cotton; for winter, cotton, wool, cashmere, velvet, and some silks.

Color: various shades of blue, including periwinkle, powder blue. He was also partial to khaki, aubergine, violet-lavender, chartreuse, oxblood. He loved white shirts as well as gingham shirts in their many color variants. Khaki trousers and shorts were his jeans equivalent. He adored certain fabrics that came in pastel hues, as they warmed his heart.

He particularly adored cotton fabric, noting that the humble cotton can be as much a workhorse as a show horse — but not so with most other precious, luxurious, expensive fabrics such as silk, taffeta, organza, lace, damask, chiffon, cashmere. And just as important to Kofi was his high regard for the language, feel, personality, poetics, and innumerable qualities that fabrics, especially the organic variety, brought to the table—the roles that these fabrics played in informing the ways we present ourselves, the ways we are perceived and, no less, judged.

Nothing is more south of elegance than an ill-fitting garment.

Besides what to wear, and when or how to wear it, there is the issue of elegance—elegance personified, elegance embodied, and not merely elegance of appearance or substanceless elegance. In this regard, and for starters, Kofi believed that no man is elegant who has any piece of food in his stomach. His body must be thoroughly scrubbed, nails manicured and pedicured, and if he is partial to facial hair of any type, then it must be smartly designed facial hair, or else completely shaved, nude faced, as it were. Likewise, funny hair sprouts about the ears, or overgrowth of hairs about the eyebrows or from the nose, or errant hairs that disgraced the curves of the eyebrows, were a no-no. Elegance started from within, on a completely empty stomach, and was of the innermost substance and purity. A body emptied of food was a sound body, a sound mind, an elegant being, Kofi adjudged.

When going out to a party, a soirée, or doing the rounds of salons held by various hostesses, he went on a fast, which had an added agreeable slimming effect on his already slender frame, allowing him to adjust his waistcoat to its tightest degree, so tight that if he were to take a Holy Communion wafer, or even one teeny Tic Tac tablet, the vest would burst. (What began for Kofi as a sartorial fast would eventually become a recurring purification ritual of sorts for him). Thus purged, body and soul were fine-tuned, sound, purified, hence elegantly furnished and good to go. Being the aesthete dandy that he was, Kofi knew that the results of his sartorial discipline, love of the beautiful, loveliness of disposition, tempered with stoicism and intellectual sympathies, endowed him with some kind of magic sheen that made him exude a marked dignity. A marked dignity so rare, so distinct, in its immensity.

Excerpted from "Kofi, Three of Ten Frames"

MAKING *SUPERFINE*

Interviews

TORKWASE DYSON *with* CHELSEA GARUNAY

TANDA FRANCIS *with* JOYCE FUNG

In the following interviews, artists Torkwase Dyson and Tanda Francis discuss their work on the exhibition *Superfine: Tailoring Black Style* with Chelsea Garunay, exhibition design manager at The Metropolitan Museum of Art, and Joyce Fung, installation manager, exhibitions and special projects, at The Met's Costume Institute, respectively. Dyson describes herself as "a painter working across multiple mediums" and is known for her architectural sculptural forms created for the "spatial liberation of Black and brown bodies." Dyson served as the exhibition designer for *Superfine*. Tanda Francis characterizes herself as an artist who makes monumental African heads and masks as part of an effort to represent and memorialize African and African diasporic people and ancestors in public and private spaces. Her hope is that people take a moment to look within themselves and consider what connects us when looking at her sculptural faces. She designed two bespoke mannequin heads for the exhibition.

EXHIBITION DESIGN

TORKWASE DYSON *with* CHELSEA GARUNAY

CHELSEA GARUNAY: After receiving the invitation to collaborate with The Costume Institute on the exhibition design for *Superfine*, and reading Monica Miller's *Slaves to Fashion*, what emotions were you feeling and what did you want to reflect on?

TORKWASE DYSON: I was honored to receive the invitation from Monica and start diving into the book. What excited me was that she takes us through a history of black dandyism—a journey that was spatial and poetic and spanned across formal disciplines. Something she discusses that drew me in was an engraving by William Austin that is said to be of eighteenth-century dandy Julius Soubise fencing with his patroness and former enslaver, the Duchess of Queensbury (p. 94). So, thinking about how painting, fashion, and dandyism intersect was compelling. From European painting Monica then moved to W. E. B. Du Bois's *Dark Princess*, an incredible text from 1928 that speaks of self-fashioning through the lenses of activism, representation, and race building. She also talks about Iké Udé and Lyle Ashton Harris, thinking through the ways in which contemporary, queer, nonbinary black bodies can explore and critique the liminal space between objects of capitalism, beauty, and freedom. These histories of black self-fashioning are discussed through performance, photography, print, advertisements, fabric, and painting, all of which contribute to the question of liberation in small and big ways. Also, the time span of the book made it clear that black dandyism is a transhistorical issue tied to fashion and a deep resistance to oppression still relevant today.

To try and wrap my mind around the project, I took note of creative principles that came to my mind while I was reading and re-reading. (I'm a slow reader.) I noted things like agility, liminality, movement, autonomy, oscillation, flexibility, scale, and tension. Drawing was critical to arriving at a sculptural space that would honor each object or image chosen for the exhibition. It all became a question of forming a space flexible enough to hold the magnitude and complexity of the black dandy.

CG: How did your shape language translate into your interpretation of the text?

TD: It put me in a position to create a hybrid. I have shapes in my practice that are ongoing. I call them "hyper shapes," a vocabulary of forms that can ask questions. What the exhibition space for *Superfine* allowed me to do is create other kinds of shapes that had to do with the history of framing—the way black people were cast in painting, performance, music, entertainment—and cull shapes from those histories and operationalize them, along with the hyper shapes, to create a poetic between my environmental interests in self-liberators and Monica's conversations around modes of display for the dandy. I was able to bring these things together to host the variety of objects in the show. It was a sort of spatial study of abstraction that included entertainment and public-facing conditions that are not necessarily in my work, but the experiment of including these shapes was exciting for me.

CG: Monica wanted to know your thoughts on the spectrum of immobility and mobility that you've discussed in the past, as it has affected how she has been thinking about how to display the garments and other artworks in the exhibition.

TD: Self-liberators are critically aware of the necessity of scaling to be free—adjusting voice, body, space, or dress. The modulation it takes to tuck oneself away in relation to opening oneself up is based on the enclosures one needs to be free from. So, someone can hide inside a small room on a plantation or yell for freedom from an auction block. Each refusal

Installation view of Torkwase Dyson's *Liveness (Multi-Scalar Motion #1)* (2022) in the exhibition *Torkwase Dyson: A Liquid Belonging*, Pace Gallery, 2022

Early architectural rendering of the construct for the "Ownership" section of the exhibition

must be multi-scaled and outpace the systems already in place to further dispossession. People are always navigating violent infrastructures in the space between freedom and unfreedom, so mobility and immobility often depend on this mastery of scale. In my forms, it's the liminal space where scale is practiced, nurtured, and operationalized toward mobility. So the works become these throughways. All of my works have them—these sorts of physical liminal spaces in service of mobility.

As I made my way through *Slaves to Fashion*, I was interested in developing a shape language around what Monica points to: the tensions between motion, freedom, and display. Each story had its own question of space and choreography—theater space, painting space, photographic space, poetry space. I wanted to compose geometries that could host these multi-spatial narratives and add to the sense of mobility so evident in the text. So sometimes the shapes feel acrobatic, and sometimes they feel like silence. It is this change in state that is the essence of multi-scaled black mobility.

CG: You are a painter and a sculptor. How is your usual artistic process being translated to the exhibition design here? I'm thinking about your skill as an improviser, how you're composing in this process, creating sight lines through these spaces, and also your role as an exhibiting artist, considering the visitor in a different way. What was it like to work within these new constraints?

TD: I had to adjust my perception. I was initially concerned about what it meant to design for display—again, the politics of display is a part of the conceptual tension in the exhibition. I was afraid that as a designer my work would be less visceral or just flat. But in my practice there is always both a system and improvisation. The better and more agile the system, the more expansive the improvisation—flight. I realized that stepping into the designer role offered constraints but also gave possibilities. So in the design process, I said, "Oh, this is a possibility for holding one or two mannequins or holding a painting." Service came into my mind. So here we have constraints. With constraints begin possibilities. And possibilities got me to service. But I was still stiff. So I tapped into my own theory of black compositional thought, or "black comp." It considers how thresholds, paths, architecture, objects, and geographies are composed by black movement, and how from these encounters properties of energy, scale, and sound interact as networks of liberation. So in thinking about black comp in relation to *Superfine*, things started flowing. I

let the question of form go and started rigorously forming. I started shaping space; the aperture came. I started drawing throughways; the contour lines came. I started stacking things and accounting for the known and the unknown; the volumes came. It all became less about translation and more about invention. Focusing on just black comp set me free from whatever form is. I just focused on the forming. It was feral. I got to a point where I felt the service in the forming and that led me to the politics of architectural thinking. It was a poetic expanse for me. I hope that neither the garments nor the visitors feel surveilled. I am going for self-guided errantry.

CG: What was your thought process behind the design for displaying both the historical and contemporary works? I know that you allowed for different views, creating relationships among these garments and the implied bodies that they housed.

TD: It was an interesting challenge because the curatorial piece is evolving as the design is evolving. I'm trying to tap into how the curators conceptualize the relationship between history and the present. Monica has led the exhibition into a situation where it's transhistorical, so the forms respond to the history and the present. It was necessary to take a discursive approach with the geometries, to take up modularity so that there was some built-in agility around how the garments, paintings, prints, text will be situated. We are trying to create an environment where the people who use the space can have some autonomy and power over the way they want it to lay out physically to really represent the breadth of dandyism.

CG: In previous interviews and talks that I've seen you do, I've heard you discuss materials as a way to modulate light, and I'm curious how you thought about that in this design process. I'm interested in how your painterly background informs your approach to materials in this design.

TD: What was exciting about the design initially was that I could deploy painting, drawing, and sculpture under the rubric of architecture and design. And because painting is so much about light, space, and scale, and color and drawing is so much about the body immediacy—images of visceral feeling—it was important to think about ideas of refraction, reflection, transparency, and opacity. I think *Slaves to Fashion* points to it as well: The institution of slavery and its aftermath are both tied up with the diasporic reality that light changes over time and throughout different geographies. It can make space appear to contract and expand. So, it's really important to make a space where light and color could not be universal but be able to absorb the different registers of spatial and temporal experiences over time and through black life and death. There are ghosts present in the room and in these garments—the contemporary and historical. They are cunning, funny, masterful, and poetic. These moments of political resistance are beautifully hauntological and errant. My job was to open up an architectural ethos. And architecture is so much about light, where the curators tell this transhistorical story.

I also thought self-fashioning can be improvisational and makes a way for autonomy inside networks of dispossession. It's an expressive resistance that works in excess of the ongoing enclosures of anti-black violence. These are acts of resistance scripted and rescripted overtime. It's unfixed but certainly structured. This tension between structure and improvisation is very much a part of my practice of painting. So is the tension between performance and display, access and exclusion, ways of knowing and deep interiority, which is bound up in questions of land and ownership. My painting is very much about all these questions. My best compositions have these great tensions, and I wanted to bring this into the gallery.

CG: It also reminds me of what you said earlier about this project being an act of service. The kind of details that you were sensitive to made me think about how you were trying to be of service, not only to the garments and the work that's presented, but also to the audience and how they're navigating the space and the content.

TD: I've not designed an exhibition before and didn't pay attention to exhibition design. It always fell into the background,

Installation view of Torkwase Dyson's *Liveness (Multi-Scalar Motion #1)* (2022) in the exhibition *Torkwase Dyson: A Liquid Belonging*, Pace Gallery, 2022

Installation view of Torkwase Dyson's *Way Over There Inside Me (A Festival of Inches)* (2022) in the exhibition *A Movement in Every Direction: Legacies of the Great Migration*, Baltimore Museum of Art, 2023

and that includes both light and texture and material and all these ideas that are supposed to recede behind the content. That's a shift from a painting—or a sculpture or a drawing—that is supposed to be the focus on a wall; all the creativity that goes into exhibition design is supposed to recede to the back. Here, the challenge was tuning my sculptural voice to the service of the narrative of fashion. My sculptures are not composed as tangible objects; they are composed of fleeting embodied experiences. They are not for looking; they are for being. For *Superfine*, each architectural zone is stationary and crafted for gazing. What I hope the audience will receive is this ethos of space, of me celebrating black spatial liberation practices at every scale—and in this case, not just geographically but on one's own body. It's so very much about audience and the ethos of the room and acknowledging the ancestorship in the room of the people who had worn these garments and the designers in the room like Virgil Abloh.

People like Virgil Abloh and André Leon Talley are ancestors to us now. So we have recent ancestors, and we have not-so-recent ancestors, but they all need to have space because their creations, their bodies, the evidence of their lived experiences are in the room. I wanted to bring some tenderness to that. I hope the space offers the proper tension but also gives permission for errantry and tenderness. The best scenography can hold discursive experiences. I hope this one can as well.

CG: It's interesting to think about *audience* as an expanded term, not just the visitors to the museum, but also the ancestors that you're making space for as well. It leads me to the broader question and the final question that I have: What does it mean for you to contribute to this show?

TD: The gift of coming into a field of knowledge that I never entered before, exhibition design; the care of the history; the proximity to objects and containers (the container being the design, the objects being the work in the show)—I'm eternally grateful for it. And I wanted to thank SAT3, the design studio that adhered to my shape language and brought the design to life. These geometries are complicated, and they worked with care, patience, and belief in my vision.

MANNEQUINS

TANDA FRANCIS *with* JOYCE FUNG

JOYCE FUNG: The Costume Institute contacted you to design mannequin heads for the *Superfine* exhibition. What was your initial reaction to the collaboration and receiving the call?

TANDA FRANCIS: At first I wanted to make sure that it was legit. And it was! I've been to The Met often and saw shows at The Costume Institute, so it was exciting. The McQueen show—I cannot forget that—was iconic and had a lasting impression on me. It was beautiful. I don't think I'd seen that kind of presentation before, with such focus and care. It made me appreciate what was happening, even down to the mannequins.

JF: I wonder if you can tell us about your artistic practice, how you got started, what inspires you, and how it translates to your work for *Superfine*?

TF: I was a designer for some years, doing beauty, skin care, and fragrance package design. The expression of the artist in their work is more of themselves and less about what's going on in the market. As a designer, I'm primed to let go of an idea and move on. With art, I have the freedom to choose the story I want to tell and shape it in the way I feel is right. Story is important to me because it strengthens the message I want to convey. It gives both me, as the artist, and the viewers something to connect with.

My mannequin head is going to be reproduced several times, which reminds me of design. But it is also an art piece, and I was able to express what I wanted to express and have it be close to my heart. I try to connect with others and have my work be something that encourages people to talk about issues that I think are important. With public art it's like, let's talk about this and let's do it in a way that brings the most people together to discuss it. What I'm doing is putting these faces out there. I want to have it be something that makes a difference. I've been doing that by talking about some of the social issues we have had in this country—how we consider who we are, our identity in this country, and how it connects to the world.

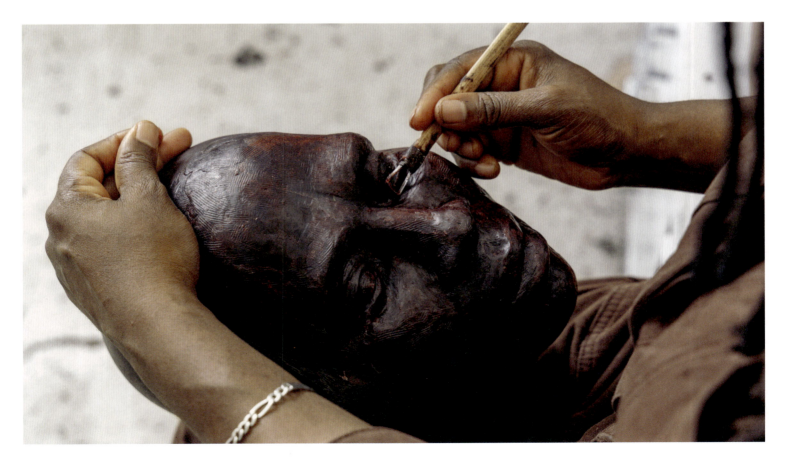

Tanda Francis sculpting a custom mannequin head in her studio

JF: How did the process of designing a mannequin head differ from that of a monumental public work? What was the process like?

TF: It's very similar in that I want to tell a story and get that out to the public. For the mannequin head, the art's not in the street—people are electing to come into the space—but I want to bring about that feeling by having the materiality of the surface be inspired by a metal statue. A bronze, cast-iron feeling. And I've been trying to communicate more with public art by bringing the element of digital presentation into it as well. It's quite similar: I'm telling a story and then elaborating on that in a digital space.

I was doing presentations purely online, where you can walk into environments and it's so beautiful. I left that alone for ten years, and now that I'm focusing on sculpture, I want to bring us back to that digital space. I started to try to express this idea in my work. It has a spiritual quality for me. There's a space in the digital realm, a spirit space that you do not see but that is definitely there. Imagine virtual reality spaces—everything is said to be there, but then you take away your device and you don't see anything. It's like that for me: a window into another realm.

JF: And you've also explored more 3D scanning and printing with this project. How has that helped you?

TF: Being able to visualize things quickly and being able to move around it quickly—to take the sculpted head and scan it in with the facets—I wouldn't be able to do that on a desk because these pieces were very physical. I love the idea of combining physical analog and digital, bringing the physical into the digital space, to look under it and move it around. My mind is going into this space, and there's a whole story there. It opens up to me, ideas come, and I can iterate. It's just a tool that allows me to think things through more quickly.

JF: You mentioned that prior to The Costume Institute asking you to sculpt a head for an existing mannequin body, you were thinking of designing a mannequin. Did you think about just the head? Or did you envision the head with a full body?

TF: I was thinking more of the head, so it kind of came out exactly as I would have wanted it to. I could focus on the head and bring out the character in that way.

JF: In terms of the character, did you have someone in mind when you were developing this head?

TF: I researched a lot, I read Monica Miller's book, and then I latched on to the Sapeurs dandiacal fashion movement in Congo, the subculture there. I've never seen anything like it. The love for fashion and the connection to disrupting culture and making a movement based on fashion—it was impressive to me. And it's their life right now.

My work looks back to Africa, this idea of being away—Africans out of Africa. It stuck with me, and I decided to roll with it, because this idea of being African American and having that connection to Africa, it's part of my work. There is a head, but you can see the slight suggestion of a mask in its surface. It's emerging out into the space, connecting one place to another.

JF: There will be two versions of the head in the exhibition. One is a plain head, and one incorporates the silhouette panels, a recurring motif in your work. Can you tell us a little bit more about where the panels come from?

TF: There's the idea of emerging out of this flat plane into a three-dimensional plane. I brought this idea into my work originally with the piece *RockIt Black*; it was inspired by an open book. I'd done that piece after working on a portrait of Maya Angelou, and it connected to the idea of walking into the space of a book and that open-chapter feel. Different sections, 360 degrees. I decided to have it break down into more chapters. You can walk into this space with the potential of having each facet tell a story. I've been working in that way with this head, and it became something like an armor.

In my mind I started to think about protective style—that's something cultural with African hair, something that you do to protect your hair. It's style, this protective style. Those two words came together, and I thought, "Wow, that's really powerful."

I was excited to express that with this piece. But this is my first time working with The Costume Institute, and I didn't know how far the language I chose to use could go. How we express ourselves is something close to me and close to my community of African Americans, and Africans in general. I was a little bit trepidatious about using that term and having it available to everyone. There's a history in this country of people overstepping. It might seem strange for other people to take this same information and be less sensitive to the context. I want this idea to be shown, and there's a certain

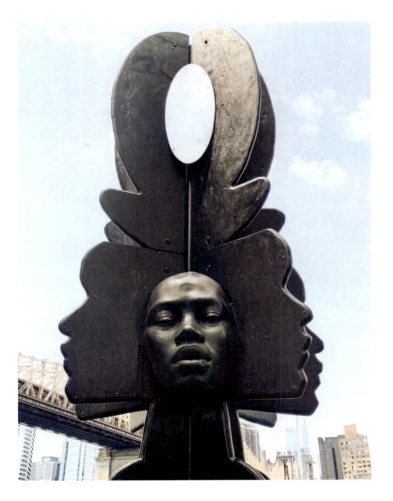

Tanda Francis's *RockIt Black* (2021) in Queensbridge Park, Queens, New York

amount of control because I know where I'm coming from and how it could be respectfully expressed.

JF: The idea of protection is interesting because people feel like fashion is armor: It's something that you put on your body before you go out, and it's to protect yourself, to transform yourself. It's what people see initially. So, the idea of armor, protection, is inherent in fashion.

TF: Absolutely. Even the idea of a mask, where you're choosing to put it on and express yourself in a certain way. That detail of having it be a mask is something I would love to see manifest itself when the clothing is articulated onto the pieces.

JF: A lot of times when we talk about mannequins, we're trying to find a universal ideal—or for female mannequins, a universal beauty. It's the model figure and you want this one mannequin to represent a multitude of people. And everyone brings their own experiences to the mannequin.

TF: It was really insightful to observe other mannequins, especially the ones you had in the past through the mannequin company Bonaveri. It's interesting, blanking the surface a little bit.

But it was challenging to make it even less representational and to try to play with how far to bring out the character I had in mind. I have been focusing on the female and the goddess. I've been working on another piece where I was inspired by a female, and it manifested into a male character, and I was like, "Wow, it was already a part of the story."

JF: In terms of mannequin design and production in the industry, androgyny is a direction too. Not specifically female or male, but very universal.

TF: Right. I appreciate it because, even when I was working with these female stories, I like creating a feeling of androgyny—you can see it both ways. With this one piece, I felt in my head that it was a woman, and then in other people's eyes, it's like, "Oh, are we sure?" It takes some time to push it in that direction, to go with what was being developed. I enjoy playing with that idea of male and female simultaneously.

JF: The mannequin will have a life of its own after it leaves your hands. It will be manufactured in multiples by a mannequin company and, later, wear the clothing of fashion houses and designers from around the world. As an artist, how do you reconcile yourself to how others will interpret your work? Does it make you nervous that other things will exist alongside the mannequin head? Do you care what the mannequin will wear and what kind of message it presents in terms of the clothing, the fashion?

TF: I'm less concerned about me and more concerned about the idea of representing someone and having that be out there. I was inspired by André Grenard Matswa, known as the first Sapeur. He's already there in the form of a mask, and that in itself transforms the piece, transforms the story, into a potential for something else.

JF: Can you speak about the materials you use and what significance they hold for you—in particular, the color black? How did that inform your ideas about the finish for the mannequin?

TF: Originally, I used clay, which feels connected to Earth in the most basic way. It's a story of Earth, especially when I use water-based clay. At some point I used actual earth from specific sites, just sprinkled in there.

I am settled on using a lot of black. The term *Blackness*—it's connected to Black people as a label, people whose ancestry leads to Africa, or being Black. Blackness is a controlled concept and has a negative connotation, and they leaned into that when we were labeled Black, on this side of the world especially, broadcasting the story of Blackness to the entire world. Blackness and negativity are paired with the idea of whiteness, which is the most positive story. And then we have this Black and white story that developed in this country. There's obvious beauty to black that I like to showcase. I'm saying let us be Black and let you keep that label. Black is beautiful. Let's show that beauty and talk about that.

JF: What color have you suggested for the mannequin?

TF: I started to use mirror for the side panels, but the angle wasn't giving me exactly what I wanted. So, I settled on a statuesque color with a metal-monument feeling. While I was working on this piece, I modeled it in wax. I formulated the colors of the wax and started to mix things in there. Sometimes when I was sculpting, I had the piece and traveled with it, and that gathered a history of my own movement.

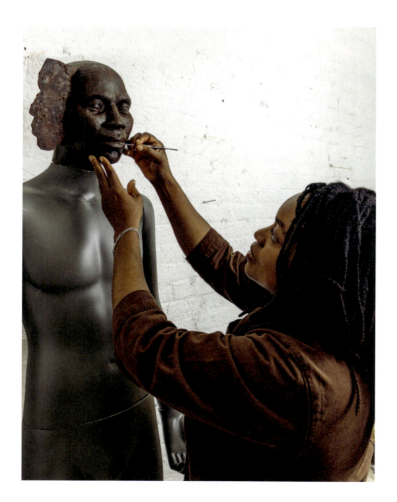

Tanda Francis sculpting a custom mannequin head with silhouetted profiles in her studio

You can see the beautiful layers that showed up in the process. I thought, "Why not make that come out in the actual mannequin?" In the end, the story that I was telling was the potential for this to be a public monument on the inside of the museum. I went in the direction of having a bronze monument—public art—wearing clothes within a museum space.

I haven't seen the pieces yet or my work attached to the fashion. But the idea is amazing to me, for people to be able to create in another situation, another story. So much heart goes into making an object, whether it's art or fashion. I love when that can be observed and understood, especially when we're dealing with fast fashion pressing out things quickly and not thinking about it. Move on, trash it—the life that we're living right now.

JF: Your sculptures are generally outdoors, readily accessible. This mannequin will live within a costume exhibition in a museum. Does that change things for you?

TF: The difference between the indoor and the outdoor is that people are either electing to see the piece or just happen to be in the same space without even planning it. People will have more of an introduction as to why this piece is in the museum, and people will already have an idea of what they might expect in the space. On the streets, people are zooming by it. They're not always going to read the plaque. I'm happy to have people stop and be able to observe. My pieces have been in these busy cities and it's an honor when people take the time out of their lives between point A and point B to stop and notice.

JF: That really summarizes the museum visitor. It is a special thing to have people come and be surprised about something that they weren't expecting.

TF: That's the cool thing about The Met. People know that it's there and they can just enter and see what they discover. I can only imagine what the garments look like, and I have no idea about what will be presented. It was interesting to see at the press conference what some of the garments would be. And of course, I thought about which piece might go with which garment. I can't wait to see how it turns out.

350
Contributors

352
Checklist

361
Credits

362
Selected Readings

368
Acknowledgments

CONTRIBUTORS

MICHAEL HENRY ADAMS is a Harlem-based historian, writer, and historic preservation advocate and activist whose books include *Harlem, Lost and Found: An Architectural and Social History, 1765–1915*, from 2001. *Homo Harlem: Black Lesbians and Gays in the African American Cultural Capital, 1925–1995* is forthcoming.

CHARLIE ALLEN is a third-generation master tailor, menswear designer, and fashion lecturer who designs bespoke suits from his North London studio.

ANDRÉ 3000 is a celebrated artist and auteur whose work in music, film, fine arts, fashion, and more continues to influence the cultural landscape on a global scale.

MARIELLE BOBO is the vice president of content at Shoptalk, a global events company driving retail innovation. A media veteran with twenty-five years of storytelling across fashion, beauty, and culture, she was editor in chief at *EBONY* and fashion director at *Essence*.

CHRISTINE CHECINSKA is the senior curator for Africa and diaspora textiles and fashion at the Victoria and Albert Museum, London, as well as an artist, designer, and scholar.

ADRIENNE L. CHILDS is a curator and scholar focused on race and representation in European and American art.

JASON CYRUS is an associate lecturer in the Cultural and Historical Studies Department at the London College of Fashion and a fashion curator exploring questions of creativity, identity, and cultural exchange.

BRENT HAYES EDWARDS is the Peng Family Professor of English and Comparative Literature at Columbia University.

MARY N. ELLIOTT is a public historian and a curator at the Smithsonian National Museum of African American History and Culture, specializing in American slavery.

TREMAINE EMORY is the creative director, designer, and founder of Denim Tears, a clothing brand using the cultural vein of fashion to address the Black experience.

EKOW ESHUN is an author, a curator, and the chairman of the Fourth Plinth, overseeing Britain's foremost public art program. His latest book is *The Strangers: Five Extraordinary Black Men and the Worlds That Made Them.*

TANISHA C. FORD is a professor of history at CUNY Graduate Center and the author of four books, including *Dressed in Dreams: A Black Girl's Love Letter to the Power of Fashion* and *Liberated Threads: Black Women, Style, and the Global Politics of Soul.*

SIR LEWIS HAMILTON, a seven-time Formula One world champion, is the most successful driver in F1 history, driving for Scuderia Ferrari HP. Outside of racing, he engages in business ventures that focus on production, lifestyle, and fashion and serves as a fierce advocate for social reform through his charity, Mission 44.

JEREMY O. HARRIS is a Tony-nominated playwright and screenwriter known for his plays *Slave Play*, *"Daddy": A Melodrama*, and *Black Exhibition*, as well as his film *Zola*. He serves as the inaugural creative director for the Williamstown Theatre Festival in Williamstown, Massachusetts.

KIMBERLY M. JENKINS is a fashion studies scholar focused on aesthetics, power, and the sociocultural influences behind how we dress. She is the founder of Artis Solomon Consulting and the Fashion and Race Database.

GABRIELLA KAREFA-JOHNSON is a New York–based stylist and fashion editor who centers her craft around diversifying representation in the high-fashion landscape.

CONTRIBUTORS

NIGEL LEZAMA is a professor of fashion studies and inclusion at Toronto Metropolitan University whose research concentrates on historical and contemporary cultural practices, marginalized through colonialism, capitalism, and heterosexism.

KAI TOUSSAINT MARCEL is a research assistant in The Costume Institute at The Metropolitan Museum of Art and a writer, researcher, and cultural historian whose work centers on the body politics of fashionability, identity, and power.

ALPHONSO D. MCCLENDON is an associate professor in the Antoinette Westphal College of Media Arts & Design at Drexel University and author of *Fashion and Jazz: Dress, Identity and Subcultural Improvisation.*

MADISON MOORE is an assistant professor of modern culture and media at Brown University and author of *Fabulous: The Rise of the Beautiful Eccentric.*

DENISE MURRELL is the Meryl H. and James S. Tisch Curator at Large, Office of the Director, at The Metropolitan Museum of Art. She focuses on the African diasporic presence in art from the nineteenth century to today.

DYNASTY OGUN is the co-founder of and a head designer at L'ENCHANTEUR and L'E Gold WILL. She is an autodidactic designer, mystic, artist, and scholar with a foundation and focus in mystic healing, design, and lifestyle.

SOULL OGUN is the co-founder of and a head designer at L'ENCHANTEUR and L'E Gold WILL. She is an artist, mystic, scholar, researcher, designer, and futurist focused on self and mystic healing as well as on lifestyle design and culture.

RICHARD J. POWELL is a professor of art history at Duke University who specializes in American art and the arts of the African diaspora.

AMY SHERALD is a painter documenting contemporary African American experience in the United States through arresting, intimate portraits.

JONATHAN MICHAEL SQUARE is an assistant professor of black visual culture at Parsons School of Design, where he specializes in the visual culture of slavery and its legacy.

CAROL TULLOCH is a writer, curator, and professor of dress, diaspora, and transnationalism at Chelsea College of Arts, University of the Arts London.

IKÉ UDÉ is a dandy, aesthete, author, publisher, and artist who has exhibited in museums worldwide, including the Solomon R. Guggenheim Museum and the National Museum of African American History and Culture. He is currently at work on portraits of eminent Black American women and on his first book of fiction, *Kofi, In Ten Frames.*

GRACE WALES BONNER is the founder and artistic director of the fashion label Wales Bonner. Her curatorial exhibitions include *Grace Wales Bonner: A Time for New Dreams* (2019) at Serpentine Galleries, London, and *Artist's Choice: Grace Wales Bonner—Spirit Movers* (2023) at the Museum of Modern Art, New York.

ELIZABETH WAY is the curator of costume and accessories at the Museum at FIT and a scholar focused on Black American and diasporic fashion culture.

DANDY WELLINGTON is a bandleader, presenter, and style activist dedicated to creating an inclusive community for vintage fashion enthusiasts.

DEBORAH WILLIS is professor and chair of the Department of Photography & Imaging at the Tisch School of the Arts at New York University. She is an artist, author, and curator whose work concentrates on cultural histories that envision the Black body, women, and gender.

351

CHECKLIST

OWNERSHIP

Half groat of Henry VII (1485-1509). British (15th-16th century). Silver, 1 × ⅛ in. (2.4 × 0.3 cm). The Metropolitan Museum of Art, New York, Bequest of Joseph H. Durkee, 1898 (99.35.3452). p. 66

L'ENCHANTEUR (American, founded 2017). Soull and Dynasty OGUN (American, b. 1984). *"Kalinago Royal Coin #8" pendant*, 2023. Bronze. Courtesy L'ENCHANTEUR. p. 67

Workshop of Jean-Marc Nattier (French, 1685-1766). *Roch Aza et Louis Armand Constantin Rohan, prince de Montbazon (1732-1794)*, 1758. Oil on canvas, 35⅞ × 28⅜ in. (91 × 72 cm). Château des ducs de Bretagne, Musée d'histoire de Nantes (2023.7.1). p. 68

I.M.P. (French). *Teapot*, mid-18th century. Silver; ebony, H. 7⅜ in. (18.6 cm). The Metropolitan Museum of Art, New York, Gift of James Hazen Hyde, 1956 (56.176). p. 69

Hyacinthe Rigaud (French, 1659-1743). *Portrait d'un jeune homme noir*, 1710-20. Oil on canvas, 22⅜ × 17¼ in. (56.8 × 43.7 cm). Musée des Beaux-Arts et LAAC, Dunkerque (BA.1982.003.1). p. 70

Livery coat and waistcoat. American (ca. 1840). Purple silk velvet trimmed with gold cotton-and-metal galloon. Maryland Center for History and Culture, Gift of Miss Constance Petre (1946.3.3a-c). p. 71

Meissen Manufactory (German, founded 1710). Modeled by Johann Joachim Kändler (German, 1706-1775), after compositions by Laurent Cars (French, 1699-1771) and François Boucher (French, 1703-1775). *Lady with Attendant*, ca. 1740. Hard-paste porcelain; mount of gilt bronze, H. 7¼ in. (18.4 cm). The Metropolitan Museum of Art, New York, Gift of Irwin Untermyer, 1964 (64.101.59a, b). p. 72

Louis de Carmontelle (French, 1717-1806). *Mlle Desgots, de Saint Domingue, avec son nègre Laurent*, 1766. Chalk, pencil, and watercolor on paper, 11½ × 8 in. (29.3 × 20.5 cm). Musée Carnavalet, Histoire de Paris (D.4498). p. 74

Claude Louis Desrais (French, 1746-1816). *Dame de qualité à qui un jeune nègre porte la queue*, published in cahier 19 of *Gallerie des Modes*, 1779. Hand-colored engraving on paper, 13½ × 9½ in. (34.3 × 24.1 cm). The Metropolitan Museum of Art, New York, The Irene Lewisohn Costume Reference Library. p. 75

Brooks Brothers (American, founded 1818). *Livery coat*, 1856-64. Light brown wool broadcloth. Historic New Orleans Collection (2013.0115.1). p. 76

Gabriel Mathias (British, 1719-1804). *Portrait of William Ansah Sessarakoo, Son of Eno Baisie Kurentsi (John Currantee) of Anomabu*, 1749. Oil on canvas, 26¼ × 21⅞ in. (66.7 × 55.6 cm). The Menil Collection, Houston (1980-60 DJ). p. 78

Galloon. Italian or French (17th-18th century). Gold tinsel and silk-and-metal thread, 11½ × 2½ in. (29.2 × 6.4 cm). The Metropolitan Museum of Art, New York, Rogers Fund, 1908 (08.103.357). p. 79

Galloon. European (late 18th-early 19th century). Silver tinsel and silk-and-metal thread, 8¼ × 2½ in. (21 × 6.4 cm). The Metropolitan Museum of Art, New York, Gift of The United Piece Dye Works, 1936 (36.90.1887). p. 79

LOUIS VUITTON (French, founded 1854). Virgil Abloh (American, 1980-2021). *Ensemble*, autumn/winter 2021-22 menswear. Coat of silver polyurethane embossed with allover *LV* monogram; shirt and tie of white cotton plain weave; trousers of white wool twill; brimmed cap of silver PVC. Courtesy Collection LOUIS VUITTON. pp. 80-81

L'ENCHANTEUR (American, founded 2017). Soull and Dynasty OGUN (American, b. 1984). *"L'E Goldwill" bullion*, 2023. Bronze. Courtesy L'ENCHANTEUR. p. 82

Wales Bonner (British, founded 2014). Grace Wales Bonner (British, b. 1990). *"Aime" ensemble*, autumn/winter 2015–16. Jacket of blue silk crushed velvet embroidered with cowrie shells, clear and yellow crystals, and ivory glass pearls; trousers of blue silk crushed velvet; shirt of white sand-washed silk plain weave. Courtesy Wales Bonner. pp. 84–85

3.PARADIS (French Canadian, founded 2013). Emeric Tchatchoua (Canadian, b. 1988). *Jacket*, autumn/winter 2019–20. Navy pinstriped wool twill and black wool plain weave with appliquéd laminated dollar bill. Courtesy 3.PARADIS. pp. 86–87

PRESENCE

Lord —, or, The Nosegay Macaroni, published in *The Macaroni and Theatrical Magazine, or Monthly Register, of the Fashions and Diversions of the Time*, February 1773. The Lewis Walpole Library, Yale University (773.02.00.01). p. 92

Matthias Darly (British, ca. 1721–1780). Mary Darly (British, 1736–1791). *Portrait of Julius Soubise ("A Mungo Macaroni")*, 1772. Engraving and watercolor on paper, 5⅝ × 3¼ in. (14.3 × 8.3 cm). The Menil Collection, Houston (P69-283PC). p. 93

William Austin (British, 1721–1820). *The D— of [. . .]—playing at foils with her favorite lap dog Mungo after expending near £10000 to make him a —*, May 1773. Hand-colored etching on laid paper, 10¾ × 14⅜ in. (27.3 × 37.6 cm). The Lewis Walpole Library, Yale University (773.05.01.09+). p. 94

Tricorne. Italian (mid-18th century). Black wool felt trimmed with gold metal galloon. The Metropolitan Museum of Art, New York, Rogers Fund, 1926 (26.56.88). p. 95

Saint James's Factory (British, ca. 1748/49–60). *Scent bottle*, ca. 1750–55. Soft-paste porcelain, H. 2⅝ in. (6.7 cm). The Metropolitan Museum of Art, New York, Gift of Irwin Untermyer, 1971 (1971.75.6a, b). p. 96

LOUIS VUITTON (French, founded 1854). Virgil Abloh (American, 1980–2021). *Bag*, autumn/winter 2022–23 menswear. Brown leather with allover *LV* monogram print and appliquéd green vines and polychrome flowers of cut leather. Courtesy Collection LOUIS VUITTON. p. 97

3.PARADIS (French Canadian, founded 2013). Emeric Tchatchoua (Canadian, b. 1988). *Jacket* (detail), 2021. Black pinstriped wool embroidered with bouquet of polychrome dried flowers. Courtesy 3.PARADIS. p. 98

Hippolyte-Louis-Emile Pauquet (French, 1797–1871). *Le Mulâtre*, published in tome 3 of *Les Français peints par eux-mêmes, or Encyclopédie morale du XIXᵉ siècle*, 1842. Musée d'Aquitaine Bordeaux (2003.4.209). p. 100

S. W. (probably American). *New Orleans Black Dandy*, published in volume 2 of *Texas and the Gulf of Mexico, or Yachting in the New World* by Matilda Charlotte Houstoun, 1844. Houston Public Library. p. 101

Iké Udé (Nigerian American, b. 1964). *Sartorial Anarchy #4*, 2012. Pigment on satin paper, 40 × 36 in. (101.6 × 91.4 cm). Leila Heller Gallery. p. 102

Iké Udé (Nigerian American, b. 1964). *Sartorial Anarchy #5*, 2013. Pigment on satin paper, 54 × 36 in. (137.2 × 91.7 cm). Leila Heller Gallery. p. 103

DISTINCTION

Alexandre François Louis de Girardin (French, 1767–1848). *Portrait of Toussaint Louverture*, 1804–5. Oil on canvas, 25⅝ × 21⅜ in. (65 × 52.4 cm). La Maison de l'histoire européenne (C.2024.023.001). p. 108

House of Dior (French, founded 1946). John Galliano (British, b. 1960). *Coat*, autumn/winter 2000–2001 haute couture. Navy wool twill with appliquéd braid of gold silk-and-metal thread and red silk piping. Alexis Thomas, Estate of André Leon Talley. p. 109

After Agostino Brunias (Italian, ca. 1730–1796). *Buttons*, late 18th century. Gouache paint on ivory verre affixed to glass with ivory backing and edged with gilt metal, ⅜ × 1½ in. (1 × 3.7 cm) each. Cooper Hewitt, Smithsonian Design Museum, Smithsonian Institution, Gift of R. Keith Kane from the Estate of Mrs. Robert B. Noyes (1949-94-1, 7–9, 12, 15). p. 110

Jan Anthonie Langendijk (Dutch, 1780–1818). *French General and Officer, St Domingo*, 1802. Watercolor on paper, 6¼ × 4⅛ in. (16 × 10.5 cm). Royal Collection Trust (RCIN 915306). p. 112

Richard Evans (British, act. 1813–17). *Henry Christophe, King of Haiti*, ca. 1816. Oil on canvas, 34¼ × 25½ in. (87 × 64.8 cm). University of Puerto Rico, Alfred Nemours Collection of Haitian History. p. 113

Engraved by Louis François Charon (French, 1783–1839), after a composition by Pierre Martinet (French, 1781–1815?). *Boyer*, ca. 1820. Color aquatint with additional hand coloring, 18¾ × 13⅜ in. (47.5 × 34 cm). The Metropolitan Museum of Art, New York, Gift of William H. Huntington, 1883 (83.2.922). p. 114

Robert Mole (British, 1800–1856). *Sword with scabbard of Faustin I (1782–1867), Emperor of Haiti*, 1850. Steel, silver, gold, wood, and silk velvet. The Metropolitan Museum of Art, New York, Bequest of William S. Delafield Sr., 2012 (2012.204a, b). p. 115

Louis Gauffier (French, 1762–1801). *Portrait de Thomas Alexandre Dumas en chasseur*, 1801. Oil on canvas, 37⅞ × 30⅜ in. (96 × 77.2 cm). Musée Bonnat-Helleu, Musée des Beaux-arts de Bayonne (CM 539). p. 116

Jawara Alleyne (Jamaican Caymanian, b. 1991). *Ensemble*, autumn/winter 2021–22. Jacket of navy shirred cotton jacquard; cardigan of orange and black cotton knit; leggings of white shirred cotton plain weave. Courtesy Jawara Alleyne. p. 117

CHECKLIST

Achille Devéria (French, 1800–1857). *Alexandre Dumas*, 1829. Lithograph, 18⅞ × 14 in. (48.1 × 35.5 cm). The Metropolitan Museum of Art, New York, Harris Brisbane Dick Fund, 1917 (17.3.756-2201). p. 118

Kennedy (American). *Cabinet card of Henry O. Flipper*, ca. 1877. Albumen print, 4¼ × 6½ in. (10.8 × 16.5 cm). National Archives and Records Administration (NAID 2668824). p. 120

denzilpatrick (British, founded 2021). Daniel Gayle (British, b. 1983). *Ensemble*, spring/summer 2025. Sweatshirt of red polyester jersey printed with military-style passementerie motifs; trousers of pink polyester jacquard with self-fabric braid and allover foliate motifs. Courtesy denzilpatrick. p. 121

James Van Der Zee (American, 1886–1983). [*Marcus Garvey in a UNIA parade*], 1924. Gelatin silver print, 6½ × 9½ in. (16.4 × 24 cm). The Metropolitan Museum of Art, New York, Funds from various donors, 2018 (2018.96). p. 122

Wales Bonner (British, founded 2014). Grace Wales Bonner (British, b. 1990). *Ensemble*, spring/summer 2017. Tailcoat of black wool plain weave; trousers of black wool plain weave embroidered with polychrome cotton crocheted waistband and appliquéd black silk satin side stripes; shirt of ivory cotton plain weave embroidered with cotton crocheted collar; brooch of silver-plated brass, freshwater pearls, and beads of lapis lazuli. Courtesy Wales Bonner. p. 123

Emory Douglas (American, b. 1943). Yolanda López (American, 1942–2021). Cover of volume 3, issue 20 of *The Black Panther*, September 6, 1969. Two-color ink on newsprint, 17⅝ × 11½ in. (44.8 × 29.2 cm). The Museum of Modern Art, New York, Collection of Patrick and Nesta McQuaid and Akili Tommasino, gift of the Committee on Architecture and Design Funds (179.2019). p. 124

TELFAR (American, founded 2005). Wilsons Leather (American, founded 1899). Telfar Clemens (American, b. 1985). *TELFAR × Wilsons ensemble*, 2024. Coat and trousers of black leather; mock-neck sweater of black ribbed wool knit. Courtesy TELFAR. p. 125

Antonio's Manufacturing (American, founded 1971). *Afro rake*, 1970s. Injection-molded plastic; silver metal. Anonymous. p. 126

BOTTER (Dutch, founded 2017). Rushemy Botter (Dutch, b. 1984). Lisi Herrebrugh (Dutch, b. 1989). *Afro pick and pouch*, autumn/winter 2021–22. Pick of black plastic and steel; pouch of black crocodile-embossed calf leather. Courtesy BOTTER. p. 126

DISGUISE

Runaway slave advertisement, published in *The New-York Gazette, Or, the Weekly Post-Boy*, October 27, 1763. Schomburg Center for Research in Black Culture, Photographs and Prints Division, New York Public Library. p. 132

Cabinet card of William Headley, ca. 1864. Albumen print, 3⅝ × 2¼ in. (9 × 5.5 cm). National Gallery of Art, Washington, D.C., Ross J. Kelbaugh Collection, Purchased with support from the Ford Foundation (2023.39.56). pp. 134–35

Who Decides War (American, founded 2015). Ev Bravado (American, b. 1993). Téla D'Amore (American, b. 1994). *Suit*, autumn/winter 2024–25. Pieced wool twill with exposed black and white polyester interfacing and horsehair. Courtesy Who Decides War. p. 136

Joseph Andrews (American, 1806–1873). Stephen Alonzo Schoff (American, 1818–1904), after a daguerreotype by Luther Holman Hale (American, 1823–1885). Frontispiece to *Running a Thousand Miles for Freedom; or, The Escape of William and Ellen Craft from Slavery* by William Craft, 1860. Boston Public Library, Special Collections (RARE BKS E450.C84R 1860x). p. 138

Samuel O. Aborn (American, 1817–1899). *Hat*, ca. 1840. Beige beaver fur with band of beige silk grosgrain. The Metropolitan Museum of Art, New York, Gift of Mrs. James F. Lawrence, 1965 (C.I.65.2.2a). p. 139

Ellen and William Craft, published in *The Underground Rail Road* by William Still, 1872. Schomburg Center for Research in Black Culture, Manuscripts, Archives and Rare Books Division, New York Public Library. p. 140

Off-White (Italian, founded 2013). Ib Kamara (Sierra Leonean, b. 1990). *Suit*, spring/summer 2023. Jacket of black wool plain weave with white thread embroidery of anatomical chest and torso motif; trousers of black wool plain weave with white thread embroidery. Courtesy Off-White. pp. 142–43

"Thirteen Years a Girl-Husband," published in *The Ogden Standard*, June 13, 1914. J. Willard Marriott Digital Library, The University of Utah. p. 144

Vicente (American, act. mid-20th century). *Stormé DeLarverié*, 1956. Gelatin silver print, 24½ × 19¾ in. (59.7 × 50.2 cm). Schomburg Center for Research in Black Culture, Photographs and Prints Division, New York Public Library. p. 145

FREEDOM

Edward Williams Clay (American, 1799–1857). *Philadelphia Fashions, 1837*, 1837. Lithograph, 18½ × 12¾ in. (47 × 33 cm). Library Company of Philadelphia (6281.F). p. 150

Quizzing glass. Probably English (second quarter 19th century). Clear glass and gold filigreed metal. Mark Wallis Collection. p. 151

George Endicott (American, 1802–1848). Cover of *"My Long-Tail Blue" sheet music*, ca. 1827. Lithograph, 9 × 5⅜ in. (22.9 × 13.5 cm). The Miriam and Ira D. Wallach Division of Art, Prints and Photographs: Picture Collection, New York Public Library. p. 152

354

CHECKLIST

Matthew Schmitz (American, b. Prussia, act. mid-19th century). Peter S. Duval (American, b. France, 1804/5–1899). *"Dandy Jim from Caroline: a celebrated Ethiopian song": sung by the Virginia Minstrels / arranged by J. T. Norton*, 1844. Color lithograph, 13¼ × 10¼ in. (33 × 26 cm). The Jay T. Last Collection of Graphic Arts and Social History, Huntington Digital Library. p. 153

Attributed to George Washington Mark (American, 1795–1879). *Untitled [African-American musicians]*, 1838. Oil on canvas, 22⅛ × 17⅛ in. (56.2 × 43.5 cm). Memorial Hall Museum, Pocumtuck Valley Memorial Association, Deerfield, Mass. (2002.45.01). p. 154

Newton (British). *Tailcoat*, 1829. Navy wool broadcloth. The Metropolitan Museum of Art, New York, Purchase, NAMSB Foundation Inc. Gift, and Judith and Gerson Leiber Fund, 1995 (1995.292a). p. 155

Portrait of James Forten. American (ca. 1820). Oil on panel, 19 × 13¾ in. (48.3 × 34.9 cm). Flint Institute of Arts, Flint, Mich., Gift of Edgar William and Bernice Chrysler Garbisch (1981.7). p. 156

Portrait of a Gentleman. American (ca. 1830). Oil on panel, 26 × 21¼ in. (66 × 54.1 cm). Bowdoin College Museum of Art, Brunswick, Maine, Museum Purchase, Hamlin Fund (1964.5). p. 158

Attributed to William Matthew Prior (American, 1806–1873). *William Whipper*, ca. 1845. Oil on canvas, 27 × 22½ in. (68.6 × 57.2 cm). Fenimore Art Museum, Cooperstown, N.Y., Gift of Stephen C. Clark (N0246.1961). p. 159

William Wood Thackara (American, 1791–1839). William G. Mason (American, act. 1819–60). *A New Mode of Perfuming & Preserveing Clothes from Moths*, ca. 1819. Pen and ink on paper, 8⅛ × 11 in. (20.5 × 27.8 cm). Historical Society of Pennsylvania (Bd.61.T.32). p. 160

Shirt. French (ca. 1800). White linen plain weave. The Metropolitan Museum of Art, New York, Purchase, NAMSB Foundation Inc. Gift, 2004 (2004.170). p. 161

George Cruikshank (British, 1792–1878). Frontispiece to *Neckclothitania or Tietania, being an essay on Starchers, by One of the Cloth*, 1818. Victoria and Albert Museum, National Art Library, London (L.1783.1980). p. 162

Off-White (Italian, founded 2013). Ib Kamara (Sierra Leonean, b. 1990). *Ensemble*, spring/summer 2023. Sleeveless jacket and trousers of cream wool twill. Courtesy Off-White. p. 163

Jean-Baptiste Sabatier-Blot (French, 1801–1881). *Philippe Aime LeGoaster*, ca. 1840. Watercolor on ivory, 6⅝ × 6 in. (16.8 × 15.2 cm). Virginia Museum of Fine Arts, Richmond. Floyd D. and Anne C. Gottwald Fund, John Barton Payne Fund, Gift of John Stewart Bryan, by exchange and Adolphe D. and Wilkins C. Williams Fund, by exchange (2024.311). p. 164

Clement (French, act. mid-19th century). *Cravat*, ca. 1850. Black, gray, and blue silk jacquard patterned with scrolling floral motifs. Mark Wallis Collection. p. 165

Life in New York. "Shall I hab the honour of glanting . . .?" American (ca. 1830). Hand-colored lithograph, sheet: 7¼ × 7¾ in. (18 × 20 cm). Library Company of Philadelphia (7993.F.2). p. 166

Top hat. American (1830). Brown beaver fur with band of brown silk grosgrain decorated with self-patterned foliate motifs and buckle of silver metal. The Metropolitan Museum of Art, New York, Purchase, Irene Lewisohn Bequest, 1972 (1972.139.1). p. 167

Bianca Saunders (British, b. 1993). *Ensemble*, autumn/winter 2024–25. Jacket and trousers of double-faced blue wool-silk-polyamide twill. Courtesy Bianca Saunders. p. 168

Bianca Saunders (British, b. 1993). *Ensemble*, autumn/winter 2024–25. Jacket and trousers of red vinyl. Courtesy Bianca Saunders. p. 169

Charles Hunt (British, 1803–1877). *Tregear's Black Jokes: "The Promenade,"* plate 1 from Tregear's Black Jokes: being a series of laughable caricatures on the march of manners amongst the Blacks series, 1834. Hand-colored aquatint, 10⅝ × 14⅝ in. (27 × 37 cm). Yale Center for British Art, Paul Mellon Collection (Folio A 2018 3). p. 170

Charles Hunt (British, 1803–1877). William Summers (British, act. 1850–59). *Life in Philadelphia. "How you like de new fashion shirt . . .?,"* ca. 1831. Hand-colored aquatint, 15 × 11 in. (38 × 28 cm). Library Company of Philadelphia (P.9707.2). p. 171

Winkley & Co. (American, act. mid-19th century). *Trousers*, ca. 1840. Blue-and-white striped cotton seersucker. The Metropolitan Museum of Art, New York, Purchase, NAMSB Foundation Inc. Gift, 1997 (1997.109). p. 172

Bianca Saunders (British, b. 1993). *Ensemble*, spring/summer 2025. Coat of yellow nylon; shirt and trousers of blue-and-white striped cotton plain weave; tam of white cotton knit. Courtesy Bianca Saunders. p. 173

American Mutoscope and Biograph Company (American, 1895–1916). *Dancers Performing the Cakewalk*, 1903. Gelatin silver print, 6¾ × 9½ in. (17 × 24 cm). Schomburg Center for Research in Black Culture, Photographs and Prints Division, New York Public Library. p. 174

LOUIS VUITTON (French, founded 1854). Virgil Abloh (American, 1980–2021). *Ensemble*, spring/ summer 2023 menswear. Jacket and trousers of black wool plain weave; belt of black cotton rope beaded with *LV* monogram charms of polychrome metal and plastic; hat of black leather. Courtesy Collection LOUIS VUITTON. p. 175

355

CHECKLIST

CHAMPION

Edward Troye (American, b. Switzerland, 1808–1874). *Ansel Williamson, Edward Brown, and the Undefeated Asteroid*, 1864. Oil on canvas, 28¼ × 38¾ in. (71.8 × 98.4 cm). Virginia Museum of Fine Arts, Richmond. Paul Mellon Collection (85.647). p. 180

Jockey suit. American (1830–50). Jacket of red silk satin with stripes of appliquéd green silk satin ribbon; breeches of white buckskin. Charleston Museum (HT 6339a, b). p. 181

Charles Christian Cook (American, 1873–1957). *Jimmy Winkfield*, ca. 1902. Digitized from glass plate negative, 5 × 7 in. (12.7 × 17.8 cm). Keeneland Library. p. 182

John C. Hemment (British, 1862–1927). *Isaac Burns Murphy*, ca. 1891. Gelatin silver print, 4½ × 5 in. (11.4 × 12.7 cm). Keeneland Library. p. 184

Isaac Burns Murphy at Salvator's Clambake, 1890. Gelatin silver print, 5 × 4½ in. (12.7 × 11.4 cm). Keeneland Library. p. 185

Denim Tears (American, founded 2019). Tremaine Emory (American, b. 1981). *"T.G.B.J." ensemble*, 2024. Coat and trousers of red, blue, and brown cut lamb leather pieced in allover diamond pattern; shirt of zebra-patterned viscose satin. Courtesy Denim Tears. p. 186

Honest Long Cut Tobacco (American). Miners Extra Tobacco (American, founded 1912). *Jack Johnson*, from *Series of Champions (T227)*, 1912. Commercial color lithograph, 3⅜ × 2¼ in. (8.5 × 5.8 cm). The Metropolitan Museum of Art, New York, The Jefferson R. Burdick Collection, Gift of Jefferson R. Burdick (63.350.247.227.9). p. 188

Boxer Jack Johnson of Galveston, Texas, 1908. Gelatin silver print, 3½ × 5½ in. (8.9 × 14 cm). National Archives of Australia (NAA: A1861, 848). p. 189

Jack Johnson Driving an Automobile, Chicago, IL (detail), 1910. Print made from glass negative, 4 × 5 in. (10.2 × 12.7 cm). Chicago Daily News Collection, Chicago History Museum (1960.784). p. 190

James Van Der Zee (American, 1886–1983). *Untitled [Boxer]*, 1924. Gelatin silver print, 6¼ × 4½ in. (16.6 × 11.5 cm). James Van Der Zee Archive, The Metropolitan Museum of Art; Purchase, Louis V. Bell, Harris Brisbane Dick, Fletcher, and Rogers Funds and Joseph Pulitzer Bequest, Alfred Stieglitz Society Gifts, Twentieth-Century Photography Fund, Ann Tenenbaum and Thomas H. Lee Gift, Joyce F. Menschel Fund, and Ford Foundation Gift, 2021 (2021.443.116). p. 192

Saul Nash (British, b. 1992). *Ensemble*, autumn/winter 2023–24. Hoodie and joggers of black merino wool-PrimaLoft knit; padded scarf of white nylon; gloves of black and white nylon. Courtesy Saul Nash. p. 193

Thomas Hoepker (German, 1936–2024). *World heavyweight champion Muhammad Ali is fitted for a new suit, London*, 1966. Photograph. p. 194

Everlast (American, founded 1910). *Shorts worn by Muhammad Ali*, 1972. Black and white polyester satin. Private collection. p. 195

Cover of *Jet*, April 4, 1974. The Metropolitan Museum of Art, New York, The Irene Lewisohn Costume Reference Library. p. 196

PUMA (German, founded 1948). *Clyde's*, 1970s. Red and white suede calf leather and white rubber. Courtesy PUMA. p. 197

3.PARADIS (French Canadian, founded 2013). Emeric Tchatchoua (Canadian, b. 1988). *Ensemble*, spring/summer 2024. Coat, jacket, and trousers of light blue leather; basketball net top of cotton cord embellished with allover Swarovski crystals. Courtesy 3.PARADIS. pp. 198–99

RESPECTABILITY

Front cover of *Pennsylvania, Delaware, Maryland, and Virginia almanac, for the year of our Lord 1795* by Benjamin Banneker, 1794. H. Furlong Baldwin Library, Maryland Center for History and Culture (Rare MAY 42 .B21 1795F). p. 204

George Kendall Warren (American, 1834–1884). *Frederick Douglass*, 1876. Albumen silver print from glass negative, 5¾ × 4 in. (14.7 × 10.2 cm). The Metropolitan Museum of Art, New York, Gilman Collection, Museum Purchase, 2005 (2005.100.754). p. 205

Philip T. Hall (American, 1854–1925). *Shirt worn by Frederick Douglass*, late 19th century. White linen plain weave embroidered with *D* monogram in red thread. Department of the Interior, National Park Service (FRDO 3139). p. 206

Tailcoat worn by Frederick Douglass. American (late 19th century). Black brushed wool Melton. Department of the Interior, National Park Service (FRDO 6). p. 207

W. E. B. Du Bois at Paris International Exposition, 1900. Gelatin silver print, 8⅛ × 8⅞ in. (20.5 × 22.5 cm). Special Collections and University Archives, University of Massachusetts Amherst Libraries. p. 208

W. E. B. Du Bois' receipt from Newman and Son Tailors, July 1911. Special Collections and University Archives, University of Massachusetts Amherst Libraries. p. 209

[*Young African American man, head-and-shoulders portrait, facing slightly right*]. Probably American (1899–1900). Matte collodion silver print, 5⅜ × 3¾ in. (13.6 × 9.5 cm). Library of Congress, Prints and Photographs Division, Washington, D.C. (LOT 11930, no. 99). p. 210

Frances Benjamin Johnston (American, 1864–1952). *Tailor boys at work*, 1899–1900. Platinum print, 7½ × 9½ in. (19.1 × 24 cm). The Museum of Modern Art, New York, Gift of Lincoln Kirstein (859.1965.86). p. 212

CHECKLIST

Who Decides War (American, founded 2015). Ev Bravado (American, b. 1993). Téla D'Amore (American, b. 1994). *Suit*, spring/summer 2024. Black wool twill decorated with white topstitching and visible lining of gray polyester plain weave. Courtesy Who Decides War. p. 213

Morty Sills (American, act. mid to late 19th century). *Suit*, 1986. Gray, red, and white check wool twill. The Metropolitan Museum of Art, New York, Alfred Z. Solomon-Janet A. Sloane Endowment Fund, 2023 (2023.784a–c). p. 214

Jeffrey Banks (American, b. 1955). *Ensemble*, ca. 1980. Coat of polychrome check wool tweed; jacket and trousers of brown wool tweed; shirt of yellow-and-white striped cotton plain weave; tie of brown ribbed silk faille patterned with gray geometric motifs. Courtesy Jeffrey Banks. p. 215

Winold Reiss (American, b. Germany, 1886–1953). *A College Lad*, 1924. Pastel and conte crayon on paper, 30 × 21¾ in. (76.2 × 55.2 cm). The Wolfsonian–Florida International University, Miami Beach, Fla., The Mitchell Wolfson, Jr. Collection (XX1990.4474). p. 216

Alfred Eisenstaedt (American, 1898–1995). *Howard University students*, 1946. Photograph. LIFE Picture Collection. p. 218

Polo by Ralph Lauren (American, founded 1968). Ralph Lauren Purple Label (American, founded 1994). *"Morehouse College" ensemble*, 2019–22. Sweater of maroon wool knit with white *M* monogram motif and appliquéd elbow patches of brown leather; trousers of cream wool crepe; scarf of maroon-and-white striped wool knit with appliquéd *M/C* crest of matching felted wool; brimmed cap of felted maroon wool-viscose with embroidered white crown motif and appliquéd white strips of woven viscose and *M/C* patch of maroon and white wool-viscose felt. Courtesy Ralph Lauren Corporation. p. 219

Loïs Mailou Jones (American, 1905–1998). *A Student at Howard*, 1946. Watercolor over graphite on off-white wove paper, 20 × 14 in. (50.8 × 35.6 cm). Bowdoin College Museum of Art, Brunswick, Maine, Gift of Eliot O'Hara (1962.79). p. 220

Mains (British, founded 2017). Skepta (British, b. 1982). *Ensemble*, spring/summer 2025. Jacket of brown synthetic leather; shirt of white polyester twill; tie of red, pink, and white striped polyester twill; scarf of red polyester plush; sweater of green merino wool knit; sweatpants of gray polyester knit; brimmed cap of gray and blue polyester twill embroidered with MAINS logo. Courtesy Mains. p. 221

JOOK

Miguel Covarrubias (Mexican, 1904–1957). *Harlem Dandy [African American man (head & shoulders) wearing a hat with tilted brim]*, ca. 1930. Litho crayon on paper, 10⅞ × 8⅜ in. (27.7 × 21.3 cm). Harry Ransom Center, The University of Texas at Austin, Nickolas Muray Collection of Mexican Art (66.2.32). p. 226

[Studio portrait]. American (1940s–50s). Gelatin silver print, 4 × 3⅛ in. (10.2 × 7.8 cm). The Metropolitan Museum of Art, New York, Twentieth-Century Photography Fund, 2015 (2015.330). p. 228

Zoot suit. American (1940s). Striped navy wool twill. The Metropolitan Museum of Art, New York, Alfred Z. Solomon-Janet A. Sloane Endowment Fund, 2024 (2024.2a, b). p. 229

Charles Henry Alston (American, 1907–1977). *Zoot Suit*, ca. 1940. Watercolor on paper, 10½ × 8½ in. (26.7 × 21.6 cm). Telfair Museum of Art, Savannah, Ga.; gift of Walter and Linda Evans (2023.14). p. 230

Progress Tailoring Co. (American, 1893–1950s). *Zoot suit*, 1940–45. Green wool check novelty twill. Collection of Benny Reese of Reese's Vintage Pieces, La Verne, Calif. p. 231

Melvin Tapley (American, 1918/19–2005). Cover of *Dan Burley's Original Handbook of Harlem Jive* by Dan Burley, 1944. The Metropolitan Museum of Art, New York, The Irene Lewisohn Costume Reference Library. p. 232

Willy Chavarria (American, b. 1967). *Ensemble*, autumn/winter 2024–25. Jacket of black wool plain weave; shirt of black silk crepe; trousers of brown, white, and gold check wool novelty twill. Courtesy Willy Chavarria. p. 234

LUAR (American, founded 2017). Raul Lopez (American, b. 1984). *Suit* (detail), autumn/winter 2024–25. Black wool crepe with pinstripes decorated with iridescent polychrome embroidered thread. Courtesy LUAR. p. 235

Miguel Covarrubias (Mexican, 1904–1957). *The Bolito King*, published in *Negro Drawings*, 1927. The Metropolitan Museum of Art, New York, The Irene Lewisohn Costume Reference Library. p. 236

Joe Casely-Hayford OBE (British, 1956–2019). *Shirt*, ca. 1989. Cream silk plain weave with red and black embroidered playing-card motif. Maria, Charlie, and Alice Casely-Hayford Collection. p. 237

Isaac Julien CBE RA (British, b. 1960). *Pas de Deux No. 2 (Looking for Langston Vintage Series)*, 1989, printed 2016. Kodak Premier print, Diasec mounted on aluminum, 70¾ × 102¼ in. (179.7 × 259.7 cm). p. 238

Salvatore Ferragamo (Italian, founded 1929). Maximilian Davis (English, b. 1995). *Ensemble*, spring/summer 2023. Jacket and trousers of black wool crepe; draped top of white polyester organza. Courtesy Salvatore Ferragamo. p. 239

357

CHECKLIST

Gladys Bentley: America[']s Greatest Sepia Piana Artist—Brown Bomber of Sophisticated Songs, 1946–49. Silver and photographic gelatin on photographic paper, with ink on cardboard, 5¼ × 3⅜ in. (13.3 × 8.6 cm). Smithsonian National Museum of African American History and Culture (2011.57.25.1). p. 240

Brandon Murphy Collection (American, founded 2012). Brandon Murphy (American, b. 1991). *Ensemble*, autumn/winter 2020–21. Jacket, shirt, and trousers of white silk satin. Courtesy BMC Studio. p. 241

Teddy Piaz (French, 1899–1966). *Inscribed and autographed photograph of Joséphine Baker*, ca. 1932. Gelatin silver print, 22⅝ × 30⅛ in. (57.5 × 76.5 cm). Cifonelli. p. 242

HERITAGE

Neils Walwin Holm (Nigerian, 1866–ca. 1927). *Untitled* [*Portrait of two men*], 1890–92. Albumen print, 5¾ × 4 in. (14.5 × 10 cm). Musée du Quai Branly–Jacques Chirac, Paris (70.2022.6.145.38). p. 248

Untitled [*Portrait of four young men*]. Possibly Congolese or Angolan (ca. 1890). Albumen print, 4¾ × 6¾ in. (12.1 × 17.1 cm). Michael Graham-Stewart Collection. p. 249

W. E. B. Du Bois and Du Bois Williams, July 1959. Dye diffusion transfer print, 5 × 3½ in. (13.5 × 9 cm). Special Collections and University Archives, University of Massachusetts Amherst Libraries. p. 250

LOUIS VUITTON (French, founded 1854). Virgil Abloh (American, 1980–2021). *Ensemble*, autumn/winter 2021–22 menswear. Jacket and trousers of cream polyester-wool barathea; shirt and tie of white cotton poplin; blanket of black and gray polyester-cotton-wool jacquard with allover kente-style *LV* monogram and geometric motif; airplane brooch of silver metal. Courtesy Collection LOUIS VUITTON. p. 252

Barkley L. Hendricks (American, 1945–2017). *Slick*, 1977. Oil, acrylic, and Magna (acrylic resin paint) on canvas, 67 × 48½ in. (170.2 × 123.2 cm). Chrysler Museum of Art, Norfolk, Va., Gift of the American Academy and Institute of Arts and Letters, New York (78.62). p. 254

Skullcap. Probably American (ca. 1968). Polychrome crocheted cotton. The Metropolitan Museum of Art, New York, Gift of Barbara and Gregory Reynolds, 1984 (1984.598.57a, b). p. 255

Amiri Baraka wearing sunglasses. Probably American (1967). Photograph. Amiri Baraka Archives, Columbia University Library. p. 256

Wales Bonner (British, founded 2014). Grace Wales Bonner (British, b. 1990). *Ensemble*, autumn/winter 2019–20. Jacket of white wool plain weave with lapels of white silk satin; shirt of white silk plain weave; trousers of black silk plain weave with appliquéd side stripes of brown silk satin; hat of polychrome wool knit with wool pom and brown wooden beads; polychrome brooch of coral, shell, and feathers. Courtesy Wales Bonner. p. 258

Reed Evins (American, b. 1954). *André Leon Talley*, 1975. Polaroid print, 4¼ × 3½ (10.8 × 8.9 cm). Reed Evins Art. p. 260

Patience Torlowei (Nigerian, b. 1964). *Caftan*, ca. 2020. Black, orange, and yellow patterned cotton plain weave trimmed with brown silk velvet. The Metropolitan Museum of Art, New York, Purchase, Friends of The Costume Institute Gifts, 2023 (2023.100). p. 261

3.PARADIS (French Canadian, founded 2013). Emeric Tchatchoua (Canadian, b. 1988). *Ensemble*, spring/summer 2025. Trench coat of beige wool twill with hand-painted figurative motifs. Courtesy 3.PARADIS. p. 262

3.PARADIS (French Canadian, founded 2013). Emeric Tchatchoua (Canadian, b. 1988). *Ensemble*, spring/summer 2025. Jacket and shorts of crocodile-embossed leather printed with orange, white, and yellow check pattern. Courtesy 3.PARADIS. p. 263

Kwasi Paul (American, founded 2020). Samuel Boakye (American, b. 1991). *Ensemble*, 2023. Coat of yellow and orange hand-woven cotton Fugu; trousers of orange hand-woven cotton Fugu. Courtesy Kwasi Paul. p. 264

Agbobly (American, founded 2020). Jacques Agbobly (American, b. Togo, 1998). *Ensemble*, 2024. Coat with self-fabric belts and trousers of green, yellow, red, and blue plaid cotton twill; shirt of green, yellow, red, and blue plaid cotton poplin. Courtesy Agbobly. p. 265

Denim Tears (American, founded 2019). UGG (American, founded 1978). Tremaine Emory (American, b. 1981). *"Tasman Onia" slippers*, spring/summer 2022. Brown suede embroidered with floral motif of green, yellow, and white seed beads. The Metropolitan Museum of Art, New York, Millia Davenport and Zipporah Fleisher Fund, 2023 (2023.247a, b). p. 266

Agbobly (American, founded 2020). Jacques Agbobly (American, b. Togo, 1998). *Ensemble*, 2023. Jacket and trousers of green cotton-Lycra denim with grid motif of topstitched pink, blue, yellow, and green thread and embroidered polychrome Swarovski crystal beads; shirt of white cotton plain weave with topstitched pink, blue, yellow, and green thread. Courtesy Agbobly. p. 267

BEAUTY

Cover of *EBONY*, August 1972. The Metropolitan Museum of Art, New York, The Irene Lewisohn Costume Reference Library. p. 272

Ebet Roberts (American, b. 1945). *Prince performing on stage—"Purple Rain" tour*, 1985. Photograph. p. 274

358

Kenneth Nicholson (American, b. 1982). *Ensemble*, spring/summer 2019. Trained shirt of white cotton lace; trousers of cream cotton canvas. Courtesy Kenneth Nicholson. p. 276

Marvin Desroc (French, b. Martinique, 1996). *Ensemble*, 2019. Mesh top of white synthetic knit and crochet; trousers and bow of white synthetic leather. Courtesy Marvin Desroc. p. 277

Pat Campano (American, 1932–1989). *Jacket worn by Sylvester*, ca. 1980. Black and white silk twill embroidered with allover clear plastic sequins. GLBT Historical Society, San Francisco, Calif. p. 278

Bruce Talamon (American, b. 1949). *Earth Wind and Fire*, 1978. Photograph. p. 280

Theophilio (American, founded 2016). Edvin Thompson (Jamaican, b. 1993). *Ensemble*, spring/summer 2024. Jacket of purple snakeskin-embossed goat leather; trousers of brown, yellow, and blue snakeskin-embossed goat leather; cap of polychrome pieced snakeskin-embossed lambskin. Courtesy Theophilio. p. 281

Theophilio (American, founded 2016). Edvin Thompson (Jamaican, b. 1993). *Ensemble*, spring/summer 2025. Coat of blue polyester plain weave embroidered with allover navy plastic sequins; trousers of light blue polyester plain weave embroidered with allover light blue plastic sequins. Courtesy Theophilio. p. 282

Theophilio (American, founded 2016). Edvin Thompson (Jamaican, b. 1993). *Ensemble*, spring/summer 2025. Trousers of green polyester plain weave embroidered with allover green plastic sequins; cap of black lambskin leather with silver metal grommets. Courtesy Theophilio. p. 283

Chantal Regnault (French, b. 1946). *Avis Pendavis Ball, Red Zone*, 1990. Photograph. p. 284

LaQuan Smith (American, b. 1988). *Ensemble*, spring/summer 2025. Robe of green silk organza; trousers of green silk charmeuse. Courtesy LaQuan Smith. p. 285

Chantal Regnault (French, b. 1946). *Grandest March Ever Aids Benefit, Palladium 1990 Darryl Overness*, 1990. Photograph. p. 286

BOTTER (Dutch, founded 2017). Rushemy Botter (Dutch, b. 1984). Lisi Herrebrugh (Dutch, b. 1989). *Suit*, spring/summer 2023. Blue polyester-elastane plain weave. Courtesy BOTTER. p. 287

COOL

Michael Manley, Prime Minister of Jamaica, 1972–1980 and 1989–1992. Photograph. Library of the London School of Economics and Political Science. p. 292

Ivy Ralph OD (Jamaican, 1928–2018). *"Kareeba" shirt*, 1970s. Brown cotton plain weave decorated with white cotton topstitching and openwork embroidery. Ivy Coco Maurice Collection. p. 293

Bianca Saunders (British, b. 1993). *"Pull Over" ensemble*, autumn/winter 2022–23. Jacket, shirt, and trousers of beige wool plain weave. Courtesy Bianca Saunders. p. 294

Art Kane (American, 1925–1995). *Harlem*, 1958. Photograph. Art Kane Archive. p. 296

Bill Ray (American, 1936–2020). *At the Watts Tower*, 1966. Photograph. LIFE Picture Collection. p. 298

LOUIS VUITTON (French, founded 1854). Virgil Abloh (American, 1980–2021). *Ensemble*, autumn/winter 2021–22 menswear. Cardigan of light brown shearling; shirt and tie of polychrome striped cotton plain weave; trousers of orange wool plain weave. Courtesy Collection LOUIS VUITTON. p. 299

John Goto (British, b. 1949). *Untitled*, from Lover's Rock series, 1977. Photograph. p. 300

Wales Bonner (British, founded 2014). Grace Wales Bonner (British, b. 1990). *Ensemble*, autumn/winter 2020–21. Suit of two-tone brown wool tweed; turtleneck sweater of light blue wool ribbed knit. Courtesy Wales Bonner. p. 301

DJ Kool Herc. American (ca. 1985). Polaroid print, 4¼ × 3½ in. (10.8 × 8.9 cm). Private collection. p. 302

Bianca Saunders (British, b. 1993). *Ensemble*, spring/summer 2023. Jacket and jeans of blue cotton denim. Courtesy Bianca Saunders. p. 303

Gordon Parks (American, 1912–2006). *A Great Day in Hip Hop, Harlem, New York*, 1998. Photograph. Gordon Parks Foundation (70.038). p. 304

Dapper Dan of Harlem (American, founded 1982). Daniel Day (American, b. 1944). *Jacket worn by Jam Master Jay aka Jason Mizell*, 1987. Brown and tan leather with allover *LV* monogram and collar of brown mink fur. Sid Sankaran, owner, and Prime Minister Pete Nice, curator of The Hip Hop Museum, Bronx, N.Y. p. 305

Who Decides War (American, founded 2015). Ev Bravado (American, b. 1993). Téla D'Amore (American, b. 1994). *Jacket*, spring/summer 2025. Brown leather edged with brown wool ribbed knit and quilted with WHO DECIDES WAR logo, stars, stripes, airplane motifs, and figurative portraits of Martin Luther King Jr., Barack Obama, Frederick Douglass, and Malcolm X outlined with cream, gold, and green contrast topstitched thread. Courtesy Who Decides War. p. 306

Juicy Couture (American, founded 1996). *Tracksuit*, ca. 2004. Jacket of purple cotton-synthetic velour edged in purple cotton-synthetic ribbed knit and embroidered with *ALT* and *Emperor* in white thread; trousers of purple cotton-synthetic velour. The Metropolitan Museum of Art, New York, Alfred Z. Solomon-Janet A. Sloane Endowment Fund, 2023 (2023.791a, b). p. 307

359

CHECKLIST

Jamel Shabazz (American, b. 1960). *Untitled*, three photographs from Back in the Days series, 1985. Photographs. p. 308

Wales Bonner (British, founded 2014). Grace Wales Bonner (British, b. 1990). *"Adidas Originals" ensemble*, spring/summer 2021. Jacket and joggers of pink polyester jersey with cuffs of yellow polyester ribbed knit; shirt of yellow and pink wool knit. Courtesy Wales Bonner. p. 309

Thirstin Howl the 3rd (American, b. 1970). *Flexin' on the Deuce*, 1987. Polaroid print, 3½ × 4¼ in. (8.9 × 10.8 cm). p. 310

BOTTER (Dutch, founded 2017). Rushemy Botter (Dutch, b. 1984). Lisi Herrebrugh (Dutch, b. 1989). *Ensemble*, spring/summer 2022. Shirt of blue polyester plain weave with appliquéd stripes of distressed navy polyester plain weave and contrast collar of white synthetic twill; trousers of black synthetic twill. Courtesy BOTTER. p. 311

COSMOPOLITANISM

Passport of W. E. B. Du Bois, July 22, 1921. Special Collections and University Archives, University of Massachusetts Amherst Libraries. p. 316

United States passport belonging to James Baldwin, August 2, 1965. Cardboard, ink on paper, 7½ × 6⅛ in. (19.1 × 15.6 cm). Smithsonian National Museum of African American History and Culture, Gift of The Baldwin Family. p. 316

Air Afrique stamps, 1960s. Anonymous. p. 318

LOUIS VUITTON (French, founded 1854). Pharrell Williams (American, b. 1973). *Ensemble*, spring/summer 2025 menswear. Jacket and trousers of blue, green, and black wool check jacquard; shirt of black cotton-silk plain weave; tie of brown silk crepe-backed satin; beret of black felted wool. Courtesy Collection LOUIS VUITTON. p. 319

Sanlé Sory (Burkinabe, b. 1943). *Air Afrique, Nous Voilà!*, 1979. Digital print, 27½ × 27½ in. (70 × 70 cm). p. 320

Air Afrique (Pan-African, 1961–2002). *Bag*, 1970. Green and blue tartan polyester basketweave with white stamped AIR AFRIQUE logo, black vinyl trim, handles of black plastic, and hardware of gold metal. Air Afrique Club Collection. p. 321

LOUIS VUITTON (French, founded 1854). Virgil Abloh (American, 1980–2021). *"Amen Break" show notes*, spring/summer 2022 menswear. Courtesy Collection LOUIS VUITTON. p. 322

LOUIS VUITTON (French, founded 1854). Virgil Abloh (American, 1980–2021). *Ensemble*, autumn/winter 2021–22 menswear. Coat and jacket of black wool twill with white, blue, and red plastic-and-metal airplane buttons; trousers of black wool twill; shirt of white and purple striped cotton plain weave; fedora of black felted wool. Courtesy Collection LOUIS VUITTON. p. 323

Tom Stoddart (British, 1953–2021). *Ozwald Boateng walks along Savile Row (at Vigo Street), London, England*, 2009, from Johnny Walker's Walk with Giants campaign. Photograph. p. 324

Ozwald Boateng (British, b. 1967). *Ensemble*, 2022. Jacket and trousers of red silk jacquard with allover geometric motifs and lapels of black silk satin; trousers of red silk jacquard with allover geometric motifs; shirt of red silk satin. Courtesy Ozwald Boateng. p. 325

LOUIS VUITTON (French, founded 1854). *Suite of luggage owned by André Leon Talley*, ca. 1990 and 2004. Hard-sided suitcases of brown *LV* lacquered monogram canvas finished with golden brass hardware, trimmed with tan lozine leather, and affixed with cowhide leather handles and hand-painted with orange, brown, and cream *ALT* monogram; travel bags of brown *LV* monogram canvas finished with golden brass hardware, trimmed with tan lozine leather, and affixed with cowhide leather handles. Quin Lewis Collection. p. 326

LABRUM London (British, founded 2014). Foday Dumbuya (Sierra Leonean). *"Maya Angelou Passport" ensemble*, autumn/winter 2023–24. Coat and shirt of polychrome wool-synthetic jacquard with allover passport motif; trousers of black cotton twill. Courtesy LABRUM London. p. 328

TELFAR (American, founded 2005). Wilsons Leather (American, founded 1899). Telfar Clemens (American, b. 1985). *TELFAR × Wilsons Leather Carry Bags*, 2024. Brown full-grain pebble leather embossed with TELFAR logo. Courtesy TELFAR. p. 329

LABRUM London (British, founded 2014). Foday Dumbuya (Sierra Leonean). *Ensemble*, autumn/winter 2024–25. Jacket and trousers of ivory polyester twill with appliquéd strips of polychrome polyester twill with printed boarding pass motifs. Courtesy LABRUM London. pp. 330–31

360

CREDITS

PORTRAIT OF THE MODERN DANDY

pp. 15–43, featuring in order of appearance: Lamine Seck, Michael Henry Adams, Abdou Ndoye, Craig Shimirimana, Von Penn Jr., Dandy Wellington, Grailing King, Serigne Sene, Iké Udé, Steven Castillo, Cameron André, Mou Lam, Olivier Rogers, Babatunde Adeyemi, Cloud, Ken Crawford, Shamar Smith, and Aaron Kingsley Adetola

Photography by Tyler Mitchell
Styled by Carlos Nazario
Hair by Dre Demry-Sanders
Makeup by Keita Moore
Casting by Rachel Chandler
 at Midland Agency
Set design by Julia Wagner
Executive produced by
 Alexander Dorr at
 Tyler Mitchell Studio
Produced by Ben Gutierrez
 at AP Studio
Photo equipment provided
 by Vivid Kid

PHOTO CREDITS

p. 49, fig. 1: From the British Library archive / Flickr Commons; p. 51, fig. 2: Wikimedia; p. 52, fig. 3: Photo by julio donoso / Sygma via Getty Images; p. 53, fig. 4: Image by Mickey Delcambre, courtesy the Shadows-on-the-Teche; p. 53, fig. 5: Internet Archive; p. 54 , figs. 7, 8: © 2022 Chicago Historical Society, all rights reserved; p. 55, fig. 9: Photo by Marcus Tondo; p. 56, fig. 10: Photo: Nadine Ijewere / Ralph Lauren Corporation; p. 57, fig. 11: Photo © Laura Daniela Fierro De Ramroop; pp. 66, 67, 72, 79, 82, 95, 96, 115, 126 (left), 139, 151, 260, 318 (top left, top right, bottom right, bottom left): Images © The Metropolitan Museum of Art, photos by Anna-Marie Kellen; p. 68: © David Gallard, Château des ducs de Bretagne–Musée d'histoire de Nantes; pp. 69, 75, 114, 118, 122, 124, 188, 192, 196, 205, 228, 232, 236, 272: Images © The Metropolitan Museum of Art; p. 70: © Direction des Musées de Dunkerque, MBA. Ph. Emmanuel Watteau; p. 74: Musée de la Ville de Paris, Musée Carnavalet, Paris, France /

Bridgeman Images; p. 78: Photo: Hickey-Robertson; p. 93: Photograph: Paul Hester; p. 100: © Mairie de Bordeaux, Musée d'Aquitaine; p. 101: Courtesy Internet Archive / Houston Public Library; pp. 102, 103: Courtesy Leila Heller Gallery; p. 108: Private collection / Christie's Images / Bridgeman Images; p. 112: © Royal Collection Enterprises Limited 2024 | Royal Collection Trust; p. 116: © Bayonne, Musée Bonnat-Helleu / cliché: A. Vaquero; p. 120: U.S. National Archives and Records Administration; p. 132: The New York Public Library Digital Collections. 1763. https://digitalcollections.nypl.org/items/510d47db-bd19-a3d9-e040-e00a18064a99; p. 138: Courtesy Internet Archive. https://archive.org/details/runningthousandm00craf/page/n5/mode/2up; p. 140: Schomburg Center for Research in Black Culture, Manuscripts, Archives and Rare Books Division, The New York Public Library. "William and Ellen Craft." The New York Public Library Digital Collections. 1872. https://digitalcollections.nypl.org/items/510d47db-bcd1-a3d9-e040-e00a18064a99; p. 153: © Courtesy the Huntington Art Museum, San Marino, Calif.; p. 154: Courtesy Pocumtuck Valley Memorial Association's Memorial Hall Museum, Deerfield, Mass.; p. 156: Photo: Heather Jackson; p. 159: Photo: Richard Walker; p. 162: © Victoria and Albert Museum, London; p. 164: Photo: Troy Wilkinson. © Virginia Museum of Fine Arts; p. 174: Schomburg Center for Research in Black Culture, Photographs and Prints Division, The New York Public Library. "Dancers performing the Cakewalk." The New York Public Library Digital Collections. 1850–1995. https://digitalcollections.nypl.org/items/7f1c693a-9d78-e4f8-e040-e00a18061c4a. © Culver Pictures; p. 180: Photo: Katherine Wetzel. © Virginia Museum of Fine Arts; p. 181: Courtesy Charleston Museum; p. 182: Courtesy Keeneland Library Cook Collection; p. 184: Courtesy Keeneland Library Hemment Collection; p. 185: Courtesy Keeneland Library; p. 189: © National Archives of Australia 2024; p. 190: Chicago History Museum / Getty Images; p. 194: Thomas Hoepker /

Magnum Photos; p. 195: Private collection. Photo © Sotheby's / Bridgeman Images; p. 204: Courtesy the Maryland Center for History and Culture, H. Furlong Baldwin Library, Rare Book Collection; pp. 208, 209: W. E. B. Du Bois Papers (MS312), Special Collections and University Archives Research Center, University of Massachusetts Amherst Libraries; p. 212: Digital Image © The Museum of Modern Art / Licensed by SCALA / Art Resource, New York; p. 216: Photo: Lynton Gardiner; p. 218: Alfred Eisenstaedt / LIFE Picture Collection / Shutterstock; p. 220: © Loïs Mailou Jones Pierre-Noel Trust; p. 230: © 2025 Charles Alston / Artists Rights Society (ARS), New York. Photo: Adam Kuehl Photography; p. 236: From Miguel Covarrubias, *Negro Drawings*, Alfred A. Knopf, 1927, p. 44. Image © The Metropolitan Museum of Art; p. 238: © The artist. Courtesy the artist, Victoria Miro Gallery, and Jessica Silverman, San Francisco; p. 242: Courtesy Maison Cifonelli; p. 248: © Musée du Quai Branly–Jacques Chirac, Dist. RMN-Grand Palais / Art Resource, New York; p. 249: Courtesy Michael Graham-Stewart; p. 250: Du Bois Family Papers (MS 1143), Special Collections and University Archives, University of Massachusetts Amherst Libraries; p. 256: Amiri Baraka Papers, box 70, folder 2, Rare Book and Manuscript Library, Columbia University Library; p. 274: Ebet Roberts / Getty Images; p. 280: Bruce W. Talamon © 2018 All Rights Reserved; pp. 284, 286: © Chantal Regnault; p. 296: Photograph by Art Kane—Courtesy © Art Kane Archive; p. 298: Bill Ray / LIFE Picture Collection / Shutterstock; p. 300: © John Goto; p. 302: Private collection. Christie's Images / Bridgeman Images; p. 304: Courtesy and © The Gordon Parks Foundation; p. 308: Courtesy Jamel Shabazz; p. 310: © Thirstin Howl the 3rd; p. 316 (left): W. E. B. Du Bois Papers (MS 312), Special Collections and University Archives, University of Massachusetts Amherst Libraries; p. 320: © Sanlé Sory, courtesy Tezeta and David Hill Gallery, London; p. 324: Tom Stoddart Archive / Getty Images; pp. 341, 342, 343, 344: Courtesy the artist; pp. 345, 347, 348: Courtesy the artist

361

SELECTED READINGS

The works that follow represent publications and films referenced in the catalogue essays, texts authored by contributors to the catalogue, and sources consulted by the curators in the creation of *Superfine*.

Abloh, Virgil, and Wu Tsang, dir. *Peculiar Contrast, Perfect Light*. 2021.

"An Act Concerning Servants and Slaves." In volume 3 of *The Statues at Large; Being a Collection of All the Laws of Virginia from the First Session of the Legislature, in the Year 1619*, edited by William Waller Hening, 447–63. R. & W. & G. Bartow, 1823.

Adams, H. G., ed. "Biographical Sketches—Toussaint Louverture." In *God's Image in Ebony: Being a Series of Biographical Sketches, Facts, Anecdotes, etc., Demonstrative of the Mental Prowess and Intellectual Capacities of the Negro Race*. Partridge and Oakey, 1854.

African American Photographs Assembled for 1900 Paris Exposition. Library of Congress, Washington, D.C. https://www.loc.gov/pictures /collection/anedub/.

African Photography, For Whose Eyes?: Constructing and Deconstructing Identities. Mandeville Gallery, Union College, 2012. Exhibition catalogue.

Amkpa, Awam, ed. *ReSignifications: European Blackamoors, Africana Readings*. Postcart, 2016.

Arabindan-Kesson, Anna. "Dressed Up and Laying Bare: Fashion in the Shadow of the Market." Department of African American Studies, Princeton University, January 11, 2021. https://aas.princeton.edu/news /dressed-and-laying-bare-fashion -shadow-market-0#:~:text=Under%20 the%20code%2C%20slaves%2were ,greater%20value%20than%20Negro %20cloth.

Armstrong, Louis. *Louis Armstrong, in His Own Words: Selected Writings*. Edited by Thomas Brothers. Oxford University Press, 1999.

Bagneris, Mia L. *Colouring the Caribbean: Race and the Art of Agostino Brunias*. Manchester University Press, 2018.

Bajko, Matthew S. "LGBTQ History Month: LGBT Artifacts Display Possibilities." *Bay Area Reporter*, October 2, 2019. https://www.ebar .com/story.php?ch=news&sc=history &id=282502.

Baker, Jean-Claude, and Chris Chase. *Josephine: The Hungry Heart*. Random House, 1993.

Baldwin, James. "Stranger in the Village." In *James Baldwin: Collected Essays*, 118. Library of America, 1998.

Ballard, Horace D. "'Foundations and Beginnings': W. E. B. Du Bois Posing as a Dandy." *Fashion Theory* 24, no. 4 (2020): 471–97.

Barry, Ben. "Fabulous Masculinities: Refashioning the Fat and Disabled Male Body." *Fashion Theory* 23, no. 2 (2019): 275–307.

Barthes, Roland. *The Language of Fashion*. Berg, 2006.

Baumgarten, Linda. "Clothes for the People: Slave Clothing in Early Virginia." Colonial Williamsburg Digital Library, July 25, 1988. https: //research.colonialwilliamsburg.org /DigitalLibrary/view/index.cfm?doc =ResearchReports%5CRR0409.xml.

Baumgarten, Linda. *What Clothes Reveal: The Language of Clothing in Colonial and Federal America*. Yale University Press, 2012.

Bechet, Sidney. *Treat It Gentle*. Hill & Wang, 1960.

Bender, Thomas, Laurent Dubois, and Richard Rabinowitz, eds. *Revolution! The Atlantic World Reborn*. New-York Historical Society; D Giles, 2011. Exhibition catalogue.

Berne, Emma Carlson. *Face of Freedom: How the Photos of Frederick Douglass Celebrated Racial Equality*. Compass Point Books, 2018.

SELECTED READINGS

Beverley, Robert. "Of the Servants and Slaves in Virginia." In *The History and Present State of Virginia, 1705*, edited by Louis B. Wright, 271–74. University of North Carolina Press, 1947. chrome-extension: //efaidnbmnnnibpcajpcglclefindmkaj /https://nationalhumanitiescenter.org /pds/amerbegin/power/text8 /BeverlyServSlaves.pdf.

Bindman, David, and Henry Louis Gates, Jr., eds. *The Image of the Black in Western Art*. New ed. Harvard University Press, 2012.

Bly, Antonio T. "Pretty, Sassy, Cool: Slave Resistance, Agency, and Culture in Eighteenth Century New England." *New England Quarterly* 89, no. 3 (2016): 457–92.

Bongie, Chris. "The Cry of History: Juste Chanlatte and the Unsettling (Presence) of Race in Early Haitian Literature." *MLN* 130, no. 4 (2015): 807–35.

Boston, Lloyd. *Men of Color: Fashion, History, Fundamentals*. Artisan, 2000.

Bourdieu, Pierre. *The Field of Cultural Production: Essays on Art and Literature*. Columbia University Press, 1993.

Brathwaite, Peter, ed. *Rediscovering Black Portraiture*. Getty, 2023.

Bravo, Tony. "Sylvester, 'Mighty Real': A New Generation Looks to the Late 'Disco Queen' as a Role Model." *San Francisco Chronicle*, April 21, 2019.

Bruns, Roger. *Zoot Suit Riots*. Greenwood, 2014.

Bunch, Lonnie G., III, and Robin Givan. *Double Exposure, Everyday Beauty: Photographs from the National Museum of African American History and Culture*. National Museum of African American History and Culture, Smithsonian Institution, 2018.

Calloway, Cab. *Cab Calloway's Cat-ologue: A "Hepster's" Dictionary*. Cab Calloway, 1938.

Campt, Tina M. *Image Matters: Archive, Photography, and the African Diaspora in Europe*. Duke University Press, 2012.

Caponi-Tabery, Gena. *Jump for Joy: Jazz, Basketball, and Black Culture in 1930s America*. University of Massachusetts Press, 2008.

Carretta, Vincent. "'Property of Author': Olaudah Equiano's Place in the History of the Book." In *Genius in Bondage: Literature of the Early Black Atlantic*, edited by Vincent Carretta and Philip Gould, 130–50. University Press of Kentucky, 2001.

Chakravarty, Urvashi. "Livery, Liberty, and Legal Fictions." *English Literary Renaissance* 42, no. 3 (2012): 365–90.

Chauncey, George. *Gay New York: Gender, Urban Culture, and the Making of the Gay Male World, 1890–1940*. BasicBooks, 1994.

Checinska, Christine, ed. *Africa Fashion*. V&A, 2022. Exhibition catalogue.

Checinska, Christine. *Fashioning African Diaspora Masculinities*. Forthcoming.

Cherlise, Renata. *Black Archives: A Photographic Celebration of Black Life*. Ten Speed Press, 2023.

Childs, Adrienne L., and Susan Houghton Libby. *The Black Figure in the European Imaginary*. Cornell Fine Arts Museum, Rollins College; D Giles, 2017. Exhibition catalogue.

Clyde, Wanett. "Clothing the Black Body in Slavery." In *Textile Society of America Symposium Proceedings*. University of Nebraska–Lincoln, 2020. chrome-extension:// efaidnbmnnnibpcajpcglclefindmkaj /https://digitalcommons.unl.edu /cgi/viewcontent.cgi?params= /context/tsaconf/article/2138/&path _info=Clyde__Clothing_the_Black _Body__2020.pdf.

Coggins, David. *Men and Style*. Abrams, 2016.

Cohen, Ashley L. "Julius Soubise in India." In *Britain's Black Past*, edited by Gretchen H. Gerzina, 215–33. Liverpool University Press, 2020.

Collins, Patricia Hill. *Black Sexual Politics: African Americans, Gender, and the New Racism*. Routledge, 2005.

Combs, Rhea L., and Deborah Willis. *Through the African American Lens*. National Museum of African American History and Culture, Smithsonian Institution; D Giles, 2014. Exhibition catalogue.

Craft, William. *Running a Thousand Miles for Freedom; or, The Escape of William and Ellen Craft from Slavery*. William Tweedie, 1860.

Cutler, R. J., dir. *The September Issue*. 2009; Lionsgate, 2010. DVD.

Dany, Hans-Christian, and Valérie Knoll. *No Dandy, No Fun: Looking Good as Things Fall Apart*. Sternberg Press, 2023.

Dixon, Terence, dir. *Meeting the Man: James Baldwin in Paris*. Buzzy Enterprises, 1970.

Douglass, Frederick. *Narrative of the Life of Frederick Douglass*. Dover, 1995. Originally published in 1845 by Anti-Slavery Office.

Douglass, Frederick. "There Is Something in Dress." *Frederick Douglass' Paper*, May 25, 1855.

Driskell, David C., with Leonard Simon. *Two Centuries of Black American Art*. Los Angeles County Museum of Art; Alfred A. Knopf, 1976. Exhibition catalogue.

Droth, Martina, Nathan Flis, and Michael Hatt, eds. *Britain in the World: Highlights from the Yale Center for British Art*. Yale Center for British Art, 2019.

Du Bois, W. E. B. *Dark Princess: A Romance*. Harcourt, Brace, 1928.

Du Bois, W. E. B. *The Philadelphia Negro: A Social Study*. University of Pennsylvania Press, 1899.

363

SELECTED READINGS

Du Bois, W. E. B. *The Souls of Black Folk*. A. C. McClurg, 1903.

Du Bois, W. E. B. "Strivings of the Negro People." *Atlantic Monthly* 80 (August 1897): 194–95, 197–98.

Edwards, Brent Hayes. *The Practice of Diaspora: Literature, Translation, and the Rise of Black Internationalism*. Harvard University Press, 2003.

Equiano, Olaudah. *The Interesting Narrative of the Life of Olaudah Equiano, or Gustavus Vassa, The African. Written by Himself*. Bedford/St. Martin's Press, 2016. Originally published in 1789 by the author.

Eshun, Ekow. *In the Black Fantastic*. MIT Press, 2022.

Fanon, Frantz. *Black Skin, White Masks*. Translated by Charles Lam Markmann. Grove Press, 1967. Originally published in 1952 by Éditions du Seuil.

Ferraro, Roda. *The Heart of the Turf: Racing's Black Pioneers*. Keeneland Library, 2023. Exhibition catalogue.

Fillin-Yeh, Susan. *Dandies: Fashion and Finesse in Art and Culture*. New York University Press, 2001.

Fish, Eric S. "Race, History, and Immigration Crimes." *Iowa Law Review* 107, no. 3 (2022): 1051–106.

Fontanes, Michel. Interview by Alphonso D. McClendon. 2010.

Ford, Tanisha C. *Dressed in Dreams: A Black Girl's Love Letter to the Power of Fashion*. St. Martin's Press, 2019.

Foreman, Gabrielle. "Who's Your Mama? 'White' Mulatta Genealogies, Early Photography, and Anti-Passing Narratives of Slavery and Freedom." *American Literary History* 14, no. 3 (2002): 505–39.

Foster, Helen Bradley. *"New Raiments of Self": African American Clothing in the Antebellum South*. Berg, 1997.

Gainer, Nichelle. *Vintage Black Glamour: Gentlemen's Quarters*. Rocket 88, 2020.

Gamson, Joshua. *The Fabulous Sylvester: The Legend, the Music, the 70s in San Francisco*. Henry Holt, 2005.

Gates, Henry Louis, Jr. *The Signifying Monkey: A Theory of Afro-American Literary Criticism*. Oxford University Press, 1988.

Gaugele, Elke, and Monica Titton, eds. *Fashion and Postcolonial Critique*. Sternberg Press; Akademie der bildenden Künste, 2019.

Gillespie, Dizzy. *To Be, or Not . . . to Bop: Memoirs*. Doubleday, 1979.

Gilroy, Paul. *Black Britain: A Photographic History*. Saqi Books, 2011.

Godfrey, Mark, and Allie Biswas, eds. *"The Soul of a Nation" Reader: Writings by and About Black American Artists, 1960-1980*. Gregory R. Miller, 2021.

Goodyear, Frank H., Jr. *American Painting in the Rhode Island Historical Society*. Rhode Island History Society, 1974.

Gould, Philip. "'Remarkable Liberty': Language and Identity in Eighteenth-Century Black Autobiography." In *Genius in Bondage: Literature of the Early Black Atlantic*, edited by Vincent Carretta and Philip Gould, 116–29. University Press of Kentucky, 2001.

Grigsby, Darcy Grimaldo. *Extremities: Painting Empire in Post-Revolutionary France*. Yale University Press, 2002.

Gualdé, Krystel. *L'abîme: Nantes dans la traite atlantique et l'esclavage colonial, 1707-1830*. Château des Ducs de Bretagne, 2021. Exhibition catalogue.

Hall, Stuart. "Reconstruction Work: Images of Post-War Black Settlement." In *Selected Writings on Visual Arts and Culture: Detour to the Imaginary*, edited by Gilane Tawadros, 239–49. Duke University Press, 2024.

Hilaire, Michel, and Pierre Stépanoff, eds. *Le voyage en Italie de Louis Gauffier*. Snoeck; Musée Fabre, 2022. Exhibition catalogue.

Hoff, Henry B. "Frans Abramse Van Salee and His Descendants: A Colonial Black Family in New York and New Jersey." *New York Genealogical and Biographical Record* 121 (October 1990): 207–8.

Holiday, Billie. Interview by Mike Wallace. *Night Beat*, DuMont Television Network, November 8, 1956.

Holmes, Marian Smith. "The Great Escape from Slavery of Ellen and William Craft." *Smithsonian Magazine*, June 16, 2010. https://www.smithsonianmag.com/history/the-great-escape-from-slavery-of-ellen-and-william-craft-497960/.

Holt, W. Stull. "Charles Carroll, Barrister: The Man." *Maryland Historical Magazine* 31, no. 2 (1936): 112–26.

Howard, Sarah Elizabeth. "Zoot to Boot: The Zoot Suit as Both Costume and Symbol." *Studies in Latin American Popular Culture* 28, no. 1 (2010): 112–31.

Hughes, Langston. *The Langston Hughes Reader*. George Braziller, 1958.

Hunt-Hurst, Patricia. "'Round Homespun Coat & Pantaloons of the Same': Slave Clothing as Reflected in Fugitive Slave Advertisements in Antebellum Georgia." *Georgia Historical Quarterly* 83, no. 4 (1999): 727–40.

James, C. L. R. *The Black Jacobins: Toussaint L'Ouverture and the San Domingo Revolution*. Allison & Busby, 1980.

James, Erica Moiah. "Decolonizing Time: Nineteenth-Century Haitian Portraiture and the Critique of Anachronism in Caribbean Art." *Journal of Contemporary African Art* 2019, no. 44 (2019): 8–23.

Jones, Dylan. *London Sartorial: Men's Style from Street to Bespoke*. Rizzoli, 2017.

Jules, Jason, and Graham Marsh. *Black Ivy: A Revolt in Style*. Reel Art Press, 2021.

Karaminas, Vicki, Adam Geczy, and Pamela Church Gibson, eds. *Fashionable Masculinities: Queers, Pimp Daddies, and Lumbersexuals*. Rutgers University Press, 2022.

Kramer, Lloyd. "James Baldwin in Paris: Exile, Multiculturalism and the Public Intellectual." *Historical Reflections/Réflexions Historiques* 27, no. 1 (2001): 27–47.

Kuchta, David. *The Three-Piece Suit and Modern Masculinity: England, 1550–1850*. University of California Press, 2002.

Lazaro, Ned, and Barbara Mathews. "Picturing Slavery: Clothing, Appearance, and New England Advertisements for Run-Away Enslaved Men During the 18th Century." *The Village Broadside* (blog). Historic Deerfield, August 14, 2020. https://www.historic-deerfield.org /2020-8-14-picturing-slavery -clothing-appearance-and-new -england-advertisements-for-run -away-enslaved-men-during-the -18th-century/.

Léonforte, Pierre, and Éric Pujalet-Plaà. *Louis Vuitton: 100 Legendary Trunks*. Abrams, 2010.

Lewis, Shantrelle P. *Dandy Lion: The Black Dandy and Street Style*. Aperture, 2017.

Licón, Gerardo. "Pachucos: Not Just Mexican-American Males or Juvenile Delinquents." PBS SoCal, February 8, 2017. https://www.pbssocal.org /shows/artbound/pachucos-not-just -mexican-american-males-or -juvenile-delinquents.

Luana. *What Makes That Black?: The African-American Aesthetic in American Expressive Culture*. Luana Luana, 2018.

Lugo-Ortiz, Agnes I., and Angela Rosenthal, eds. *Slave Portraiture in the Atlantic World*. Cambridge University Press, 2013.

Martone, Eric. *Finding Monte Cristo: Alexandre Dumas and the French Atlantic World*. McFarland, 2018.

Masciotra, David. "Queen of Disco: The Legend of Sylvester." *PopMatters*, February 12, 2013. https://www.popmatters.com/167895 -queen-of-disco-the-legend-of -sylvester-2495781452.html.

Maza, Sarah C. *Servants and Masters in Eighteenth-Century France: The Uses of Loyalty*. Princeton University Press, 1983.

McClendon, Alphonso D. *Fashion and Jazz: Dress, Identity and Subcultural Improvisation*. Bloomsbury Academic, 2015.

McCollom, Michael. *The Way We Wore: Black Style Then*. Glitterati, 2006.

McCord, David J., ed. *Containing the Acts Relating to Charleston, Courts, Slaves, and Rivers*. Volume 7 of *The Statues at Large of South Carolina*. A. S. Johnston, 1840.

McDaniels, Pellom, III. *The Prince of Jockeys: The Life of Isaac Burns Murphy*. University Press of Kentucky, 2013.

McNeil, Peter. *Pretty Gentlemen: Macaroni Men and the Eighteenth-Century Fashion World*. Yale University Press, 2018.

Medhurst, Eleanor. *Unsuitable: A History of Lesbian Fashion*. Hurst, 2024.

Miller, Monica L. *Slaves to Fashion: Black Dandyism and the Styling of Black Diasporic Identity*. Duke University Press, 2009.

Miller, Monica L. "W. E. B. Du Bois and the Dandy as Diasporic Race Man." *Callaloo* 26, no. 3 (2003): 738–65.

Mitchell, Robin. *Vénus Noire: Black Women and Colonial Fantasies in Nineteenth-Century France*. University of Georgia Press, 2020.

Moers, Ellen. *The Dandy: Brummell to Beerbohm*. University of Nebraska Press, 1978.

moore, madison. *Fabulous: The Rise of the Beautiful Eccentric*. Yale University Press, 2018.

Murrell, Denise, ed. *The Harlem Renaissance and Transatlantic Modernism*. Metropolitan Museum of Art, 2024.

Nell, William Cooper. *The Colored Patriots of the American Revolution*. Robert F. Wallcut, 1855.

Odumosu, Temi. *Africans in English Caricature, 1769–1819: Black Jokes, White Humour*. Harvey Miller, 2017.

Ostendorf, Berndt. "Celebration or Pathology? Commodity or Art?: The Dilemma of African-American Expressive Culture." *Black Music Research Journal* 20, no. 2 (2000): 217–36.

Peffer, John, and Elisabeth Lynn Cameron, eds. *Portraiture & Photography in Africa*. Indiana University Press, 2013.

Peiss, Kathy Lee. *Zoot Suit: The Enigmatic Career of an Extreme Style*. University of Pennsylvania Press, 2011.

Perry, Regenia A. *Selections of Nineteenth-Century Afro-American Art*. Metropolitan Museum of Art, 1976. Exhibition catalogue.

Powell, Richard J. *Cutting a Figure: Fashioning Black Portraiture*. University of Chicago Press, 2008.

Powell, Richard J. "Sartor Africanus." In *Dandies: Fashion and Finesse in Art and Culture*, edited by Susan Fillin-Yeh, 217–42. New York University Press, 2001.

SELECTED READINGS

Prince. "Baby I'm a Star." Prince and the Revolution. Performed November 20, 1984. https://www.youtube.com/watch?v=9Lgf2VU_M70.

Prude, Johnathan. "To Look Upon the 'Lower Sort': Runaway Ads and the Appearance of Unfree Laborers in America, 1750–1800." *Journal of American History* 78, no. 1 (1991): 124–59.

Pryor, Elizabeth Stordeur. *Colored Travelers: Mobility and the Fight for Citizenship Before the Civil War.* University of North Carolina Press, 2016.

Ramírez, Catherine S. *The Woman in the Zoot Suit: Gender, Nationalism, and the Cultural Politics of Memory.* Duke University Press, 2009.

Reiss, Tom. *Black Count: Glory, Revolution, Betrayal and the Real Count of Monte Christo.* Broadway Books, 2012.

Romero, Elena. *Free Stylin': How Hip Hop Changed the Fashion Industry.* Praeger, 2012.

Rothenstein, Julian, ed. *Black Lives 1900: W. E. B. Du Bois at the Paris Exposition.* Redstone Press, 2019. Exhibition catalogue.

Samuels, Ellen. "'A Complication of Complaints': Untangling Disability, Race, and Gender in William and Ellen Craft's *Running a Thousand Miles for Freedom*." *MELUS* 31, no. 3 (2006): 15–47.

Schoener, Allon, ed. *Harlem on My Mind: Cultural Capital of Black America, 1900–1968.* Random House, 1969. Exhibition catalogue.

Selvin, Joel. *San Francisco: The Musical History Tour.* Chronicle Books, 1996.

Shaw, Gwendolyn DuBois. *Portraits of a People: Picturing African Americans in the Nineteenth Century.* Addison Gallery of American Art, 2006. Exhibition catalogue.

Shaw, Gwendolyn DuBois, ed. *Represent: 200 Years of African American Art in the Philadelphia Museum of Art.* Philadelphia Museum of Art, 2014.

Shaw, Madelyn. "Slave Cloth and Clothing Slaves: Craftsmanship, Commerce, and Industry." *Journal of Early Southern Decorative Arts* 42–43 (2021–22). https://www.mesdajournal.org/2012/slave-cloth-clothing-slaves-craftsmanship-commerce-industry/.

Shon, Sue. "Runaway Slave Portraiture, Aesthetic Culture, and the Emergence of Racial Sense." *Journal of the New Media Caucus* 18, no. 1 (2022): 6–30.

Simpson, Jeff, dir. *Queens of Disco.* Aired March 10, 2006, on BBC One.

Snorton, C. Riley. *Black on Both Sides: A Racial History of Trans Identity.* University of Minnesota Press, 2017.

"Speech by William Whipper. Delivered Before the Colored Temperance Society of Philadelphia, Philadelphia, Pennsylvania, 8 January 1834." In *The Black Abolitionist Papers, Volume III: The United States, 1830–1846.* Edited by C. Peter Ripley. University of North Carolina Press, 1991.

Square, Jonathan Michael. "A Stain on an All-American Brand: How Brooks Brothers Once Clothed Slaves." *Vestoj,* October 19, 2020. https://vestoj.com/how-brooks-brothers-once-clothed-slaves/.

Stauffer, John, Zoe Trodd, and Celeste-Marie Bernier. *Picturing Frederick Douglass: An Illustrated Biography of the Nineteenth Century's Most Photographed American.* Liveright, 2015.

Stearns, William. "Zoot Suit Riots: Opportunities for Discovery Using Suggested Searches in Hispanic Life in America." *Readex Blog,* September 22, 2023. https://www.readex.com/blog/zoot-suit-riots-opportunities-discovery-using-suggested-searches-hispanic-life-america.

Still, William. *The Underground Rail Road: A Record of Facts, Authentic Narratives, Letters, &c., Narrating the Hardships, Hair-Breadth Escapes, and Death Struggles.* Porter & Coates, 1872.

Tackley, Catherine. *Benny Goodman's Famous 1938 Carnegie Hall Jazz Concert.* Oxford University Press, 2012.

Talley, André Leon. *A.L.T.: A Memoir.* Villard, 2003.

Talley, André Leon. *The Chiffon Trenches: A Memoir.* Ballantine Books, 2020.

Talley, André Leon. Interview by Terry Gross. *Fresh Air,* National Public Radio, May 31, 2018. https://www.npr.org/2018/05/31/615752676/for-vogue-titan-andr-leon-talley-fashion-was-a-gateway-to-the-world.

Talley, André Leon. Interview by Tom Power. Q, Canadian Broadcasting Company, May 25, 2018. https://www.youtube.com/watch?v=vVlmI3hZAwQ.

Talley, André Leon. "North African Figures in Nineteenth Century French Painting and Prose." PhD diss., Brown University, 1972.

Tamagni, Daniele, Paul Goodwin, and Paul Smith. *Gentlemen of Bacongo.* Trolley, 2009.

Tatham, David, ed. *Prints and Printmakers of New York State, 1825–1940.* Syracuse University Press, 1986.

Taylor, Paul C. *Black Is Beautiful: A Philosophy of Black Aesthetics.* Wiley, 2016.

Thaggert, Miriam. *Images of Black Modernism: Verbal and Visual Strategies of the Harlem Renaissance.* University of Massachusetts Press, 2010.

Thomas, Sarah. *Witnessing Slavery: Art and Travel in the Age of Abolition.* Paul Mellon Centre for Studies in British Art, 2019.

Thurman, Wallace. *Infants of the Spring.* Macaulay, 1932.

Tulloch, Carol. *The Birth of Cool: Style Narratives of the African Diaspora*. Bloomsbury Visual Arts, 2020.

Tulloch, Carol. *Black Style*. V&A, 2004. Exhibition catalogue.

Udé, Iké, Mark Bessire, and Lauri Firstenberg, eds. *Beyond Decorum: The Photography of Iké Udé*. Institute of Contemporary Art at Maine College of Art; MIT Press, 2000. Exhibition catalogue.

Vale, Ken. *Count Basie: Swingin' the Blues, 1936–1950*. Scarecrow Press, 2003.

Vargas, Mary. "Fashion Statement or Political Statement: The Use of Fashion to Express Black Pride During the Civil Rights and Black Power Movements of the 1960s." *Undergraduate Review* 5, no. 1 (2009): 95–99. https://vc.bridgew.edu /cgi/viewcontent.cgi?params =/context/undergrad_rev/article/1127 /&path_info=Vargas_v05_2009.pdf.

Voynovskaya, Nastia. "How the World Caught Up to Sylvester." KQED, April 11, 2019. https://www.kqed .org/arts/13854644/how-the-world -caught-up-to-sylvester.

Walden, George, and J. Barbey d'Aurevilly. *Who Is a Dandy?* Gibson Square Books, 2002.

Waldstreicher, David. "Reading Runaways: Self-Fashioning, Print Culture, and Confidence in Slavery in the Eighteenth-Century Mid-Atlantic." *William and Mary Quarterly* 56, no. 2 (1999): 243–72.

Way, Elizabeth, ed. *Black Designers in American Fashion*. Bloomsbury Visual Arts, 2021.

Way, Elizabeth, and Elena Romero, eds. *Fresh Fly Fabulous: 50 Years of Hip Hop Style*. Museum at FIT; Rizzoli, 2023. Exhibition catalogue.

Webb, Frank J. *The Garies and Their Friends*. Arno Press, 1969. Originally published in 1857 by G. Routledge.

White, Shane, and Graham White. *Stylin': African American Expressive Culture, from Its Beginnings to the Zoot Suit*. Cornell University Press, 1998.

Willis, Deborah. *Posing Beauty: African American Images, from the 1890s to the Present*. W. W. Norton, 2009.

Willis, Deborah. *Van Der Zee: Photographer, 1886–1983*. Harris N. Abrams, 1993.

Willis, Deborah, and Barbara Krauthamer. *Envisioning Emancipation: Black Americans and the End of Slavery*. Temple University Press, 2013.

Winch, Julie. *A Gentleman of Color: The Life of James Forten*. Oxford University Press, 2003.

Worthington, Norah. "Hidden in Plain Sight: Uncovering the Livery of Tilghman Davis and Thomas Brown." In *Spectrum of Fashion*. Maryland Historical Society, 2019. Exhibition catalogue.

Zaidi, Tariq. *Sapeurs: Ladies and Gentlemen of the Congo*. Kehrer, 2020.

ACKNOWLEDGMENTS

We are grateful to the many people who provided generous support for the exhibition *Superfine: Tailoring Black Style* and this associated publication. In particular, we are fortunate to have had the advice and encouragement of Max Hollein, Marina Kellen French Director and CEO of The Metropolitan Museum of Art; Jameson Kelleher, COO, CFO, and Treasurer; Quincy Houghton, Deputy Director for Exhibitions and International Initiatives; Andrea Bayer, Deputy Director for Collections and Administration; Whitney W. Donhauser, Deputy Director and Chief Advancement Officer; Inka Drögemüller, Deputy Director for Audience Engagement; Lavita McMath Turner, Chief Diversity Officer; and Anna Wintour, Met Trustee, Global Editorial Director, *Vogue*, and Chief Content Officer, Condé Nast. We offer our special gratitude to Louis Vuitton, Instagram, the Hobson/Lucas Family Foundation, Africa Fashion International and Dr. Precious Moloi-Motsepe, and The Perry Foundation for their generous sponsorship of the exhibition. Our heartfelt appreciation goes to Condé Nast for its longtime support of The Costume Institute. We would also like to thank Colman Domingo, Lewis Hamilton, A$AP Rocky, Pharrell Williams, and Anna Wintour, co-chairs of The Costume Institute Benefit, as well as honorary chair LeBron James. We are also grateful to André 3000, Chimamanda Ngozi Adichie, Simone Biles and Jonathan Owens, Jordan Casteel, Dapper Dan, Doechii, Ayo Edebiri, Edward Enninful, Jeremy O. Harris, Branden Jacobs-Jenkins, Rashid Johnson, Regina King, Spike Lee and Tonya Lewis Lee, Audra McDonald, Janelle Monáe, Jeremy Pope, Angel Reese, Sha'Carri Richardson, Olivier Rousteing, Tyla, USHER, Grace Wales Bonner, and Kara Walker, the Host Committee of The Costume Institute Benefit.

From the beginning, this exhibition has been an innately collaborative effort, from scholarship to design. Our sincerest thanks go to Torkwase Dyson for her highly inspired and innovative design of the exhibition; to Tanda Francis for her striking mannequin heads; and to exhibition creative consultant Iké Udé for his invaluable support. We are especially grateful for the generosity and guidance of the exhibition advisory board, including Christine Checinska, Jason Cyrus, Thelma Golden, Denise Murrell, Deborah Tulani Salahu-Din, and Jonathan Michael Square. Our deepest appreciation also extends to the "Voices," who contributed thoughtful and insightful essays to the exhibition catalogue, including Michael Henry Adams, Charlie Allen, André 3000, Marielle Bobo, Christine Checinska, Adrienne L. Childs, Jason Cyrus, Brent Hayes Edwards, Mary N. Elliott, Tremaine Emory, Ekow Eshun, Tanisha C. Ford, Lewis Hamilton, Jeremy O. Harris, Kimberly M. Jenkins, Gabriella Karefa-Johnson, Nigel Lezama, Kai Toussaint Marcel, Alphonso D. McClendon, madison moore, Denise Murrell, Soull and Dynasty OGUN, Richard J. Powell, Amy Sherald, Jonathan Michael Square, Carol Tulloch, Grace Wales Bonner, Elizabeth Way, Dandy Wellington, and Deborah Willis. Thanks to the design team at SAT3 Studio, including Tyler Dusenbury, Stefan Klecheski, and Alan Lucey, for their invaluable efforts to realize this project.

The Publications and Editorial Department of The Met, under the direction of Mark Polizzotti, Publisher and Editor in Chief, provided the guidance to bring this catalogue to fruition. We are especially grateful to Gwen Roginsky, whose vital expertise and steadfast oversight culminated in this publication. Our deepest appreciation also extends to Gwen's gifted team: editorial manager Elizabeth Levy and editor Jane Takac Panza; production managers Nerissa Dominguez Vales

ACKNOWLEDGMENTS

and Sue Medlicott; production designer Anna Rieger; image acquisitions specialist Elisa Frohlich Gallagher; and Lina Palazzo, who handled many administrative duties. Rachel High again provided valuable insights to the project while coordinating the marketing. Sincere thanks to Tyler Mitchell for his extraordinary photographs and to Zach Berry, Cas Cabrera, Landon Carter, Alexander Dorr, Zack Forsyth, Ben Gutierrez, Brandyn Liu, Jordan McCollough, Carlos Nazario, Madeleine Peacock, Julia Wagner, and Jackson Wakefield for their help in organizing the shoots. We were fortunate to work with Jim Gao, Eric Wei, and Sharon Ou, who oversaw the printing at Artron Printing in Shenzhen, China. Special thanks to Elizabeth Karp-Evans and Adam Turnbull of Pacific for their intelligent and understated design and art direction. Sincerest thanks also to Anna-Marie Kellen, Photographic Program Manager, and Mark Morosse, Senior Photographer, Imaging, for their photographs of accessories and artworks—images that were carefully retouched by Jesse Ng.

We are so grateful for the exceptional dedication and expertise of The Costume Institute team, without whom this exhibition would not be possible. We extend our deepest thanks to Clarissa Agate, William DeGregorio, Alexandra Fizer, Joyce Fung, Kaelyn Garcia, Amanda Garfinkel, Bethany Gingrich, Alyssa Hollander, Mellissa Huber, Ayaka Sano Iida, Mika Kiyono, Stephanie Kramer, Julie T. Lê, Kai Toussaint Marcel, Christopher Mazza, Marci Morimoto, Emily Mushaben, Rebecca Perry, Glenn Petersen, Michelle Ralph-Fortón, Laura Scognamiglio, Hector Serna, Elizabeth Shaeffer, Shelly Tarter, and Tracy Yoshimura.

We would like to extend our immense gratitude throughout The Metropolitan Museum of Art, especially to Gillian Fruh, Senior Manager for Exhibitions and the project manager for the exhibition. We also want to thank: Tom Scally, Buildings General Manager; Taylor Miller, Buildings Manager for Exhibitions; Maria Nicolino, Associate Buildings Manager; Marci King, Exhibitions Project Manager; and technicians John Meroney and Miroslaw Mackiewicz; Alicia Cheng, Head of Design, and her team of Maanik Singh Chauhan, Jourdan Ferguson, Chelsea Garunay, Amy Nelson, Sarah Parke, Maru Perez, Sarah Pulvirenti, and Alexandre Viault; Douglas Hegley, Chief Digital Officer, and his team of Melissa Bell, Peter Berson, Kaelan Burkett, Paul Caro, Kate Farrell, Reid Farrington, Isabella Garces, Lela Jenkins, and Brett Renfer; Meryl Cohen, Chief Registrar, and her colleague Becky Bacheller; Young Bae, Jennifer M. Brown, Kimberly Chey, Sarah S. Creighton, Kate Dobie, Jason Herrick, Stephen A. Manzi, Jane Parisi, Sarah Pecaut, Kate Thompson, and John L. Wielk in the Development Department; Scott Geffert, Imaging Department General Manager, and his team of Xue Chen, Chris Heins, Heather Johnson, and Wilson Santiago; Alyssa Santos and Kristen Vanderziel of the Visitor Experience Department; Heidi Holder, Frederick P. and Sandra P. Rose Chair of Education, and her colleagues Martina Lentino, Rebecca McGinnis, Mary Jaharis Senior Managing Educator, Accessibility, Elizabeth Perkins, Marianna Siciliano, Zev Slurzberg, Soo Hee Song, Kate Swanson, Sierra Van Ryck deGroot, and Sherri Williams; Jennifer Bantz and Briana Parker of the Editorial Department; Emily Balter, Caroline Chang, Cristina Del Valle, and Amy Lamberti in the General Counsel's Office; Marco Leona, David H. Koch Scientist in Charge, Department of Scientific Research, and research scientists Federico Carò, Adriana Rizzo, and Nobuko Shibayama; conservators Linda Borsch and Marina

Ruiz-Molina; Ann Bailis, Head of Communications, and her colleagues Rebecca Schear and Matthew Tom; Gretchen Scott, Head of Marketing, and her colleagues Taylor Latrowski, Feng Lu, Tiffany Lucke, Victoria Martinez, Micah Pegues, and Karen Vidangos; and Stephen Mannello, Head of Retail and Global Licensing, Emily Einhorn of Retail Sales, and Leanne Graeff of Merchandising. We would also like to thank C. Griffith Mann, Michel David-Weill Curator in Charge of the Department of Medieval Art and the Cloisters, and Melanie Holcomb; Sarah E. Lawrence, Iris and B. Gerald Cantor Curator in Charge, Department of European Sculpture and Decorative Arts, Joy Kim, and Iris Moon; Nadine M. Orenstein, Drue Heinz Curator in Charge, Department of Drawings and Prints, Ashley E. Dunn, and Liz Zanis; Stefan Krause, Arthur Ochs Sulzberger Curator in Charge, Department of Arms and Armor, Sean Belair, and John Byck, Marica F. and Jan T. Vilcek Associate Curator; and Jeff L. Rosenheim, Joyce Frank Menschel Curator in Charge, Department of Photographs, Zalika Azim, Lexi Brown, Karan Rinaldo, and Candice Yates.

We would like to express our sincere appreciation to the docents of The Costume Institute, including Peri Clark, Ronnie Grosbard, Francesca Gysling, Ruth Henderson, Dorann Jacobowitz, Betsy Kahan, Linda Kastan, Stephanie Katz, Mary Massa, Cynnie Ogden, Ginny Poleman, Celia Rodrigues, Eleanore Schloss, and Charles Sroufe. We want to especially thank conservation fellow Margherita Barone and interns Aniyah Smith and Anathea Woirhaye.

We are grateful for the ongoing support of Friends of The Costume Institute, effortlessly chaired by Wendi Murdoch and co-chaired by Eva Chen and Mark Guiducci. Sincerest thanks also to Lizzie and Jonathan Tisch for their enduring support.

We are extremely grateful to our lenders: 3.PARADIS (Emeric Tchatchoua, Taylor Yu); Addison Gallery of American Art, Phillips Academy (Allison Kemmerer, Gordon Wilkins, James M. Sousa); Agbobly (Jacques Agbobly); Air Afrique Club; Jawara Alleyne; Balmain (Olivier Rousteing, Marie Valot Kouby, Julia Guillon); Jeffrey Banks; Bianca Saunders (Nina Verano); BOTTER (Rushemy Botter and Lisi Herrebrugh, Iulia Matiukhina, Marijn Rikken); Bowdoin College Museum of Art (Anne and Frank Goodyear, Laura J. Latman, Theresa Choi); Brandon Murphy Collection (Brandon Murphy); Casely-Hayford (Maria, Charlie, and Alice Casely-Hayford); The Charleston Museum (Carl Borick, Virginia Theerman, Jennifer McCormick, Jude Arendall); Château des ducs de Bretagne, Musée d'histoire de Nantes (Bertrand Guillet, Krystel Gualdé, Anne Bouille); Willy Chavarria (Cathy Lee, Sarah Carbonaro, Danielle Hoppenheim); Chrysler Museum of Art (Erik H. Neil, Mark A. Castro); Cifonelli (Lorenzo Cifonelli, Romain Le Dantec); Cooper Hewitt Smithsonian Design Museum (Maria Nicanor, Christina De Leon, Antonia Moser); Cummer Museum of Art & Gardens (Andrea Barnwell Brownlee, Holly Keris, Rachel Bradshaw); Denim Tears (Tremaine Emory, Tatum Dorrell, Daniel Corrigan); denzilpatrick (Daniel Gayle and James Bosley); Marvin Desroc; Diktats (Antoine Bucher, Nicolas Montagne); Reed Evins; Adrien de Felcourt; Fenimore Art Museum (Paul S. D'Ambrosio, Julia Madore, Cassidy Percoco); Ferragamo (Maximilian Davis, Marco Gobbetti, Stefania Ricci, Ludovica Barabino); Flint Institute of Arts (Tracee Glab, Sarah Kohn, Lori Motley, Peter Ott); Frederick Douglass National Historic Site, Department of the Interior, National Park Service (Tara Morrison, Mike Antonioni); GLBT Historical Society (Ramon Silvestre); Michael Graham-Stewart; Harry Ransom Center at the University of Texas at Austin

ACKNOWLEDGMENTS

(Stephen Enniss, Tracy Bonfitto, Ester Harrison); Hip Hop Museum (Prime Minister Pete Nice); Historical Society of Pennsylvania (David R. Brigham, Steve Smith); The Historic New Orleans Collection (Daniel Hammer, Lydia Blackmore, Mallory Taylor, Beth Bahls); Howard University Gallery of Art (Dr. Benjamin Talton, Kathryn E. Coney-Ali); Kenneth Nicholson (Brooke Ochoa); Kwasi Paul (Samuel Boakye); LABRUM London (Foday Dumbuya, Aneta Pejcharova); LaQuan Smith (Jacqueline Cooper, Krystal Taylor); Latimmier (Ervin Latimer); L'ENCHANTEUR (Soull and Dynasty OGUN); Quin Lewis; The Lewis Walpole Library, Yale University (Nicole L. Bouché, Cynthia Roman, Kristen McDonald); Library Company of Philadelphia (John C. Van Horne, Sharon Hildebrande, Sarah Weatherwax, Erika Piola); Library System, University of Puerto Rico, Río Piedras Campus (Abreu Báez, Aura M. Díaz-López); Los Angeles County Museum of Art (Michael Govan, Sharon Takeda, Clarissa Esguerra, Marisela Ramirez); Louis Vuitton (Pharrell Williams, Imed Soussi); Louis Vuitton Malletier (Alix Blechet, Clémence Bachollet); LUAR (Raul Lopez, Keyla Exclusa); Mains (Skepta); La Maison de l'histoire européenne (Constanze Itzel); Maryland Center for History and Culture (Katie Caljean, Paul Rubenson, Catherine Rogers Arthur, Katie Campbell, Abby Doran, Martina Kado, Mallory Harwerth); Ivy Coco Maurice; Maurice Sedwell (Andrew Ramroop); The Menil Collection (Rebecca Rabinow); Musée Alexandre Dumas (Franck Briffaut, Cyrielle Danse, Yorgos Argyriadis); Musée Bonnat-Helleu (Emma Delgado, Hélène Ferron, Aurélia Botella, Sabine Cazenave); Musée des Beaux-Arts, Dunkerque (Sophie Warlop, Claude Steen-Guélen, Claudia Duponchel, Kevin Milnik); The Museum of Modern Art (Glenn D. Lowry, Tasha Lutek); Saul Nash; The National Gallery of Art (Kaywin Feldman, Sarah Greenough, Paula Binari); National Museum of African American History and Culture, Smithsonian Institution (Kevin Young, Elaine Nichols, Klarissa Ruiz, Laura Mina); New York Public Library (Anthony W. Marx, Alexander Garcia, Joy Bivins, Tammi Lawson, Kassidi Jones, Barrye Brown, La Tanya Autry, Maira Liriano, Jack Patterson); North Carolina Museum of History (J. Bradley Wilson, Michael Ausbon, Camille Hunt); NSU Art Museum (Bonnie Clearwater, Jordyn Newsome); Off-White (Ibrahim Kamara, Simon Lee, Eleonora Silvestri); Ozwald Boateng (Angelica Colucci, Tiffany Siaw-Misa); Pocumtuck Valley Memorial Association (Tim Neumann, Ray Radigan); PUMA SE (Ulrich Planer, Sonja Huegel); Ralph Lauren Corporation (Ralph Lauren, James Jeter, Allison Johnson); Reese's Vintage Pieces (Benny Reese); The Rhode Island Historical Society (C. Morgan Grefe, Richard Ring, Luis Vasquez); Martine Rose; Sid Sankaran; Special Collections and University Archives, University of Massachusetts Amherst Libraries (Nandita Mani, Danielle Kovacs, Kirstin Kay); Telfair Museums (David A. Brenneman, Erin Dunn, Elyse Gerstenecker, Jennifer Levy, Snow Fain); TELFAR (Telfar Clemens, Ashley Lee); Theophilio (Edvin Thompson, Norie Williams); Alexis Thomas; Virginia Museum of Fine Arts (Alex Nyerges, Sylvain Cordier, Michael Taylor, Nancy Nichols, Howell Perkins); Wales Bonner (Grace Wales Bonner, Aisling Connell, Ly Mai); Mark Wallis; Dandy Wellington; Who Decides War (Ev Best and Téla D'Amore); and The Wolfsonian–Florida International University (Tiarna Doherty, Silvia Barisione, Kimberly J. Bergen).

For their guidance, expertise, and generosity, our sincere gratitude also extends to Paloma Alarco, Kate Anderson, Michael Ausbon, Raúl Àvila, Keith Baptista, Lynn Bassett, Nia Beckett, Beatrice Behlen, Esther Bell, Lucy Bishop, Bonaveri, Mar Borobia, Brandon W. Brooks, Denis Bruna, Eaddy Kiernan Bunzel, Rose Carlisle, Olivier Cheng, Paul Clammer, Martina D'Amato, Victoria Damidot, Katy Darr, Marlene Daut, Nathalie Elmaleh, Rachel Elwes, Lila Frost, Nichol J. Gabor, Cy Gavin, Olivia Ghosh, Imogen Gibbon, Titi Halle, Leila Heller, Colleen Hill, Kerby Jean-Raymond, Matthew Keagle, Benjamin Klemes, Sergio Kletnoy, Hildy Kuryk-Bernstein, Ned Lazaro, Justin Levine, Baz Luhrmann, Katherine Mandel, Catherine Martin, Derek McLane, Sosi Mehren, Siobhan Meï, Laura Mina, Mkunde Nicole Mngodo, Elaine Nichols, Alden O'Brien, Kwame Onwuachi, Jonquil O'Reilly, Alexandra Palmer, Wayne Phillips, Jessica Pochesci, Jessica Pushor, Elizabeth Randolph, Ricardo J. Reyes, Neal Rosenberg (DK Display), Tico Seifert, Elizabeth Semmelhack, Phoebe Shardlow, Diane Shewchuk, Stefan Siegel, Jeremy K. Simien, Jennifer Swope, Sache Taylor, Laurent Teboul, Christina K. Vida, Becky Wehle, Jill Weiskopf, Lauren Whitley, Gordon Wilkins, Peter Wisbey, and Anna-Lisa Yabsley.

Monica would particularly like to thank Andrew Bolton, whose invitation to do this work ignited her imagination and indelibly expanded the impact of her scholarship and teaching. His guidance and wise, witty advice enabled her to approach this project with wonder, confidence, and curiosity—which was a real gift. She is also grateful to Andrew for trusting her with his colleagues William DeGregorio, Amanda Garfinkel, and Kai Toussaint Marcel. Monica treasured their curatorial partnership. Their dedication and tenacity impress; their kindness was cherished.

Monica's greatest thanks is, of course, to her family. Carl, Langston, and Selma have encouraged and cared for her during this wonderful, busy time. Their love sustains and inspires.

For their ongoing support, Andrew would like to extend his deepest and heartfelt thanks to Paul Austin; Marion and Harry Bolton; Miranda, Ben, Issy, and Emily Carr; Christine Coulson; Brooke Cundiff and Michael Hainey; Alice Fleet; Harold Koda; Alexandra and William Lewis; Shannon Bell Price; Rebecca Ward; Sarah Jane Wilde; and especially Thom Browne.

MONICA L. MILLER AND ANDREW BOLTON
Guest Curator and Curator in Charge
of The Costume Institute

This catalogue is published in conjunction with *Superfine: Tailoring Black Style*, on view at The Metropolitan Museum of Art, New York, from May 10 through October 26, 2025.

The exhibition is made possible by

LOUIS VUITTON

Major funding is provided by Instagram, the Hobson/Lucas Family Foundation, Africa Fashion International, founded by Dr. Precious Moloi-Motsepe, and The Perry Foundation.

Additional support is provided by

CONDÉ NAST

Published by The Metropolitan Museum of Art, New York
Mark Polizzotti, Publisher and Editor in Chief
Peter Antony, Associate Publisher for Production
Michael Sittenfeld, Associate Publisher for Editorial

Publication Management by Gwen Roginsky
Project Coordinated by Rachel High
Editorial Management by Elizabeth Levy
Edited by Jane Takac Panza
Designed by Elizabeth Karp-Evans and
 Adam Turnbull, Pacific
Production by Nerissa Dominguez Vales and
 Sue Medlicott, The Production Department
Production Design by Anna Rieger
Image Acquisitions and Permissions
 by Elisa Frohlich Gallagher

Photography by Tyler Mitchell
Additional photography by Anna-Marie Kellen
 and Mark Morosse
Additional photography credits appear on page 361.

Typeset in Adobe Garamond Pro, ABC Arizona Text,
 and Kuenstler Script
Separations by Altaimage, London/New York
Printed and bound by Artron Art Printing (HK)
 Limited, Shenzhen

Front cover: Wales Bonner. Grace Wales Bonner. *Ensemble* (detail), spring/summer 2017. p. 123, Tyler Mitchell (2025)

Back cover quotation: Olaudah Equiano, *The Interesting Narrative of the Life of Olaudah Equiano, or Gustavus Vassa, the African. Written by Himself.* Originally published 1789

p. 2: Daniel Orme, after a composition by William Denton. Frontispiece to *The Interesting Narrative of the Life of Olaudah Equiano, or Gustavus Vassa, the African. Written by Himself* (detail), 1789. p. 49, fig. 1

The Metropolitan Museum of Art endeavors to respect copyright in a manner consistent with its nonprofit educational mission. If you believe any material has been included in this publication improperly, please contact the Publications and Editorial Department.

Copyright © 2025 The Metropolitan Museum of Art, New York

Photography © 2025 Tyler Mitchell
"The Fabric of Our Lives" © 2025 by Gabriella Karefa-Johnson
"Sartorial and Aesthetic Sympathies" © 2025 by Iké Udé
"Kofi: The Sartorial Frame" is excerpted from "Kofi, Three of Ten Frames," which was first published in *Alphabet* magazine's inaugural issue, June 2024. Reprinted with permission.

First printing

All rights reserved. No part of this publication may be reproduced or transmitted in any form or by any means, electronic or mechanical, including photocopying, recording, or any information storage and retrieval system, without permission in writing from the publishers.

The Metropolitan Museum of Art
1000 Fifth Avenue
New York, New York 10028
metmuseum.org

Distributed by Yale University Press, New Haven and London
yalebooks.com/art
yalebooks.co.uk

Authorized Representative in the EU:
Easy Access System Europe, Mustamäe tee 50,
10621 Tallinn, Estonia,
gpsr.requests@easproject.com

Cataloguing-in-Publication
Data is available from the
Library of Congress.
ISBN 978-1-58839-799-7